The Cineaste Interviews

on the art and politics of the cinema

The Cineaste Interviews

on the art and politics of the cinema

Dan Georgakas
Lenny Rubenstein

Lake View Press
Chicago

For Gary Crowdus
founder of Cineaste

ISBN 0-941702-02-2 (hard)
0-941702-03-0 (soft)
Library of Congress 82-83804
Design by Larry Smith

Editorial Assistance:
Rod Such
Harvey Teres

Photographs courtesy of:
Cinema 5, Columbia Pictures Industries, Inc.
Judy Janda, Libra/Specialty,
Museum of Modern Art/Film Stills Archive,
New Yorker Films, John Springer Associates,
Universal City Studios, Inc.

Americom Typesetting, Ltd.
Printed by BookCrafters

LAKE VIEW Press
p.o. box 578279
Chicago, Illinois 60657
CAN 230 2400

CONTENTS

Roger Ebert: *Foreword* vii

Dan Georgakas, Lenny Rubenstein: *Preface* xi

1—Constantin Costa-Gavras: *More and more of our films
 will be political* 3

2—Glauber Rocha: *Cinema Novo vs. cultural colonialism* 10

3—Miguel Littin: *Film in Allende's Chile* 24

4—Bernardo Bertolucci: *I am not a moralist* 33

5—Ousmane Sembene: *Filmmakers have a great
 responsibility to our people* 41

6—Elio Petri: *Cinema is not for an elite, but for the masses* 53

7—Constantin Costa-Gavras (2): *A film is like a match,
 you can make a big fire or nothing at all* 64

8—Dusan Makavejev: *Let's put the life back in political life* 77

9—Gillo Pontecorvo: *Using the contradictions
 of the system* 87

10—Alain Tanner: *Irony is a double-edged weapon* 98

11—Jane Fonda: *I prefer films that strengthen people* 105

12—Francesco Rosi: *The audience should not
 be just passive spectators* 119

13—Lina Wertmuller: *You cannot make the revolution
 on film* 130

14—Bernardo Bertolucci (2): *The poetry of class struggle* 138

15—Roberto Rossellini: *Marx, Freud and Jesus* 149

16—Tomas Gutierrez Alea: *Individual fulfillment
 and collective achievement* 155

17—Gordon Parks: *Beyond the Black Film* 173

18—Rainer Werner Fassbinder: *I let the audience feel and think* 181

19—John Howard Lawson: *Organizing the Screen Writers Guild* 188

20—Paul Schrader: *"Blue Collar"* 205

21—Agnes Varda: *"One Sings, the Other Doesn't"* 216

22—Bertrand Tavernier: *Blending the personal with the political* 225

23—Andrew Sarris: *Confessions of a middle class film critic* 232

24—Bruce Gilbert: *Hollywood's progressive producer* 248

25—Jorge Semprun: *The truth is always revolutionary* 265

26—Vincent Canby: *The power of the* Times *critic* 282

27—John Berger: *The screenwriter as collaborator* 298

28—Gillo Pontecorvo (2): *Political terrorism in "Ogro"* 307

29—Andrzej Wajda: *Between the permissible and the impermissible* 313

30—John Sayles: *Counterculture revisited* 325

31—Krzysztof Zanussi: *Workings of a pure heart* 333

32—Molly Haskell: *Film criticism and feminism* 340

33—Budd Schulberg: *The screen playwright as author* 360

34—Satyajit Ray: *In retrospect* 380

35—Constantin Costa-Gavras (3): *"Missing"* 390

Index to interviews in *Cineaste* 397

FOREWORD

By Roger Ebert

Cineaste has always been known as the film magazine with a particular interest in politics, and the following interviews for the most part are intended to consider the political aspects of the subjects' careers. Yet one of the truest lines quoted in the interviews, and one of the few with which I suspect most of the people in this book might agree, is Andrew Sarris' statement, "Art and Revolution. Choose one. I choose Art." For whatever their reasons, most of the directors, writers and actors in these *Cineaste* interviews have chosen to make movies rather than to engage in direct political action. Some of them may view their filmmaking as a form of political action, and some films of course have political consequences, but making a film is such a cumbersome form of political expression that unless the maker has some additional purpose in mind, it can be a waste of energy. To move from the barricades to the movie location requires an artistic commitment that is often more complex than it seems.

To make a "political film" is one thing. But observe here how all even avowedly political directors want to make a good political film. And isn't it true that the better a film is, the less it seems limited to its specific political context, the more it seems to embrace universal human emotions? Isn't it possible that for every member of the audience who saw *Battle of Algiers* as a consideration of the Algerian question, fifty saw it as an absorbing human story in the form of a thriller? Satyajit Ray observes with some astonishment that his *Apu Trilogy* was of interest even to non-Bengalis. Yes, and I would add, even to many who did not know precisely what a Bengali was.

Carlos Diegues, the Brazilian director, has observed, "The more specifically national a film is, the more international it is." The reverse also holds. "International co-productions" inevitably seem to belong to no time, no place, and no creative mind, and to be paralyzingly provincial. But the close and sympathetic observation of specific human behavior in a particular place and time is often of universal interest. Ousmane Sembene has made some of the most specific films I have ever seen, films that come directly out of his experience

of Senegal. He does not speak very much here of the political content of his work, but his voice can almost be heard glowing from the page as he explains what he means by "the music of the wind":

> The whites, for example, have music for everything in their films—music for rain, music for the wind, music for tears, music for moments of emotion, but they don't know how to make those elements speak for themselves. They don't feel them. But in our own films we can make the sensation of these elements felt, without denaturing the visual elements, without broadcasting everything to the audience.... In *Emitai,* when the women are forced by the soldiers to sit out in the sun, the only sound you can hear is the sound of the rooster and the weeping of the children; however, there was also the wind. I did not look for music to engage the audience. I just wanted to show, by gestures, that the women are tired, their legs are tired, their arms are burdened—one woman has the sun shining in her eyes, another two are sleeping. All this is shown in silence, but it is a silence that speaks.

There is a political statement in the scene that Sembene describes, and it is made by his style as much as by his narrative content. For Sembene himself, there is a political significance in the absence of sound track music—a statement most audiences cannot be expected to interpret, although Sembene, interpreting it himself in the *Cineaste* interview, reveals how politics are contained more in specific artistic detail than in "messages."

"You cannot make a message picture," Sidney Poitier has said. "A message picture is a statement, a preachment, a speech without entertainment values unless you make some laughs as you go along." Well, right and wrong. You can make a message picture, but then what you have is a message picture. Since the message is usually well-known to the audience before it enters the theater, and can be divined in the opening scenes of the film, and is usually a message that the audience (having paid to see the film) is already in agreement with, the question is not whether you can make a message picture, but why you should bother to go to the effort.

The "good" political movies are not message pictures, because they are too muddy with human ambiguities. Istvan Szabo's *Mephisto* resembles uncounted Eastern European films in that it uses the Nazis as subject matter. The difference is that Szabo's film is actually about Nazis. The Nazis have had to stand for so many things

in films from Hungary, Poland, East Germany, Czechoslovakia and Bulgaria that it is rare to find them being themselves. Szabo arrives at that achievement by considering them as individuals. His hero, an actor who sells his soul to rise in the Nazi theatrical establishment, while all the time protesting his "personal" liberalism, works better to explain the Nazi phenomenon than most of the other Nazi movies put together. *Mephisto* has no message that I can find. It says, this is what this man did, and here is what happened to him as a result.

Many of these interviews make the same point, sometimes unintentionally. As we read Paul Schrader observing with surprise that *Blue Collar* came to "a very specific Marxist conclusion," and Dusan Makavejev declaring, "More than ever I believe that film should in the spirit of Wilhelm Reich unite with revolutionary movements all over the world," we can wonder privately whether Schrader cared as much about his Marxist conclusion as about the dramatic surprise of the scene in which Yaphet Kotto is spray-painted to death, or whether Makavejev was really thinking about Reich when he hit on the image of the ice skater beheaded by her own blades. I suspect that with all good directors, the spirit of the artist dominates on the location, and the philosopher emerges only in the post-mortem interview.

Perhaps as a consequence, these interviews move from the general to the specific with almost astonishing speed. I have the impression that in many cases the interviewers set out with general political questions in mind, but that they, and their subjects, found themselves almost at once distracted by the wonderful appeal of the particulars.

Film is not made of ideas but of moments, of a time of day, the angle of a head, the cast of the sun, the sound of a voice, the expression on a face, the voodoo of a location. Filmmakers, asked about those moments, will almost inevitably be reminded, not of the theoretical purpose of a shot, but of the realities during the filming of the scene. It is probably a given of the genre that interviews with directors quickly descend from the philosophical to the anecdotal. What we have here are a group of filmmakers remembering the people they worked with, and the people they worked to create on the screen. Most of the filmmakers represented in this book hoped, by and large, to make movies that would share with the audience their vision of some of the preferable possibilities in being alive. None of these filmmakers devoted their careers to demeaning and exploiting their audiences. There is where the politics come in.

THE *CINEASTE* INTERVIEWS

Preface

The art and politics of the cinema have been the twin concerns of *Cineaste* ever since its founding in 1967. We feel that most American film criticism has not provided the political analysis demanded by films with overt political content and that criticism has failed to cope with the complex social context from which new cinemas have emerged in nations as diverse as Cuba, India and Senegal. Pronouncements like the famous Hollywood axiom that "if you want to send a message, use Western Union" have obscured the reality that Hollywood more than any other film center has effectively disseminated its particular social messages into every area of the globe.

Cineaste has made extensive use of the interview as a critical tool to address questions of form and content. Our objective has been to do the interview soon after a film's completion in order to get a fresh and detailed account of the filmmaker's aesthetic and political choices. A long term benefit has been to establish a kind of data bank from which responsible criticism can draw. An indication of the need for such a record was manifested in 1982 when *Commentary* magazine carried a long attack on Costa-Gavras charging him with, among other things, misleading the American public on the nature of his radicalism. Examination of any of the three interviews here, the earliest dating to 1969, shows that Costa-Gavras has been exceptionally and consistently frank about his beliefs and purposes. On the occasions when such candor has not been forthcoming from other filmmakers, the manner in which they express their views and the nature of their evasions can be instructive. An argument might be made that filmmakers often do not comprehend the full cultural implications of their own work or tend to emphasize those aspects most congenial to the particular interviewer. Granting this is sometimes so, it is still important to know what the creator thought the film was doing or what he or she wanted the audience to think was important.

The most frequent interview opportunity for us has been at the time of a commercial opening of a new film in New York or at a major film festival. These interviews usually deal with a single film at

some length and relate that film to previous work and current political events. Less frequent has been the more inclusive career interview, usually possible upon the publication of a book, during a major retrospective, or at a time when the filmmaker is undergoing a major shift in orientation. In a number of instances we have been able to interview the same person at regular intervals and have sought to record the developing range of concerns and diverse work methods. When considering the various ways the interviews in this book might be organized, we finally opted for a chronological approach in order to use multiple interviews with one filmmaker in the most logical sequence. Chronological order also provides a sense of the artistic and political currents felt by various individuals as they moved from project to project. In some ways the collection provides a kind of cardiogram of the political cinema of the fifteen years highlighted.

Our approach to interviews, whether conducted by staff or accepted from free-lance contributors, has been to regard them as literary forms rather than public relations or informal journalistic events. The emphasis has been on films rather than personalities, on completed projects rather than planned projects, and on specifics rather than generalities. We have avoided abstract ideology and theory in favor of how abstract concepts were manifested in particular films. Anecdotal chitchat and showbiz hoopla have been discouraged. Considerable effort has been spent on devising demanding questions which would not be hostile or antagonistic, for that would be counterproductive to achieving a fruitful dialog. The transcript of the interviews has been treated like raw footage that requires considerable editorial work to obtain a final cut for the public. This process entails consolidating separate answers into one longer response, rearranging the order of questions for increased lucidity, and paring down the length of questions (even when the interchange which called forth the answer was a prolonged one). Whevenever possible the interviews have been returned to the interviewee for approval, changes, and additions. The thought has been that the final product should be a podium for the interviewee to present his or her views and not a showcase for the scholarship and wit of the interviewer.

Although the largest number of interviews are with directors, *Cineaste* does not agree that the director-as-auteur theory is a very satisfactory approach to understanding how the final thematic and aesthetic particulars of a film are determined. The concept of a single

author is borrowed from literature where the creator is usually self-evident and where production considerations are usually of minor consequence to the style or content of the work. The creation of motion pictures is more akin to the collaborative model seen in the creation of ballets and operas, where an ensemble shapes the final product and where production concerns are major considerations. Unlike either of these forms, or the theater, cinema has only one recorded performance, greatly elevating the importance of those who mount the production. To deny that the director is the chief creative force in many films would be boorish, but it is just as boorish to apply that claim to the many films shaped by other influences. Just limiting alternative examples to the old Hollywood studio system, there is the studio style such as the old Warner Brothers and MGM "looks," the impact of the star system, and the resonances furnished by talented supporting actors accustomed to working together. Certain writer/director and cinematographer/director teams are other phenomena not sufficiently commented upon. The unusual discussion which has arisen about who was the chief creator of *Citizen Kane*, if indeed one person can be so credited, is one that could be extended to many notable films.

As a consequence of our views of auteur theory, even in our director interviews we are less concerned with elaborating on individual idiosyncrasies than with how the directors approach the overall conceptualization of their films and the nature of their collaboration with other key creative personnel. A theme frequently probed is to what degree auteur theory has unfairly eclipsed the actual or potential importance of the screenwriter. We have observed that filmmakers with very strong political views and those involved in emerging cinemas often are far more sensitive to the complex of forces shaping their films than those working within the Hollywood context, where individual celebrity is part of the marketing strategy and where geniuses come cheaper by the dozen.

Four of our interviews are with critics. Vincent Canby discusses the role of the *New York Times* critic as a cultural institution. That particular interchange grew out of another interview in which Bernardo Bertolucci took American film critics to task. The discussion with Andrew Sarris questions one of the earliest champions of auteur theory on how he views its popularity and interpretation in the industry, universities, and the press. Molly Haskell addresses the impact of sexism on film production, touching some of the same themes Jane Fonda was concerned with some years before. The

interview with John Berger, who has written extensively about various visual arts, allows a Marxist critic to put film into a broader theoretical perspective. Berger is also asked about his work as a scriptwriter on some of the films of Alain Tanner.

Some omissions from the collection require comment. Most notably, although *Cineaste* has done many interviews with outstanding documentary filmmakers, none are included. We have argued that documentaries are in no way inferior to feature films and that they present unique aesthetic, commercial, and political challenges. However, a book at least as long as the present one would be needed to deal adequately with documentary production. Rather than treat documentarians in a cursory manner, we thought it wiser to index our interviews for reference purposes and to plan for an entire book on documentary filmmakers at a later date. Space considerations also have forced us to exclude some filmmakers still at the onset of their careers, shorter interviews focused on narrow topics, and interviews with exhibitors, publicists, and others peripheral to the creative process. These interviews are also indexed. Finally, there are major film personalities, such as Jean-Luc Godard, and some major cinemas, such as Japan's, for which we lacked interview opportunities.

Among the first of many political leaders to realize that film would be the most popular art of the twentieth century was V. I. Lenin. What Lenin did not foresee was that for many decades American films would dominate the world market. The values exemplified by American cinema would enter everyday life as a kind of prepackaged mythology which had an amazing ability to use itself for continuous reference and validation. When this hegemony came to an end in the wake of World War II, filmmakers advocating social change had to determine if it was desirable or even possible to use Hollywood's established forms for their own ends or if it would be better to create variations or entirely new approaches. Even those sharing the same general political outlook might opt for entirely different strategies and do so without necessarily condemning one another's choices. They realized that different options involved different advantages and risks. In the interviews collected in this book, filmmakers discuss the reasoning behind their decisions and the responses elicited by those decisions.

—Dan Georgakas
—Lenny Rubenstein

The
Cineaste
Interviews

on the art and politics of the cinema

1—CONSTANTIN COSTA-GAVRAS

More and more of our films will be political

Constantin Costa-Gavras (b. 1933) left his native Greece at age nineteen to study in Paris. He soon abandoned literary studies for film, enrolling at l'Institut des Hautes Etudes Cinematographiques (IDHEC). Later he was an assistant to Marcel Orphuls, Rene Clair, and Rene Clement. His first film, a thriller titled Compartiment Tueurs (The Sleeping Car Murders), *was released in 1964, and the cast included Simone Signoret, Yves Montand, Jean-Louis Trintignant, and Charles Denner. His second film,* Un Homme de Trop (One Man Too Many), *dealing with the resistance movement in occupied France, appeared in 1966 and indicated the kind of subject Costa-Gavras excelled at depicting on the screen. Retitled* Shock Troops *by United Artists, the film was never widely seen in the United States. In 1969, however,* Z *was a critical and commercial sensation, winning the Academy Award for best foreign film. The Greek colonels had been in power for more than two years by this time, and the film greatly aided in publicizing the international movement aimed at removing them. The interview with Costa-Gavras was conducted by Gary Crowdus, the founder of* Cineaste, *and, making his first* Cineaste *contribution, Dan Georgakas, then a spokesperson for anti-junta groups in the United States. Georgakas had been in Greece at the time of the Lambrakis Affair, the real-life murder upon which* Z *is based. The interview was primarily in English with some sections in French or Greek.*

Cineaste: *What were your reasons for making Z?*

Constantin Costa-Gavras: The main reason for making *Z* was my Greek origins, of course. I can't see how anyone without those origins could possibly have made such a film. I had been concerned about the Lambrakis murder ever since it occurred in 1963, but after the military coup of 1967, I wanted to do something concrete against the dictatorship. I had also been troubled by the murder of Ben Barka in Paris during the fall of 1965. There were many parallels with Greek events, but the Lambrakis murder had all the classic elements of political conspiracy posed most clearly. It had police complicity, the disappearance of key witnesses, corruption in government—all those kinds of things. There was the additional question of the way some men make culprits of others. Most important for me was that the Lambrakis affair had a conclusion. There was a trial which produced concrete testimony and evidence. This was not so in the case of Ben Barka or some of the assassinations in the United States.

Cineaste: *You mention a parallel with the Ben Barka affair. Were you influenced by the John F. Kennedy assassination? The murder scene, for instance, is shown several times and one of the 'replays' is a slow motion, almost frame-by-frame analysis that bears striking similarities to the Zapruder films taken of the JFK assassination.*

Costa-Gavras: People here have often mentioned Kennedy, but in Europe no one has really seen the Zapruder films. I hadn't thought of them as having any influence on me. I was more interested in showing how an important event is perceived. First we see it as it actually took place, then as the general retells it, and finally, as a lawyer friend of *Z* remembers it. The last viewpoint is the most interesting, for the man is trying to be very factual. He does not say he saw this or that but that he *thought* he saw this or that. The lawyer strives to eliminate new information he has learned since the event and he excludes uncertain details.

Cineaste: *It's interesting that Europeans don't see this sequence in relation to the Zapruder film and that Americans would not be likely to see it in relation to the Ben Barka affair.*

Costa-Gavras: Yes, none of the reviewers here has mentioned Ben Barka.

Cineaste: *The dramatic focus of the film is not Lambrakis but the investigating judge. Could you explain why you chose that dramatic framework?*

Costa-Gavras: I thought that showing the story through the investigating judge would be the most effective way of revealing the political situation in Greece. My film hoped to probe the mechanics of political crime. If I had wanted to do justice to the achievements of Gregory Lambrakis, I would have had to make a far different film, a film of his life. I didn't set out to do that. I wanted to study the mechanics. And the investigating judge was truly an incredible character. At any point he was free to halt his investigation. He was quite crucial to the expose of the police. He was a man of the Right, a man of the Establishment, but he was an honest man.

Cineaste: *Your first film,* Sleeping Car Murders, *was a detective thriller which* Z *resembles in its dramatic construction. Do you have a penchant for this type of film or did you think more people could be reached if a political film was presented in this manner?*

Costa-Gavras: It was neither of those. From the time Lambrakis was struck until the time he died three days later, there was intense suspense throughout Greece. The unraveling of the conspiracy was something that was followed daily in the press. It was nothing I interjected. That was how events took place.

Cineaste: *But there were many things that happened that you didn't show. There were public demonstrations, particularly the mammoth funeral in Athens.*

Costa-Gavras: But I didn't have half a million extras.

Cineaste: *Wasn't it possible to use newsreel footage to depict the funeral? It's a popular device now.*

Costa-Gavras: As I said before, from the beginning we had decided to do the film as a study of political crime. We did not want sentimental feeling to interfere with that. Had we shown the funeral the film would have been more revolutionary, but also more sentimental. It was really after the events in the film that the Lambrakis Youth Movement developed into an important force in Greece. As for newsreel, we had also decided from the beginning that it would be a completely directed film with well-known actors playing the major roles. I do not like the use of documentary material in a film like this because it cheapens it. I have been working on a documentary, however, which deals with the funeral of George Papandreou. Most of the footage was shot by Greeks hidden in the crowd and then the film was brought out of Greece secretly. But that is something altogether different. That will be a documentary film.

Cineaste: *The musical credits state that the music for the film is original work by Mikis Theodorakis, but the songs are some of his*

best known and most popular — isn't this all music he had composed earlier?

Costa-Gavras: Exactly. The music is not original. I don't know about the presentation of it as original. All the Greeks will recognize the songs at once.

Cineaste: *There's an interesting placement of music early in the film. When a black tie crowd comes out of the Bolshoi Ballet you use music from a song that mocks the good Germans of the Nazi era. Obviously you are striking out at the upper class of Thessaloniki which is enjoying ballet at the moment Lambrakis is being killed elsewhere in the city. Are you also criticizing the Soviet Union?*

Costa-Gavras: It's more complicated than that. Lambrakis was in complete agreement with the Soviet Union on a number of issues, including certain positions on Greece. The proof of this is that he scheduled his meeting for the same night as the opening of the Bolshoi in Thessaloniki. I think this is an important point to make.

Cineaste: *You've also made a point out of the homosexuality and pederasty of one of the killers. Did you take some liberty in portraying him quite as obnoxiously as you do?*

Costa-Gavras: Quite the opposite. We didn't want to stress the fact that he was homosexual. Certainly we aren't saying that homosexuals are dangerous people or rightists. We had to tone down some of this individual's characteristics to make him more credible. His homosexuality was important because it was the factor which made him a lackey of the police. He was a victim himself. We might have stressed his victimization more, but after all, he was the man who murdered Lambrakis.

Cineaste: *Were there other things which you chose to omit or tone down?*

Costa-Gavras: Many, but these were things which would have detracted from the film's effect and credibility. When the general was brought for questioning he had a pistol with him which he waved about shouting that he would commit suicide if there was an indictment. That was really too incredible to include...something you might expect in a poor Western. At another point, the investigating judge asked him what he had done a particular morning and he answered, "I was looking for my long underwear." Those things would have made him look too foolish. There were other omissions concerning Lambrakis himself. He ran a free clinic for the poor every week. Just before he was killed a little old woman had asked him to look at her sick son and he had agreed to come first thing the next

morning. That would have been far too sentimental for the film even though it actually happened. John F. Kennedy sent a telegram to the widow expressing sorrow at the tragedy. At one point we mentioned there had been a telegram from the president of the United States, but it would have been too incredible to mention Kennedy by name. He would be dead himself within a few months.

Cineaste: *You build Z to an exhilarating climax where the conspirators are all indicted. Then you more or less pull the rug from under our feet in an epilogue where we learn key witnesses have been killed under mysterious circumstances and that the conspirators have been freed and reinstated by a military coup. Americans will again be reminded of events in the Kennedy assassination. Was that your intent?*

Costa-Gavras: No. In France they thought of Ben Barka, where so many witnesses died and disappeared. For instance, a reporter who shot pictures for *Paris Match* in front of the police station committed suicide by shooting himself in the head. Later, it was revealed that the revolver was held in his right hand but that the photographer was left-handed. The Ben Barka affair was very much in mind while doing this film, but not the Kennedy events.

Cineaste: *Did the Ben Barka parallel influence your decision to make the film?*

Costa-Gavras: Not exactly. In Europe we make films by cooperation. Two companies from different countries produce pictures jointly. We made this picture with Algeria because no one in Europe would cooperate. Not the Italians, not the Yugoslavians. I went to Yugoslavia personally—they said it was "too political."

Cineaste: *Too specifically political or too generally political?*

Costa-Gavras: Both, I think. I showed the director of the Yugoslavian cinema the script and he said, "No, we cannot do this." The Italians and the French had the same attitude. The Algerians finally said, "Come film the movie here." Most of it was finally shot there except for a few interior scenes done in Paris. They didn't give much money but they helped with extras and in giving us locations. It may seem strange that a semi-police state like Algeria would allow us to make such a film. Perhaps it was partly luck. They didn't know the film would be so good or popular. They wanted to have good rapport with the French intellectuals. They want to show they are the most advanced Arab nation in the Mediterranean. I want to make it

very clear, however, that if they had not taken part in the production, *Z* probably would not have been made.

Cineaste: *Had the film been less political, they might not have been so interested.*

Costa-Gavras: Well, it was an excellent way for them to look more liberal than they are, by attacking a nation so badly governed as Greece. If I had to choose between the Greek government and the Algerian government, I have no doubt I would choose the Algerian because the Greek government is just impossible to live under.

Cineaste: *What effect do you think Z will have in America? The Black Panthers had a print months ago and had a special screening, but that was something unusual. How do you expect the average American to react?*

Costa-Gavras: I think that it is extremely important that as many people as possible see this film to see how present conditions came about. It's important for reference purposes. Someone speaking about Greece can be challenged on specific grounds.

Cineaste: *Would there be any specific things that would make you feel the film was a success? Perhaps the fall of the junta or success at the box-office?*

Costa-Gavras: I have no financial interests in the film. I was paid a fixed salary so I'm not much interested in the financial success of the film. The most important thing is that it have a large audience because of the political possibilities. In Paris, people left notes at the door saying that they had been to Greece and loved the land and its people very much but that they would not return until the present regime fell. They transformed some of their outrage into a political act against the junta.

Cineaste: *If political results are so important to you, why have you placed so much emphasis on the mechanics of the crime and less on the motivations? You are also vague about the role of the palace and the CIA.*

Costa-Gavras: Are you sure the palace ordered the murder? Is there any proof? Are you sure the CIA was involved? Is there any proof?

Cineaste: *We have proof about certain military men and their groups and the kinds of connections they have.*

Costa-Gavras: Greece has always had these paramilitary groups and police cadres, especially since the war. Queen Fredericka has sponsored many of them. The story of Lambrakis offered many possible approaches. By sticking absolutely to what was proved at

the trial, we have made it all but impossible for people to say, "How do you know? That isn't true. That's a rumor." What we do say about the palace and the CIA is the kind of thing that came out at the trial. For instance, Theodorakis said that we should not attempt to find the murderers in two poor workers of Thessaloniki but in the palace, particularly in the Queen Mother.

Cineaste: *Your first film had no political content, but you obviously have very strong political feelings and are quite clear on how you want to develop political points. Are you a man of so many parts that we can expect more films of both types?*

Costa-Gavras: I want to explain about that. *The Sleeping Car Murders* was my first film. A first film is extremely difficult. I had to have a subject that was not too easy. The New Wave directors did other things as their first films. My situation was different. I was a stranger. I did not have a personal fortune. *The Sleeping Car Murders* was a solid film that could open the doors to the future. In the past three or four years I have been working on *Z*. Since then there has been an uprising in France in 1968 and there's been the growing feeling about the war in Vietnam. The general public has become more political. The world has become much more open-minded. I think cinema has to follow this trend. More and more of our films will be political. I will make more political films. There's no doubt I have a penchant for this kind of film—for films with real subjects.

2—GLAUBER ROCHA

Cinema Novo vs. cultural colonialism

Brazil's Cinema Novo is now regarded as one of the most important political film movements of the 1960s. The name originated in 1959 when a group of young film critics registered their disgust with the seemingly endless series of Brazil's cheap imitation-Hollywood chanchadas (musical comedies) by organizing an independent production group. They aimed to make films that would deal with the authentic history, mythology, and legends of their own country. For the first time, uniquely Brazilian elements became part of motion pictures: the sertao, *the arid, sparsely populated plains region of the Northeast and its inhabitants; the* cangaceiros *(rebel-bandits) and* retirantes *(migrant workers); Rio de Janeiro's* favelados *(hill dwellers), the peasants inhabiting the shanty towns on the metropolitan hillsides; the influence of mysticism on the populace; and so on. The most prolific filmmaker of Cinema Novo was Glauber Rocha, who was also regarded as its major ideological spokesperson. Rocha was interviewed by Gary Crowdus and William Starr, then editor of* Film Society Review, *on the occasion of the American premiere of Rocha's* Antonio das Mortes. *Rocha spoke in French with a heavy Portuguese accent. The interviewers were assisted in translation and transcription by Ruth McCormick and Susan Hartolandy. The statement which precedes the interview was issued by Glauber Rocha in 1965.*

"Wherever one finds a director willing to film reality and ready to oppose the hypocrisy and repression of intellectual censorship, there one will find the living spirit of the *new cinema*.

"Wherever there is a director ready to stand up against commercialism, exploitation, pornography and technicality, there is to be found the living spirit of the *new cinema*.

"Wherever there exists a director of whatever origin or age willing to place his art and work at the service of the mighty causes of his day, there one finds the living spirit of the *new cinema*.

"There stands its correct definition and through this definition the *new cinema* sets itself apart from commercial cinematography which, as an industry, is commited to untruth and exploitation."

Glauber Rocha, 1965

Cineaste: *One of the best known Cinema Novo films in this country is* Vidas Secas (Barren Lives), *which was made before the present military government took power. Would it be possible to make a film like that today in Brazil?*

Glauber Rocha: Yes, because although there is very powerful and oppressive censorship in Brazil, it is not a preventive one. All our films have problems with censorship but we obtain their release thanks to the international reputation which the Cinema Novo has gained through festivals and above all because of the demand for our films in France and Italy. So we have been able to win out over the censorship even though it gets worse and worse all the time. All the latest Cinema Novo films are very political and along the same lines, in the same spirit, as *Vidas Secas*.

One could say that the Cinema Novo started in 1962 with *Vidas Secas*. There were only eleven directors in the same production group; now there are thirty and we share the same political objectives despite great diversity of styles.

Cineaste: *Are there any assistant directors in the Cinema Novo?*

Rocha: Yes, three or four hundred, but after the beginnings of the movement many of them went into commercial filmmaking where they still use the name of Cinema Novo. So now there is a variation of Cinema Novo in Brazil which creates a great deal of confusion. It's natural for us to be imitated because the Brazilian cinema developed a great deal due to the Cinema Novo. For example, in Brazil in 1962 there were produced only thirty films and this year Brazil has produced one hundred and four films. True, there were a number of bad films made but for us it was just as important that Brazilian

cinema developed a production bloc, it was a cinematic affirmation and was equally important for our economy.

Cineaste: *Do you have the impression that the Cinema Novo has influenced many other contemporary Brazilian directors, either stylistically or politically?*

Rocha: Not in a political sense but it has provoked a great improvement of cinematic technique and expression—technical influence but also as concerns new ideas. In 1962 Brazilian cinema was very bad—photography, sound, cutting—and the subjects were imitations of American films, whereas today the technical quality of sound and photography is very good. And even though reactionary films are being made, they are being made about the Brazilian people. It is a small revolution but I think it is preferable to making imitative, colonized films.

Cineaste: *Your film,* Antonio das Mortes, *is frequently called very operatic in conception. Have you had any previous experience in opera?*

Rocha: No, I've had no experience in opera or theater but I've tried to make all my films, from the first to the last, very operatic. I'm not interested in theater per se but in *cinematic theater,* a new vision of theater. I'm also very interested in music as a cinematic element of expression.

Cineaste: *Do you have a specific audience in mind when you make a film?*

Rocha: No. On the contrary, all my films basically are made for popular consumption. My films are made for, and from, a popular culture. They are very popular in Brazil, Africa and in the third world in general; if bourgeois audiences find them difficult it is because of their lack of understanding of the popular culture. I think I make my films for every type of audience. I do not have a position against the public; the problem is that I do not make commercial films. But when they receive the proper distribution, they are seen by all types of people.

Cineaste: *Is there an international audience in mind when you make a film?*

Rocha: Yes. I think that film is an international language, but I make films about the third world because I am from the third world. If *Antonio das Mortes* were an American film, it would probably be a Western, or if Japanese, a Samurai film.

Cineaste: *You surely have an interest in influencing the rest of*

the world because your films are political in nature, specifically propagandist.

Rocha: My films are *not* specifically propagandist. I try to reveal the political problems of the underdeveloped world but I refuse to call this political propaganda. I make political films but not as propaganda.

Cineaste: *What sort of distribution do the Cinema Novo films receive?*

Rocha: Cinema Novo films are shown for the general public through a very large distribution company that distributes them all over Brazil and also to the cine-clubs in 16mm. They opened *Antonio das Mortes* in nine large theaters in Rio de Janeiro and in four large theaters in Sao Paolo. In the U.S. and in Paris they show it as an experimental film in small art houses. This is good because it's seen in its proper milieu although by very few people. The principal problem is not that the film is difficult for the public but that it is not properly distributed.

Cineaste: *For you, then, it's less a question of the* quantity *than of the* quality *of the spectators in all countries of the world.*

Rocha: Yes, because I think the public is very intelligent and very sensitive. The problem is that the public is dominated by the mechanism of publicity and distribution and doesn't have the chance to choose the films themselves because the distribution system is not democratic. It is a fascist system of distribution because it decides what films the people will see in each country. The public has great sensitivity but they're conditioned to like certain kinds of films by the advertising; this happens in Europe and the U.S. as well as in Brazil. For instance, the public in Latin America is very colonized by Hollywood. The penetration of Hollywood in Latin America is significant because it is not only an *aesthetic* education but also, since it is a psychological conditioning, a *colonial* education.

Cineaste: *You talk about the* values *of Hollywood. . . .*

Rocha: The values and the aesthetics of Hollywood. I like certain things about Hollywood but I think that in Latin America one should create a cinema completely in opposition to Hollywood cinema.

Cineaste: *Different or against?*

Rocha: *Against*, because Hollywood produces a colonizing cinema and we need a cinema against colonization. As regards *Antonio das Mortes*, I might say that I think I made a revolutionary film in that I made a film opposed to the aesthetic principles of the cinema of domination.

Cineaste: *Is it possible to drive an American car and have a Brazilian culture in a Latin American country that is essentially Americanized.*

Rocha: We are not against the Americans, we are against American foreign policy which is opposed to our domestic interests. As far as cinema goes, it is very hard to fight American cinema because it dominates our markets and has colonized our intellectual sensibilities. That's why we have to wage a very determined battle against the Hollywood influence—we have to develop a national cinema which will be able to combat the colonizing cinema.

Cineaste: *Do you consider the values which are communicated by Hollywood films the values of Hollywood in particular or America in general?*

Rocha: I think that the most political cinema is the cinema of Hollywood. It is the most politically effective because it disseminates an ideology of social idealism. The cinema of the left, for example, has not achieved results equal to that of American cinema. There is no popular commercial aesthetic in Brazilian cinema and the trouble with most films of the left is that they are not truly revolutionary. The revolutionary cinema should stimulate not the conformity of the public but the revolt of the public. A film like *Z*, for instance, is very Hollywoodian. I think a truly revolutionary film is Godard's *Weekend* because it is a film that provokes the public.

Ultimately, the most important thing is the language which transmits the message. We need new modes of expression. A new form that is completed, unified—not necessarily a perfect form, but one that serves our purpose. It's better to have a form that's badly polished but new.

Cineaste: *If I understand you correctly, the revolution that you envisage is as much artistic as political and perhaps even more important in the artistic sense than the political because in your view the political revolution necessarily follows the artistic revolution—the content follows the form.*

Rocha: It isn't exactly that. I think that in all revolutions the cultural development is as important as the economic development. For example, in the third world we artists struggle against the political oppression and also against existing cultural conditions—a political as well as a cultural struggle. I would not use the word "artistic," but rather the word "cultural," because in a much broader sense it encompasses the political, economic and artistic.

Cineaste: *In the traditional sense of the word.*

Rocha: Yes, I mean traditional but, for us, also new. It is necessary to seek out our own forms of language and communication because this new form is the language of the unconscious of the people. For example, in *Antonio das Mortes* I did a great deal of research on popular theater, the moral and psychological behavior and attitudes of the peasants, their poetry, music, language, and so forth. I used the popular theater form to express a realistic picture of the emotions of the people as they faced their own problems.

Cineaste: *Do you make any distinction between the artistic revolution and the political revolution?*

Rocha: That's very difficult to say because in Latin America today we are beginning to think that it's more important to make a political revolution than a cultural revolution. But at the same time we think that a political revolution is nothing without a cultural revolution. For us the two are inseparable because the society's present mode of living is under the oppression of information. Information basically is culture. Therefore we cannot think about economic development without including the development of information. We prefer to describe our efforts as investigation of culture, a culture which concerns art and aesthetics. But when we talk about art and aesthetics, we're talking about something very political, very ideological in a sense. To speak *purely* in aesthetic terms is very difficult for us.

Cineaste: *Since the Cinema Novo directors are involved in cultural change in Brazil, if it were impossible for one reason or another to change Brazilian culture through the cinema, would they be prepared to enter politics more actively?*

Rocha: All Brazilian intellectuals are politically active in a certain sense. For instance, when we combat censorship and speak out against all the social and political problems of Brazil, not only the *cineastes* but all the Brazilian intellectuals, the young intellectuals above all, are normally active in politics. That is to say, no artistic production in Brazil—music, theater, or cinema—is an activity *simply* political because we are all producers of our own works and we therefore have an economic and political struggle as well as a theoretical one. To work in cinema, for instance, we are obliged to set up our own little production companies and our own distribution systems. Along with other intellectuals we are in a conflict with the political establishment.

Cineaste: *Are the Cinema Novo directors and Brazilian intellectuals involved in an intense political orientation? That is, are they so*

dissatisfied, especially the young people, that they have formulated an ideology?

Rocha: The political situation in Brazil, the revolutionary situation, is a very complex one because there are several leftist parties with different tendencies, different objectives. Brazil is a very contradictory and violent country because it includes both underdeveloped and very highly developed land. It is a country with more contrasts than any other country in the world—there is no country that is as rich and at the same time as poor, so conformist and at the same time so revolutionary. It is a very unpredictable country where everything is possible. I don't even know whether that's a difficulty or an advantage in Brazil. I don't think any of us know.

Cineaste: *We've talked about ideas in the cinema. From an intellectual standpoint, what are the ideas behind the Cinema Novo?*

Rocha: We basically want two things which are very closely connected: a production and distribution organization independent of established economic points of view or ideas, and the freedom to make films which provide a cinematic expression of Brazilian politics and culture. We all have the same political and economic objectives but a great diversity of styles because we are against the principles of academism. We think we must become like Brazil which is very complex; we must develop many customs. For example, we make films on the same theme with different styles—films on the *sertao* like *Vidas Secas,* which is very realistic, or *Antonio das Mortes,* which is more operatic. Or when we make films about political power, they can be either didactic or dramatic.

We have just finished a very important film which will be distributed in the U.S., called *Macunaima,* directed by Joaquim Pedro de Andrade—a film very new for us because it's a comedy. It's not a dramatic film but a satiric comedy in the tropical style, a very anarchistic, violent film. We have made other films in this tropicalist style which will also be shown here, such as *Brasil Ano 2.000 (Brazil, Year 2,000)* by Walter Lima, Jr., which is a musical political film and *Os Herdeiros (The Inheritors)* by Carlos Diegues, a film about the dictatorship of Vargas in Brazil. *Os Herdeiros* is a very satiric film with all the elements one associates with the tropicalist style—the comedy, the joy, the music; it's very different from the films of the Northeast like *Antonio* or *Os Fuzis (The Rifles)* or *Vidas Secas.*

Cineaste: *Does the Cinema Novo encounter problems other than censorship?*

Rocha: A law was recently passed—something very contradictory in Brazilian politics—which has nationalized all the money of the American distributors in Brazil. It is designed to encourage the production of commercial films in Brazil, but it will only add to the intellectual corruption of our people. The money has been nationalized to form a state company to produce films, but we are against this company because it is fascist, an economic evolution which permits production of only Hollywood-type films.

Cineaste: *You said that it was a fascist company, but surely not in the strictly political sense, it is not a syndicate. Do you mean reactionary?*

Rocha: Yes, reactionary because they make "beautiful" films, films through rose-colored glasses, films which ignore misery in Brazil. Economically speaking, they want to make profitable films like France and Italy. Italian Neo-realism and the French New Wave have been practically destroyed by American distribution which has bought off all the cineastes except Godard and a few others. Today Chabrol and Vadim make commercial films for American audiences.

Cineaste: *But they are bourgeois in intent.*

Rocha: They are corrupted by the economic mechanism.

Cineaste: *They are no doubt influenced by it but not really "corrupted."*

Rocha: Yes, but some of them don't know how to avoid it. The films of all the great Italian filmmakers—Visconti, Antonioni, Fellini—are produced by American companies. A film which Carlo Ponti produces is financed with American money. Italy does not really have a national film industry, a truly Italian cinema, anymore.

Cineaste: *There is an economic reason for that because their films cost so much that it is absolutely necessary that they be placed on the international market, whereas your films don't cost so much. For instance, how much does one of your films cost to make?*

Rocha: Yes, you're right, a film of mine would cost around 40,000 *cruzeiros* [$120,000], that's all. In Brazil we must work with a very low budget, that is a principle of the Cinema Novo's organization.

Cineaste: *Has the press campaign against you begun only with the Cinema Novo's recent successes?*

Rocha: In the eight years we've been in existence, the Cinema Novo has had serious problems with the press which has consistently taken the point of view of the government against us. Their efforts have not been very successful because of our international reputation

and any drastic measures on their part could create a scandal. We have, however, received very strong terrorist threats and we expect more problems in the future with censorship and economic sabotage. We have grown very much in stature and we have been able to produce our own films, to make any kind of film we want and people are now banding together to fight us. As part of this great polemical campaign against us and our work, they call us communists, subversives, accuse us of making bad propaganda for export, saying that we show only the misery, that we do not show the great steps Brazil is taking. In short, all the arguments of reaction.

Cineaste: *In other words, it is private and not public interests that determine their motivations.*

Rocha: Private *foreign* interests because there are problems that are economic as well as political in Brazil right now. There are economic agreements between the U.S. and Brazil for coffee, oil, and all those things that keep the markets under American control. Now that the distribution of Brazilian films has increased so much, we want to change the structure of the cinema markets or even nationalize them. There was an international congress of cinema producers in Paris and a Brazilian producer from our group went and there he found himself threatened by other producers. There was one Italian who said if you succeed in doing this, it will affect the importation of foreign films into Brazil. We discussed it with IFPA [International Film Producers Association], asking what could be done because it is quite clear that Brazilian cinema cannot survive if we do not have our own market. The Brazilian industry has given effective control of films to the IFPA just as the government has given away control of coffee. If we could nationalize the cinema markets, then that could influence the other economic agreements made by Brazil.

Our government is one whose policies are imperialist, if only because of their complicity with the U.S. But there are strong nationalist tendencies even in the Army who could, as in Peru, lead a battle against the imperialist forces. I wrote an article some months ago called "The Cinematic Colonization of Brazil" where I demonstrated all these problems and said that because of this economic colonization the public is completely dominated by ideals of European and American life. Because I attacked the foreign motion picture in this article, I was attacked by certain people in the press and denounced as a communist. But it's a battle that must be fought because the problems of Brazilian cinema are not solely artistic but political as well. Brazil has eighty-five million people of

whom over fifty per cent are illiterate, or semi-literate, and cinema is therefore more important for information than books.

Cineaste: *Are the majority of the Cinema Novo directors Marxist in orientation?*

Rocha: Communist in orientation but not members of the Communist Party.

Cineaste: *In Europe, there are many Marxists who are against the communist party, and even against the socialist parties, which is even more interesting.*

Rocha: In Brazil we resist a systematization of political thinking because we are on one hand colonized by the culture of "mass cultures" and on the other colonized by the European left. Therefore, if we think that Hollywood is dangerous for us, so is Sartre, and very much so. We try to have a more profound relation with our reality in order to arrive at a more authentic political thinking.

Cineaste: *Mystical elements seem to play a very important part in the Cinema Novo. Have any of the Cinema Novo filmmakers made films that have attacked the social role of organized religion?*

Rocha: There are only four films of the Cinema Novo which deal with the religious problem: *Os Fuzis* by Ruy Guerra, my films *Deus e o Diablo na Terra do Sol (Black God, White Devil)* and *Antonio das Mortes,* and *A Falecida (The Deceased)* by Leon Hirzman, which deals with the problem of mysticism in the cities.

One can find three phases in the Cinema Novo. The first one is made up of films about the Northeast — *Vidas Secas, Os Fuzis, Deus e o Diablo na Terra do Sol, Maioria Absoluta (Absolute Majority), Aruanda,* and a film about the rebellion of the blacks in Brazil, *Ganga Zumba.* Then there is a second phase, which is composed of films about political power and which take place in the city. They are *O Desafio (The Challenge), Terra em Transe (Land in Anguish), O Bravo Guerreiro (The Brave Warrior), A Vida Provisoria (The Tentative Life),* and *Fome de Amor (Hunger for Love).* These films were made after the coup d'etat. They take place in the city and show the political corruption of Brazil, the problems of capitalism, etc. Now we are in a third phase which we call the tropical phase and which includes political and social films, but with a new facet — the tropical image, the "real" image. They are *Antonio das Mortes, Macunaima, Os Herdeiros, Brasil Ano 2.000* and *O Alienista (The Alienist).* We had a lot of European visual influence before but now we are beginning to discover the real plastic "visage" of Brazil — we

call it tropical because of the color, the style, the interpretation of the characters, and the sense of humor which is very important in the Brazilian civilization. Also the influence of black music and behavior, thus giving a real anthropological quality to the Brazilian cinema.

Cineaste: *In Brazil, as in most Latin American countries, there is the problem of birth control, the famous problem of the "population explosion." Have any of the Cinema Novo films dealt with that subject?*

Rocha: Not yet, but there is a new director, Eduardo Escorel, who belongs to our group and has edited many of our movies including *Antonio*, and his first film as director will be on that subject.

Cineaste: *Are there other films in Brazil now dealing with the subject of birth control?*

Rocha: No, I only saw one, *Blood of the Condor*, a Bolivian film by Jorge Sanjines which was shown in Venice last year. Birth control in Brazil is a grave problem. The American Peace Corps is sterilizing women en masse. They sterilized more than 100,000 women among poor families last year. These policies are carried out by the Peace Corps with more or less the acceptance of the government.

Cineaste: *Would the Cinema Novo be against birth control under any conditions?*

Rocha: I am not too acquainted with the problem but I am in principle against the sterilization of women because it's a poor way to solve the social problem. But I don't know too much about the demographic problem of Brazil and it would be necessary to consult Brazilian economists to learn which are the real problems.

Cineaste: *Have you seen many of the political films from other Latin American countries?*

Rocha: I have seen some but not in Brazil. They are not shown there because Brazil is more closely tied to Europe and the U.S. than to Latin America. We speak Portuguese and have a culture which is very different from that of the Argentinians or the Mexicans. We don't have much communication and that is a very serious problem. I have seen Latin American films in Europe. I think, for instance, that Solanas is a very important cinematographer.

Cineaste: *Have you seen La Hora de los Hornos?*

Rocha: I saw the first half of the film and what I saw I liked a lot. I have not seen the entire film but I think that Solanas is one of the most important filmmakers today.

Cineaste: *Does the documentary interest you personally as a method of filmmaking?*

Rocha: I like to see them but not make them because I don't think I have the talent for documentary.

Cineaste: *Do you think it is difficult?*

Rocha: I tried it once and it did not work. I am interested in the opera and the theater more than in documentaries. Documentary is a different discipline—it demands a severity, an objectivity which I lack.

Cineaste: *But* La Hora de los Hornos *is a documentary which speaks about a reality but it is not at all objective.*

Rocha: Yes, but the style does not interest me. I like to see it but doing it does not interest me.

Cineaste: *Are there any publications in Brazil devoted exclusively to the Cinema Novo?*

Rocha: No, we have never published film magazines because we did not want theory to precede practice in Brazil. This year we will publish our first magazine. Since there is quite a campaign being waged against us now, this is a good time to publish it.

Cineaste: *That is the way in all Latin American countries, isn't it, to start with practice and then to go theory?*

Rocha: Yes. Before we started making films there were many movie magazines in Brazil, but no films. So we decided to change that. Film magazines in Latin America are always an imitation of the European magazines. That is, they publish magazines like *Positif* or *Cahiers du Cinema,* which are good magazines, but one should not imitate them. We struggled against traditional critical thinking.

Cineaste: *So you have not yet elaborated an ideology for the Cinema Novo movement?*

Rocha: No, we have written many articles and given many interviews but we are against any systematization of thinking so as to prevent fascism and formalism. In 1961 I wrote a book on the Brazilian cinema called *Critical Revision of the Brazilian Cinema* which influenced the formation of the Cinema Novo. Next year I will write the second part of the book which will be an analysis of our efforts. And there are other books in preparation now.

Cineaste: *Which are, in general, the film publications that you consider most important?*

Rocha: I do not read American magazines because I can't read English. But I read *Cahiers* and *Positif,* which are very different magazines and very much opposed to each other. The analyses made by *Cahiers du Cinema* of film aesthetics, the studies of the language of contemporary films, although very complex and difficult

to read, are very important I think for the aesthetic development of the filmmaker, as well as the critic. And I also like very much the political and social aspects of *Positif*.

Cineaste: *Are there any magazines responsible for the creation of the cinematic ideas of the Cinema Novo?*

Rocha: None on that level.

Cineaste: *Cahiers?*

Rocha: No. For many years I was very much against *Cahiers du Cinema* because I thought it was a very rightist magazine in the beginning. I like *Cahiers* very much in its present phase, that is, with the younger reviewers. But we were educated by books on movies rather than by magazines.

Cineaste: *Any books in particular?*

Rocha: What we studied mostly in the Brazilian cine-clubs were Eisenstein's books. He wrote the most advanced theory of cinema, which has now been completely forgotten because of Stalinism. And what had the most influence on us was not the New Wave but the first films of Italian Neo-Realism—the films like *Paisan* or *La Terra Trema*.

Cineaste: *So it was mostly by films that the Brazilian Cinema Novo ideas were formed?*

Rocha: Yes, one could say that three kinds of films were fundamental in the development of the Cinema Novo: the first films of Rossellini and Visconti—*Open City, La Terra Trema (The Earth Trembles)* and *Paisan;* the Mexican films of Bunuel, like *Los Olvidados* and *Nazarin;* and the old Russian films of Dovzhenko and Eisenstein. These films interested us a lot and we studied their theory. But we fought a lot against the New Wave because we didn't like their films. We like Godard now; but before we did not since we considered him very formalist and very rational, very bourgeois.

Cineaste: *So when you said that perhaps now is the time to establish a magazine for the Cinema Novo in Brazil, you mean that it is perhaps now time to better define the ideas of the Cinema Novo?*

Rocha: Yes, because now that we have eight years' work behind us, we can discuss from practical experiences. We can also discuss on a theoretical level rather than a simply journalistic level. There are problems which I consider fundamental today for the cinema—to search for the real function of cinema, to discuss the principles of cinematic language. I think one should break in a very violent manner with an entire tradition of cinematic language so as to develop the real possibilities of cinema.

In the last ten years there have been many important things which one could say were the pre-history of future cinema—the New Wave, the underground American movies, the political cinema of the third world, etc. But all this is not a definition of cinema, but rather something leading to a future cinema. I think that today everything has to be questioned so we can discover the real possibilities of cinema.

3—MIGUEL LITTIN

Film in Allende's Chile

When Salvador Allende came to power in November of 1969, the first Marxist head of state to be elected in the Western Hemisphere, he named Miguel Littin as head of Chile Films, the country's nationalized film studio. Littin visited New York City early in 1970 to speak about the perspectives for a genuine Chilean cinema. Gary Crowdus and Irwin Silber, the arts editor for the Guardian, interviewed Littin, asking him about his film El Chacal de Nahueltoro and Chile Films. Translation was provided by Susan Hertelendy Rudge. Littin has been in exile since the dictatorship imposed by General Pinochet in 1973.

Cineaste: *Was the script for* El Chacal *fictional or based on fact?*

Miguel Littin: It was based on an actual incident, one which deeply affected public opinion in Chile. It reached all levels—no Chilean remained passive in response to what had taken place. Some were sympathetic, others against. This was very important for us in deciding to make the film because it gave us something through which we could reach the people—we thought they wouldn't remain passive about the film either. And that's what happened—the public was very interested in the film and it was the most well-attended in the history of the Chilean cinema.

Cineaste: *How did you prepare your script?*

Littin: I researched all available records of the case—public, journalistic, and legal. I interviewed people who were with this man in prison, I visited the places where he spent his childhood, adolescence and later life. In this way, the first idea I had about this character and his life disappeared and instead emerged a character immersed in public mythology. He was someone the people paid tribute to, turning him into a cult. First they cried, "Lynch him, lynch him!" but afterwards they just cried.

Cineaste: *You say the film was a popular success. How did the government react to it at the time?*

Littin: The film was done during Frei's administration but the incident had occurred during Allessandri's administration, so it had nothing to do with the then-current government. Officially it was ignored. But newspapers such as *El Mercurio,* which is the most important conservative paper, conducted a campaign against the film while we shot it, advising the public not to see it and accusing us of betraying the country, calling us jackals and hyenas. They said that if there were such good things as the history and natural beauty of the country, wine, women, etc., why did we have to dig in the dirt? So we contested that it was immoral not to dig in the dirt if there was a man in it, and that there were many more men in the dirt who had to be brought out. But they did succeed in provoking a negative reaction while we filmed. Radio and television commentators would ask why such talented young people had gone astray and in some places we were physically attacked while we filmed. But what they also achieved was to inform the entire country that we were filming.

Cineaste: *At any point, either during or after production, was there any censorship?*

Littin: No open censorship because we were simply ignored. But the censorship was there to deny us any help. They are very careful

in Chile because if they had officially censored the film it would have been much worse. Besides, we had effective ways to circumvent censorship. For example, universities can show films without censorship, so if the film had been censored we could have given it to the universities.

Cineaste: *What were your basic political intentions with* El Chacal?

Littin: First, to denounce a decaying official state—a social decay. And then, direct it to the middle class Chilean who is tied to this decay and who doesn't realize it or does not want to realize it. The middle class Chilean of the urban zones is the peasant who because of shortage of work or lack of means of survival moved to the large city. He is divided—there is in him that part which is culturally colonized, penetrated by official culture, which is the more superficial part, the cream of the cake, but if you put your finger in the "cream," you find the individual's real flesh.

Cineaste: *One of the recurrent themes of the film is the effect of alcohol on the peasant. Is this representative of a general problem?*

Littin: It is a general and a terrible problem—the rate of alcoholism in Chile is one of the highest in the world. Practically all country towns are surrounded by a circle of taverns—out of twenty houses in a small town like San Fabin de Alico or Palmillo, fifteen sell wine. It is the same with drugs. And this has its political consequences. The poorly nourished peasant, low in proteins, having nothing to do after work, drinks wine which makes him lose his lucidity and he turns his violence against himself. So the peasant spends half his time drunk and in this state, on the borderline of madness, destroys many things but not the system. Nevertheless, this is a situation which is nearing its end because the peasants are beginning to organize themselves.

Cineaste: *The church also plays an important part in the film. Would you equate the retrograde effects of alcohol with the influence of the church?*

Littin: All who participate in the system are guilty, even if they are understanding spectators. The problem is not one of good or bad people—all the people who appear in the film, and I was very attentive to this, are very good people. The priest does everything he can, but he is serving the system. The parish priest, the police, the teacher who teaches the official colonized culture—they all prepare and tame men and then, with their consent, the system comes down on them.

Alcohol, religion, smiles, law, gentleness—all are part of the system's tools to train and subdue men.

Cineaste: *What kind of distribution has the film received in Chile? Is distribution restricted to theaters in the large cities?*

Littin: There are theaters all around the country, about six to seven hundred of them. There is also a small 16mm circuit for free showings to peasants and under the new political situation they're trying to extend this. But when we made the film, practically the only thing that existed was commercial distribution. There was a very strong campaign against the film but also a very strong one in favor of it in leftist papers, so the controversy encouraged everyone to see the film. The distributors are susceptible to money matters, so it received wide distribution.

Cineaste: *We understand that you've just been appointed head of Chile Films. Is that a nationalized production company?*

Littin: Yes, not as a producing company, but the studio and facilities are rented by independent filmmakers.

Cineaste: *We understand that one of the activities at Chile Films now is the production of a regular newsreel.*

Littin: From the moment we started at Chile Films we also started to make one ten-minute newsreel per week. Right now we're making films around two different themes—the society we inherited from hundreds of years of colonialism and dependency, and the new propositions being suggested to transform society. Specific films have been made on the Mapuches [Chilean Indians], peasants, Northern workers, miners, the problems of women, and so on.

In the first newsreels, besides a narration we used titles, but this created a problem because the films couldn't be used in the illiterate sectors. So now we must make a different type of film.

Cineaste: *To what extent were the artists and intellectuals involved in the political campaign for Allende?*

Littin: Completely. All intellectuals, artists, protest singers, sculptors, painters, filmmakers, actors, theater directors, playwrights, etc., have always been leftist in Chile. I would say that 99.9% of the Chilean intelligentsia is leftist.

Cineaste: *Two or three years ago you were making this film. How many other films were made in Chile that year?*

Littin: Eight features and about four shorts.

Cineaste: *What was the general character of those films? Were any of them like yours?*

Littin: Yes, there is a current in Chilean film, the New Chilean

Cinema, connected directly to the Brazilian Cinema Novo, to Cine Liberacion in Argentina and to the Colombian Cine Nuevo, to everything that is called the new Latin American cinema. So in 1968 three films were made which could be classified as belonging to that line—Raul Ruiz' *Three Sad Tigers, El Chacal* and *Valparaiso, My Love* by Aldo Francia. The others were what the Brazilians very rightly call *chanchadas* [pig works], lacking any artistic or ideological values. They are subproducts, sub-subproducts of Hollywood, eliciting no reactions from either critics or public.

Cineaste: *How have the organization and activities of Chile Films changed since Allende was elected?*

Littin: We are now in the process of changing things. During Allende's campaign the different sectors of the country were organized in what were called committees of popular unity. The filmmakers had their own committee of popular unity and participated actively in the campaign, as well as in the political program offered to the country. So once Allende won, the filmmakers offered a proposal to the President as to how Chile Films should function and who should direct the organization. Following the proposal of the filmmakers, I was appointed head of Chile Films, although it is collectively directed.

Chile Films is the base for the construction of a National Film Institute into which the state will channel its help for the creation of a revolutionary cinema that is an authentically national cinema seeking our own culture. For in Chile there is, as I mentioned, the cream of the cake, which is the official and neo-colonized culture, but at the same time there exist the manifestations of the popular subculture. To recover these values is in itself a revolutionary action for us because they are values which give an identity to our people. This will be the basic principle of Chile Films' policy but this doesn't at all mean that there will be state control of creative activity. We believe that revolutionary cinema cannot be produced by decree, that there has to be an inner conviction in the individual. So the doors of Chile Films are open. There's absolute freedom.

Cineaste: *Since, as Glauber Rocha says, colonialism in Latin America works on a cultural as well as on an economic level, has there been any discussion of putting a quota on the import of American films into Chile?*

Littin: No. In a lot of Latin American countries that's all they see. American films force everything else off the screens. European productions do the same. But since European films sell the same

ideology, the problem is precisely how to replace the bourgeois ideology with the revolutionary ideology without being arbitrary. We hope that by stimulating our own production, the present situation will change radically—of course if we make only one film a year, we change nothing; but if we make twenty, then the American films will have to wait, and maybe a long time. We also plan to make available to the public all other third world films or films that are not products of a consumer society.

But if we take over all the movie houses of the country right now and prohibit all American films, what would we show? What's most important is to create our own cinematic expression and to insure our films massive distribution through normal commercial circuits, through circuits which reach the public free of charge in open showings, through television, and so on. Furthermore, through the showing of his film, we want to allow the filmmaker a dialog with the public to whom he directed the film, so that from this contact of producers and public may develop a distinct expression, a new and different cinema, because we have to accept, with much modesty and with great pain, that we who make films are *petits bourgeois,* in some ways neo-colonized ourselves and, if we want to reach the people, we have to know them profoundly and not patronize them from a distance or give them our values, which means only a new colonization. We are very clear about this problem because we believe that in Chile the people will be the teacher and so we have to explore and investigate and make our films immersed in the people's struggles.

Cineaste: *In what ways could this be done? Is there some idea, for instance, to train more filmmakers who come from the working class?*

Littin: We think that by being conscious of our situations as *petits bourgeois,* we are already beginning to rid ourselves of the mentality. But we are also now creating the cinematographic workshops which will be the basic centers for analysis of the national reality, with discussions among filmmakers where both students and teachers participate in a common experience. When the filmmakers go to film in Chiloe, for example, they make the film with the people from that place. They become communication vehicles of that sector of the community and so, at the same time, create a center of cinema there. This plan is going to be launched all over the country. It will permit us to create new filmmakers as well as new films and to leave behind a film center so that eventually those who create films will not

be an elite, but the people themselves who, having previously expressed themselves through folklore, music, and so on, will now be able to do so through cinema. Of course, this plan is easy to describe but it will be very difficult to accomplish.

Cineaste: *What do you think is the function of film in Chile today and what will its function be when the country is completely socialist?*

Littin: We have used a line from the poet Antonio Machado a lot in our political development: "Walker, there is no road/roads are made by walking." But, concretely, in our country cinema has to be the avant-garde of events, opening the way to the great revolutionary perspectives, clarifying what revolution is and at the same time being a witness to reality, but projecting it to future transformations—and without demagogy. For instance, now that the government is creating conditions to allow each Chilean child to have half a liter of milk, which is very important, we do not say that the problem of child nutrition is solved, but rather that it is only the first step to end the problem. So, it is precisely that which is the role of cinema in a dependent country such as ours—to break all traces of cultural colonization and to deepen the revolution.

We reject categorically the idea of the superficial pamphlet because our reality is neither schematic nor rigid. In fact, it is so dynamic, rich and transforming that, as we go deeper into it, we transform ourselves as well. We cease being *petits bourgeois* and become instead workers who use a tool—film—with the same efficiency as someone who builds a school or hospital.

Cineaste: *If the class character of the people who make the films is, as it always is in all countries, the* petit bourgeoisie, *where will the people who make the films find the political direction and the political soundness to guide their work if they operate only as independent entities?*

Littin: There is a distinct difference in attitude between one who speaks to the public from a balcony and those who work with and among the people. So, we think that as we cease speaking from the balcony and speak from within the struggles of the people, with all the richness and dynamics that this implies, we ourselves are being transformed. We change our psychological state and the *petit bourgeois* disappears—we hope. What we always accept is that we can make mistakes—we continually analyze our actions and correct our ways.

I think that Chilean reality can be characterized by two things: modesty and anti-dogmatism. We are really concerned with the

problems the country faces and I believe it would be somewhat presumptuous to suggest that we have resolved all the complexities of the modern world—all that the inheritance of a colonial society means, a society so removed from the great technology which it needs—and to say there is only one road or to walk with blinders like a horse. Thus, we discuss and analyze always. I've always liked the idea in the line from Peter Weiss' *Marat/Sade* — "The important thing is to pull yourself up by your own hair, to turn yourself inside out and see the world with fresh eyes."

Cineaste: *We understand that you and Alfredo Guevara of ICAIC [Instituto Cubano del Arte e Industria Cinematograficos] have just signed an agreement. What does it involve?*

Littin: It is an agreement which covers all aspects of film— co-productions, exchange of films and publications, exchange of filmmakers, technicians and teachers from both countries. Our co-productions will be a model for the ideal form of relations between socialist countries because there is no need for either side to patronize. It is a meaningful relationship between two liberal cinematographies.

Cineaste: *We've heard that because of the general lack of production facilities in Latin America there has been some discussion of pooling all the various production resources. What do you think of the idea?*

Littin: Speaking only as a filmmaker and not as a representative of an official agency of the government, I believe it would be a very good solution for Latin America cinema to create a central organization for production because our technical resources are very scarce everywhere. But it would be necessary to take into account certain characteristics particular to each country—Brazilian fascism, for instance, which makes it practically impossible to make films in Brazil where the police often torture and kill. In Argentina also, at the present time, free expression is very difficult. Furthermore, since revolutionary struggles have different strategies and employ different tactics in each country due to their different political situations, our relations have to be very respectful of these different methods. For example, we cannot export the method of election of the Chilean revolution to the rest of Latin America because there are countries with dictatorships where the only way is the gun. So it is important to be very careful, very realistic.

We also think that in Chile the moment of confrontation between

the classes will come, because "power comes to the one who holds the gun" is more than just a phrase in Latin America.

Cineaste: *Do you feel that what you just described will be the future for the political development of Chile?*

Littin: Yes, because I believe that the class that holds power will never give it up peacefully. In Chile there apparently was a peaceful solution, but it was neither a solution nor peaceful. We have changed the government to take over power.

Cineaste: *Will you be making another film soon?*

Littin: Yes. In May I'll start to shoot a film centered in a small peasant town. It deals with the rise and fall of large families of landowners, the peasants' climb from under subjection, and their change from object to subject and protagonist of the story.

Cineaste: *Will this be a fictional script?*

Littin: Yes, but based on facts. As I said, what apparently happened in Chile was peaceful, but the truth is that at the margin of institutionality, the class struggle has been strong and really ignored by the official colonized history. The organized forces of the Chilean people have always been in confrontation with the police and the army. I say this because now it appears as if everything in Chile is solved because the people voted. But this is just the appearance—in reality, what happened over a long period of time was a bloody class struggle and this is what I'll show in the film.

There is something in the script, however, that still puzzles me—imperialism. I'm trying to learn it from the inside because it plays a very important role in this development and it's better to seek information about it from the inside than from the outside. I'm trying to find the fundamental link, because it is impossible to go on making political films in Latin America without taking into account and without presenting the problem of imperialism and the dependent economy. We have to find the images and words which will make the people understand how imperialism affects their daily lives. The words "imperialism" and "revolution" have been used so much that now they don't know one from the other. I'm not interested in speaking an elitist language—I want to reach the people. So my problem is how to convey these ideas.

4—BERNARDO BERTOLUCCI

I am not a moralist

The first of a number of Cineaste *interviews with Bernardo Bertolucci was made by Joan Mellen, then one of the editors, in 1973. Like the series with Costa-Gavras, the Bertolucci interviews provide insight into the continuous re-evaluation the politically inspired directors undergo in relation to appropriate cinematic forms, past works, and organized political groups.*

Cineaste: *Can you tell me something about your background and education, the people, experiences and ideas making up your intellectual formation which led to* The Conformist *and* The Spider's Stratagem?

Bernardo Bertolucci: My father is a poet. I was born in Parma into a home with many books on poetry. I started to write poems when I was six years old, to imitate my father, I think. I stopped writing poems to finish imitating my father at nineteen or twenty and ended my experience with poetry with a book which created a "tomb" for my poems.

Parma is a town in the north of Italy. There is a melange, a mixture making up a very original culture in Parma because it is a "grand canton," closed off from the rest of Italy, a kind of "capital" with many elements of French culture. Parma is also a "Red Town"—the Communist Party is in the majority in Parma. So the context of my development, politically, was a communist, a Marxist, context. *The Spider's Stratagem* takes place in this region, where I was born. I became interested in cinema very early and all during my adolescence I was sure that one day I would make movies.

Cineaste: *Were your father and family in the Communist Party?*

Bertolucci: No, my father was not in the Party but all my contacts and friends were.

Cineaste: *How did you start in films?*

Bertolucci: My first work in cinema was as an assistant to Pasolini while he was doing his first film, *Accattone*. I was also doing my first film at that time and neither Pasolini nor I knew the cinema. It was a kind of new birth of cinema because Pasolini, never having made a movie himself before, was inventing the cinema as if for the first time. When he made a close-up, the film, for me, discovered the close-up. It seemed like the first close-up in movie history because it was the first time for Pier Paolo.

Cineaste: *Do you feel that today your films have any resemblance to his?*

Bertolucci: No, none. I don't think so. He has an idea about "sacerality," a sort of mysticism, and I don't have the same vision of life, of reality. The language of Pasolini's movies is very different from the language of my films.

Cineaste: *Many critics in the U.S. have said about* The Conformist *that it makes too simple an association between homosexuality and fascism. Do you think they are misunderstanding*

what you intended in the film? They accuse you of saying that all homosexuals become fascists. . . .

Bertolucci: Or that all fascists become homosexuals. No. This explanation is too simple. *The Conformist* is first a film about the bourgeoisie, the middle class, not about fascism. I was speaking about the middle class, and fascism is a moment in the history of the middle class, a means by which the middle class protects itself from the working class. Whenever the working class is coming up, up, up, at this moment fascism makes its appearance.

In the film there is a fascist and an anti-fascist, but the professor in Paris, the anti-fascist, is also from the middle class. We have two faces of the same coin, of the middle class. One face is fascism, the other is anti-fascism, but not a Marxist anti-fascism, just an idealism. Because he is also in the middle class, my anti-fascist is not a hero, not a positive man.

In the Moravia novel the presence of "fate" or "destiny" is very important. I read the book in quite a different way. Everything that in the book was attributed to "fate" in the film stems from the subconscious of the character. But I absolutely don't want it to be a question of fascism equaling homosexuality. This is really too simple. Homosexuality is just an element in Marcello's character. Marcello feels himself different because of his secret homosexuality which is never expressed, yet always inside of him. And when you feel "different," you have to make a choice: to act with violence against the existing power or, like most people, to ask for the protection of this power. Marcello chooses to ask for the protection of the power. He becomes a fascist to have this protection that he needs.

Cineaste: *But the system knows that Marcello doesn't believe in fascism. In the first part of the film the fascist says that people join the party for many reasons, very few because they believe. So Marcello does not join because he believes in fascism.*

Bertolucci: No, he wants only some protection because he is different, because inside he feels he may be a homosexual. He asks something of the power structure; this power gives him his protection, but asks that Marcello do something in return, that he kill the professor. It's a contract between the individual and the system.

Cineaste: *Are you interested in the writings of Freud or is this just part of Moravia's treatment?*

Bertolucci: No, I think that the work I did, the transformation of the novel into a film was in the sense of Freud. In Moravia everything was determined by "fate" because we never understand why

Marcello becomes a fascist. At the end of the book, the night after the 25th of July, Marcello leaves Rome with his wife and they go to the country. A plane flies overhead, killing him. What happens to Marcello is thus caused by a "divine presence." I don't accept this idea. I prefer that the force of the subconscious take the place of "fate."

Cineaste: *At the end it is a psychological fate. Once fascism fails him, Marcello doesn't intellectualize. He feels only that he must accept Lino and return to homosexual feeling.*

Bertolucci: He understands, he achieves *prendere coscienza* (consciousness), but it's also instinctual, unconscious as well.

Cineaste: *Are you interested in surrealism, in continuing this technique in other films besides* The Conformist? *In that film, surrealism expresses something about fascism, about homosexuality and the relation of the son to his mother.*

Bertolucci: Surrealism was the most important cultural element during the twenties and thirties and *The Conformist* took place at the same time. Actually, *Partner* is my most surrealist film. It's very like Cocteau. I think in *Spider* too there is some surrealism because the visual experience is from Magritte.

Cineaste: *Things happen that can't be explained in a practical way; the son gets locked in the barn, for example.*

Bertolucci: Yes.

Cineaste: *Is there a radical alternative in* The Conformist, *a hint of how to oppose fascism, in the girl who sells flowers and sings "The Internationale," and at the end, after Mussolini has fallen, when the people sing "Bandiera Rossa" in the streets? Doesn't this suggest that another political road might have meant a different experience for Italy and Marcello?*

Bertolucci: Yes, of course, an indication of something that will come. But in the sense of having any political impact, being truly effective, no. What you change with films is . . . nothing.

Cineaste: *Some people did not perceive the criticisms you were making of Professor Quadri in* The Conformist *because they are not accustomed to seeing the social democracy criticized. Would you agree that Anna Quadri was made a lesbian because her decadence was one way of showing the ineffectuality of the social democracy?*

Bertolucci: I think there is some truth in this, but I am, of course, very interested in homosexuality in general, and therefore also in lesbianism. If this theory were true, I would be very moral, but I am not a moralist.

Cineaste: *Can't you have moral truths in a film if they're expressed in a cinematic way? Then they're not noticed as making a "statement," but become part of the imagery of the film. Otherwise films could not express ideas.*

Bertolucci: I think film in general expresses "film." I know that's a tautology, but when critics ask me what did you want to say in the film, I say, nothing, with the film I want to say...just the film. Because the audiences, the public in general, and the critics as well, judge films on the story, the content, and not the style.

Cineaste: *Were you interested in Wilhelm Reich's* Mass Psychology of Fascism? *Did that book have any influence on your decision to do Moravia's* Conformist?

Bertolucci: No, it's not important. I know a little Reich, but on *The Conformist* Reich was not important for me. Freud, however, is very important in my biological-physical life. I think that *Spider's Stratagem,* for instance, was really suggested by my beginning psychoanalysis. I started to do a personal analysis four months before I began to make *Spider's Stratagem.* The relation between father and son is the real point of the film.

Cineaste: *The son wants to become the father?*

Bertolucci: Yes, all the great problems between father and son are the basis of the film.

Cineaste: *Even the incestuous relation, with Dreyfa, is present.*

Bertolucci: Yes, with Dreyfa.

Cineaste: *I thought you were interested in Reich because he makes the connection between homosexuality and fascism. Have you seen Makavejev's film,* W.R.: The Mysteries of the Organism?

Bertolucci: Although I like Makavejev very much, I haven't seen his latest film. I think in Makavejev one finds the realization of "materialism." He is the one real "materialist" director today in the Marxist sense. His second film, *An Affair of the Heart,* about the killing of a telephone operator, was really a materialist film, very interesting. Nobody else in the socialist countries is making materialist films.

Cineaste: *Some people say that Rossellini is the great materialist filmmaker.*

Bertolucci: Rossellini is a materialist, but unconsciously. Makavejev is conscious.

Cineaste: *But without hope. He doesn't feel that things can change, that we can make a better society than the fraudulent one we have now. Do you think that the treatment of political ideas in*

films, the conditions of filmmaking, are different for an East European director than those confronting you when you make a film in Italy or France? That a director like Makavejev faces different problems and therefore makes a different kind of film?

Bertolucci: I don't know because I don't know what the conditions are for my fellow socialists in Russia or Yugoslavia. Socialism is in power in the countries of Eastern Europe, so filmmakers don't have to struggle against something as they do here. We want socialism, so it's quite different.

Cineaste: *Do you believe they have socialism in Yugoslavia or Russia?*

Bertolucci: Yes, I do. It's not the final stage, but they are countries which are closer to socialism than we are.

Cineaste: *You don't believe that they are in need of a new revolution?*

Bertolucci: Are you a Trotskyist? I am not a Trotskyist. I am in the Communist Party.

The great problem of the political film is very difficult. I see a great contradiction in my work when I do political films like *Before the Revolution* and *Partner*, because political films must be popular films, and *Partner*, for example, was anything but popular. So there was a big contradiction. I don't think that *Conformist* can have a political effect. I think it is just a film about sentiment and there is a judgment in it about history. But in my country the film cannot have a real political result. And I think the same is true for *Z, Investigation of a Citizen Above Suspicion*, and the new Petri film, *The Working Class Goes to Heaven*.

Cineaste: *And Godard?*

Bertolucci: Godard, too. I think that cinema is always political, all films are political, but all films which are made within the system are also exploited by the system.

I thought during the sixties that with movies you could make a revolution, but it isn't true. Now I think you can only be at the service of the revolution. Cinema itself cannot be revolutionary—it can only be *contestatario* (in opposition).

Cineaste: *Have you seen* Hour of the Furnaces? *Solanas of course had the problem of not being able to show the film to the people he would have liked to have seen it.*

Bertolucci: When you make revolutionary film in the sense that you and I conceive of a revolutionary film it never goes into a revolutionary space. It goes into festivals. So you do a revolutionary film for

the cinephiles, the people who like movies.

Cineaste: *I was looking back at Borges'* The Myth of the Traitor and the Hero, *upon which* Spider's Stratagem *was based, but your film does not really reflect the sensibility of Borges at all.*

Bertolucci: In Borges what you have is a "rite," or ritual, a geometric composition around the character of a man who is a traitor and a hero at the same time. As soon as I read the book, I wanted to make a contemporary story of it. Then a very strange thing happened. When I wrote the script, the story was about a young man and his grandfather. But the day before we began shooting I thought that there was something that was not right. And then I understood that for me it is not about the grandfather, but the father.

Cineaste: *Did you intend* The Spider's Stratagem *to make any judgment on the trick of Athos Magnani to have the comrades whom he betrayed kill him and then blame the assassination on the fascists?*

Bertolucci: Athos Magnani can see in his friends a kind of naivete. He betrays them. Why? I don't know. Maybe because he thinks it's more important to have an anti-fascist hero, unlike the attempted *attentat* (assassination) of Wallace which was not successful. It's more important to have a dead hero. I don't give any explanation, but I am always thinking within the film about the reason for the treason.

Cineaste: *It's a terrible thing to betray, even if you no longer agree with your comrades.*

Bertolucci: I don't think it's terrible to betray. It's terrible when an idea needs a hero, to need a hero is terrible.

Cineaste: *You're more sympathetic to Athos Magnani, the father, than I would be.*

Bertolucci: I am sympathetic, but I killed him.

Cineaste: *If his son hadn't come, he'd still be the great hero, in an absolute sense*

Bertolucci: But when the son understands the truth, what does he say? He has to decide whether to tell the truth to the people or not. He doesn't tell the truth. He goes away. But he says, "A man is made by all men . . . he is all the people and all the people are he." It's the last line of Sartre's *Les Mots.* The son during the film, during his one day in Tara, can understand only one thing, the phrase he speaks at the end of the film.

Cineaste: *That is an idea from Borges, too; Borges says, if I speak one line of Shakespeare, at the moment, I am Shakespeare.*

Bertolucci: Yes, but I took the line from Sartre. Borges speaks

about Don Quixote too, about a second and third Don Quixote made by other possible writers.

Cineaste: *How successful have* Conformist *and* Spider's Stratagem *been in Italy? Were they popular?*

Bertolucci: Both films are my most successful. *Spider* was shown on television twice and had an audience of twenty million people. *Conformist* was not on television, so the films had two different lives. *Conformist* is popular here too, but it's impossible to have an audience of twenty million people—no *Dolce Vita*, no Sergio Leone film has had this large an audience.

Cineaste: *Could you tell us about your new film,* Last Tango in Paris?

Bertolucci: The new film is important for me because it is the first time I'm doing something in the present. *The Conformist* is also in the present, but it's the present dressed as the past. *Last Tango* is really contemporary, the present, the present of "fucking," the "fucking" is just one moment in the present. In *Tango* the present is the absolute present, as during a moment of love.

Cineaste: *Does* Tango *have any historic or political background?*

Bertolucci: Yes, but sexual as political. Sexuality and politics are very important, but nothing of the political events in France.

Cineaste: *What is the context of the film?*

Bertolucci: It's about a human relationship between a man and a woman in the present. I think it's the most political film I've ever done, but the characters themselves never speak about politics.

Cineaste: *Marlon Brando has lately been choosing films that he feels have a certain political importance, like Pontecorvo's* Burn! *and* The Godfather, *which Brando thought was a criticism of capitalism, but of course it isn't, it's a gangster film. Have you seen it?*

Bertolucci: I saw it last week. He's incredible, Marlon.

Cineaste: *Brando has said that the two people in the world he'd most like to kill are his father and Gillo Pontecorvo.*

Bertolucci: I know that Pontecorvo would like to kill Marlon Brando. They had a terrible relationship because of political disagreements. And Marlon felt that *Burn!* was a disappointment. But *Last Tango in Paris* is a sort of tragic *American in Paris*, because Brando is an American in the film. Do you remember *American in Paris?* Something like that, but with differences.

5—OUSMANE SEMBENE

Filmmakers have a great responsibility to our people

Ousmane Sembene is the director of Mandabi (The Money Order), *the first African feature film to be theatrically exhibited in the United States. French critic Guy Hennebelle characterizes Sembene as "the pope of African cinema" and "the father of Senegalese cinema." He describes Sembene as a filmmaker who "pursues his own way while zig-zagging between the contradictions of the Senegalese regime, French neo-colonialism, and the cactuses on the desert of African cinema." The following interview was done by Harold D. Weaver, Jr., former Chairman of the Department of African Studies at Rutgers University, and was translated by Carrie Moore. It took place in 1972 on the occasion of Sembene's participation in the 15th Annual Meeting of the African Studies Association.*

Cineaste: *What message do you have for the Afro-American community regarding your recently-released film* Emitai (God of Thunder)?

Ousmane Sembene: I think that what I want to do first of all is to give them an exact idea of Africa, a better idea of Africa, so they can learn of other African ethnic groups. Each ethnic group has a culture and I would compare the Diola, who are a minority in Senegalese society, to the Afro-Americans, who are a minority among whites. They have a culture and they must do everything to save it because that culture is what makes their personality. I think that knowing Africa better will solidify their personality with that new black personality now emerging in American society because we all have the same cultural matrix.

Cineaste: *What did you set out to do in* Emitai? *What were your objectives?*

Sembene: My first goal was to make this film a school of history. From ancient times in Africa—dating back to the medieval period—we know stories of resistance. During the period of colonialism it would appear that there were no struggles for national liberation, but that's not true. I can show that during this period not a single month passed when there was not an effort of resistance. The problem was there was no communication among the people. There were scattered struggles, even individual struggles, but they were stifled. If people had known about it before, we would have been free now for a long time. But today, with filmmaking, we can learn from each other.

For example, we are thirsty to know all about the Afro-American movement. We know that in the Civil War there were black batallions which participated. We know that Afro-American mothers have done everything to raise their children. We also know of great Afro-American writers. And if one day they can bring these facts to the screen, you can imagine the number of people who are going to realize all of this. That's why I think *Emitai* is important. That's also why we think that, for us, filmmaking has to be the school, and that filmmakers have a great responsibility to our people.

Cineaste: *Would you elaborate on you comments of last night in which you compared the behavior of the French colonialists in Africa with the present-day politicians and administrators of constitutionally-independent Africa?*

Sembene: We have to have the courage to say that during the colonial period we were sometimes colonized with the help of our

own leaders, our own chiefs, and our own kings. We musn't be ashamed of our faults and our errors. We have to recognize them in order to fight them. In recent years there have been many, many coup d'etats in Africa but not a single one of these military people fought for the liberation of Africa. At the time when there was an awareness developing in Africa, it was these military men who were killing and imprisoning their own brothers, mothers and sisters. In the majority of the African countries the leaders and heads of state are heads of state with the consent of the French. Most of their personal guards are former French military officers and their personal advisors are French.

I can give you two striking examples. When the Gabonese people wanted to overthrow their government, France sent soldiers,but the soldiers came from Dakar and Abidjan. And not too long ago in Madagascar the French became tired of their former chiefs, so when the people were struggling to overthrow the president, France declared she was not going to intervene. We have another example, Gilbert Youlou, in the Congo. When the people wanted to overthrow him, he telephoned De Gaulle who said, "No." If De Gaulle had said "Yes," Youlou would still be the president. This is to explain to you the totality of things taking place in Africa and the kind of thing I wanted to show in the film.

Cineaste: *One thing that impressed me about* Emitai *was the importance of women in the act of resistance to colonialism. Women are thought of by many Americans to have a subordinate role in Africa. Did you set out intentionally in* Emitai *to point out the important role of women in Africa, both historically and currently?*

Sembene: First of all, I have to say that the story of *Emitai* is based on an actual event. The person who led the struggle, all by herself, was a woman—and a woman who was sick. The colonialists killed her, but they didn't kill her husband. I can give you an example of the strike of Thies, I can give you an example of the birth of the R.D.A.,* I can even talk of recent times under Senghor. In 1963 the women left the indigenous quarter called the *medina* to overthrow Senghor. On their march the men also came and in front of the palace they killed more than one hundred and fifty people. I think it's a white man's vision that says that our women have never participated in our struggle. In fact, the participation of women in the

*The Rassemblement Democratique Africain, founded in 1946 by Felix Houphouet-Boigny of the Ivory Coast, was one of the foremost interterritorial nationalist movements involved in agitating for independence from France during the postwar years.

struggle has several levels, including the raising, the socializing of children, and preserving our culture. It's a fact that African culture has been preserved by the women, and it's thanks to them that what has been saved has been saved. They're also less alienated and much more independent than the men. All of this means that we mustn't neglect the participation of women in the struggle. It is true that at the present time we have a lot of "sophisticated" girls, but these are girls in the city, and most of the time it's not their fault because they don't have any symbols or points of reference. All of their symbols, all of their criteria for beauty, come from the Western world. Based on that, the Europeans always accuse the African women of being alienated. But you have to live with an African family in their own household to see—they have paid all the expenses of colonialism.

Cineaste: *How did you intend to show the traditional political leadership in* Emitai?

Sembene: There are two things in *Emitai* concerning traditional chiefs; in the tradition, what has been preserved is for them a democracy. You can't be a chief by birth. One is a chief because one is worthy, a man who is respectable. In their gathering in the film each elected person must speak. The chief is not a chief in the Western sense—he's the spokesman. He's only the chief when there's a need, he's not a chief all the time. I think it's a democracy. Another thing is that the chief, as the chief, can't decide anything as regards the women. You see that in the film. They can't decide anything even though they are all elected.

Cineaste: *What do you mean they can't decide anything as regards the women?*

Sembene: I mean that they're chiefs and from a European point of view they ought to have been able to decide to give up the rice. But they knew that it was up to the women to decide that, they could not, and the only thing they could do was to all go to war. But they couldn't bring anybody else into it—that's another form of democracy within a certain specific ethnic group. There are ethnic groups in Africa where the kings and chiefs decide. There are also a lot of ethnic groups like mine, for instance, where there are no kings or chiefs. The fellow is elected, he doesn't earn any money, he doesn't have anything more than the rest of them, and, commonly, they call him the servant of the people.

Cineaste: *You mentioned earlier the role of the military in contemporary Africa—the negative tradition, the anti-African tradition*

out of which it has come. What specifically did you intend to show in
Emitai *about the soldier?*

Sembene: Those soldiers, who were mercenaries, were called
"tirailleurs." France recruited them by force and gave them minimal
instruction, a small salary and a rifle, and they obeyed. They started
by conquering their own families, by participating in the colonization
of their own homes and villages. With the development of colonial-
ization they were everywhere. Behind two whites there were thirty
soldiers with rifles, but not a single one of them had the idea to
revolt. At no moment in history did they rebel—neither for the
people nor out of their own personal humiliation. Colonialism just
levelled them down and now, during independence, it's they—
having been formed by the French army or the British army—who
make the coup d'etats and who assume the leadership. And they are
worse today because they're fascists. Therefore, what I wanted to
show with the soldiers was that the past and the present are the
same. We see the sergeant, for example, as an obedient dog. He
doesn't even have a name; his name is Sergeant, like a dog.

Cineaste: *The term "fetish" is mentioned in the film from time to
time. Is that your term or is that the translation? In terms of describing
religious practices, is there any particular reason it is simply not called
"religion" or "traditional religion"?*

Sembene: It is the sergeant who uses the term and who explains
it—you have put yourself into his mentality because he is the man
who has been "educated." There are two words that we use every-
day which the Western world has imposed upon us concerning our
own religion and culture. When we talk about an African culture or
dance we say "folklore" and when we talk about our religion we talk
about "fetish," and that is exactly why I put that in the sergeant's
mouth. It pleases me that you noticed it, because I have it repeated
several times. But the others never say "fetish," they always say "we
are going to consult our gods."

Cineaste: *Personally, I am very sensitive about words like
"fetish," "chief," and "tribe."*

Sembene: The old men in the group never talked about Senegal.
They always said "we the Diola" because they identified with
something.

Cineaste: *The final question on* Emitai *related to movement in
the film. I would like you to comment on the tempo, the movement
of the film and how it actually relates to the nation state Senegal, with*

its diversity of languages. I just want a little bit of explanation on something you said earlier.

Sembene: The Diolas are a minority in Senegal, they speak a language that the others don't understand, so the sub-titles are in French. The majority of the people who go to see the film, first of all, don't speak Diola, and they have problems reading sub-titles. In order to have them better understand the film, then, it was necessary to have a slowness which was, however, not *too* slow—and that's why I adopted that particular approach. I also worked a great deal on the decor. Each shot includes something which lets them see for themselves that their country is very beautiful, that we are not showing them the countryside of France, that our trees are just as pretty as others—even the dead trees can be pretty. But to come back to the question of language, I think it is very important when you make a film of similar ethnic groups to work on the musicality of the words so they will have a very precise and very clear tone so that the people who see the film are not shocked, so their ears are not shocked by the sound. That's why I worked so much on this tempo, which is a little slower than that of *Mandabi.* This problem of language is one of the problems confronting filmmakers in Africa.

Cineaste: *The major problem or just one of the problems?*

Sembene: One of the problems. I think given the fact that there is such a diversity of languages in Africa, we African filmmakers will have to find our own way for the message to be understood by everyone, or we'll have to find a language that comes from the image and the gestures. I think I would go as far to say that we will have to go back and see some of the silent films and in that way find a new inspiration.

Contrary to what people think, we talk a lot in Africa but we talk when it's time to talk. There are also those who say blacks spend all of their time dancing—but we dance for reasons which are our own. Dancing is not a flaw in itself, but I never see an engineer dancing in front of his machine, and a continent or a people does not spend its time dancing. All of this means that the African filmmaker's work is very important—he must find a way that is his own, he must find his own symbols, even create symbols if he has to. This doesn't mean we are rejecting others, but it should be our own culture.

Cineaste: *You were talking earlier about the music of the wind. Would you explain what you mean by that?*

Sembene: The whites, for example, have music for everything in their films—music for rain, music for the wind, music for tears, music

for moments of emotion, but they don't know how to make these elements speak for themselves. They don't feel them. But in our own films we can make the sensation of these elements felt, without denaturing the visual elements, without broadcasting everything to the audience.

I'll give you an example, even two. In *Emitai,* when the women are forced by the soldiers to sit out in the sun, the only sound you can hear is the sound of the rooster and the weeping of the children; however, there was also wind. I did not look for music to engage the audience. I just wanted to show, by gestures, that the women are tired, their legs are tired, their arms are burdened—one woman has the sun shining in her eyes, another two are sleeping. All this is shown in silence, but it is a silence that speaks. I could have had a voice coming from the outside, but I would have been cheating. Instead, for example, there were the two children who were walking along to bring water to the women. When they crossed the woods, you couldn't see their legs, but you could hear, very clearly, the dead leaves underfoot. For me, this represents the search for a cinema of silence.

Another example: in the Sacred Forest, life continues because there is a fire and the wind is blowing. I didn't try to bring in any music, so when the empty gourd falls it makes a noise. In that case, the silence is very profound. I think all of this indicates a search on our parts, a search for African filmmaking. And I'm sure that we are on the way to creating our own cinema because we often meet as African filmmakers to discuss our films with enthusiasm, to look for the best way to transmit our message.

European filmmakers often use music which is gratuitous. It's true that it is pleasant to hear but, culturally, does it leave us with anything? I think the best film would be one after which you have to ask yourself, "Was there any music in that film?" Today there are films that you could sell with music, such as *Shaft*. You remember the music, but maybe you don't remember the images or the message. In that case I would say it was the musician who was the filmmaker.

Cineaste: *I became very much aware of your own sensitive use of music in* Borom Sarret—*it was very obvious, very overt, there. When the cart driver goes between the European borders and the* medina, *it becomes very obvious how you switch back and forth between the indigenous music of the* medina *and European traditional music, which they call "classical" in the European quarters.*

Sembene: *Borom Sarret* was my first film and I didn't have the awareness that I have now, but I wanted to show the European area and the Africans who lived in the European life-style. The only music I could relate to them was the classical music, the minuets of the Eighteenth Century, because they're still at that mentality.

Cineaste: *Regarding your reason for making* Tauw, *you are quoted as having said, "This is the basic problem of Africa, there is a terrible gulf between young people's aspirations and their accomplishments." Would you elaborate on that?*

Sembene: All young people in the world (and I think this is true) have an aspiration to surpass, or to measure themselves in relation to, something that is great—to surpass what their fathers have done. But in Africa today the youth are completely sacrificed. For example, since I made *Tauw* approximately a year ago, the situation in Africa has become worse—for the simple reason that they don't have any work. And when I say that they don't have any work, I'm only talking about the men, I'm not even talking about the women who are the majority of the Senegalese population of four million. The majority of them are under twenty-five years old and there are perhaps only about one-third of them who go to school, and even their future is uncertain.

Cineaste: *I would like you to explain another quote attributed to you—"We must understand our traditions before we can hope to understand ourselves." Many Afro-Americans feel the same way, but I'm curious about your own interpretation of what that means.*

Sembene: That is, we must understand our traditions, our own culture, the very depths of it. In African languages the word culture does not exist. They say that a man is educated, he is very well brought up, or he is from a very agreeable society. Therefore, culture is just a mental approach to a pleasant society. Culture itself, then, is like the hyphen between a man's birth and his death.

The Europeans say that our old men are good, but we never say that a man is good, we say that he is a man of culture. We mean that he is from an agreeable society and has an elevated sense of humanity. It has nothing to do with weakness. You can be present at meetings of old men where for hours they don't say anything to each other, they just sort of joke around. But in the process of joking they say what they want to say. A man of culture for us is one who has the key word for every situation. And you can go anywhere you want to and you'll always find the same attitude—you can't be a witness or a judge where we are as long as the community doesn't recognize you

as one. You can have all kinds of diplomas and not be invited to participate; and the greatest humiliation for a man in Africa is never to be called upon at difficult times. For us, then, one is not automatically a judge. Sometimes when there is a public discussion, and there is a foreigner or stranger in the area, they'll invite him—but he has to be a respectable stranger. After having exposed all the facts they ask him what he thinks, posing the question this way: "In a similar situation where you're from, how do you resolve this problem?" And depending on what he says and his manner of expression, we know whether or not he is a man of culture. So in Africa there is no man of culture in the European sense of that word. Culture for us means an honorable man, a man worthy of your faith and whose word means something. For example, if an old man sends a young person to see another old man, sometimes he sends along an object of value. He gives to the young person an object that would be recognized and he says, "Here, take this and tell the other that I sent you."

Cineaste: *One key problem the black filmmaker faces in the United States is that there are only white distributors. This appears to be the case in many parts of Africa also, including your own country. How does this affect which films are shown?*

Sembene: I am very happy you posed that problem because it is a problem for the whole third world—and we consider the Afro-American community to be a colony within American society. So, faced with the same problems, we're looking for a solution. We think that instead of innundating the African market with films made by whites, there's a place for films made by Afro-Americans. But there is no immediate solution. If Afro-Americans were rich enough to buy all of the theaters here they'd have the control, but I don't think that's going to happen. Likewise, in Africa—Francophone Africa and Anglophone Africa—distribution is in the hands either of the French, the British or the Lebanese. At the moment, we are trying to find a means of resolving this problem. Perhaps if we could get the Afro-American filmmakers and the African filmmakers together, it might be possible—by beginning on a small scale—to distribute our own films on the African continent and with Afro-American distributors. But we mustn't forget that while the cinema is an art, it's also an industry, and the problem that you pose concerns the industrial side of filmmaking. It could probably only be solved by the formation of a group which shares the same ideology. I don't mean ideology in a political sense, but in the sense of having the same interests.

Cineaste: *At Cannes, in 1970, in a conversation with the man who is responsible for distribution in Kenya, he indicated to me that there was no real interest in the distribution of Afro-American films there, that they were primarily interested in cowboy films.*

Sembene: That's the same answer we get from the French or from our African leaders because they have a complete ignorance of the role of films. We think that, little by little, we are changing this mentality which says that a cowboy film is the only kind of film that the African public likes. I think that it's up to African filmmakers to fight to change this defective distribution. The African public is now beginning to appreciate our films, so saying that it is a cowboy film that the African public prefers is not really telling the truth. For instance, there is a public now prepared to receive Afro-American films in Ghana, Nigeria, Tanzania, Kenya, etc. For the African public the most well-known actors are Sidney Poitier and Harry Belafonte and I'm sure a film like *Super Fly* would have the largest box-office of any film in Africa. So you can see that it's not really a question of a preference for cowboy films, it's just that those distributors and certain government leaders who deal with distribution prefer cowboy films.

But I think that with the Pan-African Federation of Cineastes [FEPACI] we are now beginning to change things. The Federation is now recognized by the Organization for African Unity and the Arab League and our films are beginning to circulate on the African continent. My own method has been that each time I go into an African country, I show my film and afterwards discuss it with the audience and with the government officials. For example, *Mandabi, La Noire de . . .,* and *Borom Sarret* have been all over Africa. And other films made by Africans are circulating. Of course, overall distribution is still in the hands of foreign interests. There is not a single African who controls distribution outside of countries like Guinea, Mali or Nigeria, and since in these cases it's the government which controls distribution, they take all the films made by Africans. Upper Volta also controls its film distribution and they take all the African films. While this is something very positive, it's still insufficient because there is no coordination between the various states, so what we're working for now is that coordination. Next year we're supposed to have a meeting of filmmakers and the report that I'm supposed to give is on the problem of distribution (films being distributed, their ability to gain income, their tax, and to forsee a general distribution plan). We think

that what we're going to ask for is within the reach of our govern-
ments so we're sure that in the future we'll accomplish our
goal—that's what we're working for.

Cineaste: *Have you seen any of the new films being produced
about black Americans and, if so, are there any that you have liked?*

Sembene: I saw *Sounder* and, when I saw it, I wondered if it had
been written by a white man or a black man. When I was told it had
been written by a black man, I was very happy. I don't know if it's his
first, second or third film, and I don't know how much money he had
to make it, but I sense a man who loves his people and who, by
means of this story (even though it is limited), wants to tell us
something. I don't know about his childhood but I know that he loves
his family and I know that he is respected. It's a film that I would like
for all fathers to see. And the woman who plays the mother is the
best Afro-American actress I've ever seen. I don't know if this film
has been sub-titled or dubbed into French but I'm going to recom-
mend that it be invited to Africa. I'm sure that if this film is projected
for an African audience, they will forget that it takes place in
America. The only thing which did not please me about the film is
that I'm sure that in 1933 there were an enormous amount of racial
problems in the U.S. But even if this problem isn't brought out, the
film gives a sense of a respectful family just as it exists within us in
Africa.

The other film I saw was *Black Girl*, the new film by Ossie Davis
which also deals with the family in America. It shows that within the
family it's possible to have all kinds of hate, all kinds of lowness, but
it's still the family. I think that we need to explore the inner workings
of the family, and in this film we have four generations tied together:
the grandmother, the mother of the daughter, and another younger
girl. A moral problem is raised because the grandmother is living
common-law; the mother didn't have a husband, but she worked
and raised her children, and even raised a girl who was not her own
child, she succeeded; and the only man in the film has a lot of money
and thinks that love can be bought. If we compare the man in *Black
Girl* to the man in *Sounder,* and compare the children in *Sounder* to
the children in *Black Girl*, we'd have a complete universe. And that's
the kind of film that I like to make, because it's the kind of film that
teaches us to read and to know and to enhance our sentiments. We
mustn't forget that for centuries they've been working to destroy us.
We're everything except moral men—we're gangsters, drug addicts,

criminals, as if we had no parents. So I think that films like this are useful.

Cineaste: *I would like to ask one final question. What is your next film project?*

Sembene: I'm going to make a film on the Senegalese big businessman, on the birth of the black bourgeoisie.

Cineaste: *Briefly, why?*

Sembene: Because we're witnessing the birth of an aborted child and some of these circumstances are very dangerous—too dangerous because they are being manipulated from the outside, from Europe, and I want to show how they're being manipulated, and why the people must kill them.

6—ELIO PETRI

Cinema is not for an elite, but for the masses

Born in Rome in 1929, Elio Petri graduated from the University of Rome with a degree in literature, but, soon afterwards, he became film critic for L'Unita, the daily newspaper of the Italian Communist Party. Throughout the 1950s, Petri wrote scripts and occasionally worked on documentary shorts. His first fiction film, L'Assassino (1961), starred Marcello Mastroianni but was not released in the United States until 1966 as a badly dubbed The Lady-Killer of Rome. *During the 1960s, three other Petri films were not released in the United States, and two,* The Tenth Victim *(1965) and* We Still Kill the Old Way *(1966), had limited release. It was only with* Investigation of a Citizen Above Suspicion *(1969) that Petri won the attention of a relatively wide audience. His film dealt with how a mad police official kills his mistress and tries to pin the guilt on an anarchist. The film was a sensation in Italy, where it appeared right after a young anarchist was hurled to his death from the window of a police station in Milan under the most suspicious of circumstances. The following interview was done by Joan Mellen in May of 1972 after Petri had completed* The Working Class Goes to Heaven *but had not yet begun production on* Property Is No Longer a Theft.

Cineaste: *Can you tell me something about your intellectual and political development?*

Elio Petri: I can only talk about the things I am conscious of, not of those I am not. There are things that probably escape me. We cannot have an exact, scientific consciousness of our entire development.

Cineaste: *Were there any major educational experiences in your life that led to the development of your political consciousness?*

Petri: I am of Marx's opinion that man is a social animal; but with Freud I believe as well that there is an unconscious that influences us. From one point of view I can be conscious above all of the social influence. And from what *is not* in my films you can deduce the unconscious part.

Cineaste: *How did you start in films?*

Petri: I began going to the movies as a kid. In those days the cinema was the nickelodeon. In the thirties Italian cinema was either a fascist cinema or an escapist one. But as opposed to the escapist cinema in Italy at that time, there was the American cinema as well. American cinema in the thirties, insofar as it was a cinema depicting social evils like unemployment and gangsterism, played a large part in the formation of filmmakers of my generation. Of course, American cinema at that time also involved an invasion, an army of films through which America was already occupying Italy and Europe. Before the Americans landed in Salerno and Anzio during the war they had already arrived through their films.

Cineaste: *Are you referring to a cultural imperialism of the Americans in Italy before the Second World War?*

Petri: It was not a matter of imperialism. America was using Hollywood films as propaganda in favor of the American system, presenting the American consumer society as a model. This was the real bridgehead of the Americans in Italy, the real victory. And this is why I think American capitalism should be very grateful to Hollywood and its productions. Nevertheless it must also be said that the healthy part of our youth, those with democratic tendencies, saw instead in the American cinema a democratic point of reference and an anti-fascist model. This ties in as well with the literary production in those years, from Hemingway to Steinbeck.

Cineaste: *Do you see Rossellini affected by this process?*

Petri: No, I'm speaking about my own generation rather than about Rossellini's. In my opinion, on the contrary, the generation that preceded mine was primarily influenced by French naturalism.

But after the war both generations converged to use cinema as an in-
strument leading to knowledge about reality. In the final analysis, the
best American cinema was realist.

After the years of fascist obscurantism and of provincial escapist
films, a cinema appeared which was looked on as a means toward
liberation and to freedom. I began to work in the cinema as a script-
writer in this first wave of realism.

Cineaste: *With whom did you work in the early years?*

Petri: Mostly with De Santis. Those years in Italy after the war
meant a defeat of the forces that had organized the resistance to
fascism, not only to overthrow fascism, but to change as well the
social structure that had led to fascism. This was a period of strong
capitalist restoration and a setback to the anti-fascist and popular par-
ties. The new social relationships that were being established during
this new phase of capitalist restoration immediately produced in
society the phenomenon of alienation. Rossellini, Visconti,
Antonioni and Fellini, developing the neo-realist legacy, tried to
testify to the psychological and human damage of alienation. My
earlier films also reflect this point of view. However, by the time of
my second film, *I Giorni Contati (The Days Are Numbered),* I believe
my central theme was already autonomous from the type of research
into the psyche carried out by Fellini and Antonioni.

Cineaste: *You were no longer preoccupied with this question of
psychological alienation?*

Petri: No. In my first film, *Il Assassino (The Martyr),* I was preoc-
cupied with the question of psychological alienation. In my second
film, in spite of a strong existentialist accent, there was already a clear
position taken against work. Alienation was studied not as a
psychological phenomenon, but as a social fact.

Cineaste: *The alienation of labor in the Marxist sense?*

Petri: Yes. In the sense of Marx and of Sartre. This is the basis of
my work and in the last analysis it can be found in all my work. As
the movement of opposition to capitalism in both Europe and Italy in
particular has gathered strength, the political character of my films
has been enriched and strengthened in consequence.

Cineaste: *Does the growing anti-capitalist feeling among
intellectuals in Europe account for your winning the Grand Prize at
Cannes in 1972? Could* The Working Class Goes to Heaven *have
won the Grand Prize at Cannes five years ago?*

Petri: I don't know. This could even mean the opposite, a
symptom of the contrary.

Cineaste: *Do you mean that these ideas are no longer dangerous and that therefore they can be more easily accepted?*

Petri: Yes. Ours is the kind of society that absorbs everything and turns it back into consumerism. It provokes a phenomenon of interjection through which people assimilate the reasoning of the opposition.

Cineaste: *You emasculate your opposition by giving it a prize, by saying that it's acceptable—so that it ceases to be an opposition?*

Petri: All is absorbed into consumerism. At the same time we must take into account that out of any two or three hundred films, only three or four have any social content. The rest are love stories, Westerns, mysteries, without the slightest intellectual, let alone social, engagement.

Cineaste: *We were surprised that Rosi, whose films are generally considered too radical to be distributed in the United States, should also win a prize at Cannes.*

Petri: But Rosi's *Il Caso Mattei* was produced with the help of American money. Sooner or later it will be bought by the Americans. My film *The Working Class Goes to Heaven,* sooner or later will be bought too. It remains to be seen whether we who are trying to work through the system in order to raise the consciousness of the audience, in spite of the ability of the system to absorb everything, are doing the right thing. What we can say is that all this is a mirror of what's happening now and that we cannot escape it given the way cinema is conceived today.

Cineaste: *Do you see a contradiction in the fact that in the United States* The Working Class Goes to Heaven *will be seen only by the bourgeoisie?*

Petri: This contradiction exists here too to some extent. But I think that my effort in this film can be of some use even in this direction since I tried my best to force the middle class audience to identify with the workers. The film is not aimed at convincing those who already have my political and ideological convictions. Rather, it tries, through a dialectical process, to reach those who are still outsiders to these ideas.

Cineaste: *Do you have a broader definition of the working class than Marx had?*

Petri: No. I'm saying, with Marx, that we have to wait for the workers to free us all, since they have nothing to lose. The production relationships alienate us all with the exception of the exploiters. Human beings must regain their subjectivity and escape the role of

objects into which they have been forced by today's means of production. This is true of the workers, but it is true as well for technicians, intellectuals, artists, women.

Cineaste: *Was* The Working Class Goes to Heaven *shot in an actual factory? I read somewhere that Agnelli, an owner of Fiat, told other factory owners in the Milan area not to permit you to shoot the film in their factories.*

Petri: As far as I know Agnelli himself did not try to prevent the shooting of the film. However, the factories to which we applied for a permit for shooting never granted us that permission. The film was finally shot in a factory which was about to close down, whose owners were in jail for bankruptcy. The workers were, for the most part, real workers, although many actors were used as well.

Cineaste: *Does the film have a hero in the sense of someone who has superior consciousness to the other characters — as opposed to a film like* The Battle of Algiers *which tries to have no hero, but uses the masses as hero?*

Petri: No, the hero of my film is not a positive one in any sense. The originality of the film consists in its having put aside all Soviet iconography, all the trappings of socialist realism usually invoked in films about workers, and any attempt to propagandize. The main character is split into many parts—as we all are—and he has only a partial understanding of what is happening. Within him are all the forces that exist outside of him, he is made up of them. Inside the main character all the other characters are present. He is all these things at the same time: a Stakhanovist, a slave to the boss, interested in production for its own sake, a TV watcher, an anarchist, middle class, a revolutionary, a trade unionist—as we all are.

Cineaste: *Does he resemble in any way the hero in* Investigation of a Citizen Above Suspicion?

Petri: No, there is a major difference insofar as in *Investigation of a Citizen Above Suspicion* the hero's schizophrenia was limited to the pathological use of power whereas the schizophrenia of the hero of *The Working Class Goes to Heaven* still shows some positive signs.

Cineaste: *What are they?*

Petri: The instincts within himself that aim at changing society, and reality. In some sense I believe that schizophrenia is a big step forward when compared with Manichaeanism. Of course these ideas are expressed in very simple, popular, didactic terms. Cinema is not for an elite, but for the masses. The acting and the use of the camera must be a spectacular one. We as well have to take into account the

rich, popular tradition which is the basis of the Italian theater and cinema, and of Fellini, of course, in particular.

Cineaste: *Is there a connection in* The Working Class Goes to Heaven *between sexuality and politics as there was in* Investigation of a Citizen Above Suspicion?

Petri: Yes, of course. There is a Reichian type of relationship. Because I think that nowadays there is no possibility for culture other than an interdisciplinary one. I am convinced that Reich marks a significant meeting point between Marxism and psychoanalysis. It is clear that all the repressions of our childhood are used by society to make us into instruments of production. When a worker is a slave to the machine, his sexuality is being employed in the rhythm of production.

Cineaste: *It seems clear that you were using Reich for the characterization especially of the inspector in* Investigation of a Citizen Above Suspicion. *It seems to be a case of the relationship between latent homosexuality and fascism.*

Petri: Yes, especially insofar as it is from the mechanism of sado-masochism that authoritarianism draws its strength. Of this sado-masochism, latent homosexuality is only a symptom. It is also clear that the superego wants to make love to the ego and dominate it.

Cineaste: *Is there caricature in the portrayal of the inspector or is this simply part of the expressionism of the film?*

Petri: The snobbish, intellectual cinema requires "understate-ment." But, unfortunately, reality *is* caricature and I believe that cinema should stress this, even if it means resorting to very popular forms; it should not fear sliding into kitsch. One can get lost among all those distinctions of "midcult," "highcult," "popcult," because this manner of splitting the culture can involve as well aspects of a racist nature.

Cineaste: *Do you mean in the sense of excluding certain groups from understanding the film?*

Petri: From one exclusion to the other, who is the last to be excluded? We must fight against all ghettos, and in the notion of kitsch there is the attempt to create a ghetto. There is implicit in kitsch the notion of an elite, and then there is the elite of the elite of the elite. It is a labyrinth.

Cineaste: *What is it about the young student in* investigation of a Citizen Above Suspicion *that allows him to break the inspector down in the jail scene?*

Petri: The student becomes the sadist in this case. He holds the whip, the proof of the inspector's guilt. But all this is not a science. It is also a matter of having fun while building these mechanisms. They might even be wrong from a psychoanalytic point of view, and they might even be useful only to understand *my* subconscious.

Cineaste: *That sounds like Bertolucci.*

Petri: (Laughter.)

Cineaste: *Do you find the crime melodrama, the detective story, an illuminating form to explore bourgeois society? In the crime film don't political points often get lost in the violence and in the action in general?*

Petri: Yes, but we have to understand that our entire life is a form of private investigation—a detective story—on all sorts of matters. As children we begin to investigate about sex, then about culture, then economic and social structures. Society by and large is built upon mystery; it is as if they wanted to keep secret what is really happening. I'm forty-three and in spite of all my investigations I've never succeeded in understanding what really happens on the Stock Exchange.

Cineaste: *Do you feel that these investigations of our lives involve the same degree of violence as they do in the crime melodramas?*

Petri: It depends on how earnestly you want to get to the truth. If you stop at the obvious answers, you will enjoy a pleasant life, but in total ignorance.

Cineaste: *Do you see the first scene of* Investigation of a Citizen Above Suspicion—*the murder of his mistress, Augusta—as an investigation in the inspector's own unconscious?*

Petri: I see it as a parable. The only way to eliminate his mistress—insofar as she has become the enemy, the witness of his weakness and his sexual inadequacy—is murder.

Cineaste: *Is it an evasion, an escape, from the type of investigation we have been discussing?*

Petri: On the contrary, it is the extreme consequence of an investigation. In the investigation of his sexual relationship with this woman he has discovered his own impotence—which is ultimately the impotence of authority. Thus he has to destroy the proof of this impotence so that authority can rule again.

Cineaste: *Do you admire* Z *or* The Confession, *which also employ melodramatic techinique to express political themes?*

Petri: *Z* is far better than *The Confession* although it suffers from

the fault of taking place in a half-imaginary country. But it still is a very positive film in many ways. *The Confession* has the fault of not having been made in Czechoslovakia by Czechs. Thus it is simply an anti-Soviet instrument. I think that attempting to make a film against totalitarianism, trying to find national connotations based on our own human experience, is finally against all kinds of totalitarianism. But one has to speak of his own experiences.

Cineaste: *You would then be against the Soviet invasion of Czechoslovakia in 1968?*

Petri: Of course I'm against the invasion. But a communist can make a film speaking of his own relationship with Stalinism, with the cult of personality, by talking about his own party and his own country. Why a film on Czechoslovakia when you have the French Communist Party and the Italian Communist Party. . . .

Cineaste: *With all the political filmmakers in Italy, no one has made this film about the Italian Communist Party.*

Petri: Because in spite of everything, the Italian Communist Party is still our best guarantee of freedom. Without the Communist Party we would live here as in Spain under Franco.

Cineaste: *Would you then support the Manifesto group?*

Petri: I'm in favor of a renewal, a total change of structures within the communist parties everywhere in the world, and of all the socialist societies in the sense of workers' control, a workers' democracy. In this sense I agree with the Manifesto group. However, the majority of the Italian workers are still with the Communist Party. This is the contradiction among the people, as Mao says.

Cineaste: *Have you any sympathy for Godard's recent films,* Pravda, See You at Mao, Wind from the East, *his use of film as a polemical, political weapon?*

Petri: I have great admiration for Godard. I haven't seen all of his recent films, but I did see *Struggle in Italy.* I still like his work, although I think that his efforts are useless. I don't believe one can make a revolution with cinema. To speak to an elite of intellectuals is like speaking to nobody. I believe that a dialectical process should be initiated among the great masses—through film and any other possible means. Within this strategy even Godard's films are important, especially when they are clear. Unfortunately, when you appeal to an elite, you fall into the trap of intellectualism.

Cineaste: *Which filmmakers have you admired — past and present?*

Petri: Unlike some of the *nouvelle vague* filmmakers, I don't have a complex toward great masters. To me a very great political director was Von Stroheim, maybe one of the greatest who ever lived. From him you can trace the line that comes down to me.

Cineaste: *Was there any influence of Bunuel in* Investigation of a Citizen Above Suspicion, *especially in the dream sequence at the end?*

Petri: Not Bunuel. If anyone, Lubitsch. Although I think that surrealism is one of the important components of modern expression, my main cultural matrix or influence is expressionism—which is the other main component of modern expression. I have great admiration for Bunuel, but my search for technique moves in a different direction, even in the search for effects. Bunuel is after the elements of dissociation of the real image within our consciousness. He is after the absurdity of the real while I'm looking for the absurdity of the social.

Cineaste: *How would you describe the role of women in your films? In* Investigations of a Citizen Above Suspicion *we see women through the eyes of men as castrators, whores and sado-masochists.*

Petri: In *The Working Class Goes to Heaven* the women are the best element of the film. The hero's two wives have far more consciousness of social contradictions than he. His young mistress has far more political consciousness than he. In both *The Working Class Goes to Heaven* and *Investigation of a Citizen Above Suspicion* the women are the basis of the social pyramid.

Cineaste: *In the sense of being oppressed?*

Petri: Yes. They are the human beings who suffer most from the condition of being objects. They are the objects of both sexual and economic exploitation.

Cineaste: *Have you seen the American film* Joe? *It portrays the working man as a fascist and enemy of the revolutionary. What do you think accounts for this contemptuous conception of the working class in the American cinema.*

Petri: I am not well prepared enough to answer this question. Of course I'm familiar with a great deal of American sociological analysis from C. Wright Mills to Marcuse. And I may be wrong, but I still hold onto the belief that even in America the working class is the carrier of hope. But it may be an illusion at this point. I might be wrong, but I must say that in the film you mention I saw a fascist worker, but I did not see a revolutionary student. And in this lies the ambiguity of the film. Drugs are presented as the only point of reference in the

struggle against the bourgeoisie. I don't think drugs are sufficient to change the social structure. I have nothing against the use of drugs, but I know for sure they are not going to be of any use in the political struggle. To be against drugs is not a sign of fascism. Goering took drugs. The founder of the Nazi party was a well-known junkie from Munich. Even the notion of fascism must be seen in a Reichian sense. Thus I think that springs of fascism can be found in everybody without distinction, even in the most revolutionary people. I'm using "fascism" in the same sense as Reich used the word, as a pathology of the soul. A black is not necessarily anti-fascist—or anti-racist.

Cineaste: *Do you see any connection between* Investigation of a Citizen Above Suspicion *and Bertolucci's* The Conformist, *Visconti's* The Damned *or Saura's* Garden of Delights *as treatments of fascism?*

Petri: No. I liked *The Conformist* and *The Damned* very much. But the only similarity I see is that each of these films portrays fascism from its own point of view.

Cineaste: *What is the meaning of the title,* The Working Class Goes to Heaven?

Petri: Paradise or heaven means power.

Cineaste: *Does it have a religious sense as well? Is it simply a call to the future?*

Petri: Yes, in the film it says that in paradise there is fog.

Cineaste: *Yet it involves a spiritual renewal on earth?*

Petri: Yes, of course. But the protagonists of this renewal will always be us.

Cineaste: *How do you find working in so many films with Gian Maria Volonte—as an actor and as a political personality?*

Petri: He is very good. Volonte, as not many actors are doing, is conducting his own private struggle to escape being turned into an object. This struggle is useful to the director too when he is trying to create more complex characters as well as schizophrenic ones.

Cineaste: *Did you admire the Montaldo film* Sacco and Vanzetti *in which Volonte also appeared?*

Petri: Yes, but I personally prefer films about today's political reality and I prefer a fictional treatment of political themes rather than this documentary approach. However I think it was the right time to make a film on Sacco and Vanzetti, when at this particular moment in Italy they are beginning to persecute anarchists again.

Cineaste: *Are you familiar with the Italian Marxist film magazine* Ombre Rosse *and what is your feeling about it?*

Petri: I know of it but I don't read it. I don't generally believe in extreme political positions, especially in Manichaean ones. Very often they take moralistic positions almost of a Catholic nature and they are puritanical. I believe in cinema as a social phenomenon rather than as merely an aesthetic one. I would be more interested in a magazine that would treat cinema from the sociological, political and psychoanalytic points of view. But there is not such a magazine, especially a non-sectarian one. The very fact of having these three different points of view would be a guarantee against sectarianism.

7—CONSTANTIN COSTA-GAVRAS

A film is like a match; you can make a big fire or nothing at all

Following the completion of Z, Costa-Gavras went to work on The Confession *(L' Aveu), which had its American release in 1970. Again working with Jorge Semprun, his co-script writer on* Z, *Costa-Gavras addressed the question of the Czechoslovakian purge trials of 1952. Based on an autobiography by Artur London,* The Confession *stirred considerable debate in radical circles about how far one could go in denouncing Stalinism without becoming anti-communist. In* State of Siege *the ethics in question were those of capitalism. The story was based on the kidnapping and eventual execution of U.S. Agency for International Development official Dan Mitrione by the Tupamaro urban guerillas in August of 1970. Supposedly an advisor in "traffic and communications," Mitrione was charged by the Tupamaros with actually being engaged in the training of the Uruguayan police and military in methods of torture. While in New York in June of 1973 to work on the American dubbing for* State of Siege, *Costa-Gavras was interviewed by Gary Crowdus and Harold Kalishman, an independent filmmaker. The conversation was in English and French, with simultaneous translation from the French provided by Christine Larrain.*

Cineaste: *What was your political aim in making* State of Siege?

Constantin Costa-Gavras: Simply to present a situation, a specific example of neocolonialism, and in so doing to show the faces of events that are hidden to the public. Mitrione was first presented as a diplomat, you know, then a consul, then a policeman. It was puzzling, in a sense a suspense.

It's obviously true that the largest countries in the world and not only the U.S. send this sort of "advisor" to small countries. They look a little bit like the missionaries sent by the church a long time ago.

Cineaste: *The first imperialist agents accompanied missionaries in the nineteeth century.*

Costa-Gavras: Exactly. But today everyone thinks missionaries were good people and they continue to give that impression to the general public. I always try to speak of the general public, by the way, not just a few people on the left.

Cineaste: *Your audience, in other words?*

Costa-Gavras: Yes, the audience. To further answer your question, however, *State of Siege* was intended to help people gain consciousness of this reality, of this problem. It's also important for people who are more politicized to have a movie like this. They know what it's about but it's important to have a starting point. But the other people, the sort of people who are perhaps very surprised about these things, those whom you call your "silent majority," are the most important, I think. I hope that when they see this movie they will start to ask questions of themselves or of others.

For example, I saw the Congressman Edward Koch on the plane from Washington and a friend introduced me to him. He said he had received letters from people asking if what was shown in *State of Siege* was true. I also received a letter from a senator I saw in Washington asking me to prepare a big report, a dossier, on this affair. I am making that dossier. So, this is only to say that after seeing the movie, people are very surprised and try to find out if it's true or not, and that can be very important.

Cineaste: *How would you evaluate the critical and popular reception so far to the film here, in the belly of the monster?*

Costa-Gavras: Well, you speak about the belly of the monster, it was true, we really felt that way when we arrived, but we received a fantastic response. I mean the reviews by people like the *Times* critic Vincent Canby and *New York* magazine's Judith Crist were in my opinion absolutely extraordinary. I think Canby saw the film two or three times, and Crist wrote that the audience learned more from the

film than the American media had shown them. Even *Time* was favorable. I was very surprised because for me *Time* and *Newsweek*, although some people don't like the comparison, are like *Pravda* because they represent the official opinion of the United States. *Time* and *Newsweek* are seen in the offices of politicians and businessmen all around the world, so what appears in *Time* and *Newsweek* is the absolute Truth, there is no doubt about it. The *Time* position I thought was very positive for the movie, but the *Newsweek* review I thought was dishonest. I'm not speaking about its aesthetic point of view, only its political point of view. I'm ready to have a public discussion with the reviewer about his feelings because he said exactly the opposite of the truth. *Newsweek* was the most reactionary.*

Cineaste: *Does film criticism influence you at all?*

Costa-Gavras: This is a big problem for the director. Generally, we say no, criticism doesn't influence us—this isn't so, but the complete opposite isn't true either. Nobody makes a movie because of a review or something a critic says. But, speaking for myself, favorable reviews—that is, not just from any reviewer who makes compliments, but from critics who are respected and who analyze the film in depth—these are an influence on me. That is, first I try to see if certain things they have written are true, are really there, because people sometimes see things you never thought about before. So that's a certain influence. You feel responsible...in a certain manner it influences how you make future movies. I mean, I don't consider a review as something universal—it's the opinion of one person—but at the same time it's the vision of many people.

The bad reviews, if they likewise try to analyze in depth, are also a certain influence. But it's a very vague influence and difficult to determine because you don't make one film immediately after another. The impression is an accumulated whole rather than something precise and definite. It's very hard to say exactly which parts of these reviews come into your work or in which direction they push you.

Cineaste: *You have said that a film becomes a political act as soon as one assumes a responsiblity vis-a-vis a situation or a people. What did you see as your responsibility to the situation and the people in* State of Siege? *And how did your feeling of responsiblity influence your treatment of them?*

*The *Newsweek* review was written by the magazine's first-string critic, Paul D. Zimmerman, who characterized *State of Siege* variously as "an ideological indoctrination with visual aids," "an arid exercise in ideological complacency" and a "passionless exercise in self-righteousness."

Costa-Gavras: The film clearly involves a responsibility to the Tupamaros but also a more important responsibility, in my opinion, to the audience. If I had to make a movie with complete responsibility to the Tupamaros, I would have to collaborate all the time with them on each scene, each word, so I didn't. I think my responsibility as a director to the audience is that I tried to be as close to the events, to the reality, and also to what the Tupamaros think about that specific situation, as I could. I think the Tupamaros are favorable to the movie, by the way, and they think the movie is very close to the reality. But I refused throughout to try to explain the theoretical line of the Tupamaros because they didn't make it really precise, particularly at that time.

Cineaste: *Do you think it has been precise since then?*

Costa-Gavras: Perhaps more than it was in 1971 when I was there because the situation changed completely after that. But in 1970, when the whole story happened, the line was not clear. I mean, the Tupamaros never said publicly at that time that they were a Marxist-Leninist organization—they spoke about those things privately.

Cineaste: *In the* State of Siege *book, in the interview with the Tupamaro, he says that there were two reasons for kidnapping Mitrione: one was for the release of prisoners and the second was to establish the Tupamaros as the main contradictory force in Uruguay. You don't think this was clear in their minds at the time?*

Costa-Gavras: Yes, this was, but what I'm talking about is their political line, the ideology of the Tupamaros, of the whole movement. It was a pro-Guevara movement but, on the other hand, the movie is not so much about the Tupamaros as it is about that situation which reveals neocolonialism.

Cineaste: *Were you tempted to . . . for instance, in the book you said they were an inspiration to you as they were to most radicals in this country.*

Costa-Gavras: No, first it is a problem of what *they* think—so *they* must make that kind of movie, to explain precisely their movement, to explain it from the inside. Secondly, to do all this you would need more time and it would become a movie like *La Hora de los Hornos,* very long, with detailed explanations, etc., and it would be a movie for a small, very limited audience. So, dramatically, it was impossible in *State of Siege* to do all things.

The other problem, of course, is that if I had made that kind of film, today it would have no value because the situation has

changed. If today you see a film made on the Tupamaros two years ago, you would understand nothing because everything is completely different now. That kind of intervention represented by Mitrione, however, still remains—today there is another Mitrione who is there and after him there will be another.

Cineaste: *Well, the reason I ask is that when* Battle of Algiers *came to this country, its effect was more than only to enlighten the American people about the Algerian struggle. The Black Panthers, for example, tried to copy the organizational structure. . . .*

Costa-Gavras: Yes, I know, and in my opinion that's a very bad way to see things. You don't just copy another revolution—in revolution you have to analyze the situation in your own country and try to find solutions to those precise conditions. The same thing is now happening, for instance, with the Maoists in France—they try to take the revolution of Mao and the society of Mao and adapt that in France. I don't believe that's possible.

But speaking about *The Battle of Algiers,* I think the basic difference is that *Battle of Algiers* was a historical movie, made just after the revolution succeeded. What Solinas and I tried to make concerns an event which has happened, but is also happening today—I'm not speaking of the kidnapping but that sort of intervention, that AID presence in Latin America.

Costa-Gavras: It is true, I always took the events without putting them in their historical context. But I think that until now it has been very important to do it that way because if I had put the events in their historical context—first for *Z,* then *The Confession,* and now for this one—many people could justify those events because they would say, as some people say today, the Vietnam War is justified because this and this happened. In *The Confession,* for example, if we had put Stalin in his historical context, we would have absolutely justified him—the Soviet Union was alone as a socialist country, so it was necessary to be very strong, etc. In this sense, we allowed no such justification for Stalinism in *The Confession.* In *Z,* some people could have very well justified the assassination of Lambrakis because he was strongly against NATO, he was very pacifist, and today people could say that he was wrong because at that time there were Russian ships in the Mediterranean and it was necessary for Greece to be a neutral country.

So, I try—this is, if you like a very moral position—to condemn events by what they represent, in a sense to let events condemn themselves by what they are. The reason for this is that we live in a

society which has been colonized by this type of cinema for over seventy years, since the very beginnings of cinema. And we live in that kind of Christian culture in which, when we have an event involving the bad and the good, everyone condemns the bad. The public, the audience, has been conditioned that way, so to try to make an historical explanation—you speak of Marx, for instance—you need an audience with a capability of materialist analysis. So the problem in my opinon is not just to change the movies, but also to have another kind of public which can understand that new kind of film. And if the public is colonized by traditional cinema, we directors are also colonized. So I think the change is going to take a long time.

I think the next step for the cinema will be to go to that new kind of film, one which tries to explain the historical situation and all the connections which lead to that kind of history.

Cineaste: *Can you think of any examples of recent attempts at that kind of filmmaking?*

Costa-Gavras: One could speak of *La Hora de los Hornos* but this represents the future of what we call "political cinema."

Cineaste: *I consider two films written by Solinas—*Burn! *and* Battle of Algiers—*as having a dialectical materialist approach, because they're both fairly schematic in the stages they represent. In fact, that's exactly what* Burn! *was criticized for in New York, for being too schematic. Do you think that either of those films are. . . .*

Costa-Gavras: Yes, I think in both Franco tried to develop that kind of cinema. I think they represent an intermediary stage because he tried both to reach the audience and to explain the events from a materialist point of view.

Cineaste: *But an essential element for any kind of film like this, from your point of view, would be that dramatization of historical events that would get it to a larger audience?*

Costa-Gavras: Yes, the problem is the audience, the audience goes to see this kind of film, a dramatization.

Cineaste: *In other words, they might not have an interest in a specific historical or political subject but would go to see the film because of the way in which it was mounted. In this regard, then, you wouldn't see yourself as making a documentary like* La Hora de los Hornos?

Costa-Gavras: Oh yes, I will try. I'm attempting to make a certain kind of encyclopedia by images of the different steps—political and

sociological steps—of a state. It will be for a different audience, perhaps television.

Cineaste: *Do you have a specific subject in mind?*

Costa-Gavras: Yes, but I prefer not to speak about it.

Cineaste: *Did you know there's a historical film now being made on the beginnings of the Cold War in Greece?*

Costa-Gavras: Yes, it is a small period but Greece, in my opinion, is the beginning of everything.

Cineaste: *It all began there, the whole model of counter-insurgency....*

Costa-Gavras: It came before Guatemala, before Vietnam....the Green Berets started in Greece just after the Civil War in '49. The most fantastic thing with the Greek government, which happened with all other governments after Greece, happened when James Van Fleet, a very important American general, came to Greece. The Greek Prime Minister showed Van Fleet the Greek Army in a parade and said, "Here is your army, sir." It's extraordinary.

Cineaste: *In political films like your own, where you are trying to make a point about something, where do you think the work of art ends and the piece of propaganda begins?*

Costa-Gavras: First, propaganda is a very, very bad word—it was used by Hitler who had a Minister of Propaganda. Propaganda is the victory over the mind. Through the mind you can convince people but in order to vanquish them you must prevent them from thinking. Propaganda is based on false or transformed events, events transformed in the sense of an ideology and which are also at the service of this ideology. For instance, each country around the world has its own propaganda movies—there were a few notable ones in the U.S. during the Cold War, and in socialist countries like China, and...everywhere!

Personally, I'm not trying to promote a political idea or theory. If you want to stick close to the truth, you have to get away from propaganda.

Cineaste: *Do you have a descriptive term for the kind of film that you do, that bases itself upon documented facts and attempts to uncover a reality hidden from general knowledge?*

Costa-Gavras: No, I think a new definition of such films is needed but I have no particular phrase. Propaganda is not the truth—at best it's only the truth of an ideology for certain people. But my films are basically the truth, they're based on facts. That is the

whole difference between propaganda and my films, but I have no word to substitute for propaganda.

Cineaste: *I guess what I'm getting at is that most people will not make a distinction between your method — scrupulously basing your films on documented facts, etc. — and what is generally termed "leftist propaganda." That is, there's nothing to prevent, say, someone in Iowa from seeing your film and — having no knowledge of the facts on which you've based the film — simply dismissing it because of their own preconceptions or because of what they perceive as an "anti-American" bias.*

Costa-Gavras: Well, no one can do anything about that and that's the biggest problem. Hopefully people will have seen my other films and know that I'm not a propagandist. They can also write to their Congressmen. And remember that not even the most widely-read publications cannot say it's not the truth. In this regard, the most important thing is what *Time* wrote about the movie. It was impossible for them to say it wasn't the truth, that it was propaganda, because even the *New York Times* is quoted in the film—I went to their archives and it was explained very clearly that Mitrione was there to organize the police.

Cineaste: *As a filmmaker who wants to make a point or develop a thesis in a film, do you feel any danger that sometimes you will be too deliberate, that the message will take over from the form and consequently make it less dramatic or less artistic? That is what some criticisms — bourgeois criticisms — of* State of Siege *have been here.*

Costa-Gavras: In terms of this problem of form and content, I prefer to give more emphasis to the theme than to the form. I think with a theme as difficult as in *The Confession*, for instance (not in *Z*, that was a little bit different)—not a theme difficult to understand but difficult to accept, which is worse—had I tried at the same time, as director, to create a second, formal difficulty for the audience, to try to show things in a new way, I would have run the risk of losing them. . . .

Cineaste: *Being one step ahead of them?*

Costa-Gavras: Yes. So there is a choice you must make.

Cineaste: *So you would rather make it simpler?*

Costa-Gavras: Not necessarily simpler, but use dramatic ways to show the story.

Cineaste: *As a film director, do you resent the limitations this imposes?*

Costa-Gavras: Of course, but in any art form you have limitations—when you try to paint something, the limitations are the colors or the space you have. In the cinema, we have this kind of limitation. I don't think we can completely explain something, with all its ramifications and connections, in a film. I think a film is like a match or a detonator—you can make a big fire or explosion, or nothing at all. It's just the beginning of something, not the totality.

Cineaste: *What type of commercial considerations do you have to deal with in making a film like* State of Siege? *Mounting the film in a dramatic format is one, of course, but what are the others? And how do you think they influence the political impact of the film?*

Costa-Gavras: Well, the other problem is the money problem. But after *Z*, or at least for the moment, this problem is over for me. I don't know what the future will be, it depends on the cost of future projects and so on but, generally, it's not a big problem now. For *Z*, however, it was an enormous problem. I spent a year and a half trying to find money to make it. I never considered that problem while doing the scenario—but then, it's important not to consider commercial limitations at that time.

Now, the star problem. If I take Yves Montand to play that part, it seems to be a commercial problem but it is and it isn't. Because if you need a certain type of person—fifty years old, good actor—to play the part, if he is an unknown actor, he's generally not a very good actor.

Cineaste: *At fifty. . . .*

Costa-Gavras: At fifty, yes. On the other hand, for *State of Siege* it was very important to have Yves Montand specifically because he's a very sympathetic person—at the beginning of the film the audience is for Yves Montand, they are not against him, they are for him. And it was extremely important for that character to be sympathetic from the beginning so that the audience could not subsequently refuse what's told in the film.

Besides, I also believe you don't catch flies with vinegar. People are going to see Montand and they see something they would never have seen otherwise.

Cineaste: *How much correspondence is there between Montand and the real character of Mitrione?*

Costa-Gavras: We just took Mitrione as an example, you know, and were not concerned at all with his personal life or ideas. We were only concerned with Mitrione during his time in the People's Prison, a very specific period during which we attempt no psychological

explanation of Mitrione or any investigation of what kind of relationship he had with his wife or family. Everything he says in the film is verified. You never hear him say anything that was not heard by witnesses whom I myself saw. Outside of that period, outside of jail, he never speaks, and we only show him as the Tupamaros saw him.

Cineaste: *Just out of curiosity, since we're on the commercial aspects, did American capital finance the film?*

Costa-Gavras: Yes, Palevsky and Rugoff.* Some people think it bizarre that Palevsky would finance this film.

Cineaste: *Well, he financed McGovern. . . .*

Costa-Gavras: Yes, I think he's a person who tries to be liberal.

Cineaste: *So you yourself are free to choose any subject that you want and don't think you'll encounter any difficulty in producing it?*

Costa-Gavras: I don't think so, but in a sense I am free and I'm not free. I feel a pressure from some people to make only one kind of film, only political films. I mean, people here ask me, "Why don't you make a movie about Watergate?" This is a pressure, a moral pressure, but I think for the moment I am free as far as choice of subject and financing go. But total freedom can also be a limitation.

Cineaste: *[Quizzical expressions.]*

Costa-Gavras: That's a very philosophical attitude, perhaps. . .[laughter]. With that kind of freedom I feel a great responsibility. For instance—I see a bicycle here—I feel like a champion bicyclist: I always have to be the first, the first to do good things, the right subject, the right period, etc. This is a pressure.

Cineaste: *Looking back over four years, do you now see any shortcomings in Z as a political film?*

Costa-Gavras: I think it's necessary to put Z in its historical context, that is, the time in which it was made. For me, Z was a political action, like writing on a wall, not a political movie. After April '67 I felt I had to do something against the Greek regime, so I did Z. And today we call Z a "political movie."

I think perhaps Z became a political object because people saw Greece and everything concerning Greece translated through it. Z

*Max Palevsky became a millionaire when he sold his computer firm, Scientific Data Corporation, to Xerox. He has been prominent in Business Executives for Peace and is a partner in Cinema 10 Productions with Don Rugoff.

Donald Rugoff is President of Cinema 5, distributor of Costa-Gavras' Z and *State of Siege* among many other films. He is also involved in theatrical exhibition (Cinema 5 Theatres) and production (Cinema 10).

became the basis to think about Greece—before, Greece was vacations, islands, beautiful, good-looking Greeks, the Greek Royal Guard with the little skirts, you know, that kind of Olympic Airways vision of Greece. For people who saw Z, the film became a basis to think about Greece and the colonels—so the audiences politicized Z, the way they received the movie made it political.

Cineaste: *Another impact I think it had was to allow other political filmmakers to make films.*

Costa-Gavras: Of course. During the period I was trying to find money for Z—more than a year and a half I spent talking to people, showing the list of actors, the "package"—nobody bought the film because they said, "This is a political movie, it shows a political situation and people don't like to see political situations." Those same people, when they later saw the big money that had been made with Z, immediately tried to do the same thing and they accepted every political subject. Today in France it is enough to go to a producer and say, "Sir, I have a political subject," and he receives you immediately.

Cineaste: *You defined Z as a personal political action. Now, you're Greek-born, living in Paris, in exile so to speak....*

Costa-Gavras: I don't think it's exile because exile is not a choice. I left Greece for several reasons which are related to my father's political feelings and situation and I decided to stay in France because it gave me what I think a country should give to its citizens—the possibility to study, to make a career, to work. So I don't feel I'm an exile—I asked for French citizenship.

Cineaste: *How long have you been living in France?*

Costa-Gavras: Twenty years. But what is the question again?

Cineaste: *Well, your political feelings seem to relate to such a wide variety of situations that I wonder if there's one struggle, so to speak, that you relate most personally to, that you define more as your own?*

Costa-Gavras: Yes, because I had an experience when I first arrived in France with the meetings against the atomic bomb. Naturally, they were organized by the French Communist Party and all of us—whether one was a communist or not—were against the atomic bomb because it was a horrible thing, you know. It was an enormous movement for peace and against the atomic bomb and I attended all those meetings and demonstrations. The day Russia had the bomb, however, the whole situation changed and we stopped talking about peace but not about the atomic bomb. Some people

said, "Well, there is an equilibrium, a balance"—but the problem for me personally was not the achievement of a balance but not to have any atomic bomb.

During the same period in the U.S. there was the Rosenberg affair. I was against that injustice, of course, and attended fantastic, enormous meetings organized again by the French Communist Party. We learned later, however, that at the same time in socialist countries similar injustices were occurring.

By this I'm just trying to explain the relationship to the parties and the ideologies and the change of ideologies. So then it was the Socialist Party in France—Mitterand, Guy Mollet—but they started the Algerian War and were against Algerian independence. Mitterand himself was Minister of the Interior. So the history continues and today we have China, which at one time was something very advanced ideologically, but now they've received not only Nixon but also the Greek colonels and President Numeiry of Sudan, who has killed so many communists. So there is something very disturbing in following the development of a power. Those who want to take power use us, the people, as an instrument to get it. Philosophy or ideology is one thing but power is another.

I would like to think there may be another way to follow ideology. Ideologies basically are good—for instance, Christian or Communist or Socialist ideologies—they're very positive for humanity. They were created by man during very good, even euphoric moments. I don't speak of the Right at all because it is primitivistic. Their vision is one of primitive society—in the forest with the lion who is king and the others who obey—they are for the best man, the strongest, the one who shoots the fastest. Maybe some primitive people infiltrated themselves into these other ideologies, because from a basically good ideology like Communism you arrived at Stalinism. And from another good ideology like Christianity you arrived at the Crusades, the Inquisition, the acceptance of the Nazi camps. . . .

Personally, I'm very suspicious of these ideologies, or at least the approach to them, how they are translated. Maybe we have to go back to the roots to see how these ideas were started, maybe that's the way to understand them better. I don't think it's a very positive way to see things, considering what's happening around the world today where in many countries the primitives are very strong. It's necessary to be organized to try to change the situation. But what I see is that each time a good philosophy, a good ideology, has taken power, it soon became something wrong, something bad.

Cineaste: *Well, if you don't like those ideologies in power, is there one out of power or struggling for power that you agree with, that you're sympathetic to?*

Costa-Gavras: The goals of certain revolutionary movements seem to me absolutely positive, but one must see how they are going to reach their goals.

Cineaste: *In a sense then your political evolution has been one of progressive disillusionment.*

Costa-Gavras: You know, ultimately, I think the problem is with man—we've overlooked man in all this. I think first it is he who must change—his feelings, his way of seeing things, etc. But how to do it, that's the problem. In general, I don't think revolutions which have taken power have done anything in that direction. One cannot change society only by force; people have to change, and that is the most difficult thing. You can vanquish but you cannot convince—this is not my phrase, by the way, it's from an anti-Franco general during the Spanish Civil War. We still live in primitive times—people don't want to convince, they only want to vanquish, they want victory. And it's easy to do, you know, with a gun.

8—DUSAN MAKAVEJEV

Let's put the life back in political life

When W.R.: Mysteries of the Organism *was released in Yugoslavia, the government brought a criminal indictment charging that the film director had derided the state, its agencies, and its representatives. Dubbed "ideologically harmful," the film was denied distribution in Yugoslavia and its creator, Dusan Makavejev, was expelled from the Communist Party. The free-wheeling sexual-political satire and testament to the life and teachings of Wilhelm Reich,* W.R.*, had certainly lived up to its description by Makavejev as a "cinematic test for totalitarian consciousness." The filmmaker soon left Yugoslavia altogether to pursue his belief that "to say something serious, you must do it in an entertaining way. I don't believe in political messages that are dull." Makavejev was interviewed at the 1973 Cannes Film Festival by Christian Braad Thomsen, Danish film critic and filmmaker.*

Cineaste: *Why is your film on Wilhelm Reich presently forbidden in Yugoslavia?*

Dusan Makavejev: The film is enmeshed in a sort of legal confusion which is a very clever way of banning it without us being able to fight back. The film is not legally banned, it is just not allowed. What it amounts to is a sort of irrational resistance against the film and you can't fight irrationalities so easily because you refute one thing only to have them find something else. Obviously the reaction against the film comes from a deeper level.

One of the ideas that we tried in *WR* was that of the film as a liberating trap. I believe that if you organize sequences of shots and events and emotions in such a way that people are unable to stop following the film, following their own emotions, then the film can lead them where they would otherwise never go, morally or ethically. The film thus helps them become trapped in their own liberation.

But I discovered that this trap can work in different ways because many aggressions were also liberated by the film. I believe that the film can liberate people to be more joyful, more open but, as Wilhelm Reich said, the first character layer is a layer of aggression, so often the film worked beautifully but people were just not able to control their aggressive feelings. They started reacting against the film throwing out their irrationalities very violently.

Cineaste: *You have indicated that the* WR *of the title stands not only for Wilhelm Reich but also for World Revolution. This implies that you take this condemned psychoanalyst more seriously than most people who usually consider him absolutely crazy.*

Makavejev: I think that Reich will definitely have a renaissance in the near future, not through doctors and official psychiatrists but, for instance, through the student movement. I think he will be considered much more important than Freud. And if you know R.D. Laing's concept of madness, it is very difficult to repudiate Reich as merely mad. Laing described madness as a social label applied to people who don't behave according to expectations and if a normal person is considered crazy by those around him, he may very well start to behave crazily because everyone expects him to. I don't really believe in madness because everyone is mad, and what's wrong with that? It's impossible to be normal twenty-four hours a day and in their sleep everyone has crazy dreams, so everyone is crazy without his own knowledge for at least one-third of his life.

Wilhelm Reich was such a brilliant and genial young man in the

late thirties in Austria and Germany. He started to understand psychoanalysis as a chance not only to cure one personality but to cure a whole society. At that time society—through Nazism, fascism and Stalinism—was behaving in complete opposition to Reich's ideas, but today it should be easier to understand Reich since we are developing alternative cultures. Alternative living is becoming something normal and group communal living is a beautiful thing, it's really the same kind of vision that Reich had in the thirties. He is one of the rare socialist utopians of the century and just a few decades after his death young people in many corners of the world are starting to build the kind of society that he dreamed about. To me he is a great prophet and a great scientist because he was not able to separate the world into scientific, human, loving and poetic actions.

But then fascism came and destroyed his work. The whole revolutionary ferment of Europe turned into something very stiff, ritualistic and destructive, and when Reich was forced to move to the U.S. he was forced into the very narrow and limited field of pure science. He also understood that in becoming an American citizen he would have to forget his ideas about a mass political movement that could help people. From the beginning he was under the pressure that any kind of social action from him would be misunderstood as anti-American, so he tried to be a very correct scientist, something that was against his own ideas.

During the research for my film I visited the Food and Drug Administration which saw to it that Reich was put in prison. I discovered that the FDA was composed mainly of former sailors who had worked in the Navy on the control of cans, food and sanitary conditions. They were very simple and unimaginative people who were delighted to find a crazy doctor like Reich selling orgone accumulators, that is, selling air, since their persecution of Reich could become a big publicity stunt for their agency. Some of them were also very curious because they thought he was conducting all kinds of weird sexual experiments, performing masturbation in the accumulators, keeping children in cages for scientific experiments, etc. They had very low, voyeuristic motives disguised as the highest motives of upholding the law.

This pressure on Reich, combined with petit-bourgeois animosity and the McCarthyist atmosphere against "un-American" characters, helped him to become as crazy as some people thought he was. Actually he was a great man with less and less social support and I don't wonder that from time to time he believed that the people who

were after him were actually agents sent by Moscow. He may even have identified with Trotsky who had been killed in Mexico by Moscow agents. He believed that strong powers were after him and he tried to get help from the highest possible level by supporting Eisenhower who was extremely popular after the war. But in spite of his very explicit support for Eisenhower, everyone who represented political power in the States was against Reich, and his connection with Eisenhower was on a purely fanstasy level. I heard a story about him cleaning the house one evening, saying to a friend that Eisenhower was coming to visit him that night. He had moments of absolutely pure madness or pure fantasy, but the people around him understood very well that he was under such pressure that the only solution for him was to escape into these fantasies. During the UFO craze he also believed in flying saucers and reported sighting some around his house. One week later he received a big file from the Federal Agency for UFOs in Washington which he was supposed to fill in, giving the angle, speed and size of the UFO. So if we conclude that Reich was crazy, we must also conclude that his government was crazy because they had people on rooftops watching for UFOs and for a while they really believed that the earth was being attacked from space! Reich participated somewhat in these beliefs but it just seems to be part of the general hysteria of the time.

Cineaste: *In the film you also pose the question that if Reich was really crazy, why was he then put into prison?*

Makavejev: Yes, I wondered how it was possible simultaneously to say that he was crazy and criminal, and it is very interesting to see that they did not burn only those of his books that dealt with orgone accumulators but also his European papers on fascism. The District Court in Portland gathered all his books and burnt them on two occasions in 1956 and 1960, and the majority of books never even mentioned the orgone accumulators. Reich himself was sentenced to two years in prison without even discussing his ideas. Reich was so upset by the case that he was not able to appear in court—he wanted scientific experts, not judges, to judge his work. So in the next session the judge said that he would't discuss Reich's ideas at all and instead sentenced him for contempt of court. And so he died of heart trouble in prison in 1957. Eva Reich, his daughter, saw him once in prison and said that he looked like a caged animal. He was physically shrinking from the loss of freedom, loss of space. As a man he was so alive that he was not able to stand life behind bars, so he just had to

die in prison. Society had taken a faceless and cruel revenge and his death was a true case of judicial murder.

Cineaste: *What would you say is the importance of Reich's work for you as a filmmaker?*

Makavejev: For Reich there was no difference between love and sex. When he spoke about free love, I think he spoke about the full expression of human biological necessities. And though he was of course very tolerant about masturbation as a means of discharging sexual tension, he did not go along with the psychiatric joke about intercourse being just a substitute for masturbation. For him intercourse was the most important human and biological event since there you have two individual living systems joining their pulsations and vibrations, multiplying their biological energy. For Reich one of the glorious moments of nature was this charge and discharge of human energy, mounting up and then being relieved in an orgasmic reflex. He also believed—and I mention this in the film—that this kind of fantastically pleasant activity can be spread to social events other that the meeting between man and woman. He understood fascism and totalitarianism as the wish of repressed people to recall this beautiful feeling of losing yourself in a cosmic steam of pulsation. He understood that all totalitarian movements were based on real human needs and when people were not able to discharge these needs in their private loving situations, they try to discharge them in the larger social context. Actually, if you see Hitler giving a speech it is obvious that he and his audience share a sort of orgasmic experience. I think Reich had a very profound explanations of what this necessity for orgasm in people really is and how the deformation of that need can destroy mankind. He even explained the creation of galaxies by employing the same analogy for space as when man and woman meet in intercourse—an enormous amount of energy is always generated when the two systems combine their vibrations.

Now, the question is: Is there any solution for us when we are already repressed? Reich believed that only for children was there a real solution. But I believe that if we begin de-repression processes that give us more and more freedom, we could probably find a real way tomorrow, and I think that my Reich film and some of my other films are really talking about the danger of freedom. If we jump into freedom immediately, we would probably not be able to live freely. You can die from freedom, like you can die from too much fresh air, if you are not used to it.

Cineaste: *Is that also the reason why the repressed Soviet skater kills the sexually more liberated woman after having made love to her all night?*

Makavejev: Yes, I think that this is scientifically correct. Very often people who are overflowing with emotions can't stop or control them and just go on and on and on. I think that over-controlled people have very good reasons for saying that freedom is dangerous. When over-controlled people relieve their irrationalities, they very often become chaotic, narcissistic, murderous or suicidal because they just can't stop. Reich had an understanding of life as a ferment of pulsation between charge and discharge, work and rest, love and rest. From his viewpoint, everything was vibrating and pulsating and the question became: how do we build a society that can channel vibrations of individuals or groups into meaningful social action so that the repressed energies do not accumulate in a big pocket of totalitarian destruction. One of the imperatives of our society today is to find a way for meaningful group activities to become an enlargement of real loving actions—loving not only in terms of sex, but also in terms of work, creativity, play and rest. For me, free love embraces all kinds of human activities and not just sex. I think the sexual freedom we have today is only the freedom to discharge ourselves as machines. Sex has become a consumer society device amongst numerous other kinds of technological devices.

Cineaste: *In your first two films,* Man Is Not a Bird *and* Love Affair, Or the Case of the Missing Switchboard Operator, *there is a man-woman relationship corresponding to the Soviet skater and the Yugoslavian woman. You always seem to develop the relationship between the rather boring Communist Party member and a sexually more liberated woman.*

Makavejev: Yes, you're right. There is a lot of my own identification involved with the character of the boring Party member. He probably represents a dialogue with my own youth, my own rigidities. I don't exactly mean that I was boring in my youth. I was more of a restless Party member instead, more of a trouble-maker than disciplined and boring. During my own youth I wanted political life to be more alive and not to be dominated by men such as those now in my films. I believe in socialist ideas but I want the fight for those ideas to be closer to real human interests, more alive and witty and not to be conducted through dull lectures and programs. I was thus very happy in 1958 when the League of Communists in Yugoslavia sent out a new program saying on one page that it was

the task of communists to fight for sympathy between people. I was really enthusiastic about finding a political party that was ready to speak about love and sympathy in its program. It was a simple statement saying that if you want people to organize and improve their own lives, you must build sympathy between them. And I do believe that a society that wants to build itself not on a Western model and not on an Eastern model, not as a private enterprise society and not as state capitalism, but some kind of functioning, self-regulating, self-managing system, this society must in large measure have human values like humor, love, joy and play. So the dullness that appears in some characters in my films is really part of my permanent satirical effort to put some vitality into our everyday political life.

Cineaste: *Concerning the political content of your last film, there is one sequence in which the montage seems to be of great importance. First Milena delivers an enthusiastic speech to the workers about free love, ending with the statement that life without love isn't worth a thing. Then you cut to documentary shot of Chairman Mao overlooking a huge crowd of Chinese people, and from Mao you cut to Stalin walking with some ministers. What do you want to express with this unusual montage.*

Makavejev: Milena is making a speech in favor of free love, right? And this speech is not only an emotional fight for freedom, but also involves political demagogy—instead of making love she is making a speech about it. So this is intended as a satirical element. At the same time I use a parallel cutting to Milena's roommate and her soldier friend making love and not thinking at all of her speech mobilizing people to love-making. There is a sort of ambivalent quality about her speech because my sympathies, of course, are on her side but at the same time I make a few joking remarks about her. My relationship to her reminds me in a way of my relationship to the leaders of the uprising all over Europe in May-June 1968. Some people made beautiful speeches but often I discovered that I didn't like the people who made the speeches even though I agreed very much with what they said! I discovered that they were doing something very useful because people started to sing, dance and carry out different actions, but again you have this kind of dialectical counterpoint between the personality that tries to lead people and the people's movement in itself. Very often the people's movement is stronger and better than the people who arouse it and lead it.

Now, when the workers in my film are aroused by Milena's speech and start singing and dancing, I wanted some sort of glorious

continuation of this beautiful social action scene and then I found in the film archives these shots with millions of people in Peking. For me it is so powerful that I thought that putting this kind of documentary shot after Milena's speech could really be a beautiful culmination of her love speech. There is a lot of biological energy behind all sorts of political and social movements. The Chinese do not represent political energy in a limited sense. They are millions of people trying to survive who have joined together in a powerful movement. I also wanted to put a Reichian hint on the Chinese revolution—just imagine how much love energy was spent by the parents of these millions of people or what powerful love energy they themselves have. At the same time it functions as a sort of releasing shot, in a Reichian way, because after all this tension Milena builds you need some sort of big relief and relaxation.

And then I cut to Stalin, which you may interpret as a sort of science fiction cut. He represents a terrifying possiblity, a frozen and ritualistic situation, and we must try to avoid the Stalinist stifling of our love energy. A similar cut occurs where the girl is masturbating the boy and putting plaster on his penis. At first you have a very pleasant arousal through her masturbation but then the joy is stopped by the plaster. Within the same scene you have this quick change from arousal to blocking. And then as a additional joke I cut from the frozen penis to Stalin, who stands for a freezing quality and a terrible simplification.

Cineaste: *I think that there is a strong connection between* Love Affair *and* WR: Mysteries of the Organism, *not only on a formal level but also in terms of sexual themes. Were you familiar with Reich's writings when you made* Love Affair?

Makavejev: I knew his work slightly but not enough, so any similarities are more spontaneous and come from myself, I guess. At that time I knew Erich Fromm better and was influenced by his ideas of escape from freedom, of de-repression and social organization that has to involve personal happiness. Fromm and Reich worked together in Berlin and shared the same ideas at one time but knowing Reich now I see that Fromm is just a simplification of Reich, five per cent Reich. He puts Reich's wild and visionary ideas in a mild, legal and civilized United Nations style. When I discovered the true Reich I also saw that Fromm does what you could call applied art. And you might call *Love Affair* subconsciously Reichian.

Cineaste: *You have stated that* WR *is really "a story of how Joseph Vissarionovich Stalin ate Vladimir Ilyich Lenin." Lenin is*

obviously present in the film through huge posters but I wonder if
you also wanted to make Lenin physically present by naming the
Soviet skater Vladimir Ilyich?

Makavejev: Yes, partly. The skater not only has the same
Christian name as Lenin, but also some of his remarks are direct
quotations from Lenin, such as his well-known comment about
Beethoven's "Appassionata" and what it does to him.* Lenin was an
important historic personality, but at the same time—as one discerns
from the quotation—very neurotic, which is not necessarily a bad
thing, especially when he is compared with Stalin, who was com-
pletely one-dimensional in his tyrannical villainy, In a way, the skater
represents the positive possibilities of Lenin which are being
perverted by the spirit of Stalin, so at one point I identify through the
montage the skater and Stalin. It happens just after the Lenin quota-
tion,when he talks about his need for tenderness, and Milena put her
hand on his genitals. He is shocked by her act and pushes her away.
When she then looks at him, I do not cut to a close-up of the skater,
but of Stalin, because at that very moment—when the skater
responds violently to her gesture of love—Stalin has won. The song
which the skater sings in the last scene, however, after he has killed
Milena, suggest that Stalin's victory is not final. The song is written
and sung by Russian undergroung poet Bulat Okudiava and ex-
presses a deep longing for love, peace and satisfaction.

Cineaste: *Your film represents one of the rare attempts to use ex-*
plicit sexual scenes in an artistic context. You show male erection
and actual intercourse on the screen. Has it ever occured to you how
far one can really go on the screen with sexual scenes?

Makavejev: The question of how far one can really go began with
Jacopetti's right to have people killed in front of the camera.† People
had already been sentenced to death and I think all Jacopetti did was
to ask the executioners to shoot the people in the sun and not in the
shadow so that he could film the action. The principal question
is: Did he participate in the killing or not? I think the media always

* "I know nothing that is greater than the 'Appassionata.' I'd like to listen to it every day. It is
marvelous superhuman music. I always think with pride—perhaps it is naive of me—what
marvelous things human beings can do. But I can't listen to music too often. It affects your nerves,
makes you want to say stupid nice things and stroke the heads of people who could create such
beauty while living in this vile hell. And now you mustn't stroke anyone's head—you might get your
hand bitten off. You have to hit them on the head without mercy, although our ideal is not to use
force against anyone. Hm-hm—our duty is infernally hard!"

†Gualtiero Jacopetti is the Italian director of explotation flicks like *Mondo Cane* and *Africa Addio.*

participate with their presence. If you film actual killings like Jacopetti did, it means you participate because with a different action you might have stopped the killing. Of course the matter is complicated because some people believe that filming real killing can help create a protest against the murderers. But suppose the murderer is an exhibitionist? Then he may kill more people in the presence of the camera than without it. You don't know how many people are really killed by your presence.

Now as regards actual intercourse, the question is not so morally complicated, it is not a matter of life and death. But you have to realize that when you film real intercourse, it is turned into a kind of group sex with the camera as a voyeuristic participant—this can be discussed morally, of course, but I don't think it causes any harm. That scene of intercourse in my film, by the way, was not shot by myself but was done on video tape by an underground TV group from New York called Global Village. They found the couple through an ad in the *East Village Other* and you can see that they are real lovers because they are thoroughly enjoying themselves. So the shot has this Reichian superimposition which I was very delighted with. It is marvelous to show love-making as a really beautiful thing since in most pornographic films it looks really ugly.

I am not sure, however, that I would be able to film actual intercourse myself. The scene of intercourse I undercut during Milena's love speech is not real, but acted, and I remember how both the actor and actress and the crew were terribly embarrassed during the shooting. It was terribly difficult to have this relaxed game of love performed in front of the camera. One of the problems was that the actor was married to another woman and his mother worked in the laboratory, so when everyone in the lab saw the rushes, they informed his mother, who afterwards told his wife, and later he had lots of trouble at home with his wife. So the only chance to have really good love-making is when you use a couple who are really in love. I would like to do that but it will be difficult. I think one could have a lot of fun, however, combining love-making with all kinds of different social activities.

9—GILLO PONTECORVO

Using the contradictions of the system

The Battle of Algiers *(1966)* is frequently cited by critics and film-makers as one of the seminal works of the sixties, both for its form and its orientation. Its creator, Gillo Pontecorvo, was born in Pisa in 1919, the fifth of ten children in a Jewish middle-class family. In 1941, he joined the Italian Communist Party and soon became a commander in the partisan movement. Two of his films made in the fifties, The Long Blue Road and Kapo, were never widely distributed in the United States. In Burn! *(1969)*, as in The Battle of Algiers, Pontecorvo again dealt with the subject of colonialism and neo-colonialism. The time is the mid-1800s and Marlon Brando portrays Sir William Walker, a British agent sent to the Caribbean island of Queimada to foment a revolution in order to wrest the island's sugar trade monopoly from the Portuguese. Ten years later, Walker must return to the island to quell a rebellion led by the black slave he had instructed as a revolutionary years before. Pontecorvo gave this interview to Harold Kalishman in 1974. It was done in English and French with simultaneous translation by Gabriel Landau.

Cineaste: *You have said that if you were to make* Kapo *again today, you would eliminate the love story at the end between Nicole and the Russian prisoner. Would you make any changes if you were to make* Battle of Algiers *again?*

Gillo Pontecorvo: Perhaps I will seem presumptuous—or maybe it is only a lack of imagination—but I don't think I would change anything. Of course, if I put myself in the editing room, then I would probably find a lot . . . ah, but perhaps there is something, yes. When the little boy, Omar, steals the microphone, and we hear his voice, maybe it would be better to use an adult's voice. It would be less moving but perhaps more convincing, more realistic . . . little things like that.

I must say that I am really, honestly surprised by the fact that when I saw *Battle* last year, when it was seven years old, I had the impression—I don't know whether this is good or not—that it has not changed, that it is still fresh. On the other hand, when I look at *Kapo* today, I find that the sentimental love story is very old-fashioned. Eighty percent of the film I think of today as I did fifteen years ago. But the sentimental story is certainly done in an old manner—one, though, that a lot of people continue to use. But I don't like it any more and today I would not do it the same way.

Cineaste: *You also said that one of the reasons you would eliminate the love story was that you would want Nicole's moral descent to be complete. Does this reflect a change in your view of human character?*

Pontecorvo: No, nothing like that, just a desire to portray more honestly the reality of the situation, with a greater detachment from a certain narrative schema. One of the worst weaknesses of movies, generally, is to follow certain patterns of representation in which one does not attempt to portray the world in its reality but make it look nicer. I think that someone in the girl's situation in *Kapo* who had begun this descent would probably fall to the bottom. It's possible that through love she might have changed but it would have been contrary to the behavior of all the other prisoners.

There was also a lack of faith in the public on our part. Now I think we have discovered that the public can accept more than the Hollywood patterns, but at that time, surprising as it seems today, the official cinema of the whole world believed in those ironclad patterns. Fifteen years ago, the first part of *Kapo* was really a big step in France and Italy because movies then were very "soft"—escapist and romantic—and it was risky to do a film without much story and

outside of the usual patterns. Solinas and myself were afraid at a certain point of the hardness, the dryness of the story, and so we got the bad idea of introducing a little sentimental story. I say "little" because it was only a few minutes—the love story is only fifteen minutes out of an hour and fifty—but it was enough to pull down the whole film.

There's probably a thousand times more stylistic unity in the rest of the film which is supposed to show the solitude of this girl when the camp is finally liberated—happy, full of joy, ready to return to their normal lives. Amidst all this, the little girl's solitude is extremely touching, more so than any love story.

Cineaste: *Would you make any changes in* Burn!

Pontecorvo: I would make one point clearer. I don't know if people understand the end of the movie very well. When Sir William Walker advises the President-General of Queimada to free Jose Dolores, it might seem to some that Walker is allied to the cause of the Royal Sugar Company and the leaders of the new establishment, but Walker gives his advice only because he doesn't *want* them to kill Jose. If Jose is killed and becomes a martyr without even speaking one word to him, Jose would become greater than Walker who would then feel as if he had lost everything. But if, instead, Jose is set free, Walker is not responsible for what he has done on the island. I don't know if this is clear in the film, though.

Cineaste: *At one point there seems to be a moral ambiguity about Sir William Walker, when, having decimated the ranks of the guerrillas, having burned the whole island, he captures Jose Dolores and he expects Jose to welcome him back, to shake his hand. It seems to me that Sir William would understand, at this point, that Jose really hated him.*

Pontecorvo: In that scene we tried to guess the behavior of the romantic bourgeoisie of that period for whom friendship and loyalty in war were still values. For Sir William it was friendship, individual rapport which mattered. Everything was allowed in war but when it was finished, it didn't matter that he had destroyed half the island—he could still offer his hand. For Jose, the problem is more complex—the problem of exploitation by whites and how to respond to that. You know, a large part of the left and third world people believe that there is no dialogue possible between the oppressor and the oppressed. This scene is an allusion to that position. Dolores does not even want to speak to him and this silence is one of the heaviest, most important things in the whole film. In *Burn!* there is always a second story being told in parallel with the first. The first

looks like an adventure but the second is this confrontation between two ways of thinking.

Cineaste: *It is a Victorian mentality. . . .*

Pontecorvo: Not only Victorian, it was the same for the French bourgeoisie.

Cineaste: *Sir William Walker and Colonel Mathieu in* Battle of Algiers *are both products of bourgeois society. They are both amoral "professionals," both the epitome of the "professional" ethic, of rationality. I wonder if they embody your concept of bourgeois man?*

Pontecorvo: In the beginning of *Burn!* we tried to portray Walker as a typical son of the English democratic bourgeoisie of this period, a man who believed in the notion of "progress," a "progress" represented by English democracy and its bourgeoisie. In the second part of the film, ten years later, the experience of this brilliant man has shown that all that he had thought about progress, about the development of the English bourgeoisie, was wrong, completely wrong. He becomes completely empty, doing the same things as before but without believing in them any longer. He does them out of Vitalism. I think he is typical of the early period of development of the democratic bourgeoisie during the last century. And I think that to show, as it were, the bloody roots of capitalism, the matrix of our white civilization and the origin of the present threats, is not a bad idea.

I like Walker even more than Colonel Mathieu. It was more difficult to create such a character because he is more multi-dimensional. Mathieu was easier, of course, because he is closer to us and we know him better—this is no doubt why he is usually preferred, he is easier to understand. But I was surprised to see that Walker was often not well understood.

Cineaste: *You have said that in Europe after World War II there were men like Walker, men who felt that the side they had fought for had nothing behind it.*

Pontecorvo: It was not exactly like that. Walker's feeling of emptiness is very near to the sense of emptiness that a lot of people felt after the Second World War—people who had fought for a better world but who saw things start to break down, to deteriorate. I think that the phrase of Sir William Walker who says, "Sometimes, in ten years. . . ."

Cineaste: *"Between one historical epoch and another, ten years can sometimes reveal the contradictions of a century."*

Pontecorvo: (Laughter) I like these words very much. They come at a moment of melancholy. I remember the shooting of this scene because I was mad—I absolutely wanted to show a moment of tenderness in this man who was always so sure of himself, so active and aggressive. He has only this one moment of tenderness, of nostalgia, reflecting on the great hope that he had during his youth. You know, I saw *Burn!* again recently and, up until then, I had always preferred *Battle* and even *Kapo* much more. But at this recent screening, at a cine-club in Italy, I was pleasantly surprised with it—there's something there I like very much.

Cineaste: *Sir William Walker is certainly the single most interesting character in your work.*

Pontecorvo: Except in this final scene, where our intentions are not very clear. And it's a pity because it is only a question of three words or three phrases more to make it clear. But you know, sometimes when you write or when you shoot, you have it so clear in mind that it seems so obvious. But then, after one or two years, you see the film again, this time with the eyes of the public, and you think, "Shit! It's not clear here." That's the feeling I had this last time I saw it.

Cineaste: *With the character of Sir William you shifted from the choral protagonist of* Battle of Algiers *to two individual antagonists. Does this reflect a change in your interest from the movement of masses to the moral choice of individuals?*

Pontecorvo: No.

Cineaste: *In your next film on Christ, he is the main subject, isn't he?*

Pontecorvo: Yes, but he is completely immersed in and determined by the social environment of his time.

Cineaste: *Was* Burn! *your first color film?*

Pontecorvo: No, my first one was *The Long Blue Road*. It is an Italian story with a social theme, the story of an anarchist fisherman in a little village who begins to organize a union for fishermen. A very bad film. (Laughter) No, really, bad, bad, bad.

Cineaste: *How so?*

Pontecorvo: How? I was not able to make it better?

Cineaste: *No, I mean, in what way is it bad? Is it unrealistic? Romantic?*

Pontecorvo: No, no. It was the first time, the only time, that I was obliged to make a lot of concessions. They wanted Alida Valli as the wife of the fisherman. Now, I think Alida Valli is a great actress, but if

she can be the wife of a Sardinian fisherman, then I can be an airplane—if I spread my arms, I can be an airplane. Second, I wanted to make it in black and white so that it would be more realistic, stronger, harder. And there were other concessions, like putting in babies to make people cry. The film has made money but I don't like it.

Cineaste: *So* Burn! *was the first time you used color intentionally. Were you trying for any photographic effects as you were for black and white photography in* Battle *and* Kapo?

Pontecorvo: No, only to do the best I could. But in *Jesus Christ* I will be using color in a special way, like *Battle* and *Kapo*. We began with the grainy photography in *Kapo* and went forward in *Battle of Algiers*. Now, in *Jesus Christ*, we have another problem, a double problem—to find a kind of very truthful photography for those scenes of the environment, the difficulty of life in an oppressive society, under the heels of the Romans. But we also have a Jungian part of the film which portrays the eruption of the subconscious in the Christ and all the visions, for which I am trying to find a kind of photography derived from two painters very different from one another—Goya and Bosch.

Cineaste: *I know that Rossellini made an impression on you when you were starting in film. . . .*

Pontecorvo: Not only on me but on a lot of people.

Cineaste: *Have his recent historical films—*Louis XIV, Socrates, Pascal—*influenced your own ideas about how to portray Christ?*

Pontecorvo: No, I was much more impressed by his art. The only one I liked very much was *Louis XIV*.

Cineaste: *You have often said that you choose a subject for a film with great care and that, in fact, you make a film only when you think it* should *be made. What criteria do you use when considering a subject?*

Pontecorvo: I will give a very simple answer—when I feel close to the subject, when it completely merges with my feelings, thoughts, hopes. But not only this, because sometimes you have this sort of feeling about a subject but you also feel that you are not the one who can do it. You may feel that your language and your style—if this is not too big a word—might not be right for the subject. Sometimes you reject an idea because you feel weak in front of it. It is not that you are always right when you guess—but you have to follow your feeling, right or wrong.

Cineaste: *What I find interesting in your choice of subjects during the last fifteen years is that you have not dealt directly with Italy, which is your immediate cultural and political milieu.*

Pontecorvo: Your observation would be more correct if I had made a lot of films. If, out of a great number of films, one had never dealt with Italian problems, it would mean something. But for three films in fifteen years, it means nothing. Twice I tried to make something on Italy: once I dropped the subject because the story I had written was not satisfactory. The other time, it was too difficult—I was just beginning to find the money. So it is only by chance that of my last three films I have not done one about Italy. Probably one of my next films will be directly on Italy.

Cineaste: *I thought perhaps the problems of the Italian bourgeoisie, certainly, but also even of the proletariat might seem banal in comparison to the great themes of history that you've dealt with?*

Pontecorvo: No, absolutely not. I like these historical themes because I think it is worthwhile in Italy, as in France, to speak about colonialism, even if we only had a few colonies. It is the matrix of all our culture—for Italy, for America—the matrix of exploitation of colonies. So, I think that even if we speak about the colonies of other people, it is connected with our life in Italy. But again, it is only by chance that I have not dealt directly with Italy. It is possible to find a social theme of international value in Italy.

Cineaste: *But you would look for a theme of international value. What I'm getting at is that you don't seem to want to hold a mirror up to the face of Italian society, as do many of your contemporaries.*

Pontecorvo: I don't agree with what you suspect. I think that a film which reflects the society and the culture in which one lives is absolutely valuable. I don't think it is any less important than a more international theme.

Cineaste: *You were in the* maquis *during the war. You were, in fact, a guerrilla. This must have had a great influence on your choice to make two films about guerrilla movements.*

Pontecorvo: Certainly. Anything has an influence, but especially this kind of experience. It was over a two-and-a-half year period, and it was very important. After the war I went into politics, working full time for the Italian Communist Party until 1956, when I quit.

Cineaste: *Because of Hungary?*

Pontecorvo: No, because of a lot of things with which I don't agree. Please understand, I am not an enemy of the communists but

I don't agree with a lot of things—enough, at least, not to stay any more and continue being involved with politics all the time. For a long time I was responsible for the youth movement in Italy, primarily during the end of the war and the beginning of the liberation.

Cineaste: *Do you agree with Elio Petri that "Italy without the Communist Party would be like Spain under Franco"?**

Pontecorvo: I cannot guess, I am not a wizard. It seems too clear-cut to say that but I think what he meant was that the Communist Party is extremely important in the liberation of forces in Italy. I agree with this. Without the strength of the Communist Party, it is likely that something very bad would happen—I don't know if it would be as bad as in Greece or Spain. It is inconceivable...you must know, the Communist Party has nine million votes, one third of the electorate.

Cineaste: *How would you explain the large number of politically-conscious film directors in Italy?*

Pontecorvo: It is probably related to the compact strength, the solidarity of the working class and even the strength of the Communist and Socialist Parties which have left a very strong imprint on our cultural lives.

Cineaste: *Among writers on Marxist aesthetics, are there any who have influenced your thinking?*

Pontecorvo: Lukacs, of course. He influenced everybody. Among Italians, Umberto Barbaro,[†] a philosopher, now dead, who dealt with film aesthetics.

Cineaste: *A current topic of debate in film circles is whether new cinematic forms are needed for the expression of radical or revolutionary themes or whether traditional cinematic formats can be employed for this purpose. Your own evolution from the neo-realist tradition to an interpretive, or to use Rossellini's word, didascalic[‡] treatment of political themes seems to indicate that you are looking*

*"An Interview with Elio Petri," *Cineaste*, Vol. VI, No. 1.

[†]Umberto Barbaro (1902-1959) was a filmmaker and film theoretician who played a key role in the neo-realist movement. He taught at the Centro Sperimentale in Rome and was responsible for the translation of works by Eisenstein, Pudovkin and Balasz. His own works include: *Problemi del Film, Poesia del Film,* and *Il Film e il Riscarcimento Marxista dell'Arte.*

[‡]Rossellini has used the word to describe his recent historical films, which are designed to be informational and, in the best sense of the word, educational. As he says: "We must learn history in its build-up and not in dates, names, alliances, betrayals, wars and conquests, but following instead the thread of the transformation of thought." *(Cinema, Fall 1971).*

*for a new mode of expression yourself. Would you comment on
your own evolution and on the need for new forms in general?*

Pontecorvo: I don't agree with those left-wing directors who say
that films on politics made and distributed the traditional way are
practically useless because they cannot go very deep. I don't agree
because, first of all, I believe in the contradictions of the capitalist
system. I believe that a producer will make a political film, even if it is
against his class sense, as long as he thinks he can make money with
it. I think he would even make a film which shows that his father is a
thief and his mother a whore if he is sure to make money. So it
depends on the situation at the moment, that is, on the public. The
public decides which films are allowed or not allowed to be made—it
is a dialectical situation.

It also seems to me that to renounce films that are made for the
normal market in the normal way—narrative, dramatic, etc.—to
consider them not useful is a luxury of the rich, of people probably
not really interested in political results. Something for *fils de papa,*
hyper-criticism for rich kids, for sons of the bourgeoisoie. A certain
way for these "epidermic anarchists"—of whom *Cahiers du Cinema*
is a good example—to be snobs about political films is to make a
distinction between films "about" or "on" politics and "political
films." These people criticize *Battle* "from the left," they say—not
that there aren't grounds to criticize it—but they criticize *Battle* and
Burn! always saying the same thing—they are of little use. But in the
countries where the problems of colonialism and neo-colonialism are
still being confronted, the authorities—who know very well whether
something is really useful or not—have prevented the exhibition of
this kind of film—in the Dominican Republic, for instance, and in
several countries of Latin America. And revolutionary people—like
the Black Panthers and the Cuban people—they like these films and
are glad they are being shown. The people who are really fighting
consider these films not a great help but a help and even beyond
aesthetic judgement. It is not only for my own films that I say
this—it's just that I'm more aware of the reaction to them. The same
way of thinking is applied to other "films on politics," as they call
them, that are made and distributed within the system.

Cineaste: *So that's the usual criticism "from the left," for being
within the system?*

Pontecorvo: Yes, and I think that to renounce these films is an
underevaluation of what I consider the greatest problem at this time
in the approach to radical change: the problem of the alliance of

different parts of the population, the alliance of the working class with other classes, such as the petit-bourgeoisie which is its potential ally. If you consider this problem to be one of the most important, you also must see that it's important to make films for the normal channels. This doesn't mean that a new, alternative cinema must not be born. The two things must go together. Like during the Resistance, when you undertook military action but also worked among the masses. Suppose in a town you have military action, like the Tupamaros today, against the Germans, the fascists—a group armed with precise aims—but you also do political work among the masses, among women, workers, students, people who are unsatisfied in the market, etc. Of course, the analogy is a bit far-fetched and not completely accurate, but it gives you an idea of what I mean when I say that we must simultaneously work inside the system and work to build an alternative cinema.

Alternative cinema in this sense even means different methods of using the medium, cinema as counter-information. For example, if you want to get into technical details, a 16mm film on a workers' struggle to be shown to the same workers a few days later and to people in other areas, such as Zavattini's *Cine-Giornale Liberi* newsreels.* In short, whatever allows you a more elastic, more flexible system—short films, two minute films, one hour films, mixed with slides, etc.—a broad and completely different span of possibilities opens up with the alternative cinema. I believe in this very much and have even worked in it myself, for instance, some years ago, making newsreels during the occupation of sulphur mines in Cabarnardi. Films of this strike were very interesting and useful, I think, to people in similar situations to whom we showed them. So I believe that the two ways are open and valuable and it's not hard to see that the development of alternative cinema will eventually result in something very important, not only politically but also in terms of the form and substance of the cinema.

Cineaste: *For the type of film that is aimed at a more general audience—the narrative, dramatic films that you now make—what do you think is the most one can hope for in terms of political impact on an audience? What do you think that a film of yours can do?*

Pontecorvo: Honestly, I don't think that a movie can do very much. But if what we do, the little that we do, is on a large front, I think that it helps. If you reach a large front of people, you make a little step forward. It is something very valuable and useful. But

*See "The New *Free* Newsreels" by Cesare Zavattini, *Cineaste*, Vol III, No. 2.

having said what I just said, I must also say that we must not rely too much on movies. Movies are movies. The cinema is the most important of the arts, as Lenin said, but in any case it is still an art. It is not, directly, action.

Cineaste: *So a Marxist director in a capitalist system of film production, you know there are certain contradictions. But do you feel any impositions on yourself? Are there subjects you would like to deal with but cannot because of the system?*

Pontecorvo: Only once, when I was just starting out and had less influence and when the situation in Italy was even worse than now—we had a very reactionary government, the Scelba government—I tried to make something on Fiat in Turin but we couldn't find the funds. After that time, I must say, I was very free to do nearly whatever I wanted because the producers always thought they could make money doing my films.

10—ALAIN TANNER

Irony is a double-edged weapon

Alain Tanner became known to the international film public in 1972 with La Salamandre, *reminding people that there are more than bankers and diplomats living in Geneva. All of his work has dealt with the isolation and ennui of modern industrial life through characters who are often terribly aware of the contradictions demanded of them by society. His first feature,* Charles Mort ou Vif (Charles Dead or Alive) *was produced in 1969 and focused on the rebellion of a middle-aged watch factory owner whose native anarchism is doomed.* La Salamandre *featured a working class woman whose instinctive rebelliousness is nurtured by two comically intellectual, radical writers.* Retour d'Afrique (Return from Africa), *produced in 1973, dealt with a young Geneva couple whose dream of escaping to North Africa sours. This concern with the tension between the sexes found fuller expression in the 1974 film,* Milieu du Monde (The Middle of the World). *In this, Tanner's first film in color, the failure of a particular relationship becomes a metaphor for the tension between unskilled labor and technicians, Italian and Swiss, women and men, workers and bosses. Following a screening of* The Middle of the World *at the 1974 New York Film Festival, Alain Tanner spoke about his work with* Cineaste *editor Lenny Rubenstein.*

Cineaste: *Your latest film,* The Middle of the World, *seems unusually slow-paced.*

Alain Tanner: Yes, it is slow-paced. The whole film is based on a structure and technique that make it slow-paced. There have been studies published in France, by Jean-Louis Comolli amongst others in *Cahiers du Cinema,* about the relation between ideology and narrative technique. I did a lot of research as to the language in this film, and my presentation of these theories may be schematic. All the traditional narrative techniques brought to near perfection by Hollywood form the appearance of reality by the destruction of real space and time within a sequence or scene by fast-paced and quick cutting. This prevents the spectator from having a real view of space or time, and this is directly related to the ideological use of film in which the audience is led by the nose like a sleep-walker from the first scene to the last. With this technique the audience is always contented, even if it is a sad story. The audience must feel it is finished, completed at the end, so that when they leave the cinema, the film is one thing, while the rest of their lives is an entirely separate matter. What we have tried to do, by not cutting within a sequence, is to give back to a scene its reality. There is a paradox in this, since if you don't cut, instead of it being more real which it should be, in fact you are getting unreal because of the traditions in the eye of the spectator. The basis of the language of my films is the theory of alienation, and by giving a shot its full value, strength and importance, an alienation effect is caused. If you don't cut, you see everything differently.

Cineaste: *This is not new in your films.*

Tanner: I used different sorts of techniques in *La Salamandre*—the narration was broken down into bits and pieces; it really wasn't a proper story that you followed. In this film, *Middle,* it's more systematic, the story is broken down by dates. The difference, the change if you like, is the simple fact that in *Retour d'Afrique* for the first time I used the camera itself as an element of alienation. In *Salamandre* the camera didn't exist, it was just in the corner recording, while the emphasis was on actors and script, characters and performance. In *Retour d'Afrique* the camera is already one of the characters. It was an experiment for me, and it's absolutely no use in filmmaking to experiment on paper—you never prove anything. You really have to do it, and when you do, everything changes. It's an experiment in which you are really walking a tight-rope; you never know how it will end. In this respect, *Retour*

d'Afrique was a sketch for the next one, although the use of the camera was less obvious in *Middle of the World*. Think of the tracking shot, normally it is used so you forget the camera; it follows the action, the characters going from one place to the next. In *Retour d'Afrique*, and to a lesser extent in *Middle*, the camera starts moving when the characters are still. When the camera moves for no apparent reason, the alienation effect is doubled.

Cineaste: *In* The Middle of the World *the heroine's hopes, Adriana's desires, seem important, yet vague.*

Tanner: They are not really explicit; they should be born out of Paul's passion for her. She's not expecting anything; she's accepting him as a bed companion because she's alone, in exile in a small place—her life is quite empty. Along comes a man who is not unpleasant, who is nice to her, and I don't really define her hopes. Her hope is for a totality, and this man might be that. It is up to him to play the game, to go to the end of his passion for her with all that that means, the transformation of his character and life.

Cineaste: *How can we expect this transformation from someone like Paul who is characterized as a modern, bourgeois technician?*

Tanner: Of course, one can say there is no possibility—this is the pessimistic side of the film in which Paul is the symbol for our society's time when we see no possibility for change in the short run, or even in the long run. Hopes, I feel, have been delayed or "normalized," and we can't even see what shape those hopes may take. He *is* a symbol of that. One doesn't expect him to change in the course of the film, but underneath he is capable of something. He is still alive and not rotten to the bone, yet, but he is operating in such a society that his role prevents him from changing. This is the interesting thing about Paul, I feel. His character is dual, but it is too late for the human within him to cross the line. An important scene in relation to this is when he stops to piss in a field, but this playfulness is not enough.

Cineaste: *Is Adriana's disenchantment with Paul necessarily tied to politics?*

Tanner: No, not for her. She's not what might be called a progressive character or articulate. She doesn't refuse Paul because he's a bourgeois; she's not interested in that sort of thing. In the end, it's what she does without knowing it, not because of his class, but because bourgeois society forces him to behave like that. She doesn't consciously know this, and she can't tell him; she just senses it.

Cineaste: *When she talks about her working class husband and union leader father, she doesn't seem to have liked them.*

Tanner: No, she doesn't; I had to make that clear. She's not politically minded at all, but she is from that culture, brought up under that influence—after all, that is her class. But all the union business at home is the men's job. She is a very traditional Italian girl in this way. This is also why she can resist completely Paul's world without being articulate. It is because of her origin. She might be alienated in Italy, since women there are, but at the same time she has a strength that a woman's role in Italian society grants them. They are not contaminated by the way modern society works.

Cineaste: *In your other films there are characters and dialogue which link the narrative to its larger social action. Why did you exclude any conscious political character in this film?*

Tanner: Because I had the feeling that that is a rather facile way of taking revenge against everything, just to put a few good lines in a character's mouth, and that's it. I thought it was a bit facile, and I really wanted to get rid of it. I am not completely against it, because it can be ironical, but in this film none of the characters could speak for it. It's set in a small town, and if there were such characters they'd be such a tiny minority as to be irrelevant. The action takes place in a country town of perhaps 4,000 inhabitants.

Cineaste: *This film has a great deal less humor than your others.*

Tanner: Because of the subject, the place and the characters. Getting back to political irony, I was very much surprised when I saw audiences in Paris and Geneva watching *La Salamandre.* They were laughing in the right places, but far too much, far too much. I realized the oral satisfaction they had when they picked up on those lines, and I didn't like it. I realized this facility had to be wiped out from this film, which is more austere and colder. I'm not saying I won't return to irony, but especially not in this film. Irony is a kind of double-edged weapon; you can laugh at anything in the end, and it is also a sign of weakness. I had terrible rows with extreme leftist audiences over *Middle of the World.* In both Paris and Geneva the reactions of the young, extremely political audiences were identical—against the film. I could see exactly what they wanted; they'd like to see themselves on the screen with revolutionary trappings. I told them that their reaction to the film, their relationship to the screen, is exactly like that of the petit bourgeois. So they see revolutionary films from South America and feel so happy that it is a revolutionary movie, although they are sitting and living in Paris or Geneva.

Cineaste: *All your films end with an opening, the feeling of "what happens after?"*

Tanner: That's a problem, really. We might stay in a state of pre-consciousness, when something might happen, but I can't go further, for then I'd have to be a militant to show "what happens." Actually nothing happens, but people are still trying. If a militant wants to make a sequel, why not?

Cineaste: *At the end of* Middle of the World, *Adriana is working in a Zurich factory.*

Tanner: Yes, people don't understand it. They say it's horrible, I've put the lid on her—fate. Working in a factory is not pleasant, I agree, but many people work in factories, and in her case she is returning to her class where she will get a better understanding of society and the real reasons for the failure of her affair with Paul. Paul was absorbed and destroyed by production; now she is absorbed by production and here is Paul again, not in the guise of a potential lover, but as a boss. There is a repetition of a scene from Paul's factory—the same attitude toward the workers. Now she can analyze the situation, for it is Paul again. It is always better to be a worker if you are in industry—you have more capacity for understanding society and for change.

Cineaste: *Your last two films have a strong emphasis on women's roles in society.*

Tanner: This is true. When a woman moves a bit, she moves many more things. Men have been moving for a long time now without much result. In the present situation the structure of society is more affected when a woman moves. Just think, the whole social structure is based on family life. Politically speaking, this is a good reason for the emphasis on women. A more subjective reason is that when you have a two-sided story, it is always a temptation for a male artist to use the woman as an inspiration or muse.

Cineaste: *In* Retour *the female character is the more serious of the two, although the male is the one who wants to leave Geneva and talks a lot about radical politics.*

Tanner: He talks a lot, and he's capable of action because in a couple, and they are a traditional couple, he's supposed to be the one who is leading, inventing, creating and imagining things, while she follows. In the middle, when things don't work out, she becomes like a nurse to him, still a traditional woman's role. In the end, when the real practical problems emerge—a kid coming, work, rent that's too high, and transportation to work—they fall on the woman's back.

A man can imagine, perhaps create, but all the practical organization of daily life is performed by women. The female character in the film is doing that, and in the last scene they are a real couple, because he accepts her as an equal—the tossing of the coin is the symbol of that equality.

Cineaste: *What kind of films have influenced your work?*

Tanner: Well, I cannot say I've been influenced by one man or one school, although when I was in England fifteen years ago I took part in the Free Cinema movement there. At that time I was strongly influenced by the Anglo-Saxon or British humanistic school of film-making, Lindsay Anderson and Karel Reisz amongst others. This was quite different from the French school with its abstract intellectualism. In England we saw films all the time; I like the Japanese films, Kurosawa and Ozu, and the early Soviet films, including Donskoi's *Maxim Gorki* trilogy. Later, when I left England, I realized what was missing in the English approach. Although they have a direct and warm sense of collective life, so unlike the French egotism, the English lacked the theoretical and dialectical approach to life and its problems which the French have.

Now, I don't see many films these days; I cannot bear to see the same type of films. I'm really interested in directors who are inventing something, working on the language. Godard, in this respect, has of course been an influence. Bresson too is inventing something. I may be influenced by them without even knowing it.

Cineaste: *What about political influences? The posters of Karl Marx and the Marx Brothers in* La Salamandre *seem a hint of May '68?*

Tanner: Yes, of course. May '68 in Paris was an enormous event; it may have had no political significance but it was a tremendous happening. I covered the events for Swiss television—people were performing revolution without being shot at. All the ideas germinating since then show how important May '68 was for cultural and social life. One mustn't forget that there were ten million strikers, but nobody was prepared to seize power; the political structure was taken by surprise, as if in a play.

My own political foundation or philosophy is Marxist from my student years, and I suppose it will remain so. John Berger is an influence; we work together. He's a Marxist too. What is less clear for both of us is the What, When and How. Neither of us is a dogmatist; it's a basis we have, perhaps it is in our blood, but it is also a lack. We

are not militants; we are not involved in political action, we work in a different field, try to understand what is going on and to make films. The first task of filmmakers is to change films.

I am not just a poet dreaming and making films. If you want to make films in a difficult situation like ours, you must fight at every level. I organized the Association of Swiss Film-Makers, and there are constant fights with distributors and the government. Just before coming to New York I went to the Swiss Parliament to collar its members to ensure that financial credits for films are not cut. Everywhere there is this financial crisis. There is a small amount of money for filmmakers, but it is the basis of all our production, particularly for 16mm and non-commercial films. My last film had one-third of its budget covered by an advance from the government.

Cineaste: *Would you ever make a film set outside Switzerland?*

Tanner: I don't think I could, but I don't really know. It's much easier to work and create characters when you see them every day—to know how they move and speak, and when they speak. It's much easier. I couldn't make a movie in New York, for instance. I'm not sure, but I might make a film in France. The production and distribution system there is much larger and complex with regulations; we avoid that by being Swiss. *Middle* was shot three miles from the French border, and though not much different, it is. I think the center of my films will always remain in Switzerland.

11—JANE FONDA

I prefer films that strengthen people

Jane Fonda made her film debut in Tall Story *(1960). During the following decade she appeared in films ranging from* The Chapman Report *(1961) to* Barbarella *(1968). As it did for many other Americans, the war in Vietnam made Fonda increasingly critical of American foreign policy. Although living with her then-husband, film director Roger Vadim, in comparative luxury in a country house outside Paris, the events of May 1968 in France and other student outbursts of that year led to her return to the United States and her emergence as a vocal opponent of the war in Vietnam. She organized a troupe that played at GI coffeehouses and took part in numerous rallies. Her film roles took on a sharper social dimension with* They Shoot Horses, Don't They? *(1969) and* Klute *(1970), for which she received an Academy Award (Best Actress) and less conventional films, such as* Steelyard Blues *(1972) and* FTA *(1971). In 1974, with Haskell Wexler, two Vietnamese assistants, and second husband Tom Hayden, Fonda made* Introduction to the Enemy, *a documentary film about Vietnam. Dan Georgakas and Lenny Rubenstein interviewed her when the film opened in New York. Their discussion focused on the possibilities for making progressive films in the Hollywood context, on the political problems for a radical actress in terms of her art, the production of* Introduction to the Enemy, *and the cinema in Vietnam as she had seen it.*

Cineaste: *What kind of problem has becoming a political activist created for you as a performer?*

Jane Fonda: One of the first things was to resolve certain contradictions that were posed in my life, if I should continue acting or not, and if I continued, in what way? Should I continue in Hollywood films or should I join a group like Newsreel? I almost decided that it would be better to totally disappear into the faceless crowd of organizers (I thought then there were crowds), in the GI coffeehouses. The people who dissuaded me were John Watson and Ken Cockrel.* That must have been 1970 or 1971. They sat me down and said, "We've seen too many people with very important middle class skills—doctors, lawyers, and others—who have rejected their class, and with it their talents. There's a need for people who can reach mass audiences. You must continue." That was a very important statement for me to consider.

Cineaste: *What about the kind of roles you decided to play?*

Fonda: Well, I had always been the kind of actress who waited for people to come to me with scripts and ideas. The performers in Hollywood who are active producers are almost all men. Producing was an area that had been mystified to me. I found myself not working very much because I didn't like the roles coming my way. I think the problem with Hollywood is that the directors, and the writers even more so, don't view things historically and don't view things socially. Stories are unravelled in the context of an individual's particular personality and psyche and in the events of one life, never against a social background. You never see things dialectically which means they are lying to people. They lead people down blind alleys.

I started to realize that if I was going to work, and if there were going to be movies made that I thought were important and if I wanted to remain in the context of the mass media, I was going to have to produce them myself. I formed a company with a group of friends who had similar views on what movies should be. One film that we're working on now is a film about the American Revolution. Interestingly enough, I became drawn to the subject when I was in Vietnam where I discovered the Vietnamese were very knowledgeable about American history. One reason the writers and intellectuals there studied our history—Paine, Jefferson and Lincoln—was to teach about them in their public schools. This is part

*At that time, Watson and Cockrel were members of the executive board of the League of Revolutionary Black Workers.

of their attempt, which is traditional in that country, to help people differentiate between friends and enemies. They say that there are the American people and there is the American government, and that the American people are potential allies. They say there is a democratic and progressive tradition in the United States which must be encouraged. As an American I can remember saying, as I saw my first Phantom jet bombing over Hanoi, that I was so ashamed to be an American. A man who was with us at the time said: "You musn't say that; that is your country; there is much to be worked with and encouraged."

Cineaste: *Could you tell us about the film on the American Revolution?*

Fonda: I was especially interested in the subject because of the Bicentennial coming up. I knew my brother had been wanting to do a film based on Howard Fast's *Conceived in Liberty*. That's a very interesting book, but it has some problems. It doesn't deal with racism and it doesn't deal with the role of blacks in the American Revolution. Some blacks fought at Bunker Hill and others fought with the British. But reading that book and other books by Fast and various authors, I began to realize how little I knew about the American Revolution. The realities, the details, are quite complex, subtle and fascinating. My father, brother and I decided to do a film together. We asked Staughton Lynd to do the historical research. We knew what we wanted to do. We wanted to show the revolution from the point of view of working people, not just famous battles and famous names. Why did the common people eventually come in to support the idea of revolution? Why were they prepared to fight in it? How did it change their lives, if at all?

We didn't want to fall into the trap of putting the revolution down which is not difficult to do from some points of view. I have come to understand that revolution is a process. We are taught in America to view it as an event. We fought it and we won it and isn't that wonderful! In our film we want to try to view our history as a dialectical process in which many progressive things were won for some people, but not for all. In that process there were massacres and the seeds of American imperialism were sown. This is what we're going to deal with.

I will be a woman who runs a tavern which I inherited from my husband. My father will be an intellectual cobbler, of which there were many. It was one of the few working places where it was quiet enough to read and talk. They wrote proclamations in cobbler shops.

They were a center of popular intellectual activity. My brother will play an apprentice to my father. We will begin in pre-revolutionary times and show how so many people from so many different class backgrounds came together to organize and build a revolution. These same people, after the revolution was over and the class questions began to manifest themselves, became bitter enemies. Samuel Adams will be one of the few famous people who will be in the movie. It will end with Shays' Rebellion when Samuel Adams called for the imprisonment of the Shaysites. These were the people who had fought the revolution and afterwards found themselves going to prison because they had no money to pay their taxes. People were forced to move west. The westward expansion begins where the movie ends. It's a very difficult picture to do, but we'll get it done.

Cineaste: *Most students of film believe films are a director's medium. Do you subscribe to that?*

Fonda: Yes, I do.

Cineaste: *What about the role of producers, writers, performers and technicians?*

Fonda: A David O. Selznick movie was a David O. Selznick movie. And I guess a Mike Nichols movie is going to be a Mike Nichols movie and a Barbra Streisand movie is going to be a Barbra Streisand movie. There are exceptions though. Maybe it's not quite so clearcut whose medium it is, but the director can make the biggest statement in a film. The director can cut a film and shape it any way he wants. Ideally, directors weld together a team of people who share the same point of view, but that is rarely the case.

Cineaste: *You've fought with directors to get things into a character that you felt had been taken out or improperly developed. A Doll's House comes to mind.*

Fonda: That's a good example of how film really is a director's medium. I could fight as much as I wanted to have the film remain faithful to Ibsen's ideas, but eventually he could cut out whatever he didn't like. It was his point of view, somewhat modified, but nonetheless his, which finally emerged.

Cineaste: *Why are there so few women directors?*

Fonda: I think it has to do with money. There's a real reluctance to finance a major film, which nowadays means at the very least a million and a half dollars, with a woman directing because producers believe women are not good at handling large numbers of people. I have no scientific data to base that observation on, but I think it's true. I've never tried to direct and I don't know many women

personally who have tried to direct feature films. I haven't heard any discussion within the industry on the question, but I do know the people who decide where the money goes. I know those people would not trust a woman to handle a crew of men and bring in a product that is saleable.

This is less true in Europe—there, more women are given a chance to direct. Lina Wertmuller comes to mind as one of the most exciting. There are others. This is because films are not quite as much big business there as here. The bankers and the multi-national corporations don't control the film industry to the same extent as in the United States. Paramount Pictures is owned by Gulf and Western which, among other things, has large oil leases off the coast of Vietnam. Warner Bros. is owned by Kinney Leisure. It's big business. I agree with Pauline Kael when she says it all has to do with marketability and marketing. If they don't think the movie has obvious box-office appeal, they won't do it. That's why it is so important to have independent systems of distribution. If they monopolized distribution, you couldn't show anything that they wouldn't make themselves.

Cineaste: *Is it feasible to expect roles with ideas in them that are in any way compatible with your political views if you are not producing?*

Fonda: It's not impossible. I'm doing a film, at least I think I'm doing a film, based on a story by Lillian Hellman called "Julia." It's a true short story from a book of hers called *Pentimento*. It's the story of Lillian Hellman and a woman she knew who became a socialist. Well, you don't know for sure. All you know is that the woman becomes a committed activist who joins the French anti-fascist underground and gets killed by the Nazis. It's a very beautiful story about two women. It's about why people change and about the relationship of women with strong social commitments. I think it could be a very exciting film.

Cineaste: *There have been suggestions that you should play famous revolutionaries like Rosa Luxemburg and Emma Goldman.*

Fonda: I'm very wary of playing any role which makes me look like I view myself as La Pasionaria. I would rather play a fascist, if that exposed something about racism and power, than play a famous revolutionary. Someone wanted me to play one of the Weatherwomen killed in the town house explosion. A rumor has me playing Patty Hearst. Those kinds of roles are the last thing I would think of doing. There is one revolutionary woman I would like to play

though, but only when I'm old and shrivelled. That's Mother Jones.*
That would be a great joy to do.

Actually, the kind of parts that I think are the most exciting to play
and the most viable in terms of communication are characters that
are complex; that is, characters that are full of contradictions that can
be shown, that are in motion, that are trying to deal with problems
that are real to people. I prefer films or any kind of cultural expres-
sion that strengthen rather than weaken people. That's why I would
rather not play a villain's role or, if I did, I would want her to be at
least moving in an upward direction. I think all of us are trying to
figure out—what is a progressive movie, what is a revolutionary
movie? Is it really possible to make a movie that is a weapon for
political change? I don't know. I honest-to-God don't know. I do
have the feeling that, at this stage, in this country anyway, it wouldn't
necessarily be a film that offers a solution. I have a feeling that there
is a kind of frustration that may be progressive at this point. Perhaps
the best we can do now is create in the audience a sense of hopeful
frustration. Perhaps they should leave the theater with a sense of
wanting to move and a feeling that there is good reason to move.

Cineaste: *Most of the films made by Americans who consider
themselves leftist are documentaries. Why are there so few fiction
films that are radical and that appeal to masses of people?*

Fonda: There's *Billy Jack.* Maybe you don't share my view of it. I
think it was an extremely progressive film. You're not going to make
a mass movie that is revolutionary. You're not going to make a *Battle
of Algiers* that is a mass movie. I think it's important to do a picture
that is going to be seen by a lot of people. *Billy Jack* takes the
American superman as its main image, and that has to be improved
on, but here you have a Vietnam veteran who comes to the aid of a
minority people and you have a real debate about pacificism versus
armed resistance. Why, think what it means that people in Orange
County† are lined up to see this movie. That's fine. That's very good.
With the sequel, *The Trial of Billy Jack,* Laughlin goes even further.
Nothing's spared. Kids who were too young to have experienced the
sixties are brought through it in the film and, I think, are being deeply
affected. It's a film that has moved the parameters of what's possible
to do or say way out there.

*A leader in the miner's movement during the 19th century.

†A conservative area of California that is a stronghold of the John Birch Society.

Cineaste: *The films that came out of the Depression seemed much stronger, films like,* Grapes of Wrath *or the Frank Capra populist films —* Mr. Deeds Goes to Town, Mr. Smith Goes to Washington, Meet John Doe. *In Capra's films the capitalists are bad guys mainly because they're capitalists acting like capitalists. If* Billy Jack *and* Grapes of Wrath *were on a double bill,* Grapes *would win hands down.*

Fonda: Oh, I agree. But there are so few good movies that I'm not prepared to pit them against one another. Would that there were five *Billy Jacks* made each year. I think that *The Way We Were* was a good movie, and it was successful. How often do we get to see a movie in which a Jewish woman communist is the hero and a tight-lipped, anal-retentive WASP loses? And the film makes $30 million! Yes, we could spend hours discussing what was wrong with that movie. But I think we have to remember what is possible today. *Godfather II* is another recent film I think is progressive.

Cineaste: *You've expressed interest in dong a movie based on Harriet Arnow's* The Dollmaker.* *Would such a film be more like* Grapes of Wrath *in terms of themes and characters? Is it likely we'll see such films if the recession should deepen into a major depression?*

Fonda: I think so, but we must always remember that it's not 1929 and nothing repeats itself. I wouldn't want *The Dollmaker* to be a downer the way a lot of the Depression films were. I think it can be hopeful. I met with Harriet Arnow and we both share the sense that it can be a positive movie. I disagree with the thinking in Hollywood on the part of producers that people don't want to think, that they only want to be entertained. People want to be led out of the morass or at least to have a little help in clearing away the confusion. The problem is what we said earlier. People who have a social vision haven't found a way to express it in a mass language. There's so much rhetoric and so much sectarianism. It gets manifested in the cultural field and I think that's why culture gets left in the hands of the entertainers.

Cineaste: *How would you rate your own film,* They Shoot Horses, Don't They?

Fonda: I think that was a movie a lot of people related to on a political level. The author of the book was definitely drawing an analogy with American society: the tragedy of all those people killing

*A novel set in the thirties which concerns Appalachians who migrate to Detroit to work in the auto factories.

each other for a prize that doesn't exist at the behest of one man who they could replace if they were conscious of what was being done to them. I realize the shortcomings of the movie. The woman who does realize what is going on commits suicide. No, really something worse: she has a man kill her. I think for what is possible, however, it was a good movie. It would be wonderful if someone could go around with the movie and after it was over have a discussion with the audience about what it means. It's too bad that movies are sort of thrown out and left that way.

Cineaste: *Is it true that you danced with Red Buttons for fourteen hours to get realistic postures of how exhausted people would dance? That sounds like grueling work.*

Fonda: Oh, it was. I don't know how the marathon dancers did it. We were in good shape. We weren't starving and our lives didn't depend on it. I could not have gone on another hour.

Cineaste: *For* Klute *you lived on the West Side of New York for a while to get a feeling of the street scene.*

Fonda: I didn't exactly live there. I went back to an apartment that wasn't the kind of apartment a hooker would have. But I did spend quite a lot of time with call girls, streetwalkers, and madams. I spent time down at the courthouse seeing how the legal process works: the hookers rounded up and paraded through, with the length of their sentence depending on how much they paid. Obviously, if we did *The Dollmaker,* I would want to spend a lot of time in Kentucky and Detroit.

Cineaste: *It seems to us that too many artists who consider themselves leftists don't want to work as hard on their craft as you are willing to do. Their work, whether films, magazines, poetry, or what have you, often has a hurried and sloppy quality. Some of these artists seem to think that having a good political perspective is enough.*

Fonda: I've seen things from the left that were very wonderful and others that were sloppy. I've also seen Hollywood things that were wonderful and others that were sloppy. I do believe it is important that things be well done. If you're going to do a leaflet, it should be beautiful to look at. It should be easy to read. It should use language that doesn't frighten people away. If you're going to make a documentary, it should be as well made as you can possibly make it. Obviously, people who are trying to change themselves and are trying to have an effect on people's consciousness in a progressive way have a responsibility to make their work as good and sensible as

possible. It's important that a magazine like yours look good, that it has a professional quality.

Cineaste: *You improvised the scene in the analyst's office in Klute. What does that mean exactly? Did you have any script to begin with or what?*

Fonda: That was the last scene we shot and by that time I knew the character very well. You find areas in yourself that relate to the character and then learn how those things are expressed differently than you would express them. By that time, I knew Bree well enough to improvise the scene. I think it worked real well. I didn't have to think about it too much, but I set myself certain tasks. Bree was the kind of woman who at a crucial point in her analysis would find an excuse, like it was costing too much or that it wasn't doing her any good, to keep from revealing another layer of herself. She would create barriers and conflicts. It was wonderful fun to do that scene. We did it real quick. We didn't do anything twice.

Cineaste: *That seems an example where the performer gets rid of the director and writer at least in one scene and sort of takes charge.*

Fonda: Not really. We all worked closely. The director and I had a lot of discussion beforehand about how the scene was going to be used and what we wanted to convey. It was his idea that the analyst be a woman and that was an important decision. Bree would not have talked the same way if it had been a male analyst. Someone else decided where the camera should be and that was important. What's so wonderful about movies and so frustrating if you're working in Hollywood is that filmmaking really is a collective effort even though the director has the final control. That's what seems exciting about filmmaking in a socialist country. Filmmaking is a socialized process. When it is working right, everyone is participating. The cameraman is doing the lighting and setting the angles in conjunction with what is being attempted in the overall effort. Everyone has thoroughly discussed and understood what is being undertaken.

I was very interested to talk to the film people in Vietnam. They described how everyone worked together. The performers, the directors, the technicians, would discuss a story and carefully work out what was to be conveyed and how to tell the story. It would all be done truly collectively. The writers would then write and there would be more discussion. They all said this laughing about the fact that everything takes so long. That's on every level, not just movies. One of our hosts the last time told me: "We would have won long ago if

there weren't so many meetings." You wonder how they get anything done. It's difficult to work collectively. They have real problems. Their actual filming gets done very quickly though. They told me that they didn't have any film to waste, that they didn't have anything to waste. A long time goes into the planning, but the shooting is very fast.

Cineaste: *In some ways that's the opposite of the method used by western filmmakers.*

Fonda: That's right. And nothing is arbitrary. Nothing is left to the whims and fancies of any one individual. I would call it a creative process, however. Of course, it's not the way we're used to thinking about such things. With us, a lot depends on the individual attitudes of the particular director. There, everyone is working together on a task that everyone feels a share in. To hear that kind of process described made me sad the way I've seen it done here. The alienation of the technicians from the process in Hollywood is particularly sad. Most of the time, they are not given the script to read. They don't understand why the film is being made or what is being attempted in any given scene. I've never heard of a filmmaker sitting down with the crew to tell them how the film has been conceived and asking their opinion. Consequently, these guys report in to work and sit around until someone gives them a specific task. They get very alienated from the film, and it's very depressing to see it and be part of it. Only if there's a real razzmatazz scene where the actors get it up and cry and carry on do they pay attention. Sometimes they'll clap. Otherwise, their attitude is: who cares? And who can blame them?

Cineaste: *Sometimes in discussing the films you made before you became politically involved, you seem defensive, especially about the subjects of nudity and sex. Nowadays the left is generally puritanical about sex, but this wasn't always so. At the turn of the century, leftists were attacked as often for their sexual beliefs as for their political beliefs.*

Fonda: I don't object to the movies I made because of the nudity in them. I don't think that nudity is the problem. It's how it's used. The problem is that movies that are made with sex and nudity, including some of the films I participated in, were exploitive of sex. *Barbarella* is a film that's always brought up, but as a matter of fact, I was hardly ever nude. Most of the pictures where I was dressed to the teeth and played a cute little ingenue were more exploitive than the ones with nudity because they portrayed women as silly, as mindless, as motivated purely by sex in relation to men. The simplest

way to explain why women do that in this country is because there are limited avenues open to women to gain some power. One of the avenues is to marry a powerful man; another is to become a sex symbol. Things are changing slowly but it used to be if a woman got offered one of those avenues, she didn't generally turn it down.

I don't think I'm particularly sexy. I don't know why I should be made a symbol of anything. At that time, it didn't occur to me to say, wait a minute, this isn't what I am. I never felt like Barbarella. I never felt like the American Brigitte Bardot. I always felt slightly out of focus. There was Jane and there was this public figure. It was extremely alienating. I never liked it. I never felt comfortable with it. I'm not defensive about it anymore. I think it's important to try to understand why women do that and how it is possible to change. It's hard to tell what a revolutionary future might bring. Some people think marriage should be abolished. Who knows? I believe that you can't build a mass movement around the questions of sex and marriage. I've been in a revolutionary society where marriage is very much an institution. It did not appear to be particularly oppressive for women because the power distribution within the institution is different than here. We would call Vietnam extremely puritanical. I think the importance that is placed on sex is a cultural thing. I don't think that in a healthy society there would be all the importance put on sex that we do. I don't think that in a healthy society you would have to show anybody naked on the screen. I don't think it would be an issue.

Cineaste: *Could you tell us something about the documentary you've made and what you hope to accomplish with it?*

Fonda: *Introduction to the Enemy* is an hour long documentary that was filmed by Haskell Wexler and two Vietnamese assistants in April 1974. We filmed in North Vietnam and then were driven down Highway #1, a major target of the U.S. Air Force during the bombing, across the DMZ and into the province of Quang Tri, the first to fall to the Provisional Revolutionary Government in the offensive of Spring 1972. It was an unforgettable experience. Think what it means that after all the tons of bombs, perhaps the fiercest carpet bombing in the history of warfare, the people who were the targets were escorting Americans across the McNamara Line [the electronic barrier that was supposed to cut Vietnam in two permanently] on the highway which was never cut in spite of the bombing. Quang Tri was so devastated that people were forced to live underground for years. Hospitals, schools and factories had been constructed underground.

Now, the people were walking on their land again, plowing through the debris and rusting tanks and air bases the American military left behind when they retreated. We wanted to make a film that would begin to view the Vietnamese as people. We talked to many people—writers, soldiers, a movie actress in Hanoi, the woman, Madame Dinh, who is the deputy Commander-in-Chief of the army of the Provisional Revolutionary Government of South Vietnam, peasants—a broad spectrum. They speak of their feelings about the war, what they went through, how they view the future, what problems they have to overcome, how they feel about the American people. It is a gentle film. It is a first step in tearing away the mask that the Pentagon has given these people. Our ability to overcome racial stereotypes and to understand who the Vietnamese are, why our government fought the war, and why we have not won: these things will determine a lot about our future. The perception on the part of a people of how a war was won or lost is as important as anything else about the war. If the government can make us think we "bombed them into submission" to achieve peace with honor, then it will be able to use the same tactics again against other third world people they manage to define as the enemy. We feel the film has long term value and it has been proved to us as we show the film, both commercially and in schools and universities, that people are moved by and sensitized to the people of Vietnam. It is modest of necessity. The war continues. We are attempting to redefine it even as it goes on. When the Peace Agreement is fully implemented and peace comes to Vietnam, much more ambitious attempts can be made.

Cineaste: *This might be a good place to ask what films about America the Vietnamese see?*

Fonda: I'm glad you brought that up because the film association in North Vietnam asked me to do something for them concerning American films. Oddly enough, when I met with them they said: "Do you recognize this place?" I looked around and said: "No." They went on: "You were here although you don't remember." It was the Hanoi Hilton. I had come there at night and had gone to a reception hall, but it was the place where the prisoners of war had been kept. It's actually the film distribution center. All the little rooms had been turned into cells. Anyway, they are very interested in a film exchange. They want to see American films. *Grapes of Wrath* would definitely be interesting to the Vietnamese. *They Shoot Horses* would probably be good for them to see. I know the leadership and intellectuals are very anxious to see American films to better under-

stand America and Americans, but it's expensive. *The Godfather* would interest them a lot. We want to raise money to send 16mm copies of American films to them. Perhaps your readers would be able to suggest films for use there and would want to get in touch with us to work on such a project.

Cineaste: *We've been talking about different styles of acting and different conceptions of art. You spent some time at the Actors Studio with Lee Strasberg. Was that important to your development?*

Fonda: Very important. There were certain psychological reasons for that. Previous to that experience, I thought acting was standing up and trying to say lines that sounded as realistic as possible. The idea that there were scientific ways to tap your own personal experience in ways that could be repeated so that you could give a performance that comes from inside over and over again was something I hadn't realized before. Also, as an alienated upper middle class American woman, I had never used anything of myself in anything I had done. It was really an enormous revelation for me to actually have to use myself. It was very liberating. The problem with the Actors Studio was that it left out a lot of things: knowing how to use your voice, body movements, going beyond the individual psychological framework of a character. But I found it very useful. I continue to use what I learned there a whole lot.

Cineaste: *Was there any political ferment around the Actors Studio? At one time it had a leftist orientation.*

Fonda: That was pretty much gone by the time I studied there. Basically people were liberal to left, but it was not discussed.

Cineaste: *You were in France in May of 1968. How did those events affect you?*

Fonda: It wasn't just the French May. It was a period where everywhere in the world upheavals were taking place. I'm not sure what was more important: what was going on in France or what I saw on television about what was happening in the United States. It didn't happen as dramatically for me as perhaps for Godard who looked out the window and there were his people in the streets. I looked at television and saw my people, where I came from, and I suddenly felt I was in the wrong place. I was extremely pregnant at the time. I lived in the country and my husband wouldn't let me go into Paris because I was about to give birth. I wanted to do something, yet I knew that wasn't my place. I subscribed to *Ramparts* and *The Village Voice* at the time and I read everything I could get my hands on. I identified with Joan Baez. It was new. It was like

rumblings going on inside all the time. I really wanted to come home and that meant leaving a whole life. Yes, those were tumultuous times.

What was important about being in France was that for the first time I realized that it really could all come down. There were days there when we thought it was going to stop. Who would have thought that students and maybe workers were going to bring France to a halt. No gas. No food. No nothing. We were beginning to stockpile basic provisions. People were leaving Paris to come stay with us because we had a vegetable garden. Many of the people I knew were "at the barricades." It so happened that at that time my husband, Vadim, had just been made head of the union of cinema workers. So he was having to drive to Paris all the time for these mass meetings of all the movie people, including technicians and other workers, to decide if the studios were going to close down or what. I just felt—let's get this baby out, I want to pack it up and go home, I want to get involved. And that's what I did.

12—FRANCESCO ROSI

The audience should not be just passive spectators

Although Francesco Rosi is one of the most highly regarded direc-
tors internationally, he still remains largely unknown in the United
States. The interview which follows took place in 1975 at the time of
a Museum of Modern Art retrospective screening of his films and
focused on the three for which he was then best known: Salvatore
Giuliano *(1962),* The Mattei Affair *(1972), and* Lucky Luciano
(1973). In Salvatore Giuliano, *Rosi looked at the life of a Sicilian*
folk-hero-bandit with Mafia links who at one time called for Sicily to
secede from Italy. The style is a journalistic documentary-like
reconstruction in which a mass of conflicting accounts, dubious
statements, inexplicable events, and ambiguous motivations
underline the realities of postwar Sicily. Ten years later, The Mattei
Affair *utilizes the same approach to follow the career of Enrico*
Mattei, the president of Italy's state-controlled petrochemical
concern, who died in a mysterious plane crash in 1962. A key in-
terest is Mattei's activities with developing nations who wanted to
take control of their oil industries from Anglo-American interests.
With Lucky Luciano, *Rosi takes up related themes in tracing the*
cooperation between legal (state) and illegal (Mafia) power. Of par-
ticular interest is the U.S. Army's cooperation with the Mafia. Rosi
spoke about his work with Gary Crowdus and Dan Georgakas.

Cineaste: *The structure of many of your films involves a sort of journalistic reconstruction, as in* Salvatore Giuliano, *where you piece together many different facts and interpretations. In that film you also use a lot of flashbacks and flashforwards—even your style of flashback is complicated, you don't use simple flashbacks.*

Francesco Rosi: It's a new kind of flashback, maybe, because it's not used only for the temporal, the time, aspect. In *Salvatore Giuliano* and in *Mattei*, too, it involves the necessity to communicate to the audience the impossibility of reaching the truth. The structure of *Salvatore Giuliano* grows out of an attempt to get as close as possible to the truth. I utilize many different elements to present my interpretation, an interpretation of the relationship between the legitimate power, the state, and the unofficial power, the Mafia. There are many, many different facts, many, many different implications, many, many different collusions between the Mafia and the legitimate power. But in all these elements at my disposal, there are also many doubts, many uncertainties, so I have to communicate to the audience the *impossibility* of reaching the truth. This confusion in the film—of the facts, of the actions, of the different interpretations—is the same irritation that one feels in life when you realize the absolute impossibility of getting at the truth. And it's this feeling I want to convey to the audience.

In addition, this movement, this balance between the past and present and the future represents the confusion that the establishment, the power, encourages in order to keep everything in the dark. In real life, the power tries to keep everything in its place because order is the best way to keep things stable. But when you look at all the different pieces of a puzzle and move them around and you can't fit them all together, this is the beginning of a disorder that the power doesn't want. So, this confusion, this impossibility of fitting together all the different pieces of the puzzle, those things which disrupt the stable and quiet situation, for me this means the beginning of a disorder that makes the power uneasy.

When I realized this during the research for the film—all the stuff of *Salvatore Giuliano*, the various episodes, the trial, the historical and political events—I refused to narrate all these facts in the traditional way. The traditional way, of course, would have been to have used a journalist as the main character—as one of my screenwriter collaborators suggested to me—but I refused because it was clear to me that *I* was the journalist, the narrator, the camera lens was the journalist. I didn't need a journalist character, I needed to convey to

the audience the impossibility of being a journalist in this pit of vipers, this relationship between the legitimate power and the Mafia.

But attention!—because there is another problem. The Mafia is not just what the normal audience believes it to be. The Mafia is also in the first police, the second police, the third police—because we have three police forces in Italy—*carabinieri, polizia, polizia segreto.*

So with *Salvatore Giuliano* the structure was determined during the actual work on the film—the research I conducted became the basis for the film's dramatic structure. It's the same thing for *The Mattei Affair*—the feeling, the atmosphere, the relationships, are the same. In *Lucky Luciano* there is a little bit of this, but essentially that film called for a historical preparation—all the flashbacks—and even an ideological preparation in order to understand the character of Lucky Luciano. It's very different for *Hands Over the City* because there it's my presumption to have gotten something, to have gotten one opinion on it, and to communicate this opinion to the audience. I tell them, "Now I'm going to narrate to you what I pretend to have gotten and you judge for yourself." This is completely different. So it's not the same style for all my films. Each film demands its own style.

Cineaste: *You seem to have a fascination with the Mafia in your work. Why?*

Rosi: Fascination? I am fascinated because I live in a Mafia system. You, too, live in a Mafia system. The power is a Mafia system.

Cineaste: *You mean literally, that the state and the Mafia are so closely intertwined that they're one for all intents and purposes?*

Rosi: Let me read something for you, I have a definition here of the Mafia which I think is a very good one. [Reads]: "The Mafia is an association with criminal intentions for the purpose of illicit enrichment of its members and which, by the use of violent means, imposes itself as a parasitical intermediary between property and labor, between production and consumption, between the citizen and the state." This is a definition given by a Sicilian judge during one of the thousands of Mafia trials. It appears in a preface by Leonardo Sciascia to a study of the Mafia written by a German student, a marvelous study entitled *La Mafia.* I think it's the best definition of the Mafia because it's the most modern one, this conception of its function as an intermediary between property and labor, production and consumption, and between the citizen and the state. That's why I'm fascinated with the Mafia!

Cineaste: *In other words, it provides a scale model to understand the power relationships.*

Rosi: Yes, of course. And another reason is that I was born in the south of Italy where the mafioso mentality is such a reality, although it has changed considerably. I am fifty-two now but when I was a child the Mafia was another thing altogether. The Mafia went from Sicily to the U.S. and came back from the U.S. with another face, an industrial face. That's the importance, I think, of *Lucky Luciano*—it's the passage from the old Godfather to the modern conception of the Mafia, as a corporation. He's an industrialist now and in *Lucky Luciano* he's like my uncle.

Cineaste: *One of the striking things about* Lucky Luciano *is the downplaying of the violence so typical of films of this genre.*

Rosi: Yes, the choice I made for this film's approach involved a refusal—I won't say a refusal of all the temptations of this ambience of violence—but a choice above all to look *behind* these characters and events and ask myself and the audience to reflect on the ambiguity of these connections.

My intention with *Lucky Luciano* was not so much to portray the horror of violence but the horror of living in a world which is built around violence. We know that certain things for which Lucky Luciano was responsible are undeniable, even though no one was able to make him pay for his misdeeds, either because the proof was insufficient or didn't hold up, or perhaps because his protectors were high up in the government. That accounts for the pessimism which permeates the film. The film's ambiguities intended to reflect the ambiguities about the complicities amongst those people who actually held state power in their hands.

The film is also an attempt to penetrate into the obscure psychology of a man who had this illegal type of power—even though at that point most of it had been taken away from him, he still had some power left which was very useful to him. Maybe someone wanted him to remain powerful, perhaps even the police themselves, so as to in a sense justify their mistakes, their inability to capture him legally. The new Mafia bosses also felt that he was much more powerful than he actually was, maybe only in order to distract attention from themselves.

So in the film we see Lucky Luciano as an old man, sick, tired, who lives in a modest apartment in Naples, a city he doesn't love, in a country he doesn't understand, and with a melancholy for America, a powerful country, a world he has lost, where the game is

stronger, more bitter. I wanted to recount the sunset of a Caesar, the inglorious end of a *capo* who knew how to stay in the game till the bitter end, or who perhaps *had* to stay in the game till the end.

So it's this approach which distinguishes my film from others about the Mafia. I refuse the spectacular rhetoric of cinema violence, instead leaving space for a series of interrogations which very clearly imply the guilt of all the people of power, legal power, who move in the margins of the system and to whom the law gives a formal recognition which allows them to reach their criminal objectives.

Cineaste: *In* The Mattei Affair, *you seem to make Mattei a hero.*

Rosi: No, it only seems so for technical reasons, because when you make a film with one character, one protagonist, he comes out as a hero. I tried to show a problematic character with some negative aspects and some positive aspects—some of these I agree with, others not, and I hope, in fact I am sure, that that comes out from the film itself.

The danger of Mattei was the difference between his first four or five years and his last five or six. In the first years, from 1945 to 1952, the political and economic situation in Italy *needed* the rupture of a man like Mattei because the country was stagnated in a completely center-right situation, more right than center, with landowners, old industrialists, in a capitalist situation without movement. Then the same institution Mattei created to bring about social reform, even if a populist one, changed completely into its opposite. It came to be a corporation, a state capitalism stronger than the state itself. This was the danger of Mattei. But we must not forget that a man like Mattei is not one who imposes himself on a bunch of destitute people—he's evoked by the social situation and then accepted by the people. And the fact is that *all* the political parties, all the political factions around Mattei, from the Christian Democrats to the Communists, accepted him. The Christian Democrats were in control but they didn't control Mattei. There is never a strong man in a democracy unless there are also people who accept him.

Cineaste: *There are scenes of yourself making the film within the film. What was your reason for doing this?*

Rosi: Two reasons. One reason is that the film is an investigation, a research, and it needs the form of an investigation. Another reason is that one of the journalists accumulating documents and evidence for me disappeared. He was working for me because I had asked him, as I had also asked other journalists, to provide me with documentation on the last two days of Mattei in Sicily. When you

prepare a film like this, you need a lot of documentation, not only from a historical point of view but also from a human point of view, as to the behavior of the character, because my goal is to represent a real-life character, not just another character like him. I can *interpret* the reality but I cannot *create* the reality. So, anyway, I asked this journalist, an excellent journalist named De Mauro who worked in Sicily and who knew Mattei, to get me documentation on the last two days because in those two days Mattei visited many villages and had many meetings. I spoke to De Mauro twice in one week by telephone, as you see in the film, but he never told me anything else because a month later he disappeared and hasn't been heard from since. At the time, we strongly suspected that his disappearance was connected with the research for my film because it had uncovered the problem all over again. We also had certain other suspicions because De Mauro had been conducting his own research about the drug traffic from Sicily to the U.S. Now we think it all may have something to do with the current political situation in Italy, so we are completely confused about this kidnapping of De Mauro. But during the preparation of the screenplay, I decided to put myself and this episode in the film for the simple reason that it was the truth. I was convinced it was my duty to do so—it is the testimony not only of a fact but also of what a film can lead to.

Cineaste: *There are other, more ambiguous scenes in the film regarding certain events—for instance, the sabotaging of Mattei's plane.*

Rosi: I am convinced that if Mattei wasn't killed that time, surely another time someone . . . this is my conviction. I mean, I don't have any evidence to give as proof to the audience that Mattei was killed in that way. I am *very, very, very* suspicious but, finally, it doesn't make any difference because it's not so important to know *how* they killed Mattei or even *if* they killed Mattei but whether there were actually many *reasons* to kill Mattei.

Actually, I would like to make a continuation of the film—it would be very interesting to cover the period from the death of Mattei up to the present time. This is what I feel like doing when I see *Mattei* now, I would like to make another film. But it's probably too soon, we don't have the sufficient distance from the facts now.

Cineaste: *Has* Mattei *been a successful film from your point of view?*

Rosi: It has been very successful internationally, in Latin America, France, Japan—not an economic success, although it wasn't a

failure either—but from a critical point of view it has been very successful. The problematic dimension of the film is accepted much more by audiences in Europe. Here, I don't know, because the film was not really distributed—only two or three days, I don't know, maybe a week.

Cineaste: *No, you're right, I don't think* Mattei *played more than a week or so in New York and I doubt if it got many engagements outside the city. In fact, both of your last two films have received very shabby treatment from their distributors. I understand that* Lucky Luciano *opened on the West Coast on the lower half of a double-bill at drive-ins and here in New York they opened it on 42nd Street!*

Rosi: Yes, for *Mattei Affair,* I think it's fairly easy to understand, at least I think so, but I'm not sure. I mean, you know—Paramount, Gulf and Western . . . maybe no, maybe yes.*

Cineaste: *It smells. . . .*

Rosi: Yes, I mean, here was a film that won the Grand Prize at Cannes, but it was released suddenly, without publicity, without saying anything about it.

Cineaste: *They tried to release it as just a thriller. You couldn't tell from the ads that it was about the international politics of oil . . . something which six months later became very topical.*

Rosi: Yes, there was a prophecy about all that. As for *Lucky Luciano,* that was another thing. The problem was that Avco-Embassy tried to release it as a commercial gangster picture—which was completely wrong—hoping to make a quick buck on it. We arranged a special screening of the film and Norman Mailer was there and he loved it. He even gave me some lines to use but the distributor didn't use them.†

Cineaste: *Well, they opened it on 42nd Street and Norman Mailer is nothing on 42nd Street. How do you find working with Gian Maria Volonte?*

Rosi: He's very, very intelligent and very instinctive. He has a real instinct for acting and, at the same time, not only a political consciousness but also a profound consciousness of the psychological

*Paramount Pictures is a subsidiary company of Gulf and Western, a corporate conglomerate whose multinational corporations are involved in such widely diversified areas as oil, life insurance, auto parts, zinc mining, cigars, meatpacking, and sugar production in Latin America.

†"It is the finest movie yet made about the Mafia, the most careful, the most thoughtful, the truest and most sensitive to the paradoxes of a society of crime. So it is a picture with marvelous episodes, a fine sense of irony and the breath of art in every sordid detail."

structure of the character. He does research with me—it's the normal work of an actor, or at least if you're a good actor you work this way.

Cineaste: *You work with the same director of photography on each of your films, too.*

Rosi: Yes, Pasquali de Santis, my current director of photography, used to be the camera operator for Gianni di Venanzo, my preceding director of photography. When Gianni di Venanzo died, I took the camera operator and promoted him to director of photography because I like to work with people I know.

Cineaste: *In* Salvatore Giuliano *the black and white photography is sometimes almost like an abstract painting. Is this deliberate or are these accidents you accepted?*

Rosi: It's very difficult to draw the line between what you decide beforehand and what you accept during the shooting. It's very difficult.

Cineaste: *Many times the interior is dark and a door opens, there's a flash of light and these pieces of white open up the screen.*

Rosi: You know, the fact is that black and white is the only way to make good cinema. Color is the end of good cinema—I don't like color.

Cineaste: *But you have to use it.*

Rosi: Yes, I have to because now they don't accept black and white and I proposed to make many of my last films in black and white. Color is more realistic than black and white but in the worst sense, not in the best sense. Black and white is imaginative, it's a suggestion, not a limitation. In color, the red is red, the yellow is yellow, but in black and white it's absolutely free.

Cineaste: *Why is it that there are so many politically-motivated filmmakers in Italy?*

Rosi: I don't think it's too difficult to explain. In Italy, even now, there are two societies—one which has evolved at the modern, technological level, and another one at the level of the third world. Before, this difference between the North and the South of the country was very clear, very sharp. Today there is great confusion between the North and South but there is still this difference between these two kinds of societies. And it is through the struggle between these two societies that we will reach an equilibrium and a possible platform of social justice in Italy.

There is an old anti-progressive culture with a paternalistic and authoritarian conception of the state, but this conception is based on complicity and corruption at the level of under-state power—the sub-

government, the invisible government—and it is a conception based above all on a social class, the bourgeoisie in the highest positions of the government. This is a real social class in Italy, a class that defends itself and its privileges by blocking any progress, even progress on just a social level. It is not just a question of a struggle between capitalism and socialism, it is a fight between privilege and any threat or challenge to that privilege.

There is another very, very important thing—in Italy we have been oppressed for centuries and centuries by the Catholic, apostolic, Roman Church. It's a cancer of the human conscience, a cancer which devours everything, because it impedes any positive, human progress. It's a tragedy, a real tragedy, because the equilibrium between the classic left and the classic right in Italy also has to respond to its influence.

There's also the whole influence of neo-realism in the Italian cinema. You know, of course, all about the development of neo-realism. After World War II, there was a virtual human renaissance and during that period the Italian cinema was more important than Italian literature. Neo-realism was an investigation of the human condition involving a continuous balance between real life and real character and the search for a possible truth. Where was this possible truth?—we didn't know, we searched, trying to avoid the use of schemas.

After the first phase of neo-realism, there was a second phase which consisted of a time for reflection and a critical examination of the first phase. In the beginning, neo-realism involved only the attempt to be a witness to reality, with no critical perspective, just a desire to record reality. But this was not enough. After a while, neo-realism had become fashionable, it was just another mode—you had a pre-determined format and all you had to do was put all the neo-realistic gimmicks into this format. I refused this schematicism because it was merely rhetoric and my personal solution was for my investigative research to provide the narrative structure for my films.

But, to get back to your original question, I think it's this whole panorama which provokes a continuous explosion of contradictions and which accounts for the large number of filmmakers in Italy who are interested in political problems.

Cineaste: *To what extent in this process do you feel the Communist and Socialist parties play a role?*

Rosi: In Italy, all the real, progressive culture is near or within the

Communist and Socialist parties. After the war there was a big confrontation between the left and the right and that was something we needed. Today it's different but I still think we need a clear opposition, a clear left opposition and, personally, I prefer a *common* left opposition, ranging from a radical position to the Communist position.

Cineaste: *Where do you yourself fit into that spectrum?*

Rosi: I am not a militant in any political party. I am very close to the Communist Party and Socialist Party—it depends on the situation. I prefer to be a *compagno de la strada,* a fellow traveller, of both parties. The Italian political situation requires this kind of flexibility.

Cineaste: *Do the extra-parliamentarians have any influence on you?*

Rosi: It depends—Il Manifesto, yes; the other extra-parliamentarians, no.

Cineaste: *Your films demand much more from an audience. You make the audience work.*

Rosi: Yes, my films demand a little work from the audience, I ask them to cooperate with me. I think we filmmakers have a great responsibility, both political and moral. After all, we are not obliged to make films, but we do make films and I think they are a very powerful way to say something to an audience. The world often changes through the cinema. The American way of life arrived in Europe through films—first films, then through blue jeans, Coca-Cola. . . .

But I do try to have the public collaborate in my search for a possible truth. The public should not be just passive spectators of a story that's being told. In my films, I pose questions and I conduct research, and this research, this search for some truth, is quite often the very structure of the film, that is, as I explained earlier, the research itself is the narrative structure.

Naturally, I don't forget the emotional way of reaching an audience—the emotional way, of course, is the traditional way for filmmakers—but I refuse to entrust my work, my research, only to the emotions. In the traditional filmmaking, the audience is considered as a child, as having an infantile mentality. I refuse this because I have more respect both for myself and for the audience. But I am a filmmaker and I make films with emotions, not only with ideas.

Cineaste: *Otherwise you'd just make documentaries. . . .*

Rosi: Yes, all right, I don't make documentaries. My films—if it's possible to say that my films involve a particular method—my films are both, they're a compromise between the two. It's not a *documentary* way of making films but a *documented* way, because I believe that the truth very often contains much more imagination than fiction.

But for me the documentation is only the first step, a point of departure, for my work. At a certain point, after I have something documented, I stop, because I don't want to be pedantic, I don't want to be a professor. But I don't want to convey lies or stupidities, either. If you choose to narrate something about a real person—Salvatore Giuliano, Mattei or Lucky Luciano—you cannot invent, in my opinion, but you can interpret. There is a big difference. Why fabricate something just because it makes for more spectacular cinema and an easy way to grab the audience? No, I have all the room I need in my films to interpret the reality and this is the important thing for me, the interpretation of the facts. A fact, one fact, about a man means nothing. What I'm attempting to do is to connect the facts with the man, to follow the logical line from his actions to the consequences of those actions.

13—LINA WERTMULLER

You cannot make the revolution on film

In the mid-seventies, the work of Lina Wertmuller enjoyed an incredible vogue in the New York City film-going community. Love and Anarchy, Seven Beauties, Swept Away, The Seduction of Mimi, *and* All Screwed Up *were released within a relatively short period, and even politically sophisticated critics were not sure if her work was pro- or anti-feminist, pro- or anti-working class militancy. Gina Blumenfeld wrote a dissenting view of Wertmuller's accomplishment for* Cineaste. *As part of her research, Blumenfeld and Paul McIsaac interviewed Wertmuller for Pacifica Radio Station WBAI-FM. The interview was published early in 1976 as a companion piece to Blumenfeld's essay.*

Cineaste: *You have said repeatedly that your films are addressed to the working class. But the people lining up around the block to see your films in this country are most certainly not the working class. You must know that the chances of your work being seen in drive-ins in Savannah, Georgia, or any other place outside of the large urban centers or universities and art cinemas are very slim.*

Lina Wertmuller: Of course we must do everything in our power to change this situation. My greatest desire is to make popular cinema. I continue to do all that I can to avoid addressing an elite, intellectual or otherwise. For example, my first film won fourteen international awards, but it followed the conventional road of the cinema today; it was for the intellectuals. Considering the problem, I changed my politics; I changed my approach, searching for a popular cinema while trying not to reject anything which might enable me to communicate with people. I proceeded with a great faith in the power of laughter and tears, without fearing to be too obvious or to appear banal, always trying to communicate and entertain and hoping, in the end, that people would leave my films with problems to think over and analyze. I feel that I have succeeded in reaching a popular audience in many parts of the world in this way. I hope I can do the same in America without resorting to sharks or flaming skyscrapers—but, if it proves necessary, I'll do this too.

Cineaste: *How have your films been received in Italy? In particular, what was the reaction to* The Seduction of Mimi?

Wertmuller: Wonderful. *Mimi* opened in Turin, in the north, which is the most industrialized part of Italy, where they manufacture cars. It opened in a theater with three thousand seats. We had no idea what would happen, since neither I nor Giannini nor Melato were known there. But in a city of metalworkers, the word "Metallurgico" in the title of the film worked magic—the theater was filled to capacity. Then I was really terrified; here I was confronted with my real audience, not the critics or the intellectuals or the bourgeoisie. And the response was incredible, wonderful. They got my meaning. And you must understand, this was a very political audience.

I was terribly nervous because the unions in Turin are very strong and the theme of the film was very threatening to them, since the central character was a worker who was apparently becoming a leftist, but ended up working for the fascists because of his incomplete political understanding. You can see that the film was potentially very explosive.

Cineaste: *You depict the tremendous political turmoil going on in Italy, especially in your film* All Screwed Up. *But doesn't your comic approach ultimately mock politics? Doesn't it make fun of political action?*

Wertmuller: Why should serious political points necessarily be made in a serious manner? This is not the only way to present political problems. On the contrary, experience shows us that the opposite can be true; the serious approach may make its point less effectively than the comic. In fact, in Italy, the severe, macabre approach to politics drives people away. It intimidates them, making them feel politics is only for the experts. But politics is not divorced from our lives; each of our acts has political consequences. Every familiar experience partakes of all of life—which is tragic and horrendous, yes, but also wonderful. Why should we choose only to look at the tragic and heavy face of politics?

I always fear the representation of power in a totally serious light because power itself requires this seriousness to be terrifying. In order to retain our capacity for criticism, we need to see the familiar, ridiculous aspect of power as well. We also need self-critical laughter, the kind that shows that we are civilized enough to reveal that we are ridiculous. It's not so terrible to be ridiculous—I am living proof of this point. I've always been a character, a clown. I'm like the big ass in *Mimi*. My work is always serious in its intentions, but this seriousness needn't show on my face all the time.

Cineaste: *So you use laughter to demystify authority. Is this why you chose to make the fascist in* Love and Anarchy *a strutting, vain fool?*

Wertmuller: This character was not a fantastic fabrication; he was very similar to the real fascists. But, yes, it's true that I want to remove the myth from authority. Power is like a drug; it deforms everybody and we must be careful with it. Laughter is a very good antidote to the drug of power. Tell me, why should a person who attains a temporary position of power be treated like a deity who makes us tremble in fear, lest he slip on a banana peel? The deification of those in power has always been accomplished by setting them off from other mere mortals through special dress, ritual and language. We must learn to see through these trappings which give the appearance of immortal, godlike power to the mortal, human reality underneath.

Cineaste: *Don't you think there is a danger that the political*

points you are trying to make will be lost in the sensory over-load of humor and horror of your films?

Wertmuller: Apparently not, since no journalist who has interviewed me has not asked the vital questions about society which I try to stir up in my films. In spite of the agitation of vitalistic, even contradictory feelings, it seems that afterwards things must settle down and the viewer is left with a number of ideas to discuss and analyze. My films are deliberately provocative, intended to agitate problems and bring them out in the open. This is my aim—to provoke and discuss.

Cineaste: *Your most sympathetic characters in* Love and Anarchy *and in your latest film,* Seven Beauties, *seem to be the anarchists. What is the significance of the quotation by Malatesta at the end of* Love and Anarchy?

Wertmuller: Malatesta was a wonderful human being. He was the philosopher of an impossible utopia. But within his utopian dream is the core of a very important principle—that of the freedom of the individual. This idea should enlighten all of us and inspire us to create the "Man in Disorder." In Italy we have two socialist parties, the Social Democratic and the Socialist Party. We also have the extra-parliamentary left which doesn't recognize elections—groups such as Il Manifesto and Potere Operaio—not to mention the Communist Party, the Christian Democrats and all the parties on the right. This may appear very confusing to you, but actually I think there should be a hundred parties. In the wings of a few great parties too many conflicts may be hidden. If there were many more parties, it would make things much more difficult, but it would compel individuals to become more involved in politics, to understand political disagreements and take a political stand on matters of importance.

I believe in the individual and it is the Italian Socialist Party—in contrast to the Communists and the Social Democrats, who are concerned only with industrial mass society—which is concerned with the freedom of the individual. The people I respect most in Italy are Socialists.

Cineaste: *There are five of your films currently showing in New York, with people lined up around the block to see them. Do you think this popularity has anything to do with the fact that you are a woman?*

Wertmuller: I want women to know that I was able to make these films not because I'm some sort of witch with supernatural powers,

but rather because I have analyzed and come to understand the true law which governs our society. This is not the immutable law of the all-powerful patriarchal god of the Old Testament, but a law which is purely economical. The success of my films has nothing to do with the fact that I'm a woman. If five of them are playing together in New York, it's only because someone here thinks they'll make him some money.

It's not pleasant for me to think of myself in these hard economic terms but it's the way of this society. And, in a sense, it's a great equalizer because it's the same law for everyone, men and women. Women should understand this law and not fear for their self-worth. If they believe in their work, their ideas and their capabilities, they can overcome all obstacles because these obstacles are not inevitable or god-given.

Cineaste: *Speaking of the "given," what were you trying to say in* Swept Away? *Were you trying to make a point about the natural inevitability of sado-masochistic relations between men and women, or were you trying to make a larger point about the nature of domination per se—about masters and slaves in general?*

Wertmuller: Sado-masochism may be a very important element in eroticism but my movies are never erotic. *Swept Away* was not a comment on the relations of the sexes but on the power relations between social classes. In this film, the woman represents the bourgeoisie and the man represents the third world, those who are indeed helpless. In actuality, she represents men and he represents women. Seen in this light, the significance of the film is quite different. You might be offended for the woman while she is being hit, but by the end of the film you should understand that both she and the man are symbols of the relationship between the bourgeoisie and the common people, manifested through dependence and violence.

Cineaste: *Regardless of your intent, it still seems that* Swept Away *reinforces the idea that in relations between men and women, love cannot exist without domination. Given this assumption, women might try to ameliorate their situation by working for equal rights, but they must forget their broader feminist vision of qualitatively new social relations not based on domination.*

Wertmuller: When you say that feminism is concerned with more than equal rights, what do you mean, precisely? Do these new social relations require that women dominate men? Is the purpose vindictive, to get revenge? In ancient Italy there was supposed to

have been a town, Latzio, near Rome, which was governed by a matriarchy. The women had political power by virtue of their domesticity. The men were warriors and so merely agents of the women's political minds. This town was very warlike. In this case, although the power structure was inverted, with women on top, power was still used for aggressive purposes. It seems to me that we must remember above all that we are all human beings, that we should not use characteristics which differentiate us to take advantage of other human beings. The social harmony which we seek must be based on diversity, on creative disorder, on a multiplicity of people and opinions.

Cineaste: *I think many feminists would agree with these sentiments. Perhaps they are disappointed because they feel if you really intended to get to the root of domination, to understand and overcome it, you would search beyond the class struggle to a more basic locus of power relation—to the relationship between women and men. Instead, you seem to play on stereotypes of women as grotesque and funny, either physically, or in relation to men. The women always seem to lose out in the end because of this relationship. For example, Mimi's girlfriend starts out as an independent political woman—she makes her own clothes, she supports herself. But then she becomes Mimi's housewife and she gives up everything for him.*

Wertmuller: I disagree. I really like this character—she is a real woman! She never rejects domesticity, she does her housework without a complex. She lives by her own handiwork, her knitting. She is active politically. She is a virgin because she never fell in love, because she believes in *love,* not marriage. She is *not* Mimi's docile housewife. No, on the contrary, she laughs at his jealousy and false honor. But she continues to love him without hesitation. However, when she realizes, finally, that Mimi has made all the wrong choices, she leaves him, even though she loves him, because she thinks he has lost the principles she believes in. What's so submissive about this woman?

Cineaste: *But after she becomes involved with Mimi, she drops out of the picture for us; she becomes Mimi's shadow. We see her only in the most conventional situations.*

Wertmuller: First of all, you must know that the American distributor cut thirty minutes of *Mimi* which contained important scenes. I must say, though, that the film is about Mimi. We must follow him through his dilemma since he is the one who gets trapped

in spite of the political understanding which is supposed to guide him. We follow his story because Mimi is the one who represents all of us.

Cineaste: *Will you make a film in which a woman represents all of us?*

Wertmuller: Very gladly. Why not? As a matter of fact, I have already made a film about the relationship between women and men, entitled, *This Time, Let's Talk About Men*. It hasn't been shown in this country but you have seen the women in *Love and Anarchy*. These are very strong women; they instinctively rebel against militarism and the patriarchal order. Why are these women never mentioned by the feminist critics?

Cineaste: *In spite of the strong characterizations, the women do ultimately prevent the man from assassinating Mussolini, choosing love over politics. You seem to be saying that women inevitably make this choice, that they inevitably turn their backs on history.*

Wertmuller: If you look more closely, you must see that although these women are prostitutes who sell their bodies to men for their livelihood, that even in this most subjugated condition, they still manage to actively engage in political struggles against the bourgeoisie. Mariangela Melato is the political mind of this picture. It is she who is torn between pragmatically using the politically naive Giannini to commit this political act, and wondering whether he is prepared for this action and its consequences. She must decide whether it is right to exploit his instinctive sentiments for political purposes. This is her dilemma and it is the theme of the movie.

Cineaste: *There seems to be a moment in all your films, a pause in the collision of action, people and ideas, in which the camera pans over the entire scene, revealing the full horror and brutality of the situation. What is the purpose of this moment, since it always passes unfulfilled and your hero never steps over the line to rebel against his oppression?*

Wertmuller: It is true that this moment occurs in my films. The moment passes without catharsis each time because only in life can people liberate themselves and make a revolution. You cannot make the revolution on film. It is very dangerous in a movie when the bad guy dies, if the bad guy is a Hitler or a Mussolini, because the viewer can feel that he has actually killed him, that now he is free. But to go further, the deeper significance of my films is not just to agitate for the act of rebellion. We must remember that even in real life, although the Hitlers and the Mussolinis may be dead, their legacy is

still inside all of us. For this reason, I am interested in the time *after* the moment of revolt, the period in which a social structure must be established which nurtures human beings who embody a certain kind of harmony—a harmony of disorder—like I say in my films.

In order to prepare for this harmony, we must realize that each one of us reflects and is responsible for the shape of our society. We must personally take responsibility for what goes wrong, for what doesn't work. It is not just a Hitler or a Mussolini who is responsible, it is all of us. We allow these people to command us through our own ignorance and cynicism.

14—BERNARDO BERTOLUCCI

The poetry of class struggle

Prior to the American release of 1900, *Bernardo Bertolucci gave* Cineaste *permission to reprint an interview done by Fabio di Vico and Roberto Degni shortly after the 1976 Cannes Film Festival. Bertolucci speaks of the horrified reaction of his American distributors when they first saw the film and his own anticipation of how the American public might react. He responds to questions about the film which had been aired in the European press and relates this most overtly political of all his films to his other work and the work of Pasolini. The interview first appeared in* Roma Giovani, *the monthly of the Italian Communist Party's youth organization, a group to which the director had long given his political support.*

Cineaste: *What idea brought you from* Last Tango in Paris *to* 1900?

Bernardo Bertolucci: The idea had come before *Last Tango*. I'd already begun to work on a screenplay with Kim Arcalli and Giuseppe, my brother; but then I realized that it would be a very expensive, long difficult film, so I set it aside. I wasn't in a position to find the necessary financing at that time. In fact, it's because of the success of *Last Tango* that I had the opportunity to do *1900*.

The idea. It's hard to say after so much time . . . almost four years have gone by. Ideas for films come in the strangest ways: maybe the sun is covered by a cloud in a certain way at a certain time of the day and it reminds you of a similar light that you'd seen when you were a kid; all of that might give you an idea for a film. Or maybe you want to go back to the places you lived in when you were a kid. Ideas for films always come, to me, in the most coincidental, the strangest ways. First there's an intuition, it's like a seed, and what will eventually be the film starts to grow around it; it's a seed that later takes on ideological substance.

When I started working on my subject, Pasolini's desperate and tragic ideas about the situation of popular culture in Italy had just raised a lot of discussion. He said that popular culture had been completely bombarded and massacred by consumerism. That's certainly true but an exception must be made—Emilia Romagna. I wanted to see if a peasant world still existed in Emilia, with its own culture and things to say about the past, the present, the future.

When we went there, I expected to be shooting a film about the agony of a culture and instead, from the beginning, from the first location checks, when we were looking for the real faces of the people, I realized that it was going to be a film about something very much alive. I remember going into a stall, and seeing the electric cow milkers and thinking, "My god, this is no different than the assembly line," but instead of the faces of the "Bergamini"—that's what the cow herders are called in Emilia, because traditionally they've come from the city of Bergamo—were the faces that I'd remembered from my childhood, the faces that had always been.

Emilia seemed like a miracle within the context of Italy. How did this miracle happen? How come this island exists where the peasant world is still almost completely intact in its identity? I think there's only one explanation. Emilia is the region that's been socialist ever since socialism has existed and communist every since communism has existed. It's been through socialism and communism that the

Emilian peasants have become conscious of their culture and have understood that it's something to defend.

Something very paradoxical, or apparently paradoxical, but at the same time profoundly just and correct, has taken place: communism has served as an instrument of preservation and conservation. So the film which in the beginning was to be a film about the decadence, the death, the funeral of peasant culture, became instead a film about the vitality of the people and their culture.

Cineaste: *In an interview in* Nuova Generazione *you said that 1900 is meant to be a Gramscian* film since it deals with both the optimism of the will and the pessimism of reason. Would you explain a bit about the plot of the film in light of this statement?*

Bertolucci: It's kind of presumptuous to say a Gramscian film; I'd reject that definition now. But it is a film about popular culture, and it's meant to serve the interests of popular culture; in that sense, I think it's succeeded to a great extent.

The film is based on what I see as the immediate dialectic between Olmo and Alfredo, the two protagonists, born the same day, the same year, at the beginning of the century, one the son of landowners, the other the son of peasants. The dialectic between these two characters is an obvious, natural and elementary symbol of class dialectics, the dialectic between the peasant and the ruling classes.

After I got that far, I asked myself what the structure of a film about the countryside should be like, and I thought of the seasons of the year which provide the framework for agricultural work. So the first part is in summer, a grand summer that corresponds to the childhood of the two protagonists and also to pre-fascist Italy, when the peasants were still without class consciousness. In terms of narrative style, the first season of the film, this long summer, is lyric, epic, popular. The political movement at this time is still populist; there's no class consciousness, it hasn't been born yet but it's about to be.

Then the film goes on to the war and the return of Olmo, one of the two protagonists. Even though the war is just barely mentioned, it's clear that the people's enemies are more the Italian officers than the foreigners, and that's where the second part of the film begins, the film's second season. Autumn and winter correspond to the years of fascism; the characters are forced to shut themselves up

*Antonio Gramsci was one of the major figures among the founders and theoreticians of the Italian Communist Party. Many of his most significant writings were on culture, the concept of ideological hegemony, and the role of intellectuals.

in their houses. By 1919 the peasant class had acquired political consciousness and was inventing new ways of struggle; its response was very strong for a time but was to be crushed later by fascist repression. In terms of the narrative, the style of the film during this autumn-winter of fascism is transformed and becomes more psychological, almost as though fascism made it necessary to resort to psychology in order to represent it completely.

Spring, the last season of the film, corresponds to Liberation Day. April 25, 1945, Liberation Day: liberation not only from Nazi-fascism but above all from exploitation. That's how I tried to show the 25th of April, as a moment of victory and also a moment in the peasant's dream. On Liberation Day, the peasants enact the utopia of the revolution.

As I said in the beginning, the film is based on a dialectic, on class dialectics, but a dialectic exists at all levels—the dialectic between prose and poetry, for example, between lyricism and psychology, between documentary and fiction, between the means of production, that is, the cost of the film, and its ideology, which is completely aligned with the working class struggle.

Cineaste: *I'd like you to be clearer on that point. How could you make a film like this, a film where the real protagonist is the class struggle? You've already mentioned the various levels of dialectic in the film, but it's the class struggle that's always in the forefront. So how do you explain the film's revolutionary ideology and the finance from three American distribution companies that made it possible?*

Bertolucci: I've never had anything to do with American distribution companies for the film. It was produced by Alberto Grimaldi, who's an Italian. In theory I shouldn't even have to know that the film was made with dollars instead of lire. I worked my way—I don't even know how I did it—into the folds of this system's contradictions, and I managed to get a huge investment from the Americans, on faith, a rather blind faith that was based solely on the figures they had after *Last Tango*. I saw the American distributors' faces at Cannes, they'd never seen the film before. They were rather upset; it was really scandalous for them, all that unexpected waving of red flags.

"Popular" for me means talking about a system of ideas, about the class struggle, about communism, in order to give a face, many faces, to the word "communism," which has always been abstractly connected to monstrous images in America, due to all the anti-communist propaganda there. I wanted to make a film that would get everywhere, even to the places where communism is considered

to be the end of liberty, of humankind, of the individual. For the distributors, "popular" means tearing off a lot of tickets and taking in a lot of money; so there is a sort of convergence in our intentions in the sense that we both want a lot of people to see the film.

A lot of moralists on the left have made accusations against me; before seeing the film they already had a preconceived idea. They said, "A film made with a lot of money can't be politically correct." I'd really rather not respond to such moralistic statements, but there's a need to, and so what I have to say is that cinema is made with money. The political correctness of a film is not inversely proportional to its cost; low cost doesn't necessarily mean freedom, and high cost doesn't necessarily mean repression. It's all different every time.

Cineaste: *You've said that it's a popular film. Is that because it's directed to the people, that is, to the people who usually go to the movies, the average spectator?*

Bertolucci: Yes, I think it's popular because it's imbued with popular culture, beginning right with the novel and melodrama at the end of the nineteenth century, which had popular significance in the struggle for Italian independence and contains a very strong popular dynamic. The novel-like character of the film is evident in the first part, where two men are born on the same day and it's almost as though they're predestined, or condemned to be novel-like characters, just like characters of popular novels at the end of the nineteenth century.

Popular in that sense, and popular also because it's the first film I've made really thinking about utility. I've always been against the notion of utility, which was widely discussed in 1968. I hated it then and continue to hate it today because it's something that can't be measured, like some leftists tried to do in '68 by saying, for instance, that Rafaello was a lackey to the bosses. Poetry's utility isn't measurable; the usefulness of a work of art is very mysterious.

Once, in 1970, I was offended by a leader of the PCI. We were having dinner and I told him that I wanted to do a political film, a documentary. He replied, "Look, the people need a poet more than a politician." At the time, the idea really aggravated me, I got really pissed off. But I have to say that today I agree.

But I started out saying that I wanted to make a useful film, even though the word is kind of a drag, because the idea of usefulness is always owned by consumerism. Let's change it, because I don't like "usefulness." Let's say that I wanted to make a popular film, that's

the right word, I mean a film that could go even to the Midwest, the part of America most terrorized by the menace of communism, that barbaric destroyer of humankind, etc. I wanted to do that without being demagogic, but by talking on an elementary level about the struggle that the people have carried on in order to overcome the exploitation of man by man, talking in a simple, direct way; emotional and involving, too, because if there's no involvement on the emotional level, I don't think you can get very far.

Cineaste: *How do you think this film will be received in America where people have watched even* Nashville *on television, a film that in Italy is seen as being very critical of American society?*

Bertolucci: They show it on television, but they use the very fact that it is critical as a gimmick, a commercial device to sell it with. I think Altman is a great director, I admire him a lot, and *Nashville* is a very deep film, although in a way it is the other side of the same coin, the opposite extreme of the American film of earlier times, when the hero was tall, blonde, handsome and a good guy. Here, the American hero is an insufferable, disagreeable cynic, a hypocrite, a social climber. Altman mystifies in the same way the the old American cinema mystified—I mean the great stuff, the American films I adore. I mean, it's wrong to say that all Americans are monsters, like in that film, where there's not even one exception. But Altman is still one of the few directors who make a deep analysis of American society without being a Marxist.

Cineaste: *But what do you think the reaction to* 1900 *will be?*

Bertolucci: I don't know how the Americans will react. Maybe through the dialogue I should try to clear up some things that are obvious to us, some of the historical passages about the birth of fascism, and so on; but it seems to me that when Montanaro, the day laborer, cuts off his own ear in 1908, his gesture is clearly a very individual type of protest, pre-political. I think that a gesture like that is intelligible everywhere—in the U.S., in China, everywhere. I think that the film has thematic and emotional validity; emotion is inter national—when emotion exists, it exists everywhere.

Cineaste: *You chose Burt Lancaster—who was also in Visconti's* The Leopard—*for the role of the old landowner. Your film begins, basically, at just about the point where* The Leopard *ends. Does using exactly the same actor represent a continuum?*

Bertolucci: No, I never thought of *The Leopard,* even though it is a great film, because in the final analysis Visconti's film is always psychological. *1900* is more ideological. But I must say one thing:

1900, like all of my films, makes use of all the materials not only of the cinema but of literature, painting, and music as well, of everything that's come before. Basically, cinema is really a kind of reservoir of the collective memory of this century.

I don't mind thinking that my films are full of cinema. *1900* isn't only about the class struggle, it's also about the history of cinema, in the way that *The Conformist* was about cinema in the thirties, most of all French cinema. I believe there's got to be an enormous amount of freedom in the use of everything, because culture is a continuum, it's never interrupted.

I wasn't thinking of *The Leopard* when I cast Lancaster. I was thinking of a patriarchal figure just as I'd done for the peasant grandfather, Sterling Hayden, who's more than an actor, he's a poet. These two old men are seen through the eyes of the children, they're two mythological old men. Basically, I was using the mythology of the history of cinema because Lancaster and Hayden are two myths, they're two old oaks.

Cineaste: *What about the influence of American and Soviet spectacles?*

Bertolucci: It seems to me that a "spectacle" exists more in the mind of whoever says the word than it does in a film itself, whether you're talking about the American version or the Soviet one. The spectacle is another way of establishing communication with a vast public. The film is basically a small one; *1900* is a small film about a small piece of earth, dressed up like a big film, like a spectacle, but it's really a film about very simple, very elementary things.

Cineaste: *Tell us something about Attila the fascist—a monstrous figure, a cynic, a pervert. Does this character have any link to Pasolini's vision of fascism in* Salo?

Bertolucci: There is actually a link, even though Pasolini was shooting *Salo* while I was shooting *1900,* and so there wasn't any contact, no direct influence. But let me mention something that happened at Cannes. The President of the jury, Tennessee Williams, held a press conference to protest against the violence of the films presented at the festival and he made a specific allusion to *1900.* He said, "I don't want to see children murdered in horrible ways, like at the Colosseum 2,000 years ago," to which I replied, "Like at My Lai six years ago or in the Stalinist concentration camps—violence isn't just a private affair that pertains to the ancient Romans."

In France the bourgeoisie made the revolution at the end of the 1700s and then had some great, extraordinary moments in the

1800s, even culturally, and it's still a very strong class today. But in Italy there's never been a bourgeois class like that because, among other things, Italy was united as a nation very late. We've never had such a strong bourgeoisie because of many historical and geographical problems about the formation of the country. So as soon as the workers' and peasants' movements were born, the Italian bourgeoisie needed to invent a way to suffocate them; that was fascism.

In the film there's the sequence where the landowners are gathered in the church and they make contributions, just like on Sunday when the sacristan goes around with a basket to collect money. I mean, I think I showed, even though I left a lot out, how fascism is born. Immediately before the scene where the agricultural bosses finance the fascists, we see the one where a group of peasants protest against an eviction notice; the king's police load to fire at them, and the women stretch themselves out on the ground. We saw, in other words, that the struggle was organized. Corresponding to the organization of the people's struggle is the organization of the ruling class and the invention of fascism.

I tried to respect history as much as possible in the film, but in addition there's also a psychological level, which is represented by the characters of Attila and Regina who, in terms of psychology, I saw as being two small, petty, miserable creatures, a provincial version of Macbeth and Lady Macbeth. I find that even those two monstrous personalities are victims in a certain sense, victims of the ruling class because they're completely blind, obtuse—victims, in other words, because they're completely instrumentalized. The ruling class delegates to Attila and Regina all of the aggression that it lacks the strength, the guts, to express directly itself. Attila and Regina are steeped in all of the aggression that surrounds them, that's part of the class they aspire to belong to, the ruling class.

What can you say about these two? I tried to give them a tragic dimension; basically, that was false because if there's one thing that fascism lacked it's tragedy. If anything, when compared to Nazism, fascism was an operetta. But anyway, that's how these two characters turned out in the film; they're tragic in an Elizabethan sense, they commit monstrous crimes, they kill a child, they pierce a woman through with the spikes of a gate, they do incredibly horrible things.

Some people have accused me of Stalinism. If the film had been Stalinist, I wouldn't have shown the fierceness of the peasants when

they get revenge from the two fascists. That's another very important thing. The moment people who have been sucked dry, exploited, amputated, thrown in jail, the moment they react and succeed in liberating themselves, they seek revenge. These peasants are fierce and I think it would have been Stalinist not to see their fierceness; it would have been Stalinist to see them as mild and edifying.

In films, even in communist films—this has got to be said—there's often a lack of courage about looking truth in the eyes, about telling how things really stand. I think the fierceness of the peasants against Attila and Regina is beautiful, I think it's justified and very natural. And I also think that at this point in the film you find a dialectic between the moment of fierceness in which the peasants retaliate and the one in which they forget about everything else as the big red flags are unfurled.

That's where the key to the whole film is, for me. What does this film mean? It means: the boss doesn't exist anymore, he's dead. That's what the peasants say at the end of the trial. They put the boss on trial just as though they were in China, in just the same way. I saw a few photographs of the Chinese trials and that's all I needed; I saw that they always had a table and that they pointed their fingers. The role of the boss is over, it's finished.

What some people haven't understood about the film, I think, is that at that point the action no longer takes place on April 25, 1945—it's in the present and in the future. As I said before, it's today and tomorrow. The proposal made in that episode steps out of any historic context and that moment represents, for me, the real thrust of the film, where it goes beyond the narrative level, beyond the moment. Utopia becomes reality for a flash, even though "the boss" still exists in Italy today.

If Utopia becomes reality for the peasant there, on the screen, then it does so also for the audiences as they watch. I believe that making the emotion of a Utopian situation come alive is one way of doing politics—and some day it won't be Utopia anymore.

Cineaste: *It's been said that the film has several endings: when the old landowner dies; when the red flag goes off into the distance, into the fields; when Alfredo says, "The boss is alive"; when the old men fight among themselves; and when Alfredo himself, in a totally and clearly poetic ending....*

Bertolucci: Poetic license, I'd say....

Cineaste: *...Alfredo lies down on the railroad tracks as the*

soccorso rosso* *train is about to arrive, but he doesn't just lie down like a boy, he puts himself in a position as though he were ready to die. Is it suicide, like his grandfather?*

Bertolucci: It's the suicide that Olmo has been dragging him toward all his life. When Olmo takes him out of the farmyard, we see that the two of them are haggling with each other. This is the class struggle that continues even when they're old, until the moment when the boss understands that there's nothing else he can do to change what's going on. The bourgeoisie is self-destructive—not in the sense that all bosses will commit suicide—but there's a self-destructiveness in the ruling class that is related to the awakening of a consciousness about the validity of the proletariat's ideas. Maybe that's a bit excessive, but why not?

What happens next? The train about to run over Alfredo is the children's train; the grown-up Alfredo becomes again the boy Alfredo, and Olmo is on the train that passes over him. There's a lot left out of the allegory, it's made with a sort of poetic license throughout. Then a mole comes up from a hole and peers out. The mole is blind. It's the symbol of the birth of something, because it comes out of the earth; we see the earth shaken and the mole comes out as though produced by the earth itself. Time is violently shaken by the mole, everything is reversed: the old become children; the child is the father of man; and the train with its red flags goes by.

I want to mention again that the last part, the April 25th peasant celebration, was in a certain sense the most criticized at Cannes, even by the Italian papers. Here's how I explain it. There's a convention in all films that is respected in *1900* as well, but it's broken at the end, exploded. That crucial moment is when the peasants take power on that famous April 25th. At that point I said to myself, "Let's show the peasants taking power," and I started to think about the idea and began to understand that the only way to really convey the sense of power being taken over by the peasants, the truly disinherited of the earth, was for them to take over power in the film itself, to chase away the protagonists and everyone who was not a real peasant.

That's what I think upset most people. Certain people rejected the film entirely. Others liked it a lot but only up until that point; from the moment that we enter the court room, they didn't like it anymore. Why not? Because they miss the protagonists, because they aren't

*The *soccorso rosso* was originally an emergency assistance unit organized spontaneously among workers to take care of strikers' children.

able to accept this violent exclusion. What's happening at that point? The revolution, for a second there's the scent of revolution. And there's a price to be paid for it. We don't see Ada anymore, we don't see Ottavio, we still see Olmo and Alfredo but they've practically become two symbols. The living material of that part are the faces, the songs of the people.

Cineaste: *The people become the protagonist.*

Bertolucci: Yes, the people become the protagonist. It's as though the chorus in an opera had come forward, forward and forward, and at the same time the tenor, the baritone, the contralto, had stepped back and fallen into the orchestra pit and the chorus had come up front into the limelight. This is very hard to accept. At that point even the concept of author explodes; the classic concept of author in bourgeois as well as socialist countries is pulverized because the peasants acquire a weight and a presence that upstages even me.

Cineaste: *The Italian press has remarked that there's a certain difference between the first and second parts. What do you think makes them feel this way?*

Bertolucci: The film is like an architectural structure, it's unified. It would be like saying that the baptistry in Parma is beautiful only from the ground up until the third floor, from the third floor to the sixth it's not beautiful anymore; or that in *Il Trovatore* the first act is more beautiful than the last. It doesn't make sense; you've got to judge the work in its entirety.

Cineaste: *When you first thought of* 1900, *did you immediately think of a film in which the masses, the people, the class struggle were the real protagonist, or had you first thought of a psychological film that had as a corollary the class struggle and the people?*

Bertolucci: I create a structure with the screenplay, and then fill it in as I shoot. Shooting lasted eleven months for this film, a long time, and so a lot of things were changed, a lot of things were transformed during the shooting. The presence of the proletariat, which becomes the protagonist, already existed in the screenplay, on an intuitive level, but it's when you put yourself in front of reality and film it that you start to understand what you'd wanted to say, what you intuited but maybe hadn't understood yet.

I find that a film really develops when the camera is in front of the world, in front of reality. That's when the confrontation between the camera and reality takes place, that's when a film is born.

15—ROBERTO ROSSELLINI

Marx, Freud and Jesus

From his first neo-realist films to the teaching films of the last decade of his life, Roberto Rossellini continually addressed the question of what the proper or most useful form was for the political film. In an interview conducted by Giovanni di Bernardo in the summer of 1976, approximately one year before Rossellini's death at age 71, Rossellini elaborated his views on various formalistic solutions to cinematic problems and their relationship to ideology.

Cineaste: *During the last ten years or so, you have made only educational movies on the lives of great philosophers and other historical figures. What is your intention with these films?*

Roberto Rossellini: I'm only trying to clear things up. You see, in 1952 I read a speech by Comenius, one of the fathers of pedagogy, which was very enlightening. Comenius said, "Pedagogy is the queen of all the arts, but in teaching we unavoidably must use an enormous amount of words as go-betweens, which creates confusion, because those who listen must then transform the words into concepts and ideas!"

Cineaste: *Do you mean to say that you are no longer interested in dramatizing reality?*

Rossellini: Exactly, I must constantly repress my temptations. Today I show and I do not describe. I'll give you an example. If I describe an elephant, there will be as many elephants as there are people listening. If I show the image of an elephant, the elephant is undoubtedly that and nothing else. With the possibility of teaching through direct visual means there will be no more problems. This is what Comenius said in 1600! Now we have the technical equipment to do this, but do we show images? No, we show illustrations of personal, mental, and verbal processes. The image is the offer of data in its pure essence, with no sophistications and no dialectic terms around it. My movies are data. I do not show what I think, only data. This shocks many people, but many others follow my films with passion.

Cineaste: *Is this why you don't shoot close-ups but only long shots, and why you use long takes and edit very little?*

Rossellini: Exactly, so as not to sophisticate reality, and in this I am extremely disciplined with myself. I fight against an enormous number of temptations. I'll give you an example. In the last movie I made, the story of the life of Jesus Christ, when Jesus was buried, he was buried—as the gospel says—in the grave of Joseph of Arimatea. But Joseph of Arimatea himself was at the Sanhedrim, the supreme Jewish court, when Jesus was condemned. So, when I shot the sequence of the Sanhedrim, it included the actor portraying Joseph of Arimatea. Can you imagine the temptation I had to shoot a close-up of Joseph of Arimatea! I didn't shoot it, though, because it would have been merely intellectual. It would have been to underline, to state my opinion. I refuse to state my opinion. I refuse any other kind of filmmaking.

Cineaste: *Don't you think, however, that combining both educational and spectacular elements would give you a wider audience, with better results?*

Rossellini: Spectacular in what sense? Sensational? Sensationalism is the first lie. You can't arrive at the truth through lies. I think we must evolve to a new kind of spectacularity, and what greater spectacle is there than knowledge? I might be crazy; I do not profess to be wise.

Comenius wrote amazing things. I visited where he lived in Czechoslavakia, and they showed me everything, even where he used to piss. When I was there, I asked myself, 'But have they made the cultural revolution?' With the word 'revolution' I mean change, and no change can be made without first changing the whole cultural structure. Last year, at a party in the Soviet Union, I asked the same question to the Minister of Culture and he answered, 'We haven't had enough time yet, but we'll make it.'

I think there is an immense general confusion. If today we could use all the data that science has given us, we could solve the problems of humanity, but it would be obligatory to change everything. These are my fundamental beliefs now, and I work to find the best way to communicate them. Others want success; I consider success only an ornament.

Cineaste: *Do you consider your work useful to society?*

Rossellini: Yes, extremely. It hasn't been understood yet, but it will be undoubtedly useful. Perhaps my method is not the right one, but it's a path that will open on to other paths.

Cineaste: *I heard you are preparing a movie on Karl Marx?*

Rossellini: Yes, and since I started work, the Russians have also decided to make a movie on Marx. Russians always talk of Marxism-Leninism, but they never talk in pure terms of Marx. I want to tell you a story. Once there was a violent argument between Marx and Weitling, an extremely respected communist who came from the working class—in those times only intellectuals were communists. The discussion started. Weitling was for a violent revolution; Marx disagreed. Marx was convinced that the only way to eliminate class distinction was through knowledge: 'It's absurd to think you can modify the world with some enlightened prophet who talks to the flocks of sheep who listen with their mouths agape.' Weitling persisted in contradicting him and Marx finally replied: 'Look, there is a Russian sitting near you. I think Russia is the only place where someone with your ideas should go, because it is a country where

there will be absurd prophets for absurd disciples.'

Cinease: *Re-evolution, yes, it means new evolution.*

Rossellini: Sure, this word was introduced by Montesquieu in 1747. Before then it referred only to the movement of a planet around a star. For Marx, the word revolution meant change. It was he who created the term 'Industrial Revolution' to describe the advent of industrial civilization.

The world is divided between those who love Marx and those who hate him, but nobody knows him. In Italy, for example, the election campaign of the right-wing parties tried to exploit the issue of Marx's atheism, but Marx himself was against atheism and nobody knew it! He opposed atheism for complex, dialectical reasons. Marx was born into an eminently religious Jewish family. There were twenty-one rabbis in his family's lineage. When the Prussians started the persecution of Jews, Marx's father baptized the whole family so they wouldn't be considered Jews. It was an act of political defense.

Marx was a very severe critic of all religious structures that served powers in government, but he considered atheism as another religion, as a prejudice. He was against any kind of prejudice, any kind of dogma. He said the important thing for man is exploration, and knowledge without dogmas. That is why he was against atheism. The sole well-known quote—"Religion is the opium of the people'—is completely different from the complete quotation. It is, "Religion is the sigh of the oppressed creature, the heart of a heartless world, just as it is the spirit of a spiritless situation. It is the *opium* of the people." Isn't this a different meaning?

Cineaste: *Yes, it means relief from an unhappy world.*

Rossellini: Another thing few people know—Marx wrote page after page glorifying capitalism. Even in *The Communist Manifesto* he said capitalism was responsible for advancing technology and thereby increasing production so as to allow for greater freedom for all men. He dreamed of a society without classes and without government—the same ideals of the American Revolution. His reproach to capitalism concerned its having transformed money from a means into an end.

Cineaste: *Will your film on Marx be distributed in the U.S.?*

Rossellini: I don't know. They bought my last movie, but they didn't distribute it. They seemed awfully afraid.

Cineaste: *Why?*

Rossellini: Who knows?—it's hard to understand some people's craziness.

Something else we don't know is the gospel. What we have been taught by Catholicism is another manipulation. Think how great is the trust of God in human beings when you read something like Psalm 86 in the Old Testament: "All of you are Gods because all of you are sons of the same Father."

Cineaste: *I understand that in Italy your film will be distributed by ARCI, a communist company.*

Rossellini: Yes, it's true, but in perfect agreement with the Vatican. The Americans wanted to manipulate the editing of my movie, but I seized it.

Cineaste: *Then perhaps it will never be distributed in the U.S.?*

Rossellini: I don't care. You see, success nowadays means only being able to enter the social structure and find a little niche.

Cineaste: *Do you think it would be possible to structure a Western society without classes?*

Rossellini: Only through a cultural revolution.

Cineaste: *Do you think it would be possible to structure a society in which the government is not predominant?*

Rossellini: That was the principle of the American Revolution— Thomas Paine said, 'Government is a necessary evil.' He did not say a necessary good. Marx said, 'There isn't any worse dictatorship than the illusion of democracy.' We live in such a dictatorship, the dictatorship of the bourgeoisie.

Cineaste: *One suspects that you are opposed to both the competitive American system and to the centralized Soviet system.*

Rossellini: They are the same system, just two different ways of applying the same system. People think that the whole world structure can be based only on work and thus on work abilities. They sincerely believe this, and in a system such as ours it is true. But let's start thinking in terms of another system. Every day we read in the newspapers about the 'unemployment.' But I ask you now—as I ask myself, as I ask everybody—is man's ideal work? Oh no!

Cineaste: *Do you consider psychoanalysis a science?*

Rossellini: It is a science, but arbitrarily used. You touch on a fundamental point here—the whole structure of culture and knowledge in the world has been developed on the dialectic between ego and super-ego. There was a third part, once called the demoniacal, which was the unconscious. At carnival time, the people opened a little faucet and they could vent a bit of it. After carnival, the little faucet was immediately closed and that was it.

Freud discovered the unconscious, which through him became an

absolutely scientific datum, and the unconscious replaced the demoniac. Now it seems undue emphasis is placed on the unconscious, completely neglecting such traditional data as ego and super-ego. But this too becomes a distortion. It causes a monstrous impoverishment of thought. I am with Freud, but against Freudianism.

Cineaste: *I'd like to ask you about your relationship with actors. You once said, "I don't believe it's possible to collaborate with actors." Why not?*

Rossellini: Not in my kind of films. If, for example, I chose an actor such as Gregory Peck to interpret Karl Marx, the public would see Gregory Peck portraying Karl Marx and not Karl Marx. If I use an unknown person, then the public would more easily see Karl Marx. Besides this, the actor limits my freedom because of his career's exigencies. The star system is a tool of those in power, because those who have the stars dominate the masses.

Cineaste: *Why have you left your post as president of the Centro Sperimentale (the state-supported filmmaking school in Italy)?*

Rossellini: When I arrived at the Centro Sperimentale, the school was free, there was an annual government subsidy of $500,000 for the school. We had expenses of $492,000—we had to pay the teachers, the employees, the workers, and all the students to whom we gave $100 per month and one free meal a day. So, only $8,000 was left. Do you think it is possible to run a school with $8,000?

I did some work there that I hope will not change. I am against specialization classes and thus reduced the specialization classes to three months. After that, the students could make their own movies. The important thing is that everyone learns to find their personality. I always told the students, "I am here to guarantee your freedom. Don't ask me anything—I can't advise you, you have to find your own way." So they had to do their own movies, and the school had only to make sure that the money given them went into their films.

Cineaste: *So you believe in artistic self-development rather than traditional methods of instruction?*

Rossellini: If you teach something, you can magnify it or destroy it. The richness of humankind is the sum of the intelligence of each individual. Each individual intelligence is unique. One spirit is practical and another is creative—there is the imaginative, the inspired, the dramatic, the ironic, and they are all different facets of human intelligence.

16—TOMAS GUTIERREZ ALEA

Individual fulfillment and collective achievement

Cuban cinema was literally born in 1959 with the triumph of the revolutionary movement led by Fidel Castro. As the infant industry began to produce a series of engaging documentaries and features which won international film awards, the Cuban Film Institute became a champion (and often a physical haven) for radical film-makers of Latin America. By and large, the American public was not aware of the quality of Cuban cinema until the American release of Memories of Underdevelopment *in 1973. Few of the critics who hailed the film as a masterpiece and wrote about director Tomas Gutierrez Alea mentioned that it was his ninth film or that the U.S. government had consistently thwarted easy distribution of Cuban films north of Key West. The following interview with Alea was conducted in Spanish and then translated and edited by Julianne Burton, a* Cineaste *contributing editor. The exchange took place in Havana in January of 1977 and Alea used the opportunity to speak about the Cuban film industry as a whole as well as his own work.*

Cineaste: *As I'm sure you remember,* Memories of Underdevelopment *met with great success upon its theatrical release in the U.S. in 1973. How would you evaluate U.S. film critics' response to the film?*

Tomas Gutierrez Alea: I am not fully informed of critical response to the film in the U.S., because the only thing I can base my assessment on is a file of clippings which the film's U.S. distributor, Tricontinental Film Center, has sent me. Naturally, the reviews range from good to bad to mediocre, but in general I would say that several of them are extremely interesting. The tendency to interpret the film as a subversive act was not as manifest in the U.S. as, for example, in England. *Sight and Sound* published an absolutely sinister article which began by comparing the film to Bunuel's *Viridiana*—made under Franco's very nose and proceeding to blow up his face—and ended up comparing me to Solzhenitsyn. It was obvious that the intention was to misconstrue both the film and the circumstances under which it was produced, for the actual situation had nothing in common with the version put forth in the review.

It seems to me that *Memories* was in general much better understood and evaluated in the U.S. because people perceived the attempt to criticize a bourgeois mentality which, understandably, persists in our society despite the many changes we've gone through.

Cineaste: *It also seems, however, that there were many critics who articulated that critique much less vociferously than what they perceived in the film as a critique of the revolution itself.*

Alea: Yes, of course, such a critique is also implicit in the film. But what was the nature of that critique? What I'm saying is that most of the U.S. critics were on target in that they realized that in contrast to the bourgeois mentality represented by the protagonist, the film reveals an entire people in the process of being born—with all the problems and difficulties which that involves, but with enormous vitality as well. This new world devours the protagonist in the end. That is the image we wanted to convey with the film, and judging from the reviews I read, it seems to me that U.S. critics grasped it more clearly than their counterparts in other countries.

Cineaste: *I have shown and discussed the film with many audiences in the U.S., and one striking thing is the tremendous urgency and persistence with which they search for a shred of optimism regarding Sergio's fate. Because they identify so completely with him, they desperately want to believe that he is somehow*

"saved" at the end. Surely Cuban audiences view the end of the film very differently.

Alea: Yes, they do. The film had a very good response here, relatively speaking. In fact, something happened with this movie which I had never seen with either my own films or anyone else's: many people went to see *Memories* more than once, and some returned as many as four or five times. That does not happen with my movies. It makes me think that the film hit its mark, which was, first and foremost, to communicate with the Cuban public—not with audiences from other countries. It achieved its goal in the sense that it disturbed and unsettled its audience; it forced people to think. When they return to see the film again, it means that it has kept on churning around inside them even after they leave the theater. As far as I'm concerned, this is the most important thing.

Cineaste: *Though it is quite conventional for a feature film to be based on a novel, the particular adaptation process by which* Memories *was generated has always struck me as somewhat unique. Would you comment on the collaboration of novelist Edmundo Desnoes on the production of the film? To what degree was he involved in the actual filmmaking process?*

Alea: Well, obviously, the film was based on a novel which he had written and which I found to be extremely suggestive. My work with him was very good because it was an extremely creative process. We did not attempt to "translate" the novel into cinema. For me it turned out to be much easier, but for Desnoes it perhaps demanded a much higher level of violence against his own work and against himself, because at a certain point his novel was to be betrayed, negated, transformed into something else. He was fully conscious of this and worked over his novel as if it were raw material, not like something already fully achieved which was going to be "translated" into cinema. Because he maintained this attitude, which is, of course, the only one to have if you are going to do this kind of thing, our work together was very fruitful. He often attended our shooting sessions, and made many excellent suggestions.

The original screenplay which we worked out together kept being transformed in the actual shooting process. There are even several scenes—and this is very significant—which carry great weight in the film but were never anticipated in the original screenplay. There were also details. The telescope, for instance, which becomes a very important image, a symbol of Sergio's alienation from his environment, didn't occur to us until the first days of shooting, almost at the last

moment. Or scenes like the one where Sergio is returning home and comes across a group of people marching in the opposite direction on their way to a political gathering. The scene is very significant, because Sergio is always heading in the other direction from everyone else. As an image it functions very well. The sequence was filmed almost coincidentally, and at Desnoes' suggestion, because we just happened to come across a group that was preparing for a May Day demonstration or some such celebration. It was his idea that we take advantage of that situation, and I think it turned out very well because we were able to film it very spontaneously. We simply had the actor begin walking through that group of people. There were no extras involved, no preliminary preparations.

Cineaste: *What about entire sequences which did not appear in the original version of the novel, like the one which takes place in the Hemingway museum?*

Alea: Yes, he later included these scenes in the revised version of the novel on his own initiative. The fact was that I felt the need to say other things than those included in the original novel, and thus he would write something at my request which I would later expand and rework. But I think that even the second version of the novel is quite different from the film.

In my view, the Sergio character is very complex. On one hand, he incarnates all the bourgeois ideology which has marked our people right up until the triumph of the Revolution and still has carry-overs, an ideology which even permeates the proletarian strata. In one sense Sergio represents the ideal of what every man with that particular kind of mentality would like to have been: rich, good-looking, intelligent, with access to the upper social strata and to beautiful women who are very willing to go to bed with him. That is to say, he has a set of virtues and advantages which permit spectators to identify to a certain degree with him as a character.

The film plays with this identification, trying to insure that the viewer at first identifies with the character, despite his conventionality and his commitment to bourgeois ideology.

But then what happens? As the film progresses, one begins to perceive not only the vision that Sergio has of himself but also the vision that reality gives to *us*, the people who made the film. This is the reason for the documentary sequences and other kinds of confrontation situations which appear in the film. They correspond to our vision of reality and also to our view of the protagonist. Little by little, the character begins to destroy himself precisely because reality

begins to overwhelm him, for he is unable to act. At the end of the film, the protagonist ends up like a cockroach—squashed by his fear, by his impotence, by everything.

So then what happens to the spectator? Why does it trouble him or her to such as degree that s/he feels compelled to see the film again? Because the spectators feel caught in a trap they have identified with a character who proceeds to destroy himself and is reduced to . . . nothing. The spectators then have to re-examine themselves and all those values, consciously or unconsciously held, which have motivated them to identify with Sergio. They realize that those values are questioned by a reality which is much stronger, much more potent and vital.

I feel that it is in this sense that the film carries out an operation which is the most revolutionary, so to speak, with regard to the spectator. The film does not humor its audience; it does not permit them to leave the theater feeling self-satisfied. The importance of this phenomonon lies in the fact that it is the pre-condition for any kind of transformation.

Cineaste: *It is interesting to observe how well the character of the film's protagonist corresponds to a whole stratum of not just Cuban, but Latin American intellectuals from the* haute bourgeoisie. *What has been the response to the film among Latin American audiences?*

Alea: Unfortunately, it has not been widely shown, but it has enjoyed great success in the countries where it has been seen, according to the news which I've received. For example, it was shown in Chile during the Allende period, and I received very positive responses by word of mouth. Unfortunately, before the reviews could be assembled and sent to Cuba, the coup occurred and they were lost.

Cineaste: *Speaking of the need that the audience feels to see* Memories *more than once, in your most recent film,* The Last Supper, *and in other films which we've seen here in Cuba, it seems that the narrative line has become flatter, more chronological, more* linear. *Do you see this change from a more narratively fragmented and "deconstructed" kind of filmmaking as a current tendency within Cuban cinema, or have I begun to draw conclusions from too narrow a base?*

Alea: It's not really a matter of identifying a tendency since it seems a little risky and potentially premature to draw such conclusions. I believe that we are guilty of having over-indulged our interest in historical topics despite their great importance at this stage

in our national development. We are very much involved in
reevaluating our past. All of us feel the need to clarify a whole series
of historical problems because that is a way of also reaffirming our
present reality. It is a genuine necessity. It has, however, led us to
neglect our contemporary situation a bit. Clearly the challenge which
we now confront is to develop a penetrating vision of our con-
temporary situation, and to make more films dealing with current
problems.

Cineaste: *At the Pesaro Festival in Italy in September 1975, I
was able to see Sarita Gomez' film* De Cierta Manera *(In a Certain
Fashion) which I think you actually were the one to finish after her
premature death.*** *The film was extremely interesting to me precisely
because of its exploration and treatment of contemporary Cuban
reality.*

Alea: I see that film as a kind of model; I think it is quite extraor-
dinary. Unfortunately, there have been some problems in getting a
final print. The one you saw in Pesaro was somewhat deficient with
regard to technical problems with it. We had to send it to Sweden to
be restored. It's now back in Cuba and they're in the process of
reassembling the film.

Cineaste: *Related to this, there is a rather naive and superficial
criticism of Cuban cinema which is quite common abroad, that in
Cuba the only topics which are permissible in the work of art, and
film in particular, are those which confine themselves to the more or
less remote historical past.*

Your own Death of a Bureaucrat, *Manuel Octavio Gomez'*
Ustedes Tienen la Palabra *(Now It's Up to You), and most recently
Sarita Gomez' film totally invalidate that criticism. Unfortunately,
none of them as yet have been widely seen in the U.S.*

Alea: Frankly, I'm not sure about that. I can't predict what the
response would be, how the film would be handled, because, as you
know, everything is manipulable in one sense or another. One can
talk about this with films in particular, because whatever "reality" is
captured on film is capable of lending itself to tendentious uses. So in
the ideological struggle in which we're involved, we have to cover
ourselves, we have to refrain from giving ammunition to our
enemies.

*Sarita Gomez died of acute asthma in 1974 at the age of thirty-one, just short of
completing her first feature film.

Personally, I think that *De Cierta Manera* is not such a case. In my view, that film, like many others which examine our present reality, merely registers a lived situation, that is to say, one in which the contradictions are manifest and in the process of being resolved. Because the only way to eliminate the contradictions is to have a sincere and open attitude towards them and to try to resolve the conflicts. I believe that this, in the long run, is absolutely and undeniably positive.

However, I'm not always sure how this should be dealt with in distributing films abroad. For example, when *The Death of a Bureaucrat* was made, someone from the U.S., I don't remember now exactly who, requested a print of it for exhibition there. At that time, the people here at ICAIC—and I was in complete agreement with them—decided that *The Death of a Bureaucrat* was not the best film to show in the United States at that particular time, before any other Cuban film had been seen there. The decision seemed to me at the time a very wise one.

I think that now it would be perfectly possible to show it, I don't think there would be any problem. But, you see, these things depend on particular circumstances and thus must be treated with care. We cannot remain removed from the political questions or retain a liberal mode of thinking or anything of that sort. We have to be fully conscious of what our films mean and how they are viewed in a particular setting and at a particular historical moment.

On the other hand, *The Death of a Bureaucrat* in our own context—aside from the fact that it was a great success with the public—was very healthy because it revitalized the entire discussion, the whole polemic about the risks of bureaucratization in our incipient socialist society. It was very positive.

Cineaste: *Given that* The Last Supper *is the first feature film which you have made in color, I wonder if you have found any significant differences between working in black and white and working in color.*

Alea: What I've found is that many more possibilities are available. It seems much more interesting to work in color, as long as it is handled in a disciplined way. I think that we did an extraordinary job with color in *The Last Supper*. This is primarily due to the director of photography, Mario Garcia Joya, who also served as director of photography for *A Cuban Struggle Against the Demons*, which was his first feature film. *The Last Supper* is his second feature, though he has filmed many documentaries. He worked out

a very intensive and precise color analysis. Color is, after all, yet one more expressive resource, and it has great attractions for me.

Cineaste: *Do you think the fact that the film was made in color influenced the means you employed in making it? Would you have made the film differently had you been working in black and white?*

Alea: I never really thought about it in those terms, but I think I would have had to look for other solutions in order to create a similar atmosphere in black and white. For example, the supper sequence, which has an ochre color, a kind of illumination which corresponds to candlelight, would have been very difficult to create in black and white.

Cineaste: *One concrete question I had about* The Last Supper *deals with the role of Don Gaspar, the Frenchman who emigrated to Cuba after the Haitian revolution and who works on the Count's sugar mill as an engineer. How do you conceive his role within the social structure represented in the film?*

Alea: Don Gaspar is a technician, and as such he serves as a sort of archetype. At that time, he found himself in between the land-owning, slave-holding class and the slaves themselves. His position is that of a person who has a "secret," that is, a particular skill which he is able to sell to the Count and thus obtain a certain degree of freedom. As a salaried employee, he continues to be dependent on the property owner, but not to the same degree as the slaves are.

Coming from Haiti, he is more marked by French culture, by the ideas of the French Revolution, etc. He would be best identified with the position represented by the Freemasons of the period. He played a progressive role because he was a sort of philanthropist in that he was interested in finding a greater equality with his fellow man. His sense of justice was rather abstract, to say the least, but at least he was disturbed by the injustices he saw around him.

What we discovered in the course of making the film is that the character is simply too interesting. We didn't dare develop him as thoroughly as his importance demands because that would require another film. We had to reduce his importance within the film, leaving him simply as a spectator who is closer to us, the audience of the film. So that the role he plays is to underline certain significant moments in the film as a spectator who looks on with a critical eye.

Cineaste: *Since you have been so involved in the development of Cuban cinema, even before the revolution with the filming of* El Megano, *I would like to ask how you see the evolution of the Cuban cinematic process in the last decade. What do you see as the*

major influences on Cuban film activity — not only in thematic and stylistic terms, but in terms of the mode of production as well, that is, the process by which Cuban filmmakers organize their filmmaking activity?

Alea: Perhaps I won't be able to answer your question with as much depth and precision as I would like because I am not very clear about the most recent years. As a matter of fact, at this particular time I am in the process of trying to analyze and weigh the various factors influencing this situation, but I have not as yet developed a full analysis.

However, one thing is obvious. From the beginning of the Revolution, our artistic foundation was in fact essentially Italian neo-realism. Very obvious considerations account for this, and not only the fact that Julio [Garcia Espinosa]* and I had studied in Italy during that period and were pretty permeated with that mode of approaching filmmaking.

I have to say that when we returned we continued to hold a very positive estimation of that experience in an historical perspective, but when it came to our evaluation of neo-realism as an aesthetic we were no longer so positive, because we had conclusively seen all the limitations to which it was subject. What we were looking for was something else. However, neo-realism was our origin, and we neither are able nor want to deny it.

Cineaste: *Could you be more specific about the aesthetic limitations you mentioned?*

Alea: At the time it appeared, neo-realism sprang up apparently spontaneously. It reflected a very confusing reality—that of postwar Italy. To the degree that it did this accurately and honestly, it was, of course, very constructive, because it allowed the essence of that reality to be shown. It was a very transparent kind of reality, since such convulsive historical moments virtually express themselves. Because everything seems so apparent at such times, the requisite analysis turns out to be much easier. Since film is a good medium for capturing apparent realities, the neo-realist experience is a very constructive one. That reality perceived by the camera in and of itself conveyed a situation full of contradictions; the act of documenting that historical moment could not in fact avoid bringing them to the forefront.

*Julio Garcia Espinosa, founder and Vice President of ICAIC since its inception, has made feature films *(The Adventures of Juan Quin Quin,* 1967) and feature-length documentaries *(Third World, Third War,* 1970).

In our view, as that particular reality began to evolve and to change, neo-realism began to lose its earlier driving force. It did not evolve in a parallel or proportionate way, but instead began to deteriorate, to accommodate itself to a commercialized concept of film as simply merchandise. Thus only those spectacular elements of neo-realism which were capable of maintaining a hold on the public continued to be exploited. We saw this very clearly.

What happened to us, then? We date the beginning of our film-making here from after the Revolution, since *El Megano* is nothing more than a forerunner which, if you like, reveals our concerns but without yet integrating them. So when we began to make films in a post-revolutionary situation, that neo-realist mode of approaching reality was very useful to us because in that early stage we needed little more. First of all, we were not developed enough as filmmakers to posit other approaches. Secondly, our own national situation at that juncture was convulsive, very transparent, very clear. All we had to do was set up a camera in the street and we were able to capture a reality that was spectacular in and of itself, extremely absorbing, and laden with meaning. That kind of filmmaking was perfectly valid for that particular historical moment.

But our revolution also began to undergo a process of change. Though certainly not the same as that which occurred in postwar Italy, the meaning of external events began to become less obvious, less apparent, much deeper and more profound. That process forced us to adopt an analytical attitude towards the reality which surrounded us. A greater discipline, a much more exact theoretical criterion was then required of us in order to be able to properly analyze and interpret what we were living through. We, of course, retained the clear intention of projecting ourselves toward the future, of fulfilling the social function of cinema in the most effective way possible.

I'm not sure that this is really a complete answer to your question. I should add that subsequently we have had access to the entire gamut of world film production. We have obviously been influenced by the French new wave. Naturally this produced a few flawed efforts, since the concerns of the new wave filmmakers had in fact very little to do with our own reality and with our own approach to it.

Godard, for example, has exerted an inescapable influence. Since he is such a brilliant destroyer of the cinema, he offers many challenges. From this distance, I think that the Godard phenomenon can begin to be properly evaluated, noting his limitations as well as

his successes. His intention was clearly to make the revolution in the realm of the cinema before making the revolution in reality. However, his endeavor has a very constructive force because he succeeds to a certain extent in making us see, in making us question the degree to which we might be at the rear of the revolutionary process rather than in the vanguard.

Our role is to be united with the revolutionary process. Thus our language as filmmakers has to evolve parallel with the revolution. It is important to be conscious of this, because one can accommodate oneself very easily to stereotypes, to comfortable ways of doing things. Let's face it, there is a tendency sometimes to resist change, don't you think? So that I think Godard's work has been useful to us in this sense. Besides, as long as you look at that phenomenon from within the revolution, it seems to me that you see it much more clearly. This permits you to be on guard against its limitations and false steps. What condemns Godardian cinema in the last analysis is its own incommunicability. If it doesn't reach the people, it is of no use. For us, genuine communication is absolutely fundamental, so we must avoid falling into this syndrome at all costs. However, as I've been saying, to the degree that Godard provoked the destruction of an entire series of models of bourgeois cinema, his work has been very valuable.

What other influences have we felt? There's the "marginal cinema," with which we are only partially familiar. We have seen very little of the North American underground cinema, for example, so I am unable to evaluate it.

We are familiar, though, with the kind of alternative cinema which is being produced in several Latin American countries (Venezuela, for example): a militant cinema which aims at the poorest sectors of the country and seeks the kind of response that will spark a *toma de conciencia* about the social and political problems which those people face. It is a kind of filmmaking which I believe is valuable to an extent, a necessary kind of cinema, but one which must not forget that the cultural struggle must also be waged and won on the commercial screens. In making that kind of "marginal" or alternative cinema, you can obviously not compete with the kind of Hollywood spectacles shown in commercial theaters, the kinds of films which attract, among others, that very section of the population which the militant filmmakers are trying to reach. It is thus also necessary to try to reach the commercial screens with a kind of cinema which is essentially different from, for example, *Jaws*. (Actually, I haven't yet

seen *Jaws,* but I imagine that it is a fitting example of the Hollywood film-as-spectacle.)

Cineaste: *Your emphasis on the importance of a commercially viable alternative cinema makes me think of the Brazilian cinema novo movement, because of the effort Brazilian filmmakers made throughout the sixties to ensure and expand their access to a broad national public in commercial theaters. Has the cinema novo movement exerted any influence on Cuban cinema?*

Alea: Yes, Brazilian cinema also had an impact here. It was a kind of revelation for us—primarily the early works of Glauber Rocha, although a great deal of Brazilian cinema has been shown in Cuba.

In fact, we see an extremely broad range of films here. Of course, our situation is very different from that of most film-producing countries. This is due to the fact that in addition to controlling production, we also control the movie screens. That is, what we see is in fact what we choose to see. This is another way to educate the public.

The process of training the public taste is very interesting. Obviously, we made a revolution here, we won, and that revolution developed and was radicalized quite rapidly; in the process we became conscious of what socialism was. All this happened very fast, at an almost dizzying pace. But during this very fervid time, the Cuban public continued to see Hollywood and Mexican films—until the time when the U.S. imposed the blockade [1961], when it was no longer possible to continue to see the new Hollywood films, though the older ones continued to be shown with great success. Mexican movies also stopped coming, even though diplomatic relations with Mexico were never severed, once the Mexican film enterprises which existed in Cuba had been nationalized by the revolutionary government.

Initially it seemed that this cutting off of the feature film supply was a disaster. Our public was thoroughly accustomed to those films. But I think it was actually a great boon for us. Traditional Mexican cinema—apart from a few exceptions and some interesting things that are currently being done—is absolutely dismal. It conditions the public to respond to the worst commercial motives and devices, just as Hollywood films do to a very large extent. (I don't mean to say that every Hollywood film functions this way, but certainly the vast majority do.)

So what happened when the supply was so abruptly cut off? The film-going public, despite being at that time in full support of

socialism, ready in fact to give their lives in order to preserve the revolutionary system of government which was being implemented here, and unreservedly enthusiastic about the revolution, was reluctant to go to the movies to see the films which we were able to show at that time—Soviet films, Czech films, in short, what was then accessible to us—because these films represented a new kind of film language for them, one that was too alien.

There's another thing which should be noted. Because of the film shortage, we were compelled to import films rather indiscriminately, without a careful selection process to determine which films were more adaptable to the taste and needs of our people. Instead, it was necessary to bring in whatever we could because we had to fill the screens of our theaters. So, many things that were in fact quite mediocre (because mediocre films are produced everywhere) were brought in.

Subsequently, film exhibition became much more diversified. A great deal of European production was brought in. All the films imported from the socialist camp were subjected to more of a selection process. Currently, the film-going public in Cuba—well, you can see it for yourself—is massive. It's really very impressive. They have come to accept and understand other film languages, other approaches to filmmaking. I think it's very interesting that the evolution in the awareness and sophistication of our viewing public, though it was forced upon us by circumstances beyond our control, turned out to be very positive.

Cineaste: *Do you think it's possible to identify specific characteristics of Cuban cinema—not so much of the production process but on the level of the films themselves?*

Alea: I take it that you're asking whether there is an identifiably Cuban film "language." Well, let's see. Since our entire initial stage was marked by improvisation and an emphasis on what was feasible, it may have been somewhat slow in its utilization of expressive resources and whatever, but it certainly manifested itself in a very fresh and direct way. It has continued to consolidate a certain style which seems to mark each of us equally. This has been to our advantage. At this stage, the idea is not to abandon that style, but rather to take advantage of it—of its popular, authentic, organic elements. I think the formation of a certain style, a tendency or direction which marks us all is inevitable. But still there is a certain dispersion as well; many different styles and concepts continue to exist. We're still in a period of quest.

When it comes to trying to generalize as to the nature of this style, it is clear that our neo-realist foundation has not totally disappeared. Despite all of its ideological and political limitations, despite our own evolution which has gone in a different direction, one thing is sure and continues to condition us: our film production must of necessity be inexpensive. We do not have the means to undertake super-productions. So the kind of cinema which adapts itself to our interests, fortunately, is a kind of light, agile cinema, one that is very directly founded upon our own reality. We have never lost sight of this. In fact, I thnk that the best of our cinema, the most fully realized works, are achieved through a very direct link with our particular circumstances. You must have seen this in *De Cierta Manera,* for example. The film seems a bit careless, a little awkward, almost as if it had been let loose on its own. But it also succeeds in penetrating our reality to an uncommon degree, producing an impact which is somehow charged with poetry. I think that it is there above all that our reality is shaped.

Cineaste: *Changing the subject somewhat, I'd like to talk about how you see your role inside of ICAIC. Apart from directing, for instance, your name appears in many films as collaborator or consultant. What does this work consist of?*

Alea: This is merely a result of the fact that I am one of the oldest directors, and as such, I alternate my work in film direction with my work as an advisor. I simply work with some younger directors, helping them in their development. This is completely natural, and I'm very interested in this work. I think I will be dedicating increasingly more time to it.

Cineaste: *Have you worked with others besides Sarita Gomez* (De Cierta Manera) *and Sergio Giral* (The Other Francisco, El Rancheador)?

Alea: I've worked with them in particular because they have made feature-length films. I also work with a group of documentary directors. I am not the only one who provides this kind of assistance. Manuel Perez *(The Man from Maisinicu),* who is a lot younger than I, but has been involved in film a long time and has matured very rapidly, does the same thing. So does Jorge Fraga *(The New School).* We have divided ourselves among all the documentarists. When it comes to feature-length films, Julio Garcia Espinosa usually works on them, though Jorge Fraga and I often do too.

Cineaste: *Is it an explicit policy rather than just a prevalent practice at ICAIC to avoid always giving the best directorial opportunities*

to the more "consecrated" directors, to give the opportunity to make feature-length films to younger people who are still very much in the process of artistic development?

Alea: Of course. This is clearly a necessity. What happens is that not all of the young directors are sufficiently trained. Many have reached the stage of making feature films without a solid enough background. This happens with shorts as well. We have gone about learning to make films through the practical, concrete experience of making them. This method naturally carries with it a great deal of imbalance, and notable shortcomings in some cases.

Cineaste: *With regard to your future plans, will assisting in the development of younger directors be your primary activity?*

Alea: In fact my intention is to keep alternating between making films myself and assisting developing filmmakers. This year I plan to make another film. I'm already so involved in the undertaking that I have given this project priority when it comes to deciding how I will allocate my time. My second priority will be to continue working with that group of younger directors.

What I am also extremely interested in is to continue developing a level of theoretical activity. This is one of the things that most concerns us, because now, at this particular stage, we realize that we must dedicate much more attention to theoretical work, to formulating our concerns on a much more profound level. We have to analyze all that we have done in order to plan for the future with a greater awareness instead of leaving everything to spontaneous solutions, which is more or less what we have been doing up to now.

I should clarify that our work was never totally improvised; there have always been theoretical investigations, but never with the degree of discipline or insistence which we should now be able to achieve. It is not that this work is just beginning now. In fact it began some time ago, but these theoretical inquiries have to continue to expand. I think that now we will see increasing emphasis on this kind of work.

This is not likely to produce immediate results, but I'm committed to it even though I know it's a long-term process. I'd like to define more clearly all that we have done here at ICAIC. I've begun to work on the question of the relationship between the film as a spectacle and the audience. Specifically, what are the different levels of relation between film as pure spectacle and a cinema of ideas? Clearly, these are not mutually exclusive poles, but rather both kinds of film-making must be employed simultaneously because each fulfills an

important social function. I'm interested in how audience response is produced and in the uses to which this knowledge can be put. My aim would be to achieve an even greater effectiveness in the socially-committed, revolutionary propositions which can be made through film.

Cineaste: *Exactly what form does this theoretical work take? Is it primarily confined to group discussions within the organization, or do you intend for your theoretical work to reach a broader audience?*

Alea: For some time now all the film directors and camera people have been having weekly meetings. We almost always view and discuss a film made by one of us, or a foreign film which is of general interest. Then we have open discussion about the film. But in addition to this practice, there is still the need to do more directed theoretical work.

My intention with my own theoretical work is to ensure the widest exposure possible. Julio Garcia Espinosa is also continuing his theoretical writing and will soon publish a new essay on mass communications in the magazine *Casa de las Americas.*

Cine Cubano is obviously another outlet for this kind of work. As you know, the magazine ceased to appear for a time due to a vast reorganization here at ICAIC which is only now assuming its final form. But it will soon reappear, and, we hope, with much greater regularity.

Cineaste: *As a final area of discussion, I'd like to ask what you see as the personal advantages of the kind of state-owned film production system that currently exists in Cuba, in contrast to the Hollywood system, for example, or to conditions in Italy when you studied filmmaking there in the early fifties.*

Alea: I imagine that this is a very difficult thing for the majority of people in a non-socialist country to understand, because they're clearly marked by bourgeois ideology, and they find the idea of giving up certain limited bourgeois freedoms to be a very painful one because they are unable to conceive of freedom in any other terms. For me, their point of view has very grave limitations.

To the extent that we are part of our revolutionary process, to the extent that we believe in it and (to ground the discussion in our specific situation here in Cuba) to the extent that we realize that for the first time we are in control of what we're doing, of our own actions, we are exercising a much greater freedom than that which can be exercised in any country where conflict between different classes continues to exist. For a social system based on unequal

exercise of power and influence *always* works in favor of the most powerful, who sometimes grant some scraps of apparent freedom to those whose lives they dominate. However, these always turn out to be more illusory than real.

In contrast, the freedom that we feel here—I'm sorry if this sounds a little abstract, but it's hard to express—derives from the fact that we are very aware of working together toward a common goal. We feel united around an idea and involved in implementing it together.

I'm not sure whether I've succeeded in conveying to you the full measure of our feelings and point of view. This freedom which we feel in working together is a completely different experience from the purely individual creative freedom so precious to people in capitalist society.

We have to undergo certain contradictions. We discover things which we feel we have to fight against. But it is on another level. For example, the struggle against bureaucratization is one which we know we will win. It is not that despairing fight that reduces you to a state of frustration. On the contrary, we here have to be optimists. Not because anyone requires us to be, but because our real-life situation imposes that optimism on us in indicating to us that we are on the right track.

A state-owned, centralized production system like the one that we have is very different from what an "independent" private company, for instance, might be. I put "independent" in quotation marks because under such a system one is always dependent to some extent on those in power. When you attempt to free yourself from that dependence, you are reduced either to impotence or to total incommunication. So you see that there is really no means of comparison.

Cineaste: *I remember in 1973 when there was all the commotion about the U.S. State Department's refusal to allow you to attend the National Society of Film Critics' awards ceremonies where you were to receive a special award for* Memories of Underdevelopment. *I think it was in the speech that Andrew Sarris gave us as President of the organization where he lamented that you had not been allowed to make another film here in Cuba subsequent to* Memories. *Even though the assertion was false—you had already made* A Cuban Struggle Against the Demons—*it is typical of strong desire abroad to view you as a prisoner of the Cuban regime. Their idea is that you are a great director who should be putting out a film a year. If you are not, it must be because you are not allowed to.*

Alea: That was in fact the most unfortunate statement to be found in all the articles which I read, because it is evident that the man had a personal stake in giving his own interpretation, despite the fact that it had no connection with the actual situation. His lack of information was such that one suspects a kind of tendentious ignorance, if such a thing is possible. It's hard to know in such cases where ignorance leaves off and stupidity or malice begin.

The fact is that I have been dedicating a lot of my time to the kind of work which I was describing to you before—the process of acting as advisor for other *companeros*—which I view as being just as important as my own personal achievement as a director. For someone like Andrew Sarris it must be extremely difficult to understand, but I have to say that for me what I might achieve as an individual director is no more important than what the whole group of us here at ICAIC achieves together. I have no desire to stand out more than the others simply in order to fulfill my own creative needs at the expense of my fellow filmmakers. Individual fulfillment is not everything. In a situation like ours, the collective achievement is just as important as the personal one. This assertion does not grow out of any attempt to appear more generous, less egotistical, but rather from my firm belief in what we as a group are doing.

In order to be completely realistic, in order to avoid appearing saintly, like some extraterrestial being removed from all personal interest, I would like to state that in order for me to fulfill my individual creative needs as a director, I need the existence of the entire Cuban film movement as well. Otherwise, it's impossible. Without such a movement, my work might appear as a kind of "accident" within a given artistic tendency. Under such circumstances, one might enjoy some degree of importance, but without ever achieving the level of self-realization to which you really aspire. This is not measured by the level of recognition you might achieve, but rather by the knowledge that you are giving all you can and that the environment you work in guarantees you that possibility.

17—GORDON PARKS
Beyond the Black Film

Gordan Parks came to filmmaking after a successful career as a photographer (25 years on the staff of Life), writer (A Choice of Weapons, Born Black), and musician. His first film, The Learning Tree (1969), was a dramatically static account of how it was to grow up black in Kansas. In 1970, Parks made an abrupt turnaround with Shaft, which launched the new genre of black urban action movies or, as they are more often called, "blaxploitation" films. Shaft was soon followed by Shaft's Big Score and The Supercops. In 1976, Parks made yet another turnaround with Leadbelly, a film about the legendary black folk singer. In a 1977 interview by Thom Shepard, Parks talked about the problems of the black director in relation to producers, critics, and public.

Cineaste: *For the record, how did you get your start in film?*

Gordon Parks: Well, I suppose it was because I had a novel or "property" of my own, which was my first novel, *The Learning Tree*. That was a great asset because in making a film the most important thing is to have a "property." I used *The Learning Tree* as a big step toward getting into Hollywood.

Cineaste: *You had been a still photographer. When did you decide to become a filmmaker?*

Parks: I think it was possibly around 1964 or 1965, when I was on *Stromboli* with Ingrid Bergman and Roberto Rossellini. I was covering their romance on the island of Stromboli for *Life* magazine. I was close to the motion picture industry for the first time, seeing how it was done. It was interesting and, not that the still camera had yet shown its limitations to me, but I was interested in new boundaries. I never was one for saying, "Well, OK, I'm a still photographer, this is it, I'm at *Life* magazine, this is home." I always wanted to explore new areas.

Cineaste: *Who were your influences as far as film was concerned? Were there any directors or cinematographers that you really had paid attention to up to that point?*

Parks: No, I never paid attention to any particular director. I guess my greatest help and influence on *The Learning Tree* was John Cassavetes, who encouraged me not to sell my novel but to hold on to it and do it myself. He contacted Ken Hyman, who was head of Warner Brothers-Seven Arts. I went out there after Cassavetes had made arrangements for me to meet Hyman. And I didn't think anything would happen—because we had been trying to get *The Learning Tree* started for quite some time, and I'd always been told that there would never be a black director in Hollywood. But as it happens, it was all over in 15 minutes.

Hyman asked me if I wanted to do *The Learning Tree*. I said, "Yes." He said, "I read the book. I like it very much. Would you like to do the music?" I said "Well, I'll think about it." He eventually thought that I should produce it because I'd have more control over it. I wrote the screenplay as well, so I learned an awful lot on my very first film—more than most directors get a chance to learn in four or five.

But it was worthwhile, and I think it helped me settle in, because I like the motion picture. I still do still photography, but I've never gone all the way back.

Cineaste: *If storytelling is the most difficult aspect of filmmaking, what was your approach to that?*

Parks: My story was my life story, so I knew it quite well, and having written the book and the screenplay, I was very close to it, so that was the least difficult aspect of the thing.

Cineaste: *What about producing?*

Parks: Producing it, I had to have help. And Warner Bros. gave me the help, so I selected people that knew something as my assisstants. I told Warner Bros., "I want to be the only amateur on the set." I also kept my eyes and ears open.

Cineaste: *So were your camera movements intuitive since you hadn't checked anyone out?*

Parks: Oh yes, I had my own ideas as to what I wanted to do. I don't think that the transition from the still camera to the motion picture camera was that difficult for me. I did have the tendency to hang on to a beautiful picture too long in my first film. I had an awfully good cameraman—Bernie Guffy. He had retired, but I asked him if he'd just come back and do one more picture, and he did. I was very thankful that he did. Bernie was lots of help to me.

Cineaste: *Did you intend to make a statement and, if so, what was it?*

Parks: I think you intend to make a statement with every film you do. *The Learning Tree* was autobiographical. As a book it was the first of a series. *Choice of Weapons* was the second, and I'm now working on a third. It would be nice if all of them could be filmed. Certainly, the statement is about a black youth living in America, in a certain area of America, and how he survives the cruelty of it, and how others didn't survive.

Cineaste: *Is there an overall theme to your work?*

Parks: I can't really say that there is. A black director, like everyone else in this country, almost has to take what he gets. No matter what people think of how important I've become in Hollywood, it's a matter of shooting what you can shoot, when you can shoot it. I just wrote the screenplay for a suspense story with Dina Merrill, and I will direct her in it this winter. I like what it is going to say. It doesn't have a great statement, but it will be suspenseful.

When I look around and see what the American public is absorbing in terms of billions of dollars, one gets a little hesitant about talking about the importance of film. You see *Jaws* and *The Deep* and all the rest of them making millions of dollars, and you soon begin to realize that if you're going to stay in the business, you'd

better begin to do something with a touch of sensationalism to it. Otherwise, you just won't be working—and that's tragic.

But I will keep on trying to do films that I think are important. That's the only way I'll survive within my own self. I know that there are a lot of things that I would like to do, a lot of things I'd like to say with the camera in terms of what's happening in New York City, in terms of what's happening in this country and this universe. Possibly, I'll get a chance to say those things, despite what the public seems to be more vulnerable for. I think that *Leadbelly,* for instance, made a great statement, but we've fallen into a sort of trap—black people have also fallen into a trap—by supporting films that aren't important and not supporting films that are important. If there ever was a film that should have been supported, it was *Leadbelly.* It could have been a big breakthrough film.

Cineaste: *Why do you think it wasn't supported?*

Parks: I think a great deal of it was the studio's fault. I think I got caught in the middle of a studio fight. A film always suffers when that happens. Those people who saw it raved about it. There was some awfully fine acting in it, and it had all the elements of the type of film I wanted to eventually do.

Cineaste: *The white press got behind* Sounder, *but they didn't do this for* Leadbelly. *Why do you think this happened?*

Parks: In some instances they did. *The Los Angeles Times* said it was one of the greatest films ever made. A lot of the press fought on my side to get the thing released. You see, in the first place, *Leadbelly* was in danger of never being shown at all, as were several other Paramount films that just weren't shown. Frank Yablans assigned the film, but by the time the film came out, he was no longer head of Paramount. When a cross-over like that happens, the films that are being released always run into trouble because the people that are coming in don't want to put money into someone else's film. They don't want to make $2 million worth of prints. In other words, the new head of the studio wants to put his money into his films, into his projects, and if he or the studio feel that the last guy has failed them for some reason, they don't want to put millions of dollars into what they consider to be his films because they probably will be failures. Who knows the politics that goes on in those rooms?

Cineaste: *Do you think that racism was involved in the decision to withhold* Leadbelly?

Parks: I'm reluctant to say that these guys who did it or who were involved in it were racist. It was a matter of economics and inner

politics. There probably was racism to a certain degree. I don't think that was the overall intent to kill *Leadbelly,* though a lot of people do. A lot of people think that because I had shown the chain gangs, shown him being beaten, shown him being shot down out of a tree, and chased by hounds, that white people didn't want to see it. I can't come out and actually say that, because there were a lot of white people who saw it and were moved by it, who came out of the theatre in tears. So you can't generalize. Who knows what was in the minds of the people who killed it? They will call and give you an economic reason rather than an emotional one. They'll say, "Well, it's not going to sell. It's not going to be a cross-over film. We don't want to put that much money into it." They've already sold it to television. But there are still people screaming to see that film. That film will live. They only way they can destroy it is to destroy the footage itself.

Cineaste: *The emphasis in Hollywood today is on the "cross-over" films. Is it still possible to make a film specifically for the black audience?*

Parks: The black film, as such, has just about run its course. You gotta go beyond that now. People holler, "Do films with better people, with better blacks, more important blacks." OK, but if you do a film on George Washington Carver, you better have him make a peanut sauce that introduces sex. If it's Miss Bethune, you better rig up a big sex story behind it, or a murder or something. Films on those people are just not going to live, and nobody's going to see them. A handful of people will. Film is entertainment as far as the people are concerned, as far as the dollar is concerned. The real critics of a film are the people that form those lines around the block. If they don't form those lines, then no matter what a critic says, no matter what a columnist says, if those lines aren't forming, then your film is going down the drain.

Cineaste: *What is your opinion of so-called "black exploitation films"?*

Parks: Exploitation films were developed for blacks, seemingly. What about Humphrey Bogart or James Cagney or John Wayne, who blows people up and then brags about how many men he's killed?

Cineaste: *Art is exploitative by its very nature, so it was a ridiculous term. At the same time, a certain kind of film was being made that. . . .*

Parks: I know that, I know that, but there were certain white films being made that were just as bad. They don't rush to the papers yelling, "White exploitation films, white exploitation films!" The kids are going to see something. If they don't see the black, they're going to see the white exploitation films, if that's what they want. If they want to see somebody blown away on a Saturday night, they're going to watch Humphrey Bogart do it or they're going to watch Richard Roundtree do it. The thing about *Shaft* was that they had a hero at last. They had a guy that was not going to take any shit off of anybody.

Cineaste: *Fritz Lang said that Louis B. Mayer made cuts in his first American film,* Fury, *because Mayer was convinced that blacks should only be shown as menials. What kind of imprint do you think films like this made?*

Parks: When I was a kid, I went to those movies because they were the only kind of movies I could see. I spent my fifteen, twenty, twenty-five cents on a Saturday afternoon—had to sit in the peanut gallery because I couldn't sit down where the whites were sitting—and I was demeaned by his theory that that's the way blacks should be shown. I came out of there with my head tucked between my legs, ashamed of being black. That's the thing it did, it ruined, it complexed a lot of young black people. It made them feel worthless to a certain extent. So a great hue and cry went up when they saw *Shaft* kicking ass—white ass, too. They said, "This guy is changing something here." They could accept *Sounder,* of course, because Winfield never put up a fight.

Cineaste: *Doesn't that lead us in a certain direction?*

Parks: Yeah. You a good nigger, but you stole that ham. Now we gonna put you in jail, but don't you put up no fight, then we gonna let you out and you gonna come home and you wife's gonna start runnin' down the street to you and grab you, and that's it. Right? Richard Roundtree said, "Fuck off, man." Blam!, Blam!, Blam!, and knocked a group of cats out. The phenomenon was that we had a black hero. We've got a guy who is not going to back down from anybody.

Cineaste: *What's happening with black directors these days?*

Parks: If the black director isn't careful, he's going to be wiped out. The white sources out there see that a lot of money can be made off of black films if they're done right. I think that black people have done a lot to hurt black directors by falling for the propaganda. It is true that there were many so-called exploitation films that were bad. I

didn't see many of them, but I saw one or two and they were really bad. What you must remember is that those black directors were getting their first chance. They were given money to make the film, otherwise they never would have been able to set their foot through the door. They couldn't just suddenly step in the door and say, "Here I am, and here's what I want to make." Studios still tell you what to make. They still supply the money. Even some of the black businessmen who put money up decided that they wanted this kind of film in order to secure their money up there. You don't particularly care about morality and this or that. What you want to do is protect your half million dollars or whatever money you put into that film. That's the problem.

You probably have seen the last of a lot of black directors because, in a way, they are being run out of Hollywood and the white directors are taking over some of the things that they should be doing. The only thing for the black director to do is stop doing all-black films. He must do everything. That's the way it was when I worked for *Life* magazine. I would not allow them to assign me only to black subjects and ghettoize me. When a big, black subject came along, like the Black Muslims or the Black Panthers, I wanted it. I knew I could do it well. They knew I could do it well. They knew I was the only one who could do it, because the Panthers or the Muslims were not going to accept them in the first place. So, I was an asset to *Life* magazine in that way. And I was an asset to the Panthers and the Muslims because I gave them a voice. They would have never had a voice—some seven million subscriptions per week—to say something.

Meanwhile, I went off and did the world. I did royalty, fashions, sports. I did everything that came along. Why? Because I knew that as a black photographer, if I was going to make that staff, then I'd have to do more than just black subjects. I think that's the mistake that many black youths make today. They ghettoize their own talent. Black youth have got to get it in their heads that they've got to do everything in every field there is. That's the only way they're going to survive. Black directors have got to stop thinking about doing only black films. They've got to address Hollywood to that. I do it to my agents all the time. I say, "Don't just bring me black films. Bring me *Ryan's Daughter*. Let me refuse it if I want to. Let me refuse *The Exorcist*, or take it if I want to. Bring those things to me."

The white directors are doing films that black directors could best do. So what's left for black directors? Develop themselves as fine

directors and forget the fact they're black so they can do any film they want to. Because after a while there's going to be a limit to what you can do out there.

18—RAINER WERNER FASSBINDER

I let the audience feel and think

When Rainer Werner Fassbinder's films were bad, they were often very, very bad, but when they were good, they deserved all the fanfare their director received as one of the most celebrated of the German filmmakers of the 1970s. In films made rapidly on modest budgets and with a relatively stable acting company, Fassbinder explored the plight of the unhappy, non-conformist and neurotic in West German post-war society. Obsessed with various political, social and aesthetic concerns, Fassbinder was amazingly prolific, directing some forty features and television films during a meteoric career cut short by his tragic death from a mixture of drugs and alcohol in 1982. In a brief interview five years earlier, Fassbinder discussed his films and methods with Norbert Sparrow.

Cineaste: *What immediately strikes the uninitiated observer of one of your films is the melodramatic structure. How did this formal choice come about?*

Rainer Werner Fassbinder: Any life-story that deals with a relationship or whatever is a melodrama and, for this reason, I think melodramatic films are correct films. The American method of making them, however, left the audience with emotions and nothing else. I want to give the spectator the emotions along with the possibility of reflecting on and analysing what he is feeling.

Cineaste: *You have a profound admiration for Douglas Sirk. What is it that attracts you in his films?*

Fassbinder: Sirk managed to exploit all that Hollywood had to offer to make melodramas that seemingly conformed to the studio's demands but which in fact destroyed the very life-style they wished to exemplify—the sort of thing where one is fortunate to have a color TV, an expensive car, etc. Sirk showed the studio line in his films but in such a way that the audience could never really be happy with it. They had been satisfied—they didn't react by saying this is a terrible film, it's attacking my mode of life—no, Sirk's was a very tender kind of destruction. At this time, it was of course impossible to make a big, expensive film and take an overtly critical stand against materialism.

Cineaste: *In one of your essays on Sirk's films, you said that while we have a happy ending, in fact these people can't be happy.*

Fassbinder: The filmmakers in Hollywood were forced to shoot happy endings but a critical cineaste finds a way of getting around that, making one that is ultimately unsatisfying. And that's what Sirk did. There were others. . . .

Cineaste: *. . . such as. . . .*

Fassbinder: Jerry Lewis. His films contain a very destructive streak. He really showed that a TV, an apartment were worthless and he got away with that because during the last two or three minutes of the film the studio got its happy ending. Even then, it's so exaggerated that it's not believable.

Cineaste: *While your films are melodramatic, you have added the dimension of distancing the emotions with respect to the spectator. Some critics have compared this to Brecht's* vertremdungs-effekt; *you reject this analogy, don't you?*

Fassbinder: Absolutely! Intellectual thought is a process of references and categories but it shouldn't be practiced in such a quick and facile manner. With Brecht you see the emotions and you reflect upon them as you witness them but you never feel them. That's my

interpretation and I think I go farther than he did in that I let the audience feel and think.

Cineaste: *In* Mother Kuster's Trip to Heaven *I assume that you didn't show her being shot because, at that point, the audience would have identified too strongly with her, thereby nullifying any sort of distance between the spectator and the story?*

Fassbinder: It'd be terrible if the audience were to see this poor woman killed after all the suffering she had undergone. They would leave the cinema with an impression of sadness and think no more of it. I was going to show the shooting in the original script but fortunately I realized that it would be a great mistake. Some of the group who worked on this film asked me to shoot a friendlier ending, so I shot the one where the worker invites her home to eat a *himmel und erde* (blood sausage). I've come to prefer this ending over my original one—someone coming along and finishing her emancipation with a private thing—I find it so much sadder and more terrible.

Cineaste: *In both cases, we encounter a recurrent theme in your proletarian melodramas: even though the protagonist has gained an awareness of his socio-political and economic position (what could be presumed as the birth of a class consciousness), this doesn't resolve anything. On account of this, some people dismiss your films as fatalistic. . . .*

Fassbinder: They are not! And for the following reason: the film, possessing a fatalistic ending, creates a need on the part of the audience to search for the idea of a utopia. The more fatalistic the film is, the more hopeful it is.

Cineaste: *You've said elsewhere that you "make films that have a bearing on the spectator's reality: this (in conjunction with the filmic reality) gives rise to a new reality that is situated in the spectator's head."*

Fassbinder: And if the film has a terrible conclusion, an ending that you can't live with, you must find something else. Death is emancipation. . .not in the sense that the word is commonly used but emancipation meaning that the protagonist, representing the audience, learns that a utopia is necessary. They need it.

Cineaste: *What is your conception of this utopia?*

Fassbinder: That's a problem. I don't want to formulate this utopia for you because if I do, it ceases to exist as a utopia. It's an idea and it can be struggled for. Take Marxism as an example—this good idea is formulated in an inhuman manner. I think the way to change the situation is in a sort of anarchy; not an anarchy that

is combined with terrorism nor one that conceives of life without feeling, without pain . . . everyone has to become himself to hope. It's not up to me to tell him what to hope; if I do this, I dominate him. We have to find new modes that everyone can feel or know . . . there could be a form of life which is important to live.

Cineaste: *That's the reason why you don't propose any solutions in your films?*

Fassbinder: I never have and I hope I never do.

Cineaste: *In* Fear Eats the Soul, *as long as Ali and Emmi have to collectively struggle against their neighbors' racism and prejudices, the marriage prospers. But when they, for various reasons, relent and accept the couple, the relationship deteriorates. One conclusion that can be drawn is that the couple, in and of itself, is necessarily self-destructive.*

Fassbinder: Whenever two people meet and form a relationship, it's a question of who dominates whom. I've always found that people look for someone to play the paternal or maternal figure. Whenever this happened to me, I generally played the father or mother for awhile. Sure, I liked this; I liked to dominate. But then came a time to reflect upon what I had done, I'd feel grieved and I'd end this dependency.

People haven't learned how to love. The prerequisite for loving, without dominating the other, is your body learning, from the moment it leaves the womb, that it can die. When you accept that a part of life is death, you have no more fear of it and you don't fear any other "conclusions." But as long as you live in terror of death, you react likewise to the end of a relationship, and as a result, you pervert the love that does exist.

Cineaste: *You don't see oppression as a simple question of good and bad; your films point out that it is a complex and insidious thing. This has been the cause of some misunderstandings . . . you've been called a misogynist for the alleged anti-woman attitude of your films, for example.*

Fassbinder: If you look at women seriously, you can't show them better or poorer or I don't know what than they are in reality, because, since they have been oppressed a long time, they have found ways of overcoming it and if you show precisely *these* possibilities, it says more about oppression than would a simplistic black and white/bad and good "painting" of the poor woman as opposed to the tyrannical man. This doesn't prove anything.

I ran into this problem when dealing with the oppression of Jews. When I was systematically making films on minorities, I used to show the oppressor as a mean, unsympathetic person and the victims as good and kind. It became clear to me that this was not the right way to portray the oppressor/victim relationship. The really terrible thing about oppression is that you can't show it without showing the person who's being oppressed and who also has his faults. For example, you can't talk about the German treatment of the Jewish minority without evoking the Jews' rapport with money, but when you do this it seems as if you're explaining or accounting for this oppression. Now, oppression allows very few possibilities of reaction, survival. There's very little choice. I stand firmly behind this thought: you must show the victim with his qualities and his faults, his strengths and his weaknesses, his mistakes. And for this I've been called an anti-Semite!!! And when I show the mistake made by the woman living with this fucking man, they say I'm a misogynist! And when I made a film about homosexuals and showed the mistakes that, within their social context, they are forced to make...because if they didn't commit any errors, then they might just as well die. They must save themselves through their mistakes and, in showing this, you point out just how awesome and powerful the oppression has been: you show that the victim is *compelled* to do this or that *because* he's been oppressed.

That is what I'm trying to clarify when talking about the oppression of women, Jews and homosexuals, and for this I've been called an anti-homosexual, an anti-Semite, a misogynist...it's really laughable. After making *Fox,* I ran into so much trouble with German homosexuals. They were so aggressive towards me; they kept asking me why I showed them so negatively....

Cineaste: *But you didn't....*

Fassbinder: That's what I told them!

Cineaste: *In the final analysis, the film is about the class struggle that happens to take place in a gay milieu, but homosexuality per se was never posed as a "problem."*

Fassbinder: That's the film I made, but they didn't see this film; they only saw homosexuals making mistakes. They wanted to be exhibited as good, kind and friendly people, and that would have been a lie. I'd have been saying that they didn't have any problems. If everything's great...fine, you've got nothing to change.

Cineaste: *Some factions of the left have also attacked your films quite vehemently.*

Fassbinder: No one who thinks according to an ideology that comes from outside himself can like my films. I make films for people who don't think in terms of pre-formulated doctrine; the others go to see my films and they must hate me because they understand.

Cineaste: *Mother Kuster's Trip to Heaven, in particular, caused quite a stir among the left; its screening at the Forum during the 1975 Berlin Film Festival was disrupted by protests. You were very sarcastic towards the communist couple in the film: the ostentatiously expensive furniture. . . .*

Fassbinder: That's not sarcasm, that's realism. What's important is not the fact that they have a color TV or whatever, but that they're ashamed of having it. They need to justify their possessions by saying that the wife inherited it. I don't think that the revolution necessitates poverty.

Cineaste: *Did you start your career in the cinema?*

Fassbinder: Yes, I made two shorts *(Der Stadtstreicher, Das Kleine Chaos),* after which I devoted my time to the theater because I didn't have enough money to continue making films.

Cineaste: *Yet you occasionally return to the stage.*

Fassbinder: Yes, but only under certain circumstances: if I have the possibility of doing the production in a city I like, with people that I like, and who enjoy being together. If we come up with an idea that strikes our fancy, then I write the play. When I'm doing theater work, it's for myself; I'm not interested in an audience. The horrible thing about the theater is that, having found an idea that you like, you must repeat it night after night. . .it'd be much better if you could just put it on TV.

Cineaste: *What is the theater's role today?*

Fassbinder: I think it's dead. The cinema is much more interesting. Film is at the point where the theater was before Sophocles: an embryo, it hasn't even come out until now.

Cineaste: *You've also done some things for TV.*

Fassbinder: Yes. It's an interesting medium—and it is a medium, as opposed to film, which is an art. Aesthetically, my conception doesn't change but the point of departure, the reason for doing it, is different.

Cineaste: *Are you acquainted with Godard's work in video?*

Fassbinder: I haven't actually seen any of it, but from what I've read in the interviews and so forth, I get the impression that he's not interested in an audience and this I can't understand. To work with as technical an instrument as a video camera and ignore the

audience is beyond my comprehension. I can see doing that in theater because there is an exchange between the people involved, relationships are formed.

Cineaste: *I think that Godard is doing what could be termed "research" on the medium's mechanism and function.*

Fassbinder: You may be right. I think he will come back and give us something tangible one day, but if he *is* attempting to make the medium richer, in fact, he never expresses that.

Cineaste: *You admired his early films a great deal.*

Fassbinder: Some, especially *Vivre sa Vie.*

Cineaste: *Some of your early films have been described as Godard-influenced.*

Fassbinder: That's not really a just evaluation, at least not in a thematic or formal sense. What I did learn from Godard was a way of reacting quickly to the cinema in terms of my own reality.

Cineaste: *At this time he was making films for an audience whereas you consider your early films (up to* Beware of a Holy Whore) *to be too private, too elitist.*

Fassbinder: Yes. *A Bout de Souffle* is a film everybody can enjoy; it really touches people. I feel touched myself when I see it and this is what I don't like about the film...I don't like to be touched in that way.

Cineaste: *What do you mean by "touched"?*

Fassbinder: Well, to put it vulgarly, I felt as if he'd touched my cock, but not because he wanted to do something for me; he did it so that I would like his film. He didn't do this afterwards.

Cineaste: *I presume you don't consider* A Bout de Souffle *to be his masterpiece?*

Fassbinder: I think *Vivre sa Vie* may be his masterpiece...but, really, this question of masterpieces is irrelevant. In the final analysis, all that matters is the body of work that you leave behind when you've disappeared. It's the entirety of the *oeuvre* that must say something special about the time in which it was made...otherwise it's worthless.

19—JOHN HOWARD LAWSON

Organizing the Screen Writers Guild

When John Howard Lawson died at age eighty-two in 1977, he was less remembered for his screenplays (Blockade, Sahara, Algiers, Counterattack, Action in the North Atlantic) *than for his role in founding the Screen Writers Guild and his role as ideological guru of the Hollywood branch of the Communist Party-USA (CPUSA). Lawson made headlines in 1947 as one of the Hollywood Ten who defied the House Un-American Activities Committee. He served nearly a year in prison and never worked in Hollywood again. The following interview (edited here to read as a first-person narrative) was conducted by Dave Davis and Neal Goldberg in 1973 in connection with their research into labor history in Southern California which culminated in a thirty minute black and white documentary,* Strike the Set. *The memoir sheds light on the circumstances surrounding the formation of the Screen Writers Guild, but because it was only the first of what was hoped would be a series of discussions, it did not touch on the role of the CPUSA in Hollywood, nor on Lawson's role within the Party.*

My relationship with film goes back to 1920, when I'd just come back from the First World War, where I was in the ambulance service. I was broke and I had a family and, at that time, in 1920 or the first months of 1921, I sold a play to Paramount Pictures for five thousand dollars. That enabled me to go to Europe for two years to write and that resulted in the plays *Roger Bloomer* and *Processional,* which were done in the New York theater in 1923 and 1925. So I had actually had business connections for the sale of material to Hollywood as early as 1920-1921.

That first contact didn't result in any further attempts to do work for the industry because during the nineteen-twenties I was preoccupied with trying to develop an avant-garde movement in the theater, a movement towards theatricalism and away from stage realism, an attempt to introduce entirely new values into the theater. It corresponded in many ways with what Brecht and Piscator and Meyerhold were doing in Europe. The most important example of this was probably my play *Processional,* which was done by the Theater Guild. I then went on to form, along with four other writers, the New Playwrights Theater, which functioned in New York in 1927 and into 1928 at the Cherry Lane Playhouse in Greenwhich Village. Although it was important, in my opinion, and made a deep impression on many people, it became apparent that we could not subsist. The conditions under which we operated just didn't allow us to exist as writers or producers or managers.

It was absolutely essential that we find a different way of functioning, especially because I was dead broke at that time and had heavy debts. The New Playwrights Theater could no longer function, and there was really nothing else in New York theater that could afford to support an avant-garde—a so-called workers' or people's theater, which is what we were trying to establish. Just about that time, in late 1928, I received an offer to come out and work for MGM. It was interesting that they should ask me, of all people, because I was associated with a more or less revolutionary or rebellious movement in the theater. But the motion picture companies didn't care about that—they thought they could use me, get something out of me and, at the time, they weren't worried about what my opinions were. As a matter of fact, that was right at the time that Eisenstein was visiting Hollywood and had a job with Paramount in relation to a dramatization of Dreiser's novel, *An American Tragedy.*

So I came out to MGM on a contract for three months with options

running for five years. After some waste of time, I began to function very effectively at MGM. I got along very well there with Thalberg, who was the head of the studio then. I stayed there for about two-and-a-half years, coming out in the fall of 1928 and staying until the middle or end of 1930, during which time the stock market crashed. The whole economy of the country went to pieces but there was still plenty of money circulating and available in Hollywood. I did a number of very bad but very important pictures which made a great deal of money, including *Our Blushing Brides* starring Joan Crawford, another one called *The Sea Bat*, and *Dynamite*, Cecil B. De Mille's first talking picture. All of these were among my credits during those first couple of years, so I was really very successful in Hollywood.

By this time, though, I was beginning to feel that, in many ways, art should be connected with social issues. I was willing to accept the conditions under which one worked in Hollywood, but couldn't help recognizing that these conditions were abominable, that even from the point of view of turning out a satisfactory commercial product, it was very difficult and almost impossible to function effectively under Hollywood conditions. That was true in 1929 and 1930 and I suspect that, from all I know about Hollywood, it's still true today. From the point of view of the bankers and financiers, of course, it makes lots of sense because they make a lot of money out of deals. But from the point of view of turning out an effective and useful commercial product, it makes no sense at all, in my opinion. Of course, that's something that could be debated at great length.

By 1931 I'd put aside a little of my money from Hollywood and I decided to go back to New York where the conditions were more favorable for my plays than they had been earlier, because the Depression had intervened and plays with some social content were beginning to be in demand. This was just at the time when the roots of the Group Theater were being formed by Clurman and Strasberg and Cheryl Crawford. I knew them and was acquainted with their efforts. It was a period when it looked as if there would be opportunities in the theater, but to go back to New York I had to free myself from my contract with MGM. The only way I could free myself from it was to break it, so I went to Irving Thalberg and told him that I wanted to break my contract and go back to New York because I had some plays that I wanted done. Well, Thalberg, being a suspicious man by nature and having experience with the difficulties of writers, immediately assumed that the plays I wanted to go

back and produce in New York were plays I had written on MGM's time. Actually, they had not been written while I was at MGM; they were plays I had written before I left New York in 1928. There was no way of assuring him of that or even of discussing the matter, especially because the fact that I wanted to leave the studio at all was very upsetting to him.

So I left MGM in 1930 and went back to New York. My wife and I had two children by this time and we were determined not to return to Hollywood, but to establish ourselves in the East. We wanted very much to be out in the country, so we bought a house out near the Sound on Long Island. There was a lot of work to be done on it but we were very happy with it. Pretty soon, however, the expenses of running the house on Long Island were so great that I had to go back to Hollywood to pay for it. I found, as did many other people, many other artists in other fields, that it's not so simple to make a compromise about commercial undertakings—in fact, it's almost impossible.

I had marvelous credits from my period at MGM, credits that were worth dollars in the bank. I was able to make a very unusual, very unsatisfactory arrangement with RKO in 1931 which allowed me to write three original film plays in New York, not at the studio, and just come out to the studio for two weeks consultation on each of the film plays. This was a very unusual arrangement at that time and it worked very badly because that was the year the Depression began to affect Hollywood. RKO in particular was in a state approaching bankruptcy and there were frequent changes in the leadership of the studio and the idea that you could turn out a script and throw it into that maelstrom and have it come out as a picture was perfectly absurd. They were very enthusiastic about some of the things I wrote and some of them were produced, but by the end of 1931 David Selznick had become the head of RKO—for a few months, not for very long—and he was working on his own projects and had no use for the scripts I had written. He did employ me for another four to six weeks, but then my period at RKO ended and I looked in vain for another job in Hollywood. The tremendous successes I had made at MGM had been dissipated by my failures at RKO, and apparently there was just no place for me to function. My family and I remained in Hollywood anyway because we didn't have enough money to sustain a permanent program of living in the East.

Soon afterwards, I had two plays produced—one in New York and one on the road. The one in New York was *Success Story*,

which was a very remarkable play and it attracted a great deal of attention. It just so happened that Cecil B. De Mille, with whom I had worked on his first talking pictures, wrote me a letter saying that he had seen *Success Story* and thought it was tremendous, that it was the only good play in New York. He especially admired the dialogue which was so life-like, he said, that it was absolutely astounding in the New York theater. Well, I passed this letter on to my agent and it immediately resulted in an offer to work at MGM again. Thalberg was very ready to forget the conditions under which I had left the studio if I was willing to come back, and especially if I wrote such wonderful dialogue, as Cecil B. De Mille said I did—De Mille was still at MGM. So I came back and was assigned to work on a story about a General Hospital.

I was back working at MGM at a reduced salary, but very happy to get the money. At the same time, however, I was very disgusted with the conditions in Hollywood. Then came the election of Roosevelt and its impact on the whole social situation in the country—his inauguration, the closing of the banks, and the stopping of all money transactions in the United States. This was not a move which presaged a revolution, by any means; it was a practical measure to stabilize the banking system and to avoid failures of banks. But it was used by the studios as the occasion to cut the salaries of all creative personnel by one-half. At MGM and the other studios, meetings were held of all the creative personnel—all the actors, writers, technicians and directors—and at these meetings the fifty percent cut was explained. Louis B. Mayer presided over that meeting. I was sitting not very far from him and I saw that as he talked about the cut in salaries—his salary was being cut one-half, too, he said—tears streamed down his face as he explained what a sacrifice it was. Well, I and most of my friends among the actors, writers and others did not think it was such a sacrifice for MGM. We knew very well that they were making profits and would go right on making profits, and that Louis B. Mayer was retaining his enormous assets in terms of stock in MGM. About that time I had begun to hold meetings regarding a writers' guild or union. When the fifty percent cut came, it seemed obvious that the writers in Hollywood—several hundred of them, many of them unemployed, and others being cut one-half regardless of the terms of their contract—that the time had come when it was possible to really organize a union, although writers were afraid of the word union, so we called it the Screen Writers Guild.

I was very active in the preparations for the first open meeting of

the Guild. At the time of the first open meeting—I think in March or April of 1933, shortly after Roosevelt's inauguration—nobody in Hollywood knew anything about the Guild. But the word had gotten around to writers, and there was a turnout of several hundred writers that night. I had taken such a leading role in the preparations, and in the study of the legal questions in regard to the organization of the Guild, that it was unanimously agreed by the steering committee that I should make the main report, and that I should be elected without opposition as president of the new guild, which I was very proud to do.

I was interested in a Screen Writers Guild for two reasons: in the first place, from an economic point of view; and in the second place, to make better pictures, to make some sense of the production of pictures within the industry. Now I didn't labor under the delusion that the writer could control his material, which is supposedly the situation in the theater, although in the theater, too, there are all sorts of factors which determine what the writer can do with a play which is in production and under all the pressures of production. But I did think that writers should have more participation in production, that they should be part of a team which would include the director and the producers of the picture. The producer, the director and the writer, in my opinion, should work together in a collaborative effort to make a motion picture. Whether this was practical or not, I would wonder now, but anyway this was very important to us at that time, the whole question of the treatment of writers. Not only their physical treatment, their physical inability to function effectively as writers but also the custom of having four or five writers or ten or twelve writers work on the same story, and the confusion about credits. During the time I'd been at MGM I got some very big credits, and I got some fairly good credits at RKO afterwards, but the credits did not correspond in any way to the actual work I had done on those pictures, because friends of the producers were put in for subordinate credits, and the credits were juggled in all sorts of ways.

So I was very much concerned with the writer's role in relation to the industry, and I still am. When I made the opening speech at the writers meeting—I think it was held in the Knickerbocker Hotel in Hollywood—I opened with the words: "The *writer* is the creator of motion pictures." I think people have failed to recognize the significance of those words which foreshadowed by many years the development of the auteur theory which developed in France and which identified the director as the creator of the motion picture.

Nowadays I wouldn't know whether it's the director or writer, but I would be very doubtful if the writer is the creator unless he and the director are the same person, or so close that they can really work in some sort of effective artistic collaboration.

In any case, those words were sufficient to ensure the eternal enmity of producers against the writers. I say eternal because it still exists—there's a strike of writers going on right now as we sit and talk. You see, the producers regarded the Screen Writers Guild not only as an economic threat that would negotiate and get higher pay for writers, but also as a deadly threat to the whole system of making films and to their authority and power over the material. In the months and years that followed, this became a major issue. This is important to mention because it's almost always ignored in accounts of the history of Hollywood. I don't think you can possibly understand the situation that developed around the Hollywood Ten and why the attack was made at that particular time in 1947 without this perspective. You cannot regard it as an offshoot of a labor dispute that came up suddenly at that time—the case of the Hollywood Ten goes back to the formation of the Screen Writers Guild in 1933, and I am very proud of the fact that I was a leading figure in organizing the Guild. It was a dedication that I felt deeply toward the writer, toward the freedom of the writer within the limits imposed by the industry, toward enlarging those limits so that the writer could do a more effective creative job. I felt this very strongly, although my ideas about how and to what extent it could be done have varied through the years and would be quite different today. But I regard that meeting at the Knickerbocker Hotel in 1933 as really the beginning of a cycle of my life, a determination, a committment to give my life and my professional activity to this cause. It was the logical beginning of the events that came to a crisis in 1947 and that sent me to jail in 1950 and 1951. These issues are still at work today and they're still ignored.

During the Depression, with the development of organization, including trade union organization and people's organization, it became very important for the leading power in the United States—what is loosely called the "Establishment"—to control the means of communication. The means of communication were far more important in 1933 and 1934 than they had been in 1925 and 1926, because the whole situation in the country had changed. There was no threat of revolution, that would be perfectly absurd to say, but there was a threat of social change—the social changes that

were being conducted with a great deal of liberal skill by Franklin D. Roosevelt.

When I was elected president of the Screen Writers Guild, I had a contract with MGM, so they kept me for the length of my contract. When it expired a few months later, I was fired, of course. I spent most of the year 1933 and early 1934 in Washington trying to get recognition of the Screen Writers Guild under the National Industrial Recovery Act, which was one of the great pillars of Roosevelt's legislation that had been adopted by Congress at that time. Being in Washington, totally frustrated in the effort to get recognition for the Screen Writers Guild, I learned a great deal about the Establishment and about Washington politics. The process of radicalization—which began for me at dawn on the battlefield in France when I was driving ambulances near Hill 301—that process of education in the meaning of the social structure of capitalism in the United States was continued and given a decisive turn by my function as the head of the Screen Writers Guild. I learned there was no compromise you could make with the Establishment. I learned that it was simply a dream—later, of course, the dream was realized—but it was simply a dream in 1933 to suppose that the Roosevelt Administration was going to support the demands of writers against the demands of the rulers of the industry, when the Administration and the whole government depended on the industry to popularize its activities and to support it.

However, there were interesting issues which arose during that campaign. We did win certain concessions as a result of the campaign I led in Washington, but the producers were very well able to undermine all the concessions. There were also a great many internal difficulties between the Screen Writers Guild and the Dramatists Guild and the Authors Guild, the other guilds of the Authors League of America, which had offered us a home. I had two more plays slated for production in the early spring of 1934, and I had to decide whether I wanted to go on as President of the Screen Writers Guild. I was very popular. One of the reasons I had been elected President of the Guild was that even at that time there was a left-wing and a right-wing in Hollywood, but I was almost the only person who was totally trusted by all groups within the Guild. They all felt that they could rely on me, that I would serve only the interests of the writer and be perfectly honest with everybody. I think that characterization would still hold good, and I think there are people in Hollywood who would accept that characterization. It is no longer

the general opinion of people in Hollywood, though—they consider me violently prejudiced in favor of an extremely radical position.

Be that as it may, I decided in 1934 that I could not run for reelection as president of the Guild, although I wanted to be on the board and participate very actively in its activities. So when the election was held in Hollywood—I was living in the East at the time—they accepted my refusal to run for president again, and Ralph J. Block became the second president of the Guild. He was not elected by acclaim. I am still the only person in the history of the Screen Writers Guild who was elected by a unanimous vote of the membership.

The Guild and I soon entered a very difficult period. It was perfectly plain, not only to me but also to other leaders of the Guild—Ralph Block was succeeded in 1935 by Ernest Pascal—and from talking with Sidney Howard and leading writers from the Dramatists Guild of the Authors League of America—that the only way to make our point and become recognized by the motion picture producers was to form a single organization of writers, one organization that could stop the flow of material from all writing sources to the producers. As long as the Screen Writers Guild and the Authors Guild and the Dramatists Guild were all separate organizations, and all going their separate ways, there was no possible way of organizing a sufficient control of material to win a fight against the producers. So we undertook to organize one big union of writers, uniting all the various spheres, for the whole country.

Well, these were fighting words as far as the producers were concerned. When this plan was openly proclaimed, and simultaneous meetings in New York and Los Angeles were announced to establish this one organization of writers for the whole country, the producers were determined to break up these meetings and to kill the organization. Again, their attack was directed mainly against me. I had gone to Washington at that time to testify before a copyright committee regarding copyright law, and in the course of my testimony I had said that screen writers in Hollywood were treated like office boys. This was taken as a signal among the—it's a very comic idea—but this was taken as a signal among the more conservative members of the Guild that I was degrading writers and talking about them as office boys. A big movement to censure me and throw me off the board of directors of the Guild was organized and this frightened the members of the board so much that they made a compromise with the reactionaries. They offered to withdraw me in some ways and make an indirect

censure of me if the reactionaries would continue to support the program for one big union of writers. This was about May or June of 1936.

It turned out this was all a trick to destroy the Guild. The reactionaries in the Guild were very well organized. They did participate up to a certain point in the decisions to reorganize the Guild as part of one big union of writers, but then at a certain point they all got up and walked out and said they were through with the Guild. The next morning the blacklist was initiated for the first time in Hollywood—that was in 1936, not in 1947 or 1950—because the producers had decided that they could kill the Guild completely. I had warned the Guild that if they made any concessions to the attack on me, it wouldn't be myself who would suffer from it, it would be all the writers, because the Guild would be broken if we gave them that opportunity. Of course, this proved correct very rapidly—much more rapidly than I had anticipated or feared.

What happened to me personally was that I was definitely blacklisted in the industry, as were many other people, too, because of their known record as supporters and activists in the Screen Writers Guild. The Screen Writers Guild went completely underground; nobody could admit that they carried a card in the Screen Writers Guild. The blacklist was very loosely organized, however, because nobody was very worried as far as the producers were concerned. Zanuck was really the leader of the producers in suppressing the Guild, and he was very open and very frank about it. There were a great many full-page advertisements, many of them very insulting, in *Variety* and the *Hollywood Reporter* stating the positions of writers, pro and con, on the Guild. But as far as the blacklist was concerned, it really worked more or less automatically and it wasn't anything where there was a definite person or group of people to whom you applied to clear yourself or anything of that sort, as it was later. My friend Francis Faragoh, who was very successful in the industry at that time and who was Vice President of the Guild at the time it was broken up, was convinced that his fate in Hollywood was determined by his connection with the Guild and that the blacklist operated against him and against a great many other people with whom he was associated. In any case, that struggle in 1936 and 1937 marked the first stage in the rather naive effort to create a Screen Writers Guild in Hollywood.

Meanwhile, the creation of the Screen Writers Guild was responsible for the parallel and almost immediate creation of the Actors

Guild, which was founded in 1933 just a few weeks after we founded the Screen Writers Guild. The Actors Guild was founded very largely with my advice and under my guidance. I sat with the committee and we talked over all the arrangements; their basic contract, and their agreement with their members, were really modeled directly on the arrangement of the Writers Guild. The Actors Guild had one thing in their favor, though. The Actors Guild was not feared in relation to the control of material, because the only people who were a threat were the very powerful stars who were in a position to dictate what was written, but even these powerful stars were not independent enough or important enough to constitute any real threat to the power of the producers. At the same time, the actors had an advantage in that they were essential immediately to production. If actors walked off the set, that meant a loss of hundreds of thousands of dollars that very day, whereas the connection of writers with production was much more remote, and much less immediate in terms of a threat.

So this was the first stage in the history of the organization of the writers and actors. The actors had been denied any recognition at that time, and the writers not only had no recognition but they no longer had a guild. In the place of the Writers Guild, a new organization under the direction of the producers was set up. It was called the Screen Playwrights, or something of that sort, but it was simply a company union.

□

I came back to Hollywood, however, in the middle of 1937. I came back due to the courage, really, of one man, Walter Wanger, who was an independent producer desperate for material. He had established a friendly relation with Harold Clurman, formerly of the Group Theater. Clurman was working as general editor for Walter Wanger, and Wanger had a problem with a story that had been written by Lewis Milestone and Clifford Odets. The story was unsatisfactory, it hadn't worked out, and Wanger didn't know what to do with it. Clurman suggested that he call me—I was back in the East at that time at our house on Long Island, which we were still trying desperately to support—and Wanger telephoned and asked if I'd come right out to Hollywood, and I said I would.

I came out very shortly and we entered into discussions about the film. At that time it was based on a story by Ilya Ehrenburg about Russian expatriates who had refused to return to Moscow at the time

of the revolution and who were living in Paris. It was about the problems of these Russians, whether they should return to the Soviet Union and take part in the activities of their own people. Milestone had read this story and persuaded Wanger to buy it. Milestone and Odets then worked on the story on the basis that it would be changed to a story about Spaniards living in Paris who were intially sympathetic to the Franco regime, and their discovery, their great enlightenment, to the point where they decided they must go back and take a gun in their hands, even if there were no ammunition, in order to defend the democracy and the people of Spain.

Well, practically the whole story took place in France. When I went in to see Wanger, I said, "I have a really startling idea for you—why don't you have the story take place in Spain?" So, he said, "How do you do that?" And I elaborated the idea of a small town in the part of Spain still held by Franco, a small seaport town completely surrounded by the Franco forces, with the people dying of starvation, waiting for a Russian ship which was bringing supplies. The ship then appears through the mist of an early morning outside the harbor and just as it's about the reach the dock, it's torpedoed and sinks at the dock, and all the supplies are lost. That was the skeleton outline I submitted to Wanger of what I hoped would be a real documentary about the Spanish struggle, and he enthusiastically accepted it. That's why the picture was called *Blockade*. In making the film, however, there were many questions. It was agreed beforehand, of course—there was no question of the fact that we had certain limitations—that we could not call the Loyalists by name, we could not use the actual Loyalist uniform. This I accepted because it was the only way in which the picture could be undertaken. There was complete understanding between Wanger and myself and there was no attempt on my part to introduce material without discussing it, because I would consider that dishonest and would never attempt to do that with a film I was making.

The problem of *Blockade* was not only the question of how far you could go with it politically. It seemed to me that a great film could be made simply on the question of democracy in Spain, because this to me was the basis of the struggle of the Spanish people. There was also the point that Franco and Hitler and Mussolini were using Spain as a means of preparing for World War II, and if the people of Spain were defeated, World War II would follow. This we agreed upon and this was the basis of the story. But there were lots of problems—aesthetic problems, creative problems—that I was not able to solve.

I'm proud of the fact that *Blockade* did play a part in the struggle around the awakening to the meaning of Spain. I'm proud of the fact that it was the only commercial film that was made that did attempt to take the Loyalist side and to explain the Loyalist point of view in the Spanish struggle. But as for the aesthetics of the picture, it is not a fine picture in many ways. I wouldn't say it's a bad picture, because it's touched by the greatness of the subject. There are moments in *Blockade*, however, when you can see a definite conflict between the documentary aspect—the faces of the Spanish people, peasants, city people in the little town, the people on the hill watching for the boat from the Soviet Union to come in—and the second-hand spy story which is the central story of *Blockade*. You just cannot fit them together. That is my fault, no one else's fault but mine. I never could find a way of dealing with this material that would give its full weight and strength in relation to the tremendous historic issues that were raised.

There's a very interesting story about *Blockade*. It was planned to have a gala opening at Grauman's Chinese Theatre and, at the last minute, Wanger was forced to call if off. He was forced—and he told us this himself—he was forced to send copies of the script not only to Washington but also to Paris and London for advice as to the changes that would be made. When the changes were made, the picture had a much more modest opening at the Westwood in Los Angeles. So there was enormous pressure on the picture. There was so much pressure, in fact, that William Dieterle and I—he was the director of *Blockade,* as you know—William Dieterle and I felt it while working on another film for Wanger. It was to be the first film to deal with the struggle against the Nazis, the underground struggle in Hitler Germany. That film was all ready to go—it was cast, the scenery was built, and it was ready to start on a Monday morning. On Saturday of that week, Wanger called in Dieterle and myself and he said, "I'm sorry, but I've been told that I'll never get another penny of banking money in Los Angeles or anywhere else in the United States if I make this film. So all I can tell you is that it's off. Sorry, but there's nothing I can do about it."

☐

Meanwhile, tremendous changes were being made in the situation in Hollywood, because the actors and the writers had grown in strength. Roosevelt had adopted a much more radical program than

that with which he started. Roosevelt was also interested in the Hollywood situation from the point of view of preventing film production from falling into the hands of total reactionaries. From a liberal point of view, Roosevelt had become quite interested in the plight of the writer. He didn't like actors, he was always prejudiced against actors and thought they were bad people. There's a very interesting letter I have somewhere in which Roosevelt explains his attitude toward actors as opposed to the really serious people, the creators of film, who he thinks are writers.

By this time there was the National Industrial Relations Act, with its clause 7.A, which guaranteed collective bargaining. So under the Labor Relations Act, we were able to force the issue of collective bargaining. A labor election was finally held between 1939 and 1940, as I recall, and the Screen Playwrights, the company union controlled by the producers, was overwhelmingly defeated and the Screen Writers Guild was made the sole bargaining representative for the writers. I was reinstated by having worked with Wanger and because the producers and the Administration took a different attitude toward trade union organization from that they had taken in 1936. I was able to be on the committee that negotiated the contract for the writers, in 1941 I believe it was, a contract was finally agreed upon and signed. I was present during that whole procedure as one of the representatives of the writers.

However, there was a great deal of pressure mounting. Reactionaries and representatives of American fascism of various shades and kinds were beginning to work very actively in Hollywood because the question was being faced increasingly as to who would actually control communication. This is the question that the Hollywood strike in 1946 and 1947 was really about, and this same question went back to the very founding of the Screen Writers Guild.

That question was very obviously raised in regard to my film *Blockade*. It appeared just at the time when the so-called consent decree about the trustification of the industry was signed by the producers, with the producers agreeing to divest themselves of certain properties in exhibition in order to avoid an all-out anti-trust suit. The anti-trust suit was tabled and certain agreements were made in regard to it. That happened just at the time of the production of *Blockade*. One of the people who was most active in attacking the film industry as being a trustified industry, and demanding that trustification be stopped by the government, was Walter Wanger, because he was one of the independents who was most affected by

the increasingly tight concentration of capital in the industry—a concentration of capital which in other forms goes on today.

By 1941, when the Screen Writers Guild was organized and recognized by the producers, and the Screen Actors Guild had been recognized, and other guilds had also been recognized, by that time it was apparent that there would be a major struggle around the strength and position of the guilds. The Screen Writers Guild had to be controlled by the producers in such a way that it could not go beyond the limits of purely economic questions. The political attack on the Writers Guild and other guilds in Hollywood, the attempt to take over the guilds in the sense that they should be prevented from having any larger perspective or larger point of view, began in 1940 and 1941. This was when the Dies Committee was first formed. The Federal Theater was destroyed at this time—that was the first function of the Dies Committee. It was also at this time that a man named Jack Tenney became president of the musicians union on a very radical program. But the minute he became president—with the help of the writers and actors, incidentally—he immediately turned reactionary. He became chairman of a committee of the California legislature investigating communism in Hollywood, particularly in the motion picture industry. So in 1943 and 1944, Jack Tenney was operating, having hearings. I was called to those hearings and forced to give certain testimony although I refused to give other testimony that they tried to wrangle out of me. Both the national Dies Committee and the local Tenney Committee were working overtime to prove that there was a huge communist conspiracy in Hollywood.

It's important to note, in this connection, that at this time the writers began to extend their interests beyond just purely economic questions. One tremendous event which occurred at this time was our participation with the University of California in Los Angeles in holding the first Writers Congress. It was held right in the middle of the war, in 1943, and it opened with a message from the Commander-in-Chief, from Roosevelt himself, saying that this was one of the most important events that had taken place in the United States. Despite this, the Writers Congress was violently attacked in Los Angeles by Jack Tenney and it was violently attacked in Washington and by the Hearst press. It was considered a plot by communists to take over the industry.

Out of that first Writers Congress, however, came the first collaboration between working people in the media—film, radio and, later, television—with academic people. I can say with pride and

Constantin Costa-Gavras

Henry Fonda and Madeleine Carroll are brought in for questioning by one of the factions ambiguously characterized in *Blockade*.

Fox (R. W. Fassbinder) receives some comfort from his sister (Hedwig Christiane Maybach) in *Fox and His Friends* (*Fist-right of Freedom*).

Karen Trott and Maggie Renzi near the swimming hole during their reunion in *The Return of the Seacaucus Seven.*

John Sayles

Maciek Tomczyk (Jerzy Radziwilowicz) grips his martyred father's work gear in *Man of Iron.*

Andrzej Wajda

Budd Schulberg

Terry Molloy (Marlon Brando) receives a pay-off from mobster (Lee J. Cobb) as Terry's brother (Rod Steiger) looks on in this scene from *On the Waterfront.*

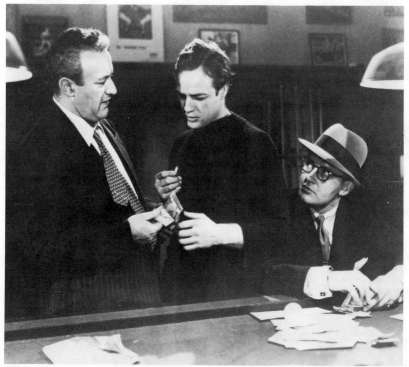

Agnes Varda

Gordon Parks

Aparna (Sharmila Tagore) returning from the cinema in
The World of Apu

Satyajit Ray

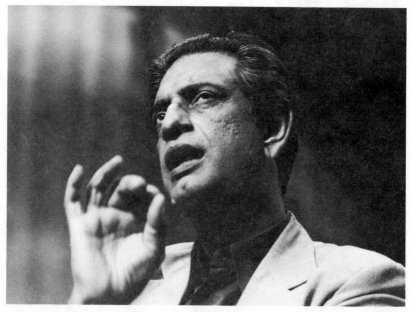

Zeke Brown (Richard Pryor) and Jerry Bartowski (Harvey Keitel) square off
for the final scene in *Blue Collar*.

Ed and Beth Horman (Jack Lemmon and Sissy Spacek) study the mounds
of dead in an effort to find Charles in *Missing*.

without any hesitation that I was largely responsible for this first collaboration. We decided to publish a magazine, *The Hollywood Quarterly*, which first came out in 1945, I think. I was one of the editors and largely active in determining policy. We wanted to make it a genuinely active academic magazine, which at the same time would go into the problems of the industry, which would try to make the making of pictures a more creative process, and which would be supported by the guilds. There are many reasons that couldn't be accomplished, but one of the main reasons was that by 1946 it was no longer possible for me to be an editor of *The Hollywood Quarterly*. I recall the day when I was called into the office of Clarence Dykstra, who was provost of the university at that time, and with great regret and with apologies, he told me that he had been told that he had to either drop *The Hollywood Quarterly*, to sever all relations between it and the university, or else I had to resign as one of the editors. "Well," I said, "I don't want to hurt the magazine, so I'll resign." *The Hollywood Quarterly* was later changed to *The Quarterly of Film, Radio and Television*, and then it was changed to *Film Quarterly*, which is still being published. It is the direct descendant of the magazine that I helped initiate in 1945.

Today, of course, there has been a proliferation of communications departments, of the study of communications and the inter-relationship of the media. It is exemplified particularly in the California Institute of the Arts which was established with the money of Walt Disney. I remember reading an article on the founding of the Institute by Corrigan—he was head of the institute for a long time until he was forced out—in which he said, "This is a revolution in the arts. This is the first attempt to have a genuinely free institute of the arts." Well, how can you have a free institute of the arts when it's got that kind of money behind it? When its function is obviously to keep people quiet and not to help them express themselves? For that matter, what happens to the film industry, what happens to independent production, when you have all this business intervention today? Paramount is connected with Gulf Oil, Warner Brothers is connected with Kinney Shoes—I mean, how can you talk about the independence of the industry, or the independence of any individual, however well intentioned, working within the industry, when all this is going on?

These questions deserve a great deal further study. And all this history is essential to understanding what happened on a certain morning when subpoenas were delivered to about twenty-five

Hollywood people who went to Washington and became the Hollywood Ten. This is the reason why the Hollywood strike in 1945, 1946 and 1947 was broken so brutally and with so much violence.* It all fits into a certain pattern, and unless that pattern is observed, it's very difficult to understand the trade union situation in Hollywood today, it's very difficult to understand how the content of pictures relates directly to the process of unionization.

*A strike was begun in Hollywood in March 1945 under the leadership of the Conference of Studio Unions (CSU), a confederation of various craft unions— painters, set decorators, machinists, electricians, etc.—which was attempting to organize a new democratically-run industrial union to replace the AFL unions which, under the domination of Roy Brewer's International Alliance of Theatrical Stage Employees (IATSE), were politically reactionary and rife with corruption. In October of that year, mass picket lines outside the Warner Bros. studio were attacked by strikebreakers and goons armed with baseball bats and tire irons, with assistance from the Burbank police, who used high-pressure fire hoses and tear gas against the strikers.

The CSU strike was eventually defeated, and the CSU itself destroyed by an alliance between Brewer's IATSE and the studios. The whole affair was characterized by intense red-baiting and ended in a series of law suits, conspiracy arrests and a congressional investigation.

20—PAUL SCHRADER

"Blue Collar"

Paul Schrader's first formal involvement with the film world was as a critic and then an editor of the now defunct Cinema *magazine. Later he was scriptwriter for* Taxi Driver, Obsession, Yakuza, *and* Rolling Thunder. *In 1977, he directed his first feature film,* Blue Collar, *which he co-scripted with his brother Leonard. The film's focus on the automobile industry in Detroit and the city's racism was particularly engrossing to Gary Crowdus and Dan Georgakas, both of whom were raised in Detroit. Georgakas also is co-author of* Detroit: I Do Mind Dying, *a book which dealt with many of the themes found in Schrader's film.*

Cineaste: *When you first decided to do a film on Detroit auto workers, what did you want to say with the film?*

Paul Schrader: I didn't set out to make a left-wing film. I had no visions of making this into a concrete political thing; it had to operate in the area of entertainment. I wanted to write a movie about some guys who rip off their union because it seemed to me such a wonderfully self-hating kind of act, that they would attack the organization that's supposed to help them. It's so symptomatic of the way that workers think about the organizations that surround them. You know, in their minds, and in the minds of a lot of people in this country, the union, the company and the government are synonymous. They have different logos but they're essentially the same thing.

While I was working on the script, I realized that it had come to a very specific Marxist conclusion. It seemed the only way to end it, the natural way to end it. I didn't end it that way out of any pre-set notion; I didn't set out to make a movie that would end that way, it just seemed to be the logical ending. On the other hand, if the logical ending to the story that I had set in motion had been a right-wing ending, I wouldn't have had any qualms about going in that direction either, or defending it.

Aesthetically, you know, Che Guevara's life is no more interesting than Rommel's life. You could make a great, rich story about either one of them. As an artist, you have to hang your film on a character and let the character give you your strength, and if a critical feeling comes out of the character, all the better. But I don't feel you should prejudge that theme, otherwise your movie becomes the acting out of a pre-set dogma, rather than arriving at it through a natural sequence of character exploration. That to me is the danger of so many left films—they know the thesis before they know the characters and the characters never live up to the thesis, and it has to work the other way around to have any dramatic sense. The left films I really like are the ones that love their characters.

Cineaste: *What are some examples?*

Schrader: *Before the Revolution, Memories of Underdevelopment*...those are two films I'm really very crazy about. I think they're very, very good films.

Cineaste: *But what drove your characters to that conclusion?*

Schrader: Well, it just seemed to me that that's the way big organizations work. If you can keep a certain amount of tension in your work force, it makes everything smoother—you can hire and fire people easier, you can change their jobs, you can get away with

poorer working conditions, because everyone is sort of going at each other, everyone's trying to outmaneuver his fellow worker. And the easiest way to create tension in the work force is through race, because everyone has this big button called racism mounted on their chest, so whenever there's an argument you just reach over and push the racism button and people start fighting amongst themselves.

When I started writing this story, I realized of course that was what was going on. As Jim Brown said—he saw the film the other night and told me he liked it a great deal—no matter what you do, the guy's going to call you a nigger. So the film is about that impossibility of integration in a work situation; there are too many tensions that will destroy any racial harmony. Racial harmony is a very weak and fragile thing which is very indispensable in certain kinds of situations.

Cineaste: *Is there any reason why you didn't have any women tension or, since it's in Detroit, Arab tension? Would it have been too much of an overload?*

Scrader: Yeah, yeah. I had enough things to talk about. There was one scene I cut out of the film where Harvey does a rap against the Arabs—you know, the Arabs are coming in, they're going to ruin the fucking economy, they're all over now, these goddam camel jockeys, and this and that. It was just to show his racism toward the next group. I liked that scene but it was cut out just because it didn't move the story along at a good clip.

And I really couldn't get into women in the film, it was just a whole 'nother thing. I mean, as I told somebody from *Ms.* magazine, as far as these men are concerned, women are ranked somewhere below beer and TV. That just happens to be what the film is about—men and racism and auto plants—and women are on the periphery of that. You can only hurt yourself by trying to cover too many bases.

Cineaste: *Is that why you didn't portray other important aspects of that working class reality? Especially in the auto plants, issues such as speed-up, unsafe working conditions. . . .*

Schrader: Sure, I mean there are a lot of things I would have loved to have touched on, but you're trying to tell a story and not do a tract. In fact, there are wonderful scenes that I cut out that *do* touch on things. There was a discussion about a five dollar doctor, for instance. One guy had a five dollar doctor—you know, somebody you can call up and for five dollars he'll say you were sick yesterday—and the other guys only have ten dollar doctors, so they're trying to figure out who the five dollar doctor is. It's a lovely scene but these little

things almost have to be used as throw-aways as you're running in order for them to work, unless you really make it the heart of a scene.

Cineaste: *Were there other scenes that you cut?*

Schrader: Sure, the first cut ran about three hours and it's down now to about one hour, fifty minutes. Some scenes were cut for length and some were cut because they didn't work. After the guy rams the vending machine and gets hauled off, I had a worker sabotage scene where the workers get pissed off and fuck up a car. I loved the idea of it but the execution was not good, it was just not a good scene. The question became, do you put in a mediocre scene just because it has a good idea? And you don't.

Cineaste: *Were there scenes added during the shooting that weren't indicated in the script?*

Schrader: I added one scene while we were filming, at Richard's request. He was right about one scene that we needed, that scene between him and "Knuckles" Johnson on the freeway overpass. Richard just felt that the character does too quick a flop, and you had to see him making the turn. So that scene was written and shot just before we left Detroit.

Cineaste: *Did you approach any of the major auto companies in Detroit about shooting in their plants?*

Schrader: Yeah, endlessly. We exhausted everything. We went through many channels but it was just a total freeze-out. In their defense, part of their reason for not doing it was that logistically they thought it was impossible. They're making fifty cars an hour, and there are two work shifts and one maintenance shift, and they said, "You tell us you can do it, but we know you can't."

Of course, the other reason was that they had nothing to gain and everything to lose—you know, they would have product identification problems, work force problems, union problems, city government problems, and so on. There was just nothing in it for them at all. We were really despairing of giving the film any reality at all when the arrangement with Checker just sort of miraculously worked out.

Cineaste: *Do you think that represents a serious compromise for the kind of reality you wanted to portray?*

Schrader: Of course, but the way I looked at it was that if I didn't get Checker, I was going to do it at a mobile home place, and that wouldn't even have been a factory, it would have been more like a craft shop. At Checker, though, I got to see the entire auto making process, because they make the whole car. They make the frame,

and they do the finishing, the painting, the whole thing, whereas with the "Big Four" it's all specialized—you know, one place makes the body, another place makes the motor, and so on. Also, at Checker, since they make only about twenty-five cars a day, we were able to really shoot there, right around the line. What you lose, of course, is that mass specialization that occurs when you're putting out fifty cars an hour rather than twenty-five a day.

Cineaste: *Did you therefore find yourself leaning heavily on the foreman as a dramatic device to convey the abrasive nature of working conditions in the plant? You lose so much. . . .*

Schrader: Yeah, I know you do, but there's just no way you can get into those plants.

Cineaste: *Why did Checker agree to let you film there?*

Schrader: Well, it was a family operation with just one guy in charge and I met with him. He and his wife had just seen *Silver Streak* and she liked it, thought it was very funny, so he said, "Well, OK, it'd be fun, you can make a movie here." He wasn't worried about product identification—Checker's image is not going to suffer from this film. He wasn't worried that much about his union because he's AFL-CIO, he's not UAW. And his union was getting ready to go on strike anyway, and he thought this would be kind of a nice way to make conditions in the plant a little more liveable as the men were preparing to vote on a strike—you know, you shoot a movie here and everybody gets to be in the movie. A lot of the workers were in the movie and they all thought that was swell. So the whole thing happened to work out.

Cineaste: *What sort of research did you do for the film?*

Schrader: We taped a lot of interviews with workers. I did a lot of reading, of course, and I saw all the films. We used your article in *Cineaste* on "Films on Work and Workers" and rented all those films. I had three of them—*Blue Collar Trap*, *Finally Got the News* and *Work*—put on video-tape and we all watched them many times.

I put quite a few things in the film which came directly from research but I ended up cutting most of them out because they had that sort of didactic, research feel to them—you know, "Oh, this is something they heard in research." One of the things I left in which came out of research was the green room scene, where you see how a negotiation is handled in the middle of making cars. You get a quick little negotiation and then everyone's back working again.

Cineaste: *The film includes a credit—"Suggested by source*

material by Sydney A. Glass." What was his contribution to the project?

Schrader: Well, it's a very ugly, complicated story of how he got credit. I'm very upset about it because he had a gun to my head. What happened was I was speaking at the Writers Guild one night and afterwards this black kid came up to talk to me. He said he was having trouble writing and wondered if he could talk to me and if he could get a copy of the *Taxi Driver* script. I told him to come over to the house sometime. So he came over, he was there about half an hour, and talked about how he was trying to write. He had done a "Movie of the Week" and it had been rewritten, so he was very disappointed and disillusioned about working in general. So I said, "Well, what do you want to write about?" He said, "I'd really like to write about my father who was an auto worker in Detroit and who committed suicide two days before his retirement." I told him, "Now that's a very interesting subject. I mean, not about your father—I'm not particularly interested in your father, that's your problem—but the idea of blacks in auto plants. It's a very interesting thing that's never really been dealt with." I said, "You should do it with two blacks and a white and it should deal in some way with how they get some information and get a chance to become bigger than they are." Then the conversation sort of drifted away and as he was leaving, I said, "Now be sure to write that movie about blacks in the auto plants, because that's a good film."

Later on that evening I got to thinking and I called up my brother, Leonard. I said, "You know, I told this guy an idea today but I think this is an idea *we* should write because, what the fuck, this guy ain't going to write it, I know that." So we wrote the thing at nights in the next three weeks. Then I got Harvey and Richard involved and I got T.A.T. Communications to agree to pay our salaries in advance. That got T.A.T. hooked into the movie, and I had to get the hooks in deep in this damn thing because I knew it was going to be very hard to finance. Anyhow, just as I was making this deal, something appears in *New West* magazine where Richard Pryor says he's going to do *Blue Collar*, a film about blacks in auto plants. So I get a phone call from Sydney Glass and his lawyer, saying I stole his idea. I said, "I didn't steal your idea. You don't even know what the movie's about." So he went to the Black Caucus of the Writers Guild and got them to bring the case up. Unfortunately, it became a sort of black/white thing—it was my brother and I against the Black Caucus since we had "stolen" this black guy's idea. So I went to the Writers

Guild and I pleaded, "Look, let the thing be arbitrated after the movie. The man may have a gripe, but let me make the movie, and then we'll take it up before arbitration and settle it. Whatever you decide is fine with me but don't make me arbitrate this while these deals are hanging in the air because that means I have no leverage, I can't do it with a gun to my head." They said, "No, we're going to have to decide it now." Then we got a one month postponement on the hearing, so that was going to be another month in which nobody was committed—T.A.T was not committed, Pryor and Keitel were not committed. So I just called him up and said, "Let's make a deal. What can we settle on?" So we settled on that credit, a cash payment of fifteen thousand dollars, and a point and a half. And that's on the basis of a half-hour talk—he hadn't written a thing, never registered a thing.

Cineaste: *Pretty heavy story....*

Schrader: Yeah. I was pissed off at the Black Caucus because of having to go into a pre-facto negotiation; with a post-facto negotiation, I wouldn't have had any problem.

Cineaste: *What did you find to be the difference between writing characters, as you have in the past for your various screenplays, and being able for the first time to write and direct them, to control their realization on the screen?*

Schrader: Well, of course, people are much more interesting alive. These three actors also do a lot of improvisation. With Richard, for instance, you'll never hear the same line the same way twice. So the exciting thing was to channel that interest and excitement, to keep all three of them moving and in balance until they became much richer. As you direct the characters, they start to take on a life of their own. If your original description is solid enough and simple enough, that complexity is only enriched by the actors. On the other hand, if they're two-dimensional to begin with, it's often hard to enrich them because the two-dimensionality just becomes expanded.

What I like to do in writing is to build contradictions right into the character, because that's the way people are, and then let the actor worry about it. An actor might say, "Well, in one scene the character says this but in another scene he does that." I always say, "So what! People do it all the time. People are continually mouthing some piety and then going off and doing something else." It's the actor's job, it's his talent, to integrate contradictions of behavior into a believable character.

Cineaste: *Did you do any re-writing as you went along?*

Schrader: Not really. The only re-writing was simply re-working scenes to suit the talents and feelings at a particular time. The scene on the porch at the end, for instance, between Pryor and Keitel, was three pages long in the script. It ended up about eight minutes long in the assembly [a first, loosely-edited version of the film—ed.] and about five minutes in the final version, so much of that dialogue was stuff that Harvey and Richard were coming up with at that time. And what gives that scene a lot of tension is that there's a lot of hostility between the two of them and they were really arguing at each other through the characters. A lot of the reactions are genuine at that point. That porch scene came after four weeks of real tension between Harvey and Richard. If I had been able to shoot the end scene later on, toward the very end of shooting, that scene would really have jumped alive because by that time they really wanted to kill each other.

Cineaste: *How did that all come about?*

Schrader: It's something I devised and set up in order to get good performances. As a first-time director, I knew I wasn't going to teach anybody how to act and I knew I wasn't going to get a big star actor. So I went to three actors, each of whom was pushing for his career and each of whom was not independently bankable. Then I took all three of these bantam roosters, dropped them into the same pit and made sure that nobody got out first. After a couple of weeks, you can imagine what it got like down in that pit, because they each wanted to put their stamp on the film. In fact, it was a clash of egos which got transferred, as it always does, into race.

Cineaste: *The porch scene is an important one, though, because it shows an understanding of why a black guy would cop out under circumstances like those. He's obviously not just a nobody who's taking the easy way—as he says, "I'm black, this is my only chance."*

Schrader: That's one of the things I'm happiest with. Richard's portrayal is one of the truest and best things in the film. You have a character, really, who is just a jive guy who told his wife when they got married, "Baby, big things are in store, I'm going to make a lot of money, things are going to be OK for us." Then he gets a couple of kids and he realizes it's all just talk and that his life ain't going to be much better than it is. Then this job promotion thing sort of falls out of the sky, all of a sudden all those fantasies of power, of actually being able to *do* something. . .*of course,* he's going to take it, I mean, what do you expect?

Cineaste: *It's surprising that Keitel doesn't take the foreman's job.*

I mean, you could have accepted that as an ending, with each of them accepting promotions.

Schrader: Yeah, actually the reason he doesn't is that he's just too damn scared. He doesn't know what to do, he's afraid; he doesn't have the strength of the other two characters.

Cineaste: *Is the FBI agent supposed to be a sort of dark character?*

Schrader: What I had in mind when I cast Cliff De Young—Cliff's performance really can't be faulted, but maybe the casting can—was to give a sense that the only difference between Harvey and Cliff was money. One of them was born and raised to be part of the Establishment and the other was born and raised to be fucked by the Establishment. When Harvey screams at him, "When I was working on the line, you were trying to decide which suit to wear to your fucking sorority dance, man!"—that's really all it is, just class. One was always going to be the winner, and the other was always going to be the dumb bastard who can't figure out how he got to be where he is. You know, at the end of the movie, he's trying to figure out why he's walking on the arm of the FBI man.

Cineaste: *You could have made the FBI agent a little more sinister for my money. I heard some people say they thought he came out as the good guy.*

Schrader: I was afraid to cast him too sinister because then he'd be a very simple villain, and I tried not to make any of the villains simple. For instance, the older union guy, "Knuckles" Johnson, I tried to make him like, you know, "This is how things are done, kid—welcome to the club." The foreman was intended to be just a pawn in a larger game. It would have been very easy to cast the FBI agent as the heavy, but I didn't want to do that.

Cineaste: *When he first came in, asking all those dumb questions, I thought he was going to be one of those plastic leftists. He's so inept, I said to myself, only a leftist could be this inept. I mean, I thought he was going to say something like, "Have you heard of the, uh, Young Workers' Alliance?" and then whip out his paper.*

Schrader: The idea was that he was pretending to be a sort of leftist professor.

Cineaste: *One thing about the three workers that didn't seem to come across early in the film, although it comes up in a later scene, is that it's unusual for these two black guys to be such good friends with a white guy. And the bar seems a little more integrated than most Detroit bars.*

Schrader: That's not realistic, it's a conceit of the film. The fact that these three men have this precious friendship and they don't quite realize how rare it is. But that's artistic license.

Cineaste: *There were a few other little touches in the film that seemed off to us. For instance, the Hamburger Helper scene — here's a guy who's working, he's not laid off, he's also moonlighting, and yet he doesn't have enough Hamburger Helper. It just seems a bit much.*

Schrader: Yeah, that was a mistake. That was played wrong and that's why I ended up by putting the TV show over it, to try to cut it down even more. It was supposed to be a more ordinary home-life scene. I mean, I came from a middle-class home and we weren't poor but I remember hearing that from my mother all the time—you know, "You've had enough to eat, have some more bread." It wasn't supposed to come out as a whiny, political thing, or about how hard things are.

Cineaste: *The other thing that seemed a little off was the scene with the IRS man. I just wondered why it wasn't set up for the wife to say, "Oh my god, I forgot to tell you the IRS guy is coming," which would have covered it better, it seems, than just having him come in out of the blue, which the IRS would never do.*

Schrader: Yes, you're probably right about that. That's a writing mistake, not a directing mistake. The assumption in the IRS scene is that the guy is really checking up to see how many kids are around the house. The idea is also a violation of the house—you know, get out of my house. It's not really realistic, but it allows a lot of things to happen.

Cineaste: *About the last scene, the freeze-frame — at what point did you decide to end the film that way?*

Schrader: That was in the script. It doesn't continue any more than what you see. That's it, I never shot a fight, it was always intended to end there. I had a lot of arguments with Universal about the ending. They were very worried. Universal felt that ending would actually cause racial confrontations in the theaters, that they would be accused of making a racist movie. So they demanded that I shoot a second ending where the two guys meet again and they're still friends. In order to get the film made I had to agree to do this, but all through the shooting I was sort of dragging my feet. They would submit their version of how it should end, and I would write another one, and then Richard said he didn't want to do it. Finally I told them, "Look, I really don't want to do this because you're trying to

get me to solve a problem we don't know exists yet." I said, "If we have a race war in the theater, obviously I'll shoot another ending. I don't want that. But I don't believe the problem exists. So let's wait until the movie is done and if it does exist, we'll shoot another ending." So they agreed to that and when they did see the movie they realized they wouldn't need the other ending.

Cineaste: *I think quite the opposite would be the reaction. It's almost a warning not to get suckered into that.*

Schrader: Yeah, that was sort of the hope. A lot of people criticized the use of the voice-over at the end, mainly for artistic reasons—that is, the movie should have done that, you don't have to underline it. But I think it sort of puts a finish on it, it pulls you back and says, "Now wait a minute, it's not important who hits who here. What's important is how they got to be here."

Cineaste: *What kind of advertising campaign will Universal be using?*

Schrader: The ad campaign is going straight at what the movie is about. We're using two different ad lines, one of which is, "The most dangerous man in the world is a man who's worked his whole life for nothing." And the other is, "The American Dream—If you're rich, you can buy it. If you're anything else, you've got to fight for it."

Cineaste: *How do you expect the people whom the film portrays to respond to it?*

Schrader: I have no idea, I'm going to be very interested to see. I'm looking forward to seeing it with an all-black audience.

Cineaste: *What would you like workers to come away with from the film?*

Schrader: I would like them to buy the movie as being reasonably realistic. And I would like some percentage, however small, to walk away with the feeling that things don't have to be that way, that you don't have to let the organization manipulate you into not changing your life. That is, you have to stop every once in a while and say, "Wait a minute, why am I doing these things?" If a percentage, however small, of workers who see this film say, "Yep, that's just the way it works," then in my mind the film will have been a huge success at a dramatic level, even if it's only a handshake.

21—AGNES VARDA

"One Sings, the Other Doesn't"

Agnes Varda has been associated with the woman's struggle and politics throughout her film career. She has dealt with topics as diverse as a pretty young woman who discovers her humanity only after learning she may be dying, Cleo from 5 to 7 (1961); the Cuban Revolution, Salut les Cubains (1963); the possibility that one person's happiness may necessitate another's suffering, Le Bonheur (1965); the creative process, Les Creatures (1966); U.S. imperialism in Vietnam, Far from Vietnam (1967); black liberation, Black Panthers (1968); the decade of the 1960s, Lions Love (1969); the Greek anti-junta movement, Nausicaa (1970); the day-to-day lives of ordinary people, Daguerreotypes (1975); and views different women hold about work, love and family, Women's Answers (1975). Her One Sings, the Other Doesn't was cheered by some feminists for its warmth and positive depiction of the friendship of two very different women over a fifteen-year period and was attacked by others for its avoidance of militant politics. Ruth McCormick, a Cineaste editor, spoke with Varda about the film at its opening at the 1977 New York Film Festival.

Cineaste: *Many feminists, especially radical feminists, have found fault with* One Sings, the Other Doesn't. *They say your characters are too male-related, that you're too kind to the men. Others think the film is too positive, not critical enough, too much like a fairy tale.*

Agnes Varda: Perhaps people want too much. But I understand what you're saying. We have the same radical feminists in France who say to me, "You don't hate men enough!" Of course, we need the radicals, they are important, but I don't agree that a feminist film must put men down, or show that it's because of *them* that we're downtrodden. It's the institutions that are the problem. Even if the institutions in society are made by men, the men are often merely carrying on the ideology that they've been taught down through the centuries of civilization when they were the leaders.

Cineaste: *Right! And men have very often been taught by their own mothers and female teachers that this is how it should be.*

Varda: I feel bad that there is not more understanding in the women's movement. As feminists, we have to be tolerant, with each other and even with men. I think our movement needs different kinds of women; there shouldn't be just one line, one way. That would be again what we have been settling for all along.

Cineaste: *Would I be correct in saying that you've tried to make a popular women's film, one that all women could relate to, not just conscious feminists?*

Varda: Yes. In politics, or as feminists, there are different ways in which we can work. If you want to make a feminist film, you can work outside the system, in the underground, and you can make a very radical statement, but even if your message is very good, you will reach perhaps five thousand people. You will never reach the mass of women.

Cineaste: *I'm thinking of people like Marguerite Duras and Chantal Ackerman, and you're probably right. Have you done well with* One Sings?

Varda: By working in the system, in normal cinema distribution, you are no longer underground. In France, our film has already been seen by 350,000 people, and the rights have already been sold in many other countries, so I would say that if the meaning of the film and its feminist point of view is even half or two-thirds as strong as that of a more radical film, at least we've gotten a lot of people *thinking*, and not in the wrong direction. I don't believe we have compromised to get a larger audience or more money, because I could

have made an easier film, with big stars. I wanted to make an honest film, and even to get this film distributed I've had to fight a lot!

Cineaste: *I can imagine that distributors would have been a little afraid of* One Sings. *After all, it's not exactly a formula film.*

Varda: I fought because I wanted thousands of people to be able, for once, to see a film about the world of women. Women in the sun, as Molly Haskell says. I like that! That's where women should be—not always off in the shadows. Pomme and Suzanne are not cop-out women, they're not stupid! Perhaps they're not radical, they don't burn their bras, they are not political in the sense that they don't want to break up the world around them just because of their own feelings. As I said, there are many kinds of women, and we should speak to all of them. Some women don't want to throw their men out. Some women still want children and a home.

Cineaste: *Perhaps most still do!*

Varda: And it's very important not to put those women down or say, "You're stupid, get out of your kitchens, get rid of all that!" Do we really want an all-women society? If there are women who feel that they have to live away from men to find their identity for a period, even for their whole lives, who may in fact be lesbians, that's fine with me. I'm tolerant with them, and they should be tolerant of me. I know these women, I've worked with them, I respect them, but I do not feel obliged to follow their rules. Each woman should be able to find her own way. If we just go into a new system of rules, like Communism or Leninism, then we are just following the same rules, as we have been doing for centuries.

Cineaste: *The point of a revolutionary society would be to really break away from all the old rules and regulations, then?*

Varda: Yes. That's my first statement. And I don't want anybody to take my film, or my position, and put me against other women and say, "At last we've found a nice feminist who still loves us and thinks the system's OK."

Cineaste: *The opposition likes to divide and conquer. They'll always try to use any artist who doesn't use the official rhetoric against the women's movement, the radical movement or whatever.*

Varda: I absolutely refuse to allow myself to be used that way. It's very important to set it straight that I'm not using the movement against itself. That would be disgusting. I hope I'm very clear.

Cineaste: *How did you get the idea for the film?*

Varda: Now, my film is a feminist film, but it's a *film*. I'm dealing

with images, images of women, and I conceive of the film as a painting with a background and a foreground. In the foreground are the figures of the two women, while the background is a very special and specific documentary about the laws and institutions regarding women's rights in France between 1962 and 1976. In 1962, as you know, abortion was very difficult, it was illegal, though if you had money you could go to Switzerland. Otherwise it was very dangerous. A man could not recognize a child if he and the mother were not married. After a lot of struggles, in which I worked—the abortion manifesto, demonstrations, trials—finally, in 1972, a girl was acquitted of criminal charges after having an abortion and now some laws have been changed. Abortion is now possible, the pill is available, and so forth.

Cineaste: *In that sense, it's a historical film.*

Varda: It's our specific French situation, where even planned parenthood groups have fought the opposition of the Catholic Church and become very open. I show this in the film. I wanted to show that if some people begin to say, "If you don't like it, change it!" and women begin to talk and fight together, things can change. The story of the evolution of our laws and institutions is the background of the film. In the foreground are these two women. Again, I didn't want to be rhetorical. I thought that two figures, with different temperaments, different backgrounds, would help to show that there are different ways of getting yourself together, of finding your own identity. My concern is with tolerance, so if radical women don't like the film, fine, but please don't take it the wrong way! They have a right to their way, too.

Cineaste: *You place a great deal of emphasis on motherhood, and this may bother some feminists. Pomme, the character with whom the radical feminists would most likely identify, insists on having a baby for herself when she decides to leave Darius.*

Varda: That's why I put that sequence in. The woman is right, and they tell her so, that she shouldn't feel guilty, but if you do have kids, or you want them, let's enjoy it!

Cineaste: *In other words, women should feel good about their bodies when they're pregnant. It's not being fat, or ugly, or sick. You're trying to say that if you want a child, pregnancy is beautiful in itself. A pregnant woman shouldn't have to be the Blessed Virgin.*

Varda: Right! If I enjoy pregnancy as a sexual event, it's my life, my body! Many anti-feminist women don't. If you choose to have children, pregnancy is a natural event, you should enjoy it. I'm not

recommending the way the Church tells me to enjoy it, as a duty, or to strengthen the state, or the family. It's never talked about, but most women actually enjoy sex more when they're pregnant, for reasons we don't really understand. I suppose that has to do with many things. But should I deny it? Would that make me a better feminist? A woman should let herself feel good being fat and full of baby, that's her privilege. A model figure isn't everything, and if that's what you want, you can go back to it later.

Let's not push women toward motherhood, let's re-invent it! But let's fight for abortion and good contraception so that we have the choice. That's most important. That's where women should get together. In the film, when Pomme goes to Amsterdam for her abortion, with so many different kinds of women, I've tried to picture this.

Cineaste: *Simone de Beauvoir tells us in her autobiography that there was a point where she decided deliberately not to have children, that it would be too great a commitment to exist with her other commitments. I and quite a few other women I know appreciate this point of view.*

Varda: As Simone says, "You are not born a woman, you become a woman." We are not slaves of our biology anymore. We've fought for that. Does anyone ask if a man is a real man if he doesn't have children? Einstein didn't have children. Lenin. Maurice Chevalier. We don't question their manhood. The same should be true of women. We are all human beings.

Cineaste: *The other thing people object to in your film, women and men both, is that you make the two women's success in finding themselves, making something of their lives, a bit too easy.*

Varda: Ninety-nine and one-half percent of the films you see are so much *against* women, that when women come to me and say, "You don't give them hell," I have to say, "Look, for once you have a film where women are shown without guilt, without shame, without dependency, without stupidity, fighting against laws and institutions, getting value and putting value into women's ventures. Don't you think you are already getting quite a lot?"

Cineaste: *Certainly.*

Varda: Then why come to me and say, "What about women's unemployment? What about lesbians? What about women not looking good? What about old age?" A film is not a basket to put everything into. It is a piece of entertainment, of communication, and if you want communication with many men and women, you

have to find a fluid way to communicate. I have tried to show women moving from the shadow into the light.

Cineaste: *The film is certainly full of light.*

Varda: I tried to show that. The film goes from dark, contrast, shadows, black and white images in the photos of women in the gallery, through fluidity to clarity. The last sequence is light, sunny, but is not a happy ending.

Cineaste: *Would you call it an ambiguous ending?*

Varda: Not at all! It's just that everyone is allowed to have a little peace for two weeks near a lake with friends. It doesn't mean that the struggle is over, that they won't get back to the family planning, the show, the demonstrations, their roles, their hopes. This is an aesthetic problem. It's like in music, like in a fugue, with its theme and countertheme, ending in a coda—one sings, the other doesn't—you get the feeling that it's not really finished, but you are allowed a certain peaceful feeling.

I don't agree when they say I've made a stupid, happy ending. Pomme is alone, without a husband. She has to support her daughter. Two of the other singers are alone, one has a man. Suzanne has a man now, but she still has her responsibilities. Her daughter is just beginning to be a woman. This is not stupid happiness, the struggle goes on! As an artist, whatever that means, I deal with images, I deal with words, I deal with dreams. If I'm utopian, that's my way! I don't agree that you should be pessimistic, or say that things are going badly. Let's fight, but let's dream, too. We need that! I think women need to know that life can be better. It could be good!

Cineaste: *Well, there hasn't been a revolution, but I'd agree that even if we don't have a just society, things are better for women, for blacks, for the third world even, than they were in 1962.*

Varda: Yes, of course. You are old enough to see that. Now I've been fighting for twenty-five years! Some of the kids speaking up now weren't even born when I began fighting for contraception. There were only a few of us, and everyone was against it—the right-wing, the Church, even the left-wing was against it, because they needed people to have children to vote for the left! We were left-wing women, but we had to fight the Communist Party which didn't want their deputy to vote for contraception!

Cineaste: *I guess they were catering to the Catholic vote, too. Not wanting to turn anyone off.*

Varda: At that time, I still fought as a strictly political activist.

Later, I began to see that I should fight in the cultural field. Reading Simone de Beauvoir and others, talking to women, I began to understand. They would give you literary masterpieces like Henry Miller, but nobody ever said at that time how he put women down, treated them like doormats. What literary critic every brought that up? Look at Orson Welles, whom we all love as a filmmaker, who was such a mysogynist! Twenty years ago, who talked about that? They said, "What beautiful films!" but who ever noticed how badly he treated his women characters.

Cineaste: *You began making films about women very early. I'm thinking of* Cleo *from 5 to 7. There have been a number of films about men facing death, but evidently a woman's life is so unimportant that aside from* Dark Victory *and* No Sad Songs for Me, *which in any case defined the dying women as chiefly worried about the men they loved, there have been no films about a woman having to reassess her life.*

Varda: Yes, because of her fear of death, Cleo discovers that she has been a doll, an object, so she gets out of her fancy clothes, takes off her wig, puts on a plain dress, and goes out to look at people. She no longer cares about being looked at, she wants to relate to people, to become a person. That was in 1961, when no one was thinking about the roots of women's feelings. In 1958, when I was pregnant, I made a short called *L'Opera Mouffe,* about a woman's feelings during pregnancy. It is a very strong film.

Cineaste: *There have been a few good films by men about women, but I think women have to re-think how we want to talk about ourselves.*

Varda: Yes. I've been around, and I hear these feminist men say, "Not bad for a woman." This is condescension, paternalism, like "Not bad for a black man." We, blacks and women, have only recently been decolonized, and we must find our own way. We have to decide what kinds of images we like about ourselves. We should not be ready to go along with the anxiety of so many male artists who try to put their problems on women's backs, like Modigliani, Giacometti, or especially Bergman.

Cineaste: *I was just thinking of him.*

Varda: And, of course, we love him. But he puts his anxiety, as a man, on our backs. A man is entitled to bring his fear, his guilt, his suffering to his art, but as a woman artist, I wouldn't want to project my anxiety onto men. We must make a break, create our own images. I don't want to be competitive, I don't want the power of a

man! I don't even feel sorry I don't make more money. I make quite enough! More than people who have to work in a factory, and unlike them, I like what I do. I find it disgusting that some directors get so much money, and actors even more.

Cineaste: *The best known actors and directors are all multi-millionnaires!*

Varda: Let them be, it's their game. I'm not in the game. The rules of the game have been made by people I don't trust. It's the game of competition, that's what women must understand. I'm not playing any kind of men's game, like I'm stronger than you, brighter than you, richer than you. I don't care. I'm strong. I'm bright in my way. I have a different scale of values, so if the critics like my film, perhaps they've found something in the film. Perhaps something new.

Cineaste: *What about Darius, Pomme's husband? He seems fine, and we understand why she loves him while they're in Europe, but, when they're in Iran, he reverts to being a real Moslem patriarch. And making him Iranian would have seemed to make it opportune to comment on the political situation there.*

Varda: When Darius is in France, away from home, he has an open mind.

Cineaste: *He even picks a feminist to fall in love with!*

Varda: Yes, and he goes to demonstrations, supports the women, but when he gets back to the Iranian family, he has to play the role. Look, I don't like the character that much, but this is his environment, and there is almost no way to get out of it in such a country. I was trying to show how people change according to where they are and with whom they are. I mean, at first Pomme was in the trap, the blackmail of love, and love can be even more beautiful in a beautiful settting, like the Arabian Nights. Think of all the sexual imagery in the architecture, like breasts and phalluses, and you begin to feel what Pomme was feeling.

Cineaste: *When she first gets to Iran, it's unreal, dreamlike. Later, when she begins to wake up, we see the veiled women, the poverty.*

Varda: It is what you call a trip. When you come down, it's no longer a trip. Pomme has been out of her world, in love. But her world is not cooking ratatouille for an Iranian man! Pomme had to get out of that mess! At that point, I first wanted to make it more political, make the point that she's also leaving because Iran is a disgusting place, a police state. But let's face it, in almost every country, it's disgusting. You can't go to Chile, to Lebanon. For years you

couldn't go to Spain or Portugal. I am half Greek, and for twenty years I wouldn't go there. I found that the image of the hidden veiled women made sense for me because as Pomme becomes more and more enlightened sexually, she finds herself surrounded by real women who have no sexual freedom at all. So I make the point that there is something twisted in the contrast between her speaking about her body and her freedom, and these unfree women who are forced to deny their bodies.

This is a political point. I didn't feel I needed to make a polemic against the police state in Iran. Feminism is political insofar as it is dealing with institutions and power, and showing how women don't need these institutions, and don't want that kind of power. The spirit of the family, love and communication, is not bad—I enjoy living with a man and children, having dinner together, protecting one another. But it is the *institution* of marriage, of the family, which the state uses to keep us down. The women sing a song in the film which quotes Engels, that in the family, the man is the bourgeois and the woman the proletariat. That's true, and we have to fight it.

Cineaste: *Orchid, the singing group in the film—do they really go around to small towns singing about Engels and women's liberation?*

Varda: Yes. I did the lyrics to the songs in the film, but their repertory is very good, a way of singing that has nothing to do with classical love songs. Phillips is putting out the original soundtrack of the film, and the songs are more political because they're not broken up as they are in the film.

Cineaste: *Are they well-received out in the country? Was your film? I guess that in France the small towns are strongholds of conservatism.*

Varda: Yes, they make friends and do well. And my film has done very well in France, in the small towns where they usually only get classical American films and big star vehicles. It's done very well in the countryside. But even there, I found a radical woman in the audience who told me, "I don't like your film because you deal too much with men," and a man who said, "I don't like your film because you don't pay enough attention to men." So it happens. Both sides. The men feel betrayed because even though they're not all that bad in the film, we really don't see that much of them. But that's the story. In a woman's life, in the long run, men are not *that* important.

22—BERTRAND TAVERNIER

Blending the personal with the political

Bertrand Tavernier has a distinguished body of work that is not as widely known in the United States as it deserves. His work includes The Clock-Maker *(1973), a film chronicling the psychological change in its title character when he learns that his son has murdered a "factory cop";* Let Joy Reign Supreme *(1974), showing the predicament of three men in pre-revolutionary France, particularly the dilemma of the ruling Regent who recognizes the injustices of his society but feels helpless to affect change;* The Judge and the Assassin *(1975), based on an actual assassination case but essentially providing a portrait of the repressive measures of the Third Republic following the defeat of the Paris Commune; and* Spoiled Children *(1977), dealing with a tenants' strike. Early in 1978, while visiting in New York, Tavernier was interviewed by Lenny Rubenstein and Leonard Quart, a* Cineaste *contributing editor.*

Cineaste: *Your films seem to operate on both a political and psychological level. How do you perceive the relationship between the two?*

Bertrand Tavernier: I think it is difficult to split. I don't find them psychological, because for me the characters are very deeply rooted in and related to their social context. I don't believe, however, that the social context can explain everything. It's too easy sometimes to blame actions on a character's background or family; it's really a combination of society and personality. I think it was Henry James who said something about character being the product of a situation, and the situation the product of character, and it's true. I cannot conceive of a character completely cut off from any kind of context. It is the important element in all the films I've made—this relationship between the character and everything around the character.

Cineaste: *Do you feel you are always successful at doing that?*

Tavernier: I don't know; if I say yes, I sound pretentious. In *The Clockmaker*, the evolution of the father was, I think, very believable. I was dealing with somebody who was moving only a little bit, one small step, yet for him it was enormous. It was difficult to show this without becoming didactic, without betraying the characterization. Even now, I wouldn't do it any differently. His evolution, the way he talks with his son and accepts him, succeeds for me; it's the dynamic and organic movement of the film.

Cineaste: *In* Spoiled Children *the movements or changes were smaller, more minuscule.*

Tavernier: Yes, they are not large. In *The Clockmaker,* though, the change is enormous for the father; in his context, they are great. I always said that *The Clockmaker* was the story of a man who would not cross against a red light, and at the end in a courtroom he is testifying for his son, affirming his loyalty to his son. What I like in *The Clockmaker* is that there is nothing heroic about the father. Some people say he is crazy not to have his son plead to a lesser crime than murder, so that his son will get only five or six years, but there he is fighting alongside his son, and I like that. It was not an easy choice and not so glibly political; there is something ambiguous about it.

Cineaste: *What was the significance of the scene between the father and son in prison, when Noiret tells about punching an officer in the face in 1940?*

Tavernier: It was Aurenche [co-scriptwriter Jean Aurenche—ed.] who thought of that because he had actually seen it during the war. I added the stupid order to save a piano from a burning house, and

Aurenche added that violent confrontation, and I like it. The incident had the kind of craziness, and absurdity, the kind of irony I've always liked. I don't know why, perhaps because people reveal things about themselves when they tell stories, perhaps because it's an image of myself, for instead of speaking directly, it's up to the audience to understand the point through the story. I feel uneasy speaking in the first person in my films, but feel more relaxed using a third person voice, which also allows me the kind of dramatic confrontation which interests me.

Cineaste: *How did the politics emerge in* The Clockmaker? *Were they in the Simenon novel?*

Tavernier: I think they are mostly mine, but the novel supplied a basis for it. You know the novel takes place in upstate New York in the mid-fifties. The murder came from the fashionable anarchic attitude of the nineteen thirties' gangsters, the rebellion against law and order, the feeling they try to get in *Bloody Mama* and *Bonnie & Clyde*. But when scriptwriters Jean Aurenche, Pierre Bost and I began work, we wanted the story to be more rooted in French society and the political background became more and more important than it had been in the novel. In my first adaptation I had made the murdered man, who remains unknown in the book, a factory cop.

Cineaste: *The anarchist influence in the film seems very strong. The father's actions are opposed by his orthodox leftist friend.*

Tavernier: The friend is a Communist Party member and a strong unionist. He doesn't know how to deal with the situation, because in accordance with his beliefs, he cannot accept this young man, whose politics are so obscure and whose act of murder is a little like the gestures of the nineteenth century anarchists. So there is a conflict between him and the father, although the Communist Party member (Jacques Denis) is right when he reproaches the father for not being deeply interested in his son. What has always puzzled me is the tendency to make one of the two characters totally right, and the other completely wrong; in this film the communist has one or two points where he is right, and two or three where he is wrong.

Cineaste: *What about the peculiar relationship between the father and the detective in* The Clockmaker?

Tavernier: The impetus for their friendship comes mostly from the cop (Jean Rochefort). That character did not exist in the novel. The inspector is one of those types who have the need to see people who are more unhappy than themselves. The detective has not

succeeded with his family, and here he sees a man who has everything he does not have. He's warm, seems to have a lot of friends, and doesn't have a difficult job, and I don't say that to be funny. It is difficult to be a policeman, a detective has a morally difficult job. I hate people who facilely make fun of cops. This detective sees a man for whom it is hard to believe there could be anything difficult happening between him and his children. However, it turns out that this man is in the middle of a horrible drama, something far worse than Rochefort and his family have gone through. The detective then must understand, and try to get warmth from his relationship with Noiret.

It's not very different from the relationship between Michel Piccoli and Christine Pascal in *Spoiled Children*. It's a fascination, a desire to understand why such a thing happened . . . perhaps, because he is relieved to see a man so different from him having such enormous problems. And the deeper he delves, the more interested he gets. When Rochefort and I talked about his last scene, he told me a lovely thing: "I want to play this scene exactly as if I was losing the first friend I had in the army." I think he got it; it's wonderful! The detective would also like the crime to be comprehensible. He would like it to fit in, to put a label on it. He cannot accept the possibility that maybe there is no real explanation or at least not a single explanation. As for the father, the clockmaker discovers that there comes a time when you have to be on one side of the barricades. Noiret cannot be on the same side as the cop and must leave him. Perhaps it's a bit unfair to the detective, but Noiret chooses to be closer to his son, so he destroys his friendship with the detective.

Cineaste: *What is your political position?*

Tavernier: I have been a Trotskyist for some time and still am, in a way. I was always interested in politics even when it was not fashionable. I worked as a press agent, and I did a lot of work on the Blacklist. I met people who influenced me, like Abraham Polonsky, Dalton Trumbo and Herbert Biberman. I re-did the subtitles of *Salt of the Earth* which I think was a very important film, and incredibly ahead of its time, especially about the women's movement. Equally incredible is the story of its production, which excuses the mistakes of its director.

I was very fascinated by what you call the "liberal movement" in Hollywood—Joseph Losey, John Berry and Carl Foreman—and how that movement was destroyed. Despite its limitations, there were good things in it, very important things which are sometimes

too easily dismissed by leftists. It's too easy to say, "It's just a liberal film." If you make a Marxist film today, it is impossible to ignore the old Hollywood films simply because they are so good and so well-made. They reflect the American idealism of the thirties—despite their optimism, they reflect reality in terms of myth. Their films were rooted in the nation's spirit, even if sometimes in fact they are not true. They caught something which is difficult to catch, the state of mind, the collective unconscious. It is too easy to dismiss *Young Abe Lincoln* or *Grapes of Wrath* by comparing them politically to today's films. As a filmmaker I know the fight led by Capra and Ford to get the freedom to do their own editing. If people like me can get to do the films they want it's because of people like Renoir and Capra. It was a political fight against the Establishment for Ford to use all those long shots without a close-up. It's a very difficult thing to explain to an intellectual leftist who cannot see these men's strength, and understand their struggle.

Cineaste: *I think in America a lot of leftist criticism has gone beyond that sort of crude, vulgar response to the topical.*

Tavernier: We should go to some of the critics I admire, G.K. Chesterton and George Orwell, to learn how not to speak in slogans. It's so easy to dismiss John Ford by saying he's not a Marxist—you don't have to write another line. They used to say that Dickens was a less class conscious writer than some contemporary Marxist—so what! It is interesting to see how progressive Dickens was for his own time. I've been raised as a Catholic, and I don't want to belong in a church, a little political church. I hate people who become teachers and cops, people who excommunicate. Zola once wrote, "You have to live with indignation," and though I know it's the classic artists' statement, I believe there are truths that go beyond party. Still, Trotsky wrote beautifully about art in *Literature and Revolution,* and when Lenin wrote about Jack London, it was wonderful. But sometimes the disciples are less impressive than their masters.

Cineaste: *Some leftists have criticized that the focus in* Let Joy Reign Supreme *is on the Regent rather than the peasants. . . .*

Tavernier: When a film is about a subject, you must see if that subject is treated, not ask for another subject. If I had wanted to make a film about the peasants, I would have. I had a reason for making a film about the Regent; the first thing any critic must look for is the reason behind the film, and then whether it is well handled. I chose the Regent because I could easily approach some modern feelings and facts, some political ideas which fascinate me. I was

interested in the Regent's character because he seemed unusual and dramatic and very modern. The Regent's story was one of a man who saw what he had to do very clearly, and because of the pressure on him and the nature of his character, was too weak to do it. It was a situation representative of the political conflicts in any transition period. You can find men like the Regent in pre-fascist as well as pre-revolutionary moments; you found them in the Weimar Republic and the 1905 Revolution in Russia.

That criticism is exactly as if somebody was making a film about the 1905 Revolution, and the first thing critics ask is, "Why didn't he show Lenin in 1917?" I did that because I wanted to show the story of three men who tried to change the world around them—the reformer, the regent; the cynical politician, the Abbe; and the crazy idealist, the Breton nobleman; and the girl who looks at them, and in a way judges them. The three men all have qualities, they have their reasons and they all do good things, but it's not enough. At the end I show people without names, unknown peasants, the people who are going to change the society. That is the story and structure of the film.

If I make a film about the impossibility of change in those times, I must discuss the real power in that period. That's what drives me crazy; I've never seen a literary critic who suggests that Shakespeare should have written a play about the gravedigger and not Hamlet. It's so cliched to say a film cannot be political unless it deals with gravediggers rather than princes.

Cineaste: *Are you politically active now?*

Tavernier: Yes, I think I am in my films. After showing *Spoiled Children* I held at least fifty discussions with public groups and tenant committees. In connection with *The Judge and the Assassin* I conducted as many meetings with unions, the public, the "Red" judges. . . .I'm very active in that way. I was active, of course, in the tenants committee, since I prefer working in some local, exact, modest project—like actually dealing with the capitalists, by going over the landlord's account books. It's no big thing, but that is the kind of political activity I prefer.

Most of the time I'm active through films, not only the ones I make but the ones I try to help. I co-produced *The Question,* the first French film to deal with the torture of the French by the French in Algeria. I'm trying to help a young director who is preparing a film about a hospital where he worked, both as a surgeon, for five years, and as an orderly for two, so as to see the other side. That man is

a Maoist, my assistant is a Communist, and though I have disagreements with the Communist, I am committed to helping all film people who are honest and interesting. The worst thing now is all the barriers between the left factions and movements; you have the Maoists who want to destroy the Trotskyists and they in turn want to destroy the communists. I'm tired of leftists dismissing, with words like "horrible," the films of other leftists. One should keep some of the adjectives like "disgusting" for the real reactionary films. I'm interested in all kinds of political films—commercial and militant—and I feel the militant film director can learn from me, just as I can learn from his work.

Cineaste: *Your latest film,* Spoiled Children, *seems to deal both with the despoilation of Paris and, importantly, with the gap between the generations.*

Tavernier: I love cities—to walk in them and feel their essence—and the film was partially inspired by my son's remark that he felt oppressed about the impossibility to play in a great many places in the city. It struck me then how much of modern Paris is built by people who never live there.

The theme of generational conflict is the basic one in *Spoiled Children*. The film began as a story of a man (Michel Piccoli) who was provoked by a young girl, a girl (Christine Pascal, who worked with me on the screenplay) who is closer to her own emotions, her fears and anguish, than the man. She is also more self-conscious and willing to express and share her feelings.

She has lost her job, and she's with a man who has everything. He has a job that he likes and a kind of solidity behind him, and she hasn't. I myself feel closer to Christine. I feel that at my age there is a need to be provoked and confronted.

23—ANDREW SARRIS

Confessions of a middle class film critic

Over the years, radicals have had their fair share of quarrels with Andrew Sarris, the chief film critic of The Village Voice. *His polemics from the protected precincts of the "vital center" often seemed to take better aim at the left than the right. His emphasis on form over content and his over-appreciation of aesthetics distorted many of his views. Nevertheless, his contribution to cinematic appreciation and standards has been considerable. If nothing else, he has acted as a prod and a goad for leftists seeking a coherent schema for their own ideas and concepts. On the occasion of the publication of* Politics and Cinema *(Columbia University Press, 1979), Al Auster,* Cineaste *contributing editor and producer of film programs for WBAI-FM in New York City, and Leonard Quart,* Cineaste *contributing editor and cultural editor for* Marxist Perspectives *(now defunct), interviewed Andrew Sarris on WBAI-FM. An edited transcript of that broadcast appeared in the Spring 1979 issue of* Cineaste.

Cineaste: *You conclude your introduction to* Politics and Cinema *with the comment that, "My aesthetics have been my politics all along." What brought you to that conclusion?*

Andrew Sarris: Well, of course, there are two theories of art that have run side by side, or one in reaction to the other, all through history. One, that art is concerned with life and with social issues, and the other—a more modernist view, I think—that art is really about itself, about its own relationships, its own unique attitudes, and so forth. I grew up at a time when there was a great deal of controversy about these two positions—for instance, the controversy between Thornton Wilder and Edmund Wilson on *The Bridge of San Luis Rey,* and whether an artist in that third decade of the twentieth century should concern himself with such trivial matters. In the recent history of the cinema, however, we've seen the decline of neo-realism and the coming of Fellini and poetic fantasy, and the rise of Ingmar Bergman, after a long reign of social consciousness as one of the ruling criteria of film. So I always felt I was one of the art for art's sake boys, you know, one of the people who believe art exists for itself. Gradually, though, I found that as I kept reviewing more and more things, political considerations kept coming in, both within the films themselves and in respect to the audiences, in respect to other critics, and in respect to the community at large. So I found there was a closer tie between my particular tastes and my political convictions than I had realized. In other words, politics was not something you put aside, politics sort of crept into everything—it crept into sexuality, it crept into what stars you liked, into what genres you liked.

I think that's one of the contributions made by the structuralists. They've indicated how even certain art forms have political assumptions. The whole idea of individual narrative, the idea of the journalistic human interest story, has a kind of ideological structure to it. If you talk about the individual in a certain sense, you are talking about some kind of revivalist individualism that is not collective in nature and doesn't address itself perhaps to the solution of fundamental social problems. I have always stood in a certain place, and my writing is confessional to an extent, so I wanted to acknowledge what my biases and prejudices are, because I think the reader is entitled to know where you start from and what you are. You know, let the reader beware.

Cineaste: *This fusion of a political critique and a formalist*

critique—is it just a bias or have you systematized it in some way? Have you created some kind of coherent structure for that?

Sarris: Well, I wouldn't say systematized in the sense that I begin with a *structure* of criticism. I don't ask whether a film satisfies this or that ideological criterion. For example, we were having a discussion last night about *The Deer Hunter,* which some people consider an interesting example of fascist art. This is an argument we used to have years ago—you know, are art and fascism compatible? I would like to believe that you can have a Marxist art, you can have a fascist art, that there can be people with whom you disagree ideologically, and yet who do create. There's a problem, though, with film. There's no problem with painting or music—we don't even really question the ideology of people in these areas, although there are ideological implications, sometimes, of a sort. But in narrative, especially film narrative, we're up against two questions which are very difficult to resolve. That is, is the artist telling the truth as he sees it, or is he lying, or oversimplifying? The question of lies and truth becomes very complicated when you deal with fictions. This is a very complex area.

For instance, one of the things in *The Deer Hunter,* to use that as an example, is that a lot of people are asking, "Did anybody—either in the VC or in Saigon—at any time play this strange game of Russian roulette?" Some people say, "Well, maybe they did and maybe they didn't. Anyway, it's the artist's option to make it up." Then there's the point Andre Bazin made, that it's a more bothersome question in film because an audience is sitting there and they're looking at a sort of simulation of Vietnam, done in Thailand, and they're supposed to believe in certain plastic things. So the question of whether it did or did not happen I find more crucial than one would think—it raises certain questions. I think if it did happen, it has one type of status as art, and if it didn't happen, it has another status.

Anyway, to get back to your question, I would say that on the whole, no, I don't approach criticism systematically. I approach it, I hope, intuitively, that is, trying to strike a balance. There is certain Marxist art that I have endorsed, like some of Rosi's films and, of course, a great deal of Brecht's work is interesting, although many Marxists consider it somewhat problematical. On the other hand—and this is a point I make in my introduction—I think most serious film art has been of the left of one kind or another, more than of the right. Right wing people usually don't deal in art, they have

other means of operating, of persuasion. People of the left are con-
cerned with art to a great extent, and, consequently, I think the
preponderance of bad political art is there simply because of the fact
that more people are involved in it. So you get these people who
send in letters saying, "How can you oppose this film? It's on the
right side!" It's the whole question of thesis art, so these two things
become complicated. I must admit, thought, that there is something
perverse in me and I sometimes attack things ideologically, and I can
be called for it. I'm the first to acknowledge it.

Cineaste: *You conclude your piece on* State of Siege *by saying
"Art and Revolution. Choose One. I chose Art." Why?*

Sarris: Well, I think, basically, it's again a confessional self-
definition. I'm a bourgeois, middle class intellectual. I work for the
Village Voice. I teach at Columbia. I'm not out in the streets, I'm not
organizing people—if indeed I did want to organize them, which I
don't. I'm basically a liberal meliorist—you know, try to improve
things gradually, get people to vote, and vote perhaps for better peo-
ple. I was one of those people who said we should have voted for
Humphrey in '68 and not let Nixon come in by default. I think that's
where I stand. So, on that basis, it's silly for me to say, "Well, it
doesn't matter." I'm concerned with the world, and with a relatively
stable work in which the arts and culture can survive. I think a revolu-
tionary world would be a world of complete upheaval, and whether
art would survive in such a world—indeed, whether criticism would
survive in such a world—I don't know.

Cineaste: *Of course, one could point to Cuba where, within cer-
tain ideological limits, there is a range of films, both formally and
psychologically, that are being produced. In other words, revolution
does not necessarily preclude a certain diversity in the arts.*

Sarris: Cuba is now being cited as a fairly benign example of this
situation, certainly more than China or Russia or places like that. I
think in Cuba there is perhaps somewhat more opportunity. And I
don't want to take a simplistic view and say that there is no
ideological control in right wing governments or even in so-called
bourgeois democratic governments. There is, but it's of a different
order. This is one of the areas where we can go into ideological
analysis.

Cuba had almost a nothing film industry before. In fact, the only
genre the Batista regime mastered was the blue movie, which I think
had become quite prodigious by the time Castro came along, so it
was a question of starting from ground zero. What this will mean in

the future, that's a question. But you're right, it need not be hopeless. I had a run-in with Alea and with people about that.*' We had a strange situation a few years ago at the National Society of Film Critics with his *Memories of Underdevelopment,* which I thought was a much more interesting film than his most recent film, *The Last Supper.* But then, of course, I tend in politics to be more interested in ambiguity. I was surprised that Alea did not come to this country on the recent visit of Cuban filmmakers. I've heard different stories, but it's a very delicate situation, and I don't want to comment on it. I realize there are all kinds of pressures and problems.

I think here in the West we tend to be a little too facile about certain aspects of art, as in a way people were with Hollywood. Jean-Luc Godard, for example, looked at the May Day parades the way you can look at Leni Riefenstahl's *Olympiad* or even *Triumph of the Will.* You can see certain formal graces in these things, a certain kind of purity of expression, a certain kind of iconic art. Perhaps this doesn't satisfy our definition of the humanistic novel—you know, the rich, complex things we like to celebrate—but there is art of all kinds, and I think we have to define it.

Cineaste: *In your writing you often see leftism as synonomous with totalitarianism, with all-or-nothing, either/or constructs. Can you not see both a leftist film criticism and a leftist filmmaking which is permeated with a sense of tragedy, a sense of paradox, of ambiguity? The Italians, for instance—whatever one may conceive of a Rosi, a Petri, or an Olmi, who are leftists—have created a cinema filled with skepticism, irony and self-parody.*

Sarris: Oh yes, I definitely feel that. A great deal of Petri and the other people you've mentioned—and, in fact, the Italian cinema as a whole—is primarily a Marxist cinema with a deep sense of doubt. I think that's very much part of the Italian condition. It would be interesting to see, if a totalitarian regime came in, whether this could change appreciably, whether there would be pressure on these same filmmakers to be less tragic, less ambiguous. But I think that option for left art certainly exists and it's certainly the most interesting

In early 1974, the National Society of Film Critics announced its awards for the previous year's films, including a special award citing *Memories of Underdevelopment* as "one of the year's outstanding cinematic achievements." The National Society extended an invitation to Alea to attend the awards ceremony in New York, but the U.S. State Department denied the director a visa. In addition, the U.S. Treasury Department notified the Society that anyone accepting the award (which included a plaque and $2,000 in cash) on Alea's behalf, would be subject to imprisonment and fines for violations of the "Trading with the Enemy Act."

expression of this particular area. In Italy the political tradition goes very deep. Verdi sort of antedates the whole thing—you know, this whole sense of populism and the rise of the people. It's an ancient Italian theme.

Cineaste: *In the past you've criticized the sociological critics for their emphasis on the* what, *the content of a film, rather than the* how. *Do you still have that same criticism of them, or do you see them as having changed to some degree?*

Sarris: Well, of course, when you start out journalistically, you tend to just lay around yourself with a meat ax, first of all to get people to pay attention to you and, secondly, to show that you're better than anybody else. But I think the problem with sociological criticism is that it's very difficult to do. It's very presumptuous, and very often you have sub-critics, people who are not very good, doing sociological criticism. I think it takes much better critics to do sociological criticism than to do aesthetic criticism. I find it much easier to say whether I think a movie is good or not, than to say what its impact is on everybody in the audience. I'm never quite sure of that, I'm never quite sure of what people take, what signals people get from films. It's a very complex area, and I think you have to have a great deal more knowledge. I don't say you have to go into mass media research, but I think you have to go into a great many other areas outside the cinema—you have to go into crowd psychology, into people's private attitudes, and into all their other frames of reference. It's very complicated.

I think, therefore, that the big critique of sociological criticism is not that it should not be done, but that it's been oversimplified in the past. The tendency of a great many sociological critics is that they get a bunch of films together, look at the synopses of them and from the synopses they deduce the social content. Now the fact of the matter is that some movies have much greater impact than others because certain values come more to the fore and they're more convincing. On the other hand, some movies are completely discounted by the

A telegram from Alea was read at the ceremony by Sarris, the Society's Chairman that year, who also made his own statement characterizing the events which had brought the film critics' organization to the "bloody crossroads of art and politics." Although deploring the State Department's denial of the visa, Sarris also encouraged the notion of Alea as a Cuban Solzhenitsyn, misinforming his audience that Alea had not made a film in the five years since *Memories*. Alea's telegram and Sarris' statement appear in a special section on "The Alea Affair" in *Film 73/74*, the National Society of Film Critics' annual anthology edited by Jay Cocks and David Denby (Bobbs-Merrill). Alea's own comments on Sarris' statement appear in an interview with Alea in *Cineaste*, Vol. VIII, No. 1 (Summer '77) issue.—eds.

audience, they have no impact at all. Therefore you can't tell. Sometimes people draw different conclusions from a movie than its apparent ideology would indicate, sometimes the casting may shift things, and so forth. So I think sociological criticism requires a much more subtle approach—for instance, the kind of thing that Manny Farber and Patricia Patterson did in *Film Comment* when they analyzed all the different ideological drives in *Taxi Driver*.

The *perspective* is also very different. What I object to is the simplistic idea that *they* out there are doing it to *us* here. It doesn't quite work that way. I mean, you have the filmmaker—he's got a whole political situation, he's got people above him, he's got people below him, he's got a subculture in California—and then there is the audience over here. It's a very complicated question. For instance, there are *different* audiences—there always have been—and there are different subcultures that are participating. So the sociological critic has a tremendous burden of explaining all this complexity, and when he doesn't—when he just sort of piles on the titles—then I think he can be attacked for vulgarity and over-simplifying.

Cineaste: *Following up on that, many of these Hollywood films which come out of a capitalist matrix have a subversive content in that they undermine the very values they seek to promote.*

Sarris: I always find Hollywood films *fascinating* sociologically, much more so than people realize. Critics, for instance, always complain about the happy ending, but the happy ending can be very hollow. I mean, you can have a happy ending but the rest of the film is the complete opposite—like these films about people who get a house out in the country, and everybody's gouging them, and they have trouble getting money, and so on. I think that's a hellish view of American life. A great many so-called family situation comedies are rather grim statements about the values of our society.

Yes, I think there *are* subversive things. This is the great appeal of the *film noir*. The *noir* films exposed this great underside—it was not the official view of American society that you got—and you suddenly began to see all these wretched people around the edges of society, and you began to get a glimpse of what life is really like. This is the great epiphany of these things—you know, where you have characters like Elisha Cook, Jr., these sort of worms and moles and gnomes working on the underside of the culture. You get an idea of all the dark sides of a society.

I also think the violence in film conveys the very violent and anarchic feeling that people have. America is a very violent and anarchic

country—people have tremendous hostility, and it's getting worse. Fewer and fewer people are voting, they are very cynical about everything and everybody, and most of this is very destructive, very dangerous. But it's there. Nowadays, of course, there's very little official culture anymore. You don't have these public service studios anymore, or studio heads having dinner with the President and agreeing to do a picture. So the sky's the limit. I don't think this attitude is necessarily constructive, though. I think a lot of it is very damaging, but it is and has been a subversive thing. Movies are subversive in the sense that they deal with people's psychic needs, and people tend to discount the official varnish put on things. You know, the myth still holds that family life is wonderful in America, but underneath people realize that life is much more difficult.

Cineaste: *When we as critics sometimes applaud action genres that use violence, do you think that in a sense we are indirectly encouraging violence?*

Sarris: This is a problem many critics are now confronting. Many people today—particularly older people, mature people our age, and especially women—are shocked by the amount of violence they see on the screen. They don't want to look at these movies, they think they're very dangerous. A lot of people are concerned about the family, they're concerned about the impact of screen violence on children. Of course, this same situation existed in the thirties and forties, too, with *Scarface, The Big Sleep* and *The Maltese Falcon,* and the war pictures. Some people have even argued that all these ostensible anti-war pictures do is glamorize war and make it more palatable.

How much does it contribute? I don't know. But even with the most violent things you can think of—like the Peckinpah movies, with all their bloodgushing—I still have to defend the right of the artist to express himself in those terms. Of course, sometimes they go overboard. The sadism in *Midnight Express* I deplore, I find it tasteless and stupid. But on the other hand, I wouldn't ban it. If people don't like violence, they can stay away from it.

There may be a question here about escalation, of people just getting more and more that way. You get that sometimes in the midnight screenings of films like *El Topo* or the John Waters movies. There seems to be a youth cult for this sort of thing, and young people seem to have much stronger stomachs than old people. But I can't say even when I'm driven out of the theater, or forced to close my eyes, that I would deny anyone the right. I've battled too long

against censorship. It's a problem, but I think it's a risk we have to take. It's a mistake to just stop screen violence, because in societies where it is stopped, the violence doesn't stop. The world was violent long before the cinema came along.

On the other hand, this doesn't give artists a free ticket, they can't just lay the violence on and say, "This is what life is really like." That's not true, because film tends to distort the violence. For example, the 6:00 News tends to make our society seem much more crime-ridden than it really is. So you can attack these people for sensationalism, but I wouldn't block them.

I think sometimes the increased information about it may actually defuse it. For instance, hatred was not generated for the Vietcong in Vietnam, mainly because television showed these people looking very much like the the people who were on our side. It tended to humanize. I think if we had had television full force during the McCarthy era, McCarthy would not have been able to point to a map and say, "This whole country went red, we lost this country," because people would have seen pictures of the Chinese and they would have looked human. In a peculiar way, the more television and film there is, the more complex it makes the world seem and not more simple.

Cineaste: *How would you respond to a hypothetical semiologist's critique of your work as being unsystematic, subjective, and individualistic?*

Sarris: I would plead guilty on the whole. A lot of my work has been intuitive, it's my nature. It's also partly because of my occupation. I'm a journalist. To the extent that I'm an academic, I try to systematize, but I haven't done much systematic writing up to now. My alibi, I suppose, would be that we have a long way to go before we can codify what film really is. I find it very difficult to confront a film and one of the areas I've been working on is trying to find some perspective on a film. The means that we use to describe film, for instance, are completely inadequate. I have never written anything that I feel apprehends the experience of a film. The question is are the semiologists doing any better? I think they touch upon interesting connections and relationships. One of the greatest contributions the semioticians have made to the whole nature of language is the sense that the existence of certain words in the language restricts the definitions of other words. That is, you have to see language in a contextual way. I believe that's true about cinema, too. You can't

talk about one film individually, apart from every other film that's been made. I think the contextual attitude is correct.

My reservation about the semioticians is that the methods, the instruments, they've used up to now have not been supple enough to handle the multiple perspectives of film. The idea of relevance is useful, but that's almost a cliche. Actually, I think all good critics are basically semioticians at heart—you know, you talk about the weather, you talk about ideology, you talk about the use of costume and lipsticks, whatever.

One of the big critiques of the semioticians and of the Levi-Strauss crowd is that by presupposing a structure, a model that they build and develop, they can almost inevitably find connections. If you are looking for resemblances, you can always find them. In order to build up their models, very often they pile up all the resemblances and tend to ignore the distinctions. I think we evaluative critics may often go the other way and look only for the distinctions.

Cineaste: *Would you agree that the semioticians have very little feeling for film, that their interest is basically in aesthetic theory rather than the aesthetic experience itself?*

Sarris: It's not so much that the semioticians are hostile to film—I mean, they're not unsympathetic, a lot of them are. . .you know, like the old joke, some of my best friends are semioticians—but the generation of critics I grew up with—the *Cahier*ists, the auteurists—I think we discovered new cinema, we discovered things from the past that had been neglected and ignored. The semioticians tend to function more like an appellate court. They don't introduce much new evidence, they use basically the tastes that have already been established, and they proceed to use a new method of expressing it. They'll talk about *Bringing Up Baby* or *The Searchers* from a structuralist or semiotic point of view and, consequently, most of them are not very active in journalism, in reviewing.

There has been a lot of agitation at Columbia for semiotics. A lot of students want to get into it so I'm always looking for texts. Whenever the semioticians have a convention I ask, "Well, where do you stand?" You know, Christian Metz has come out with a couple of books, so I say, "All right, this is where we stand, can I analyze this, can I analyze his analysis of *Adieu Philippine* or the *Cahiers du Cinema* analysis of *Young Mr. Lincoln?*" And someone like Eco will say, "No, that's where we were six months ago, now we've moved on." In other words, it's a continuing process, you can never find the

bible, you can never find the gospel printed. It's always into the next convention.

But it's still rather new and I don't want to foreclose it. I don't want to take the philistinish cackle because I've been the victim of it myself in the past. So I'm keeping an open mind. What I'm afraid of is that there isn't really much communication between them and the other people, and that's the trouble. I don't know whose fault it is. Recently, for instance, Raymond Durgnat wanted to do a critique of semiotic writers, the people who write for *Screen* and so forth, and the University of California Press decided that the people who are semioticians will not accept the critique, and the people who are not interested in semiotics don't want to read about it at all. It's like so much of politics, where you have everybody preaching to the converted. I'd like more dialog, more debate, but I don't find it very forthcoming at the moment. Perhaps that will change.

Cineaste: *One of the things about* Politics and Cinema *that impressed us was that we felt you cared very much about politics, which is very different from what we feel about many auteur critics who've accepted your theories. Is this latest volume, then, perhaps your way of making up for having created a generation of critics who are more interested in form than in content, or who may ignore content altogether?*

Sarris: Well, I wouldn't characterize people who followed me as being apolitical. I find they're very political in different ways. Some of them are feminists, some of them—like Stuart Byron, who's been very close to me over the years—is very much into gay liberation. Many of these people are on the left, some of them have been on the right. There's been a charge made by some of the older humanists— this is a charge made in France—that all the old *Cahier*ists were fascist. Well, this wasn't true. Truffaut was perhaps more to the right. Godard was more to the left, Chabrol was somewhere in between, neither one nor the other. These were Left Bank people. It's been a much more complex thing.

I think where the contradiction arises is that many of us felt for a long time that the humanist critics—people like Bosley Crowther and Siegfried Kracauer—had talked so much about content, so much about social ideas, that forms were completely ignored and we had to make up for all this lost time. In catching up, of course, we created the impression that we were little dandies running around talking about tracking shots—I remember Leslie Fiedler once said at a meeting, "I always want to scream when I hear the phrase tracking

shot." This is a kind of ideological philistinism toward film. It's no worse than talking about the lack of adjectives in Hemingway. I mean, it's a significant stylistic thing—you have to talk about these things. We wanted to end stylistic illiteracy.

But everybody's taken different paths. I don't feel there is an auteurist school. I think there are different critics, there are individuals. We're not all the same. Even in the early days, the French, the British and the Americans differed on a great many people. The emphases were in tremendously different directions and we had different assumptions, but what we agreed on was that some things had been overlooked and we had to redress the balance.

Cineaste: *Is your dispute with Pauline Kael based solely on differing notions of aesthetic judgement or does it also have some political connotations?*

Sarris: A distinction has to be made between my arguments with Pauline Kael, on the one hand, and my arguments with people like John Simon, Richard Gilman and Stanley Kauffmann, on the other. Those are ideological grounds, in terms of aesthetics. I think we have a different view of the camera—I mean, when I read something that Gilman, Simon or Kauffmann writes, I completely disagree. My disagreement with Kael is much more complex. It's largely personal—we don't like each other. But I think our positions have crisscrossed over the years. Very often I pick up *The New Yorker,* and I see a complete auteurist analysis of something, so I don't think that distinction exists anymore. It's also very ironic, because in the beginning she got a lot of points with the cultural establishment for attacking the auteurists for their liking of trash, and now most of the time she's defending or rationalizing trash, and I'm sort of attacking it. So I don't think it's an ideological point. I think it's more competitive, in a certain sense.

I would also say, in answer to what the semioticians say, that it they think *I'm* disorganized, Pauline is even more disorganized than I am, for better or worse. I think she's much more intuitive, she really puts things together in a helter-skelter way. I have to teach somewhat, so I have to try to organize things a *little* more coherently than that, although I don't always succeed. So I think on that basis she's the furthest out, possibly, of the completely intuitive critics. She *hates* systems and theories. She's much more intolerant of them than I am. I mean, she didn't just go after auteurism, she went after everybody. She hasn't even acknowledged structuralism. I don't think she wants to admit that there is a system that can operate.

What she's always stressed is this multiple perspective and, to a certain extent, I tend to agree with that approach.

There's another big, fundamental difference—you might call it an ideological difference or a temperamental difference—and that is that I'm very much into the past. In fact, the past always interests me much more than the present, and the future doesn't interest me at all. I think the future is boring. But the present I find is always very chaotic. I review because I have to, I'm a journalist, but a lot of times I'm wondering what I'll think about this film ten years from now. If I had my way I wouldn't write in such haste, I wouldn't write the day after the picture opens. I'd like to wait six months. I can't do it because I'm on a weekly paper and everybody wants to know immediately—you know, you like it, you don't like it, the gut reaction.

Pauline is anti-past. Pauline is the party of the future. She came to Columbia once to talk and she said she never sees a film more than once, she never analyzes or studies it, she trusts her own gut reactions right off the bat. She says you should never look back, you should always try to go forward, always think new. She takes that Cocteau thing—you know, *etonnes moi*—quite literally and a great deal of her rhetoric deals with breaking the molds and moving on...continual excitement. I think she wants to be eternally young, she wants to identify with young people, young things. I'm much more skeptical of youth. I see film as an aging thing and I'm concerned always with the classical tradition.

Cineaste: *In the last few years you seem to have attempted in your work to redress your frequent dismissal of European cinema during the earlier years of auteurism. For example, you've obviously shifted your perceptions on Bergman. I don't know if it's your wife's influence, or what, but you're much more sympathetic now to Bergman's work.*

Sarris: Actually, I started out very much as a Bergman enthusiast, then I ran into a period about the time of *The Magician* and *Winter Light* when I became very negative toward Bergman. That's when I started writing for *The Voice*, so when things like *The Silence* came along, I was always writing the anti-Bergman review, and people got the idea that I was hostile to Bergman. I must say that Bergman's admirers gave me a lot of trouble, especially those theologians—there must have been about twenty-nine books on the theme of God in Ingmar Bergman. I got so tired of all that that I began, I think, to take it out on Bergman. Meanwhile, Bergman just kept plodding along, doing his thing. Bergman is an example of

somebody who is not a natural—he doesn't have the natural kinetic flair that a lot of directors have—but he has a kind of substance. I think he's one of the few grown-up people who ever made movies. Consequently, the body of his work is massive and I think he becomes major for that.

Yeah, I am trying to redress. I'm even trying to find some virture in old Fred Zinneman and Stanley Kramer...who knows? In a historical framework, of course, many of us reacted against what they represented. But I think now we have to try to describe all these people, to describe what it was that was interesting about them, what people saw in them, and why.

Cineaste: *What is your reaction to the recent Hollywood trend of working class films? I know you praised* Bloodbrothers *very lavishly.*

Sarris: I don't think it's a trend. I think it's an isolated thing. *Blue Collar* did not do that well; it did not do well enough for people to say, "Let's make more movies about ordinary workers." There may be more movies, but they'll be like the Price novels that are being filmed now. They're picking up the working class but in a very garish way, the way Odets did in the thirties, adding to that the current fascination with violence. The interesting thing about *Blue Collar* is that they started off with something and then ended it up with this anarchic violence. I know some Marxists who are very upset about the resolution of that film—again, it's the whole Schrader/Milius/Cimino gun-happy axis out there.

What I find interesting, just in a bemused sense—because my taste has alway been more romantic than realistic—is that you never see a movie in which anyone has money problems. All these new stars, I mean, they're all funky, but they never seem to worry about where their next buck is coming from. It's all taken care of magically, mysteriously. But if there's one problem in our society, it's that everybody's wondering where his next buck is coming from, and how he's going to pay his bills. This is a situation not handled in movies anymore. All the genres used to handle it—the family genre, the comedy, even the Andy Hardy things. In Andy Hardy the central thing was how he was going to get enough money to go to the prom. But you hardly ever see that anymore. And something that's a real danger sign, I think, is the Feel Good Syndrome in movies today. For instance, films on the drug scene. Every film that has dealt with drugs as a problem has failed. The only way drugs can be handled on the screen with a young audience now is as a joke—like in *Animal House,* the whole idea of taking your first puff and not knowing how

to do it, it's a comical rite of passage—or the very painless, easy caricatures in Cheech and Chong's *Up in Smoke*. But the minute you show it as a problem, showing the ravages of drugs, showing how people get hooked, and so forth—failure. Kids don't want to see it.

There's a tendency now for even the best movie-makers to indulge in these kinds of fantasies. One: money is easy, you can always get money when you need it, and you don't have to take shit from anybody to get it. Two: guns solve everything, you just pull out a gun, pull a caper, and your problems are solved. In the long run, that doesn't really address itself to the real world. It gets further and further away from it. Although I don't like genres, and I've accepted their fantasies and ironies over the years, I think these new directors want to have it both ways. They want to do these magic shows, and yet on the other hand they want to pretend they're making statements about the human condition. Some people ask why I'm so hard on *The Deer Hunter* when I like the Sam Fuller and Anthony Mann war movies, and I say, "Well, they didn't come on so pretentiously. They were little movies, they didn't have a special run for Oscars and film critics awards, and they didn't make special claims. And in many ways, if you look at them, they were more intelligent when they were dealing with character."

Cineaste: *But* The Deer Hunter *had an emotional and visual expressiveness which often, from my point of view, transcended its lack of intelligence. It's an incoherent, self-indulgent film, but I still remember the images of the steel town, of Thailand as Vietnam. . . .*

Sarris: But you know that's the same argument that was made for *Days of Heaven*. Cinematography today is tremendously advanced. Films are incredibly expressive and beautiful, more so than ever before, but I think the structures are not there to link these images together. The Ukrainian wedding in *Deer Hunter* was completely unrevealing, unyielding, opaque, and several Ukrainians I know claim it was a Polish joke wedding more than anything else. Towards the end, in fact, as they all stood around with their bowling shirts, in a very unconvincing tableau, I kept thinking of the old Polish joke about the bridegroom being the one with the clean bowling shirt. Cimino and company are so superior to these characters, they're really acting circles around this minimal script, and I get uncomfortable with that kind of sophistication lavished on this supposedly realistic subject and done in what I find to be a very arrogant and excessively expressive way.

Cineaste: *In* Talking Pictures, *Richard Corliss has emphasized the role of the screenwriter, and you yourself wrote an article on the actor as* auteur. *In this context, perhaps the auteur theory is more important as a* historical *tool.*

Sarris: That's my big argument with the structuralists and semioticians. They presume to stand outside of history, but I see myself as a part of a historical process. The fifties and sixties were a period of exploration, of explosion, of excitement. And I've said that, for me, the seventies and eighties are a period of consolidation. I don't repudiate anything I ever did, but on the other hand I'm always rewriting. I'm always rethinking. That's where I differ from someone like Pauline. Pauline feels that once she has made a judgement, it's for forever, and then she wants to forget about it and launch into something else. To me, everything is swirling, we are possessed by the past, we can never escape it completely. That doesn't mean that we should just live in the past. I think we should move forward, but we should move forward in a kind of skeptical spirit.

The thrust of auteurism has changed. I think we now realize we have to do everything. You know, people used to say to us, "What about the actor?" Well, the actor is the first thing you notice. It didn't take *me* to come along and tell people that actors were important. But a lot of people didn't know anything about directors when I started. Even people who were writing criticism didn't really know about directors. Now that we've established that, we can look at all the nuances, and come up with a more complete approach, and also bring in sociology again. But in a more sophisticated way, in a more complex way. I think that's the future. I'd like to think—and of course this may be a fantasy on my part—that I am trying to open up, to include more than I did, that my mind is not closing, it's opening up.

24—BRUCE GILBERT

Hollywood's progressive producer

A question which has always intrigued Hollywood radicals is whether it is possible to make films with controversial content and social values, yet still get them accepted by mass audiences. In the early seventies, Bruce Gilbert, a young anti-war activist who had just left Berkeley, spent a great deal of time talking with his colleagues at the Indo-China Peace Campaign about the kinds of films that should be made. Scores of other activists who were also madly in love with the movies had had similar late night rap sessions, but Gilbert's situation was unique—his conversations were with Jane Fonda. In 1973, they took the key step of forming IPC Films, an independent production company. Their first project was Coming Home *(1978), which won Academy Awards for Best Screenplay, Best Actor, and Best Actress. The second IPC film was* The China Syndrome *(1979). No sooner had the nuclear industry mounted a press campaign to demonstrate that the film's scenario was impossible than the Three Mile Island accident occurred to confirm the film's perspective on the dangers of nuclear plants and on the coverups to be expected from the utilities and the government. Early in 1979, Bruce Gilbert spoke with* Cineaste *contributing editor Barbara Zheutlin and Jim Richardson about why he thought Hollywood was now wide open to the prospect of making the kind of films he'd always wanted to make.*

Cineaste: *Why are there so few entertaining and provocative films like* The China Syndrome *created in Hollywood?*

Bruce Gilbert: Because they are not being written. I don't mean that people are not choosing the right themes to write about. I think I get all the political scripts that are written [laughs]. But 99.9 per cent of them are terrible. Even though they may have an interesting subject, they're so poorly written that you would never want to make them and nobody would want to see them.

I began in Hollywood as a reader and read over a thousand scripts during my first year, and I happen to feel that most people just don't know how to write. The screenplay form is so rigid in its structure, and it is so difficult to develop a story and theme and characters that work, that writing screenplays is the equivalent of writing haiku. Yet everybody thinks they can become a screenplay writer just out of the blue. In fact, most of the scripts that we get are written by people who say to themselves after seeing a movie, "Well, I can write a better movie than that!" But then they write a script that is *not as good* as that bad movie they just saw.

Cineaste: *How many scripts did you get last year?*

Gilbert: I don't know, we couldn't count them there were so many. So we cut it off. We're no longer accepting unsolicited manuscripts except under very special circumstances where we ask writers to sign a release.

Unfortunately, there's no good place that I know of where you can be taught how to write a good screenplay, or even what *makes* a good screenplay. So that's one problem. I suppose the other problem is that—generalizations here—people who get into writing screenplays tend to want to do it simply for the money. Consequently they have nothing to say [laughs]. So their screenplays may be well-crafted, but they have no content. It's this drought of good writing that propelled us [IPC] into developing our own screenplays from our own ideas. If we waited for the great screenplay to drop in our laps, we'd do a film every ten years or something like that.

Cineaste: *How do you at IPC come up with the ideas for films? And how central are those ideas to your decisions about what films to develop?*

Gilbert: For us the idea is all important, it's the only thing. You have to feel passionate about it or you can't ever get up the energy to go through all of the trials and tribulations and the hurdles for the many years that it takes to make a movie from an idea.

It's so hard to make a film, any film, I just can't understand why

people spend years of their lives and enormous amounts of emotional energy to make a film they don't give a damn about. I couldn't do it. Every time I say something like that, people tell me that what motivates others is greed—it's the money. But you know most films don't get made, most ideas don't get made into films, and if you amortize the number of years that it takes to get a film made, it turns out that you don't make very much money.

Cineaste: *Why did you make* The China Syndrome? *What were the ideas that you hoped to communicate through the film?*

Gilbert: We don't live in a vacuum. We're fairly charged politically and try to be aware of what's going on in the world. We know that this is a time in history where we are at a turning point, where we haven't become so committed to nuclear power that we are locked into it. That became a motivating force to do the film.

There were so many things I thought the film could get across. Everything from trying to convince the American public not to put their faith entirely in scientific experts, nor to defer all decision making to those who supposedly know, to a critique of the low level of television journalism.

There's a line which I'm so glad got into the ad campaign, believe it or not. It's that *The China Syndrome* is not about China, it's about choices. That's really what the film is about. On so many levels things are in bad shape, and they can only get better depending upon the choices people make. I believe generally that people will make the right choices when they have all the information, which is basically what the film is trying to demonstrate.

Cineaste: *What was the relationship between your company, IPC, Michael Douglas, the producer, and Columbia Pictures? Who owned the picture? Who financed it? And did this make a difference in how the film got made?*

Gilbert: It gets a little complicated. But, in short, it was a Michael Douglas-slash-IPC Presentation. We got Columbia to agree to distribute the project, which allowed us to establish a negative pick-up agreement with the banks to finance the film, with Columbia guaranteeing the completion and the distribution of the movie. By setting it up as a negative pick-up arrangement, we made the film independently—off the Columbia lot. It's as close to a purely independently financed film that you can make while arranging to have distribution by a major studio.

It allowed us to be more quiet about the nature of the film, which helped us get through the difficulties we were facing in getting into

certain places to photograph. Not that we ever got into a nuclear power plant. But we had to get into places to approximate nuclear power plants, and we used assorted shots which taken together look like a nuclear power plant.

Also, we didn't know how much opposition, possibly even sabotage, we were going to get. Peter Bart had told me years before that while he owned for a time a book which had a nuclear power background *(The Prometheus Crisis)*, they were getting an average of a threat a week, after there had been one little announcement in the trade publications that they were intending to do the film. It never was made. But in the beginning we were also worried about sabotage and threats and things like that. Luckily, nothing happened.

Cineaste: *Did the Columbia studio executives acknowledge that the content of the film was potentially controversial?*

Gilbert: From what I've been told, yes. They thought Jane Fonda in a movie about nuclear power was potentially very dangerous. Not very dangerous in that it might stop nuclear power, but very dangerous in that they might lose their investment. That was mainly what they were concerned about. They have to be concerned about that. It probably helped somewhat that Dan Melnick was the studio head when we had to get the final script and budget approved before production began, because he's a very progressive man. I really don't know if he's pro-nuclear or anti-nuclear, that never became an issue. But I just assume that his outlook helped get the picture over the final hurdle, through the big final arguments over the budget and script.

Cineaste: *What were the arguments about the script?*

Gilbert: They had nothing to do with the politics of it. They had to do with the dramatic structure. In fact, just in those terms, they wanted us to take out the boardroom scene that appears toward the beginning of the film because they felt it slowed down the pace. But we felt the scene was necessary to give some insight into the problems the chairman of the utility company faced. The chairman is confronting a very difficult economic situation, because he's running the company for profit and he can be removed from his position if he doesn't produce those profits. Without that scene the chairman appears only at the end of the film in a big limousine, ordering his own men to "scram" the plant. He's too evil unless you realize the pressures on him. After all—and I don't know how well this got across in the film—he doesn't know what the Jack Lemmon character knows. From what he can see, Jack Lemmon is a babbling

lunatic who has just hijacked a nuclear power plant with a gun and is threatening to flood the containment with radiation. And Jack Lemmon can't get the information that he knows out, and the people that are under the chairman have never let that information filter up, so all the chairman knows are the economic pressures that he must face.

Cineaste: *Who was in control of publicity for the film?*

Gilbert: What's important for people to understand is that there can be legal, contractual agreements which give Columbia the final determination, while giving us only certain consultative rights. But as a practical matter, *The China Syndrome* is a six million dollar film about a dicey subject matter that everybody's a little afraid of. The studio wants Jane Fonda, Jack Lemmon, Michael Douglas and Bruce Gilbert to ultimately be happy with the way it's being promoted and advertised, otherwise they're not going to get all of our cooperation and support. And they need the principals' support because they're the ones who go out and talk with the press. With the support of Fonda, Lemmon and Douglas, *China Syndrome* became one of the biggest promotion junkets in the history of Columbia.

So, because of that, which is not written into the contract anywhere, the principals have leverage. The studio is not likely to do anything that is going to unduly anger us or do something that we would find in bad taste or couldn't agree with. Then, as a practical matter, since we don't have any expertise in advertising other than our particular taste, we listen to professionals who do this for a living. There were several campaigns developed, because initally even the professionals don't know what's going to work. They are guessing to a certain extent and you want to have options.

Cineaste: *When the film first came out, the key people—Fonda, Douglas, Lemmon and Bridges—all made statements to the press that* The China Syndrome *was just a movie. No one was talking about nuclear power. Was this a conscious decision and, if so, who made this decision?*

Gilbert: There was a lot of discussion that went on between the publicity department and Michael Douglas and I about how the film would get "positioned" in the public's mind. The film works on a number of levels. The question is how do you talk about it in public *before* people have seen it.

We believe that for the most part the public doesn't want to see films that they think are good for them. They have to pay four dollars for a ticket and pay for a babysitter and maybe pay for dinner, so the

first question they ask themselves is, are they going to be entertained and have a good time for all this money that they're putting out. We didn't want to keep anybody from seeing the film by positioning it in a way where they would believe that it was one of those films that would be good for them, like castor oil or medicine. So we tried to position the film as a thriller. This is not false advertising, because it *is* a thriller and it is a thriller that works.

I'll give you one example of a tremendous argument we had over the title, *The China Syndrome.* We changed our own minds about the title a few times. For one reason, there were a number of people who thought the title *The China Syndrome* indicated that the film was in a sort of grade B thriller genre like *The Eiger Sanction.* That's why I didn't like it at first. And for another reason, we felt if we went in there with a film that was titled *The China Syndrome*, even though the public didn't know what that meant, people associated with the nuclear power industry did know what it meant, and they would have a tendency to stay away from the film. So we changed the title during production to *Eyewitness* and later to *Power.*

The advertising department had done some testing, and *Power* didn't test very powerfully [laughs]. And *Eyewitness* was okay, but it wasn't anything great either in terms of both audience response—what an audience would want to see—nor in terms of what they thought the film was about. We had also included *The China Syndrome* in that testing. It tested the worst of all, which shows you how twisted we are. People thought it was about China, they thought it was about disease, they thought it was about the Cold War, something to do with U.S.-China relations. They thought it was about everything but what it was.

So the studio tried to convince us never to use that title. Everybody at Columbia came up with alternative titles. They gave us pages and pages of titles, which can end up being self-defeating because after a while the greatest title in the world looks bad. You can't just come up with a title that way. But Michael and I kept coming back to *The China Syndrome* because we felt that we could indicate that the film was not what people thought it was, and that you could take this big negative and turn it into a positive. *The China Syndrome* could be more provocative than taking a name that tested only so-so because you couldn't get any pizazz out of that kind of title.

Cineaste: *It sounds like a classic Hollywood move. You wanted a*

title that actually had some content and meant something, but the studio wanted a title that tested okay.

Gilbert: They just didn't want to say anything that led to *The China Syndrome*. It finally came down to us becoming galvanized ourselves that we could do it, and should do it, and they fought us all the way on it, until we finally used our biggest gun, which was Jane. She called up and said she wouldn't go out on a promotional tour for a film called *Eyewitness*.

Cineaste: *Were you fighting for the title* China Syndrome *in part because of its educational value?*

Gilbert: Well, we knew it ultimately would have that, but at the back of our minds was that the audience would *get it*. We'd start with a tease. We'd say what the film wasn't and therefore try to get people interested in what it *was*. If it wasn't what they thought it was—about China or disease—something like that, well then what the hell is it? And by that method we would hopefully get people interested enough to go into the theater and find out. We were totally confident that once they got into the theater we were home free, because the film would deliver for them. That was the base of everything.

Once the decision was made to go with *The China Syndrome* as the title, the studio generated a lot of activity to go along with what we wanted to do. The actual campaign, the graphics and the script that you hear in the voice-over on the television commercial and so on, was generated outside the studio by an independent house that the studio contracted called Saraban, a company that does trailers, featurettes and commercials.

Cineaste: *The film cost six million dollars to produce. How much has the company spent so far on the advertising campaign?*

Gilbert: About five million dollars. Two and a half million of that in television alone before the opening of the film. It's the first time in Columbia's history—and I don't know of any other studio that's done it—where the teaser campaign was begun three weeks in advance of the opening of the film. Usually they begin during the week before the opening.

Cineaste: *How did the studio executives react to the film?*

Gilbert: When we finally showed them the rough cut of the film, they were astounded. They had no idea that the film was going to be as good as it was. They were overjoyed. They thought it was a really well-made movie, althought they—particularly the advertising and publicity departments—were still worried about how it was going to be perceived and how they would promote a film with that much

controversial content. But generally they had no idea it was going to be as affecting as it was. They guys are hard boiled, they've seen it all. So to have affected *them* emotionally was. . . .

Cineaste: *So it was at that point that the studio got behind the film?*

Gilbert: Yes. At that point they realized that they had something special on their hands. A controversial film that was an exceedingly well made thriller and that had very special performances in it. Fortunately, Jack Brodsky, who was the head of advertising and publicity, has a philosophy that you can convey to an audience before they see a film how good the movie company thinks the movie is. You do this through a number of factors that are hard to define, but it has to do with the whole quality of the presentation. Fortunately for us, he saw this as one of those films that needed that kind of attention.

Cineaste: *What was the nuclear power industry's reaction to the film?*

Gilbert: Total condemnation in the beginning. I don't want to pussy-foot around about General Electric's withdrawal of sponsorship of the Barbara Walters show. They made an attempt at censorship, pure and simple, by withdrawing their sponsorship of the show because Walters was interviewing Jane Fonda. I think people should know that GE owns television stations and they're attempting to buy the Cox broadcasting system. Next year they're going to own even more television stations. If they don't like the content or point of view being broadcast because it happens to go against company policy, well you can forget whether it's in the interests of the American people to know about it. GE will have the power to keep it off the air on their stations. And they'll use it. They've proven that they'll use it because they withdrew their sponsorship of the Walters show even though Jane didn't even talk about what *The China Syndrome* is about. Just the mention of the title of the film provoked them, which shows the extent to which they'll go. I think it's a very dangerous situation and one that does not bode well for the future.

Cineaste: *What other signs of their reaction to* The China Syndrome *have you heard of?*

Gilbert: Well, the Atomic Industrial Forum, which is an industry lobbying group that is euphemistically called the trade group, and the Edison Electric Institute both sent out press packets to virtually every reviewer and news editor in the country referring to certain films that were going to come out in the near future and which misrepresented

the nuclear power industry. They said that they wanted to provide them with the facts of how safe it was and why what the film depicted could never happen.

There were a lot of commentators who tried to rake the film over the coals during the first week that it opened. They called it irresponsible and not true and said that the accident could never happen, that there were back up systems to back up systems and that no one ever died in a nuclear accident—which is untrue, but they keep saying it. We took a lot of heat, even though we were not trying to portray the film as a film about nuclear power. But they apparently saw the threat. I think their reaction was so vociferous because they knew how accurate the film was, and the proof of the pudding was that during the second week of release, the accident at Three Mile Island happened.

Cineaste: *There were a lot of jokes made after the accident about the nuclear power industry's stocks going down and Columbia's soaring. Is there any way to gauge the impact that the accident had on* The China Syndrome *at the box-office?*

Gilbert: No real accurate way to tell. The assumption would be that it helped a lot, but the fact was that the grosses were high the first week because the film had been promoted as a thriller. This was continuing into the second week when the Three Mile Island accident happened. So there's just no accurate way to figure it out.

My own feeling is that just in terms of box-office, it probably helped in the short run—in terms of keeping the percentage of the opening week's audience up to the same level over several weeks—but that it hurt us in the long run. I'm talking now in terms of box-office, which I don't think is all that important—important, but not all that important. But it probably hurt us in the long run because the film became tied to a particular place, a particular event and a particular issue. We always knew that the film would finally become tied to an issue, but to get so tied to Three Mile Island that early on meant that people might get bored with the film because it related to a current news event. And every current news event rather quickly becomes old news. So *The China Syndrome* would be seen as tied to a current event rather than as "pure entertainment," like *Jaws II*, which was seen as a terrifying film that you want to go see in the summer because it's about sharks and you want to be scared.

Cineaste: *Do you feel there were any weaknesses in the film? Some critics have said that Jane Fonda consistently plays a*

*good-hearted, naive woman who becomes radicalized by her cir-
cumstances and wonder how long she will go on playing that kind
of role.*

Gilbert: I disagree with that characterization of Jane's roles, at
least the good-hearted, naive part. I think the characters are very
different. If you recall, Kimberly Wells wants to become an anchor
woman. She is upwardly mobile, ambitious, and will do anything—
including not to rock the boat on this story—to rise within the
television station. She wears the right clothes, she does her hair in a
certain way, she does everything—not because she's good-hearted
and naive, but because she's old-fashioned ambitious. You know,
ambition without content again. The only thing that begins to turn
her around is information that comes from the outside, not that she
generates herself. Also, remember, the accident is a good news
story. It's going to be a feather in her cap. She doesn't change out of
any sense of naive idealism.

Likewise the Sally Hyde character in *Coming Home*. It's funny
how sometimes audiences can look at a character through rose
colored glasses. I mean, when you think about it, this is a woman
who cheated on her husband, a man who was fighting a war. That's
not a very likeable thing to do. Yes, she became radicalized by
external circumstances but I wouldn't call her entirely good-hearted
and naive when she began a love affair with a paraplegic who was
not her husband. And she ultimately had to pay a price for that.

Characters that start on one note and just continue all the way
through a motion picture on that one note are not very interesting.
What's interesting is being able to see a character go through a
transformation, but that's also very hard to do and make it
believable. I consider it a sign of Jane's talent as an actress, and of
her good judgment about drama, that these are the kinds of
characters she portrays.

There's also a political side which is that most people aren't aware.
Most people don't crusade or try to effect change. Most people
are just ordinary folks. They come to consciousness through many
different roads and it usually happens by something impacting upon
them from the outside, events of one sort or another, personal
or political. And I want to glorify that process of becoming
conscious—forty feet high and sixty feet wide, or whatever it is—up
there on the screen.

Cineaste: *When you reflect on your role in society and your
position within Hollywood, an industry that produces most of the*

culture for the country and dominates the culture of the world, what are your goals and how do you develop your strategies? How do you decide, for example, which issue to focus on at a certain time?

Gilbert: Usually the issues pick us, not the other way around. But that's not entirely true, it's obviously a two way street. I don't know [laughs]. It's somewhat a mysterious process. I guess it happens in a number of different ways.

Coming Home was conceived while the war was on. When the war ended, however, we were still working on the film. It still was important to use because we knew that there was going to be a cultural battle of ideas to interpret the lessons of the war. And we wanted our film to be out there as a cultural expression and to hopefully help people learn some lessons from the Vietnam War.

Cineaste: *What was your response to the two films dealing with the Vietnam War getting so much attention at the last Academy Awards ceremony? Have you seen* The Deer Hunter?

Gilbert: I was delighted about *Coming Home*, appalled about *The Deer Hunter*. Yes, I've seen it. I saw it before it was released to the public, and I felt then and I feel now that it's one of the most dangerous films that's ever been made in the United States. I felt in a complete bind because I wanted to say something about it, particularly given the critics' positive reaction to the film, but I felt completely strapped by the mere fact of having made another film that dealt with the Vietnam war during the same year and knowing that it might possibly be in contention with *The Deer Hunter* at the Academy Awards. I felt my comments would just be construed as backbiting or something. People wouldn't hear the conflict, given the level of discussion in Hollywood.

Cineaste: *Is that true? Is the level of discussion in Hollywood that low?*

Gilbert: As far as issues are concerned, yes, quite low. In fact, most people try to argue that the content of films is not what's important, it's the level of craftsmanship that matters. I usually say to those people that they would probably have praised Nazi films in Germany in 1939. It's just appalling to me, it disgusts me, that critics could be so overwhelmed just by the craftsmanship of the film. *The Deer Hunter* is a well done movie, and is in many ways state of the art, though you can argue about the editing. It is a well mounted production, and it is well acted, and it is precisely that which makes it such a dangerous film. It's the *Green Berets* recycled. It's one of those films that not only doesn't allow us to learn anything from the

Vietnam experience but it reinforces some of the worst aspects of the American character—attitudes toward people of color and toward the Vietnamese in particular.

The reaction which got to the content of the film finally surfaced after the Academy voting was over and at the very tail end. Peter Arnet, a Pulitzer Prize winning reporter who covered the Vietnam War, wrote an article in the *Los Angeles Times* opinion section the day before the Academy Awards presentation. Slowly people began to talk privately about it, and there was a rippling effect, but for a while you could only argue about the film in private. With *Midnight Express* the critical reaction came a lot faster than it did with *The Deer Hunter*. That film also made me quite angry. There was a critical reaction to the manipulative violence and the attitude toward the Turks, but criticisms didn't surface toward *The Deer Hunter* for a long time.

What really appalls me is that some former anti-war activists like Thom Mount and Sean Daniel were at Universal, the studio that partly financed *The Deer Hunter* and, while they say they were powerless to stop it from being made, they didn't do very much to attempt to do that and in fact are now apologists for the film.

Cineaste: *On a craftsmanship level?*

Gilbert: They'll go even further and argue that it's not racist, that it's an anti-war film. I defy anyone to argue that this is an anti-war film. It's a celebration of violence and it's not one of those films like *Patton,* for instance, where you can look at both sides of the coin. A lot of people view *Patton* as an anti-war film and yet, at the same time, it was Nixon's favorite film, and he viewed it over and over again in the White House. I don't mind that kind of ambiguity. But I don't believe you can argue that with *The Deer Hunter*.

Cineaste: *While we're discussing state of the art filmmaking, do you think it's possible for an independent film which doesn't come up to the technical level of a Hollywood film to reach a large audience?*

Gilbert: Yes, I think it's already been proven. What you need is a good story. If you take a look at *Easy Rider* now, for instance, you'll see the lack of Hollywood sheen and polish on that film. The film is technically shoddy, yet when it was released, there was a tremendous reaction to it because it impacted on something that was happening culturally in the country and it was sort of being shown back to ourselves for the first time on the screen.

There was a big audience that went out to see that film. I'm sure that if we sat here for five minutes we could think of a few more, so I

don't think a film has to have the highest level of technical expertise to be powerful. Mainly what I argue is that film critics are swayed too much by that; or worse, they go further and say that technique is what they should be concerned with and not content, which is just an appalling and scandalous thing to say.

Cineaste: *What do you see as the impact of the conglomerates taking over all the film companies, book publishers, magazines and TV stations?*

Gilbert: So far, to my knowledge anyway, it has not made itself felt on the content of films. As long as the balance sheet is looking good. But the potential exists, like in the case of GE, for the multinational corporation to exert control. So I think it's potentially a very dangerous situation.

Cineaste: *I'm troubled by the corporate takeover of the film companies because they seem to be homogenizing the culture by 1) marketing one idea as a book, a film, a record and a TV show and by 2) going for the one or two pictures that could become another* Jaws, *rather than developing numerous ideas that would become films to reach different, more diverse, though smaller audiences. It also disturbs me that these corporations use the profits that they make off movies to purchase other companies, rather than to improve the culture. Why couldn't the profit from* Alien, *for instance, be spent to set up training programs for screenwriters?*

Gilbert: It's a real problem if you're going to have private owner- ship of the production entities and the name of the game is making films for profit. It's a situation where a few films make a really big score, while most films lose money. So you're going to find movie studios taking a big portion of their profits and investing them in other businesses that have a more stable profit picture. Part of the reason for that, something that I think is a real problem and has to be dealt with by progressive people, is the rising cost of making a movie. The production cost of movies is really galloping out of sight. A low- budget Hollywood film without stars or top-quality production and technical crews costs about two and a half million.

It's getting ridiculous, because for a film to break even it has to earn back about three times its production costs. A low-budget film has to make back seven and a half million dollars. When you look at the yearly *Variety* and you see how many films make seven and a half million dollars in film rentals, the list isn't real long. So if just to break even a film has to do a giant amount of business, the tendency is going to be towards making films that have television spinoffs, record

albums and pocket book spinoffs to them. And the homogenized effect that we have talked about will happen.

Maybe there will have to be a technological breakthrough or an economic collapse, I'm not sure which, to reduce the cost of working in the medium. That may be the only way that people on any appreciable scale are going to be allowed into the industry and be allowed to make mistakes. Right now the stakes are so high that it's not a very conducive environment to grow in. A person has to perform right away. If their film doesn't make money, they may never get to work again. One shot—that's all you get.

Cineaste: *Are people, particularly those in positions of power within the industry, beginning to talk about doing something about this?*

Gilbert: Not that I've seen. But I wish they were, and I hope anybody who's thinking about it will contact me. But there is no easy way out. The only long-term idea that offers even a partial solution is to give people a chance to do twenty- to thirty-minute shorts. They've found that they can bring back the short film by programming it with a feature like *The Rocky Horror Picture Show* and distributing it to theaters in the major cities which have midnight showings on Friday and Saturday nights. This would be a way to give someone a chance to get their scripts produced or to get their directorial debut and to do it several times while they perfect their craft before putting everything on the line for a big feature film. It's a way to develop talent without risking everything.

Cineaste: *Is anyone suggesting a more organized effort to change the consciousness and priorities of those who work in Hollywood?*

Gilbert: I don't know of any organization in the short run that could do that within the Hollywood framework. I suppose one could say that's because it's an industry that fosters individualism, but I don't think it does except for the very few people on the top. And I think you can show that any industry fosters individualism for a few at the top. Hollywood is actually a very collaborative industry. It's just that I think it reflects the larger society, which at this point sees no need for organized action. Or worse, people have seen some of the outgrowths of the sixties-style organizations and don't want that. That's why I think that at the present time one organization in Hollywood would not be very effective. I don't know if one ever has been. I know that there were organizations that existed, from the Communist Party to the Entertainment Industry for Peace and

Justice. But I'm less clear on the consciousness of the people in those organizations or what they were attempting to do.

Cineaste: *There's been a debate recently about whether or not progressives are gaining more influence in the industry. To what extent are you a part of the Hollywood community, and has it changed over the past few years?*

Gilbert: I wasn't very interested in the Hollywood community during the development of *Coming Home.* I was simply interested in the people that I wanted to work with. And vice versa. The Hollywood community wasn't very interested in me. I was just another kid out there developing a screenplay. I've found that over the last few years I've gotten more involved, met more people and talked to more people. I've come to see Hollywood as not necessarily all bad, which is what I used to think. I used to think that if you get too close, they're going to taint you or something. New people are entering the industry all the time, and they're better and more interesting.

Cineaste: *How do you explain that?*

Gilbert: I think it's a natural outgrowth of the sixties. People think the sixties are dead, but I just think that everyone went to work. They're in the institutions. It's very difficult to calculate or imagine how much the general public consciousness has changed after Vietnam and Watergate and incidents like Three Mile Island. People have changed—fundamentally changed, I think—in terms of their view toward society and their sense of who is telling them the truth and who isn't. And that's reflected by the younger blood that's coming into the industry.

We can't, nor are we going to, change Hollywood or motion pictures in general by ourselves. We (IPC) can do one film a year, or something like that. Even if it's great—which every film can't be—it's just piddling really. You hopefully inspire other people to do it, or to want to do it, or to try to do the best they possibly can. Part of that happens by releasing a film and having people see it and they get inspired. Other parts happen by talking to people and getting to know them and letting them know you. So I've become more involved in the Hollywood community, but I also have a lot of friends who are not in the industry.

Cineaste: *Bruce, you're optimistic about the possiblities for progressives who work within the industry. But isn't that because you're in a unique position as Jane Fonda's partner? Do you think that*

someone could enter this industry and accomplish what you've been able to accomplish?

Gilbert: Someone could. I hope someone is. I'm not quite sure how to respond to this. I got my practical experience in the industry at least initially by working in another independent production company that had nothing to do with Jane.

Cineaste: *But doesn't Jane Fonda, because she is a star and therefore "bankable," have more opportunities to control her work within the industry?*

Gilbert: Stars are important, but there are other factors, like how commercial a project is perceived to be by the studios, or how expensive it is, or how big a star is. Take a film like *Coming Home*. Jane Fonda's commitment to it when there was just an idea was very important. But in the beginning when there was just her and I and a writer, there was no studio that would finance it. We had to do it ourselves. Nobody wanted to touch Vietnam with a ten-foot pole. Even Jane Fonda wasn't enough. Even when we had Waldo Salt, who had won an Academy Award for *Midnight Cowboy* and had written *Serpico* and a number of other things, it wasn't enough. We needed Waldo Salt and Jane Fonda and a top-flight director that the studios had faith in, plus another two stars to fill the other two roles. Some combination of those is what it took to get the project off the ground. So stars are important but, more often than not, more than that has to come together to get a film off the ground.

I don't think Jane Fonda is totally unique. She's unique as an actress, for sure, but she's not unique as far as having progressive ideas. She doesn't have a monopoly on them in Hollywood, and there are plenty of other progressive people that are doing things. I always start to draw a blank when I think about this, but films like *Network, All the President's Men,* and *Norma Rae* have been made because people who have strong, passionate feelings in a progressive direction got behind the film. That's a little bit oversimplifying it, but, unless there were some progressive people involved in each of those projects, they wouldn't have been made. And they wouldn't have been made fifteen or twenty years ago because, in general—and I've said this before—the industry's potential has opened up.

It's opened up for real material reasons. The old autocratic rule of the studios has broken down. The original owners no longer are in place. The level of the audience and what it's interested in is different from what it was. And, you know, in a funny kind of way it's that the competition for the leisure dollar has expanded beyond movies.

When movies used to be the only thing you could do, and they were changing every two days in a movie theater, and there was no television and no Sea World and no Disneyland and spectator sports were not has huge as they are now, everybody went to the movies. There were formulas for hit pictures—you put a star in 'em and you cranked 'em out and people would go. It was a machine almost.

Well, that doesn't work anymore. Now nobody knows what makes a hit picture. The people who think they know are people that generally run studios. And generally they don't run them for very long, because nobody has that long a streak of knowing what makes hits.

What makes hits? I looked at that in 1969, not really knowing anything about the industry in terms of feature films. When I saw *Easy Rider,* what sort of jelled in my mind was: "Wait a minute, they can make that kind of picture and every one goes to see it. Well, I can make something a lot more provocative with a lot more content and make it better." And because they don't know what makes hits any more, they are more willing than they once were to take risks on things that are not formula pictures. Therefore, if you can get a good picture in there with content, you've got a chance. If you can do it once, you can get another chance to do it again. And that's basically the strategy.

25—JORGE SEMPRUN

The truth is always revolutionary

Jorge Semprun is renowned for his work on the scripts of La Guerre est Finie *(1966),* Z *(1968),* The Confession *(1969),* Stavisky *(1974),* Special Section *(1975) and* Les Routes du Sud *(1978). His novels,* The Long Voyage *(1963) and* The Second Death of Ramon Mercader *(1969), were awarded the Prix Formentor and the Prix Femina, respectively. Prior to these artistic achievements, Semprun had led quite a different life. Far from the limelight, under the* nom du guerre *of Federico Sanchez, Semprun had served from 1952-1962 as a key organizer of Communist underground operations in Madrid. Later, in 1964, he and the Spanish Communist Party's most sophisticated theorist, Fernando Claudin, were expelled from the Party on charges of "factionalism," "anti-Sovietism," and "capitulationism." Semprun has explicated his ideological quarrels with his former comrades in the complex* Autobiography of Federico Sanchez *(U.S. publisher: Karz, 1979). Rather than taking an anti-Marxist position, Semprun/Sanchez writes in the spirit of Victor Serge and has the honesty to hold himself up to scorn for various writings and activities, especially his quiescence in relation to the hanging of his comrade Josef Frank by the Czech authorities in 1952. Thus, his work on* The Confession, La Guerre est Finie, *and* Les Routes du Sud *involves far more than the usual input of most "engaged" writers. Early in 1979, Theo Blomquist obtained this exclusive interview for* Cineaste.

Cineaste: *Your first novel, charged as it is with the constant flash-back and flash-forward technique that we also find in your latest book, seems to have been patterned very much after a modern film. Were you influenced by cinema as well as your own "grand voyage" to Buchenwald when you wrote* The Long Voyage *in 1963?*

Jorge Semprun: I didn't think of cinema in any clear, conscious way when I wrote that novel. This form, with flash-backs and flash-forward projections, imposed itself on my work in a perfectly natural, almost organic manner from the book's structure and the fact that I was recounting an experience seventeen years after it happened. I had a vision of this experience that was completely different than actually living it. Time had to play a role in the book.

Still, it is entirely possible that my spectator's interest in cinema played an indirect role in this. It's one of the more banal phenomena of the twentieth century that the work of more than a few novelists—starting with the Americans—shows a certain influence of cinematic narrative technique, even if it's well assimilated or immediatized. In any event, it's a fact that Alain Resnais' asking me to write a film for him was precisely a function of my way of conceiving that first novel. He said, "You are someone who can do film."

Cineaste: *And so you did* La Guerre est Finie?

Semprun: Right. *La Guerre est Finie* is a consequence of Resnais' reading of *The Long Voyage.*

Cineaste: *Were you a film aficionado?*

Semprun: Very much so. Going back to when I was very young, there has always been a very long memory of movies. There were periods of my life when, if I had the material means to do so, I might be seeing two films a day. Sure, there were other periods when I saw a lot less, but my overall consumption was pretty huge.

Cineaste: *In terms of things like creative challenges, artistic control and impact on audiences, which do you prefer to write — screenplays or novels?*

Semprun: Despite the fact that I've written more screenplays than novels, I think I'd sooner give up writing films than books if I were ever faced with such an absurd choice. That said, I'm going to continue trying to do both.

But for me it is not a question of preferring to write one or the other. It's different. With regard to impact on the audience, the immediate repercussions—the transmission of information, ideas and views on the world, be they political, aesthetic, or personal—cinema is obviously a much more effective means of action. Not one of my

novels has had an impact even comparable to that of a film like *Z*. However, I don't believe that a novel's essential role is its immediate impact. It is rather something more profound—a solitary, personal rapport. There is the writing itself, the expression of certain ideas and obsessions regardless of whether or not the book will succeed. The book of mine that has had the least success—*L'Evanouissement*— happens to be, for many reasons, the one that I most prefer. It was an almost automatic writing where many personal obsessions poured out. It's the one I most prefer and almost nobody read it.

Cineaste: *Which do you consider your most successful screenplay?*

Semprun: That depends on the point of view. You can't judge original scenarios—like my two for Resnais and the one for Losey—directly alongside the adaptations I have done. A consideration of the adaptation must take the original source book into account. My adaptation of Artur London's *The Confession*, for example, presented enormous difficulties because it was the direct testimony of what someone had actually experienced and it had to be respected. Not someone from the nineteenth century, London was someone living, someone who had the right to judge our work on his account.

Cineaste: *Someone you knew?*

Semprun: And someone I knew, yes. It's really necessary to consider these problems in order to respond precisely to your question. I would say though, if you like, that in terms of the effectiveness of my adaptations in the projection of a given truth to a wide public, it is surely *Z* that has best succeeded. But as far as my innermost feelings are concerned, my favorite script was for Resnais' *Stavisky*—not a smashing commercial success, but nevertheless a very interesting film in my opinion. It was a creative, imaginative work on the reality of an epoch. I believe—though I could be wrong, you never know—that this film could well outlast the others I've written.

Cineaste: *In contrast with much of the rest of your work, which is often abounding with political references, Stavisky's politics were so muted that it would almost have taken a historian to properly extract them, let alone an average member of the audience.*

Semprun: Yes, well I don't think *Stavisky* functions on the French historic reality of 1934 exactly, nor do I think it's a political film, in the strict sense of the term. While we were making it, everyone awaited a film about *l'affaire Stavisky*, like *l'affaire Watergate*, and they expected all the truths and explanations of this

celebrated *affaire*. But the project was nothing of the sort and it's not this sort of project that you can do with Alain Resnais. What you can do with Resnais, and what I was interested in doing with him, is to produce a kind of reflection. There are historical and theoretical connections, but it's also aesthetic. It's an aesthetic reflection on an era that goes beypond political events and cuts even deeper.

Cineaste: *So what sort of films can you do with Costa-Gavras, then, one of the most "political" directors today? What are the differences in working with these two directors?*

Semprun: With Costa-Gavras, you work *from* a document, a witnessed account or a historically rooted novel, and you work *on* a historic reality. It has always been a case of giving aesthetic and dramatic form to something that's already there objectively. Vassilikos' *Z* was a novel, but nevertheless taken from a real historical event—the assassination of Lambrakis in Greece. *The Confession* is from Artur London's testimony. *Special Section* is based on the dossier of an event that actually took place in France in 1941.

With Resnais, the work is an original screenplay, like *Stavisky*, that has a certain rapport with reality; or like *La Guerre est Finie*, which also has this rapport but rather with a reality more intimate, personal.

Cineaste: *Your reality.*

Semprun: That's it. And then, their work methods are very different too. With Resnais, you work with him while the film is being written and you disappear while the film is being shot. He doesn't want you on the set at all. He doesn't want you again until the last phase of editing. Editing itself is a form of rewriting and Resnais likes having his scenarist around for that. Conversely, Costa-Gavras and Joseph Losey are completely open to my presence on location and will even change the script with me during a shoot. Resnais rejects that. He works forever to perfect a screenplay—months and months and dozens of versions at times—but when he has the script ready to shoot, he changes absolutely nothing.

Cineasate: *Was he completely faithful to what you wrote for* La Guerre est Finie?

Semprun: Completely. But it's not a question of fidelity, it's a matter of work method. Of course these key differences also stem from the very different personalities of the directors. The universe of Resnais is very much that of imagination and his work is on images, dreams and obsessions rendered visual. With Costa, the work is much more on the materiality of the cinematic action, and the movement of this action.

Cineaste: *Whatever happened to the film you and Costa-Gavras were supposed to do on the Paris Commune?*

Semprun: That was never a real project. Costa-Gavras once thought about doing a film on the Commune, spoke to me about it, and engaged a team of young researchers to do the initial research for it. I never worked on this research and I wasn't especially keen on doing a great historical piece on the subject. I had an idea for something more personal, original, but nothing ever came of it because Costa abandoned the project.

Cineaste: *And what was your idea?*

Semprun: I'm not at all sure that he would have ever accepted it. My idea was to imagine a French journalist going with his camera to interview Arthur Rimbaud in Abyssinia when Rimbaud is engaged in arms commerce ten years or so after the Commune and not long before his death. "You were in Paris then," says the journalist, and we go on to see what the Commune was like through Rimbaud's eyes. Therefore, a totally personal view: Rimbaud and the Commune, his writing poems on the Commune, with Verlaine and the flight of Commune exiles to the cafes of London in 1872-'73. And therefore, a film employing this mythological figure of French literature—Arthur Rimbaud—as the guiding thread of a personal reflection and critique. Nothing at all orthodox about the method. It never resulted in a complete scenario, and I don't know if anyone will ever make the film.

Cineaste: *Are there other pet projects and ideas that you might like to realize someday?*

Semprun: There are a number of them. There's a book that was recently published in Barcelona—*Films que Nunca Veremos.* It has scenarios that were never shot by Fellini, Berlanga and several others, and it includes a script I wrote for Alain Resnais—*Fleurs Carnivores.* As published in this book it is not at all like I would want it were we to shoot it today.

Cineaste: *Are there other such projects?*

Semprun: Oh yes, there are others. It's a bit hard, a bit idiotic to speak of these dreams and all. But I'd say the better part of my ideas, whether they be only a few pages or completed screenplays, have never been shot and I don't think they will be.

Cineaste: *Do you ever want to direct? I'm thinking especially of your having an idea perfectly visualized on screen, and the desire to see it through exactly as it must be done.*

Semprun: Yes. I have often wanted to direct, but I never will. To-day, to be a director, one has to find the money to make the film, to be like a producer. I don't want to stop writing to get messed up in all of that. But I do have the desire to see scenes done a certain way.

Cineaste: *Who are directors with whom you haven't yet col-laborated, but whom you admire and might like to work with?*

Semprun: Paradoxically, the directors that I admire are often those with whom I could never work. It's either because they work in a language that's not mine or because they don't need a screen-writer. During a certain period in his life, I would like to have worked with Jean-Luc Godard. Of course, whether we could have col-laborated on the same wavelength or not is another queston. Godard has often said that he doesn't like the genre of cinema that I have written, and he doesn't need a screenwriter anyway.

At other times I've thought I might like to write a film for Fellini, or Bergman, but Bergman doesn't need somebody to write him a film. I don't know the American film scene that well. The name that comes to mind of someone I might like to work with intellectually and culturally is Woody Allen, but of course he doesn't need me either. You see? Generally the ones I'd like to work with are total authors, who don't need me.

Cineaste: *I suppose you have often been compared to the Italian Franco Solinas, who has scripted films for Pontecorvo like* Battle of Algiers *and* Burn!, *Costa-Gavras'* State of Siege *and Losey's* Mr. Klein.

Semprun: Sure, we are compared because, first of all, there's a certain resemblance in our political positions.

Cineaste: *The fact that you're both leftists, or rather Marxists.*

Semprun: Marxist, yes. And secondly, because he and I have both worked on similar political/historical subjects and with two of the same directors.

Cinesate: *A* Times Literary Supplement *article on* The Autobiography of Federico Sanchez *credited you with having written* State of Siege.

Semprun: That's certainly not the only place where you could have found this confusion. In fact, a Communist critic in Barcelona who, because of *The Autobiography,* will brutally pan anything he reviews of mine, just murdered *State of Siege* when it opened in Spain because he thought I wrote it. "Of course the film is such and

such because Semprun. . . ." Mind you, this is a professional critic, but his animosity for me so blocked up his viewpoint that. . . .

Cineaste: *Right. By the end of 1978, over 340,000 copies of* The Autobiography of Federico Sanchez *had been sold in Spain. Apart from causing bad press for Costa-Gavras, what kind of effect did this controversial book really have?*

Semprun: It is difficult to say exactly what role it played. I had purposely published it—in November of '77—*after* the legalization of the Spanish Communist Party (PCE) and the June elections.

Cineaste: *Were you concerned about hurting the plan to legalize the PCE?*

Semprun: That's it. And above all I didn't want the book to be used or manipulated by the right during the electoral period. It was published at a perfect time: midway between the free, democratic—well, almost democratic, pre-democratic—and the first legal PCE congress in Spain since 1932. Hence, there had to be a very intense discussion going on in the Party and the book played a role in this. Perhaps that sounds a little pretentious, immodest, but I think I can say so as an objective fact. It's certainly one of the elements that permitted militants to demystify and desacralize the persons of Carrillo and the other leaders, and to have a critical attitude and lack of respect—in the good sense of the term—for the leaders. It made for a different discussion.

Now, all that is long ago, as the Party has since taken back in hand the whole system, apparatus, internal life, and so on. It's finished. Though for several months there, with the explosion that it created, the book did play a certain role.

Cineaste: *Was that your intention?*

Semprun: Definitely. My intention was to publish the book at a moment when the Communists could listen to its arguments.

Cineaste: *What results had you honestly hoped to see?*

Semprun: Listen. That is a bit of contradictory situation for me. I could possibly have written a studiously historical work on the subject, but in opting for an impassioned, personal, strongly subjective autobiographical approach, I clearly placed myself in the era about which I was writing. One is easily given the impression that, while my criticism is very hard, its purpose is actually to transform and correct this Communist Party. But in reality, this is not my position at all. That is to say that today, I am no longer Federico Sanchez, no longer someone who fights to make the PCE play a revolutionary role. Today I believe, in what is a historically definitive manner for me,

that the Communist Parties issued from the Stalinist tradition are incapable of auto-transforming and reforming themselves into viable, democratic instruments capable of effectively proposing the revolutionary transformation of society.

Cineaste: *Did the PCE ever really take on the arguments of* The Autobiography *in an official reply.*

Semprun: Well, first there was silence. Then, there was a moment when the book was so widely read in Communist organizations that the party leadership had to make some kind of reply. After a feeble effort at political refutation, they fell back on personal methods. Not disputing the testimony, they tried to discredit the witness. "How could Semprun dare? It's part of a CIA campaign!" Everything, really, that sidesteps a serious discussion. Carrillo himself wrote several articles on the book, but always saying that he hadn't read it yet. Finally, he said he'd never write his own memoirs, because a man of politics can never tell the whole truth.

Cineaste: *He said that?*

Semprun: He said that.

Cineaste: *Around the time of your expulsion from the PCE in 1964, you wrote that "truth is always revolutionary." Much of your work, like that of George Orwell's, seems to be pegged to this underlying assumption*—The Confession *and* The Autobiography of Federico Sanchez, *for example.*

Semprun: Yes. I suppose I cited that. It's a formula that I've used at certain times—a formula of Gramsci's—against cynicism, against the absence of memory and the falsification of history of the Stalinist epoch. I don't think that you should make more of it than a kind of personal moral [smiling]. I don't know if the proclamation of truth could really transform society and make the revolution. But as a personal, writer's moral, I find this formula just. And the experience of Orwell—a writer whose character and literature really fascinate me—with regard to Spain, shows to what point it is just.

Cineaste: *What is literature capable of?*

Semprun: Great literature, to the extent that it is great literature, is that which transforms culture and, through this process, society. Only minimally, of course. It's obvious that it is wars, revolutions and big capital that really make the crucial differences.

Still, I believe that literature must above all set itself up as an end and not as a means. I mean that literature should not be at the service of this or that blah blah; it should be at the service of literature. And not in an idealistic manner, but rather in a way that is

materialistic—that's a big word—critical. Literature is not a privileged activity separated and alienated from the real world. Even the most abstract writers still somehow bear witness to reality.

I think that if *Man's Hope* is a great book, it is not because Malraux said, "I'm going to write a book at the service of the Spanish Republic."

Cineaste: *You don't think so?*

Semprun: No. I don't think he said that at all. When you analyze the book and all its internal contradictions, what you see, what is really interesting after all, is this same old problem of the tragic rapport between revolution and the individual life, and between culture and political systems. You see these same problems that made Malraux what he eventually became—a man of the political right. He never recognized and theorized his crisis with communism. Instead of learning from experiences, like those of his related to the Spanish Civil War, he censored them. For me, that explains his "atonement"—to twist Lenin's well-known phrase that "leftism is the atonement of a reformist sinner." I'd say that this rightist aspect of Malraux is the atonement of a Stalinist sinner.

Cineaste: *Could one also say that* The Autobiography of Federico Sanchez *is a kind of "atonement of a Stalinist sinner"? Not rightist like Malraux, but still an atonement?*

Semprun: If you like, yes, OK.

Cineaste: *One problem. If the author of a great work of literature that isn't trying to serve a cause nevertheless writes a book that is extremely effective politically and helps "transform culture," is this just because the author is so great? Are the politics and political consequences of the book just a by-product of genius?*

Semprun: No. All things considered, I don't think that politics are ever a by-product because I believe that politics are linked to humanity's tragic destiny and all history. If one writes a novel with all one has to say, politics will evidently have to have some importance. I don't imagine that when Tolstoy wrote *War and Peace*—and history and politics took a very important place in the novel—that he wrote it in order to explain Russian strategy in the war against Napoleon. He wrote it for other reasons.

Cineaste: *How do you see yourself in relation to the long string of other writers who broke with their respective Communist Parties? I'm thinking of Arthur Koestler's* The God That Failed *element: along with Malraux (who was never actually a member), writers like Andre Gide, Ignazio Silone, Stephen Spender, Milovan Djilas, etc.*

Semprun: That is really a passionate subject—a phenomenon very particular to the twentieth century that's worthy of a several thousand page university thesis. There are those who broke with the party and became reactionaries, tending to confirm the Stalinist "renegade" theory. I place myself among those who tried to go to the end of the rupture with the party and who remained aligned to what we must call without any mysticism the movement of the left. No necessarily leftist institutions or electoral forces, but still a certain left vision, a theoretical and moral conception of society. Silone's experience resembles mine on several points, though officially he became a Socialist. Personally, I try to stay aligned to the leftist movement, but without the paternal and patriarchal security of a party. That's obviously a more solitary position, but it's the only one that interests me.

Reading all these related books and memoirs is almost like being in a Kafka story or a novel by Borges. You have the impression of reliving what you have already lived. When you see certain conflicts and episodes before you again you feel like exclaiming: "But this is ridiculous. It has all happened before!" It's a kind of terrifying historical repetition, and a bit derisory. But, of course, everyone has to learn it for themselves.

Cineaste: *That reminds me. I saw a very specific repetitioon of past experience in that part of an unfinished novel you included in* The Autobiography. *It was the satirical consideration of the left-wing's special affection for the word "concrete." "Concrete, concretely," you wrote, "magic words that dash away the darkness and illuminate the perspectives." It was funny how this was very much like something in Koestler's piece on his experience with the German Communist Party. Like yours, Koestler's was a kind of ironic comedy that really had a basis in reality. Concrete! If the line is too hard to swallow and you haven't understood yet, comrade, your analysis is insufficiently. . . .*

Semprun: Concrete.

Cineaste: *Exactly. . . . When you adapted Artur London's book, did you take special care to write a film that would not be interpreted as anti-Communist, as opposed to anti-Stalinist? An American professor of Marxism commented that* The Confession *was a good film, but one that should be seen only by Marxists.*

Semprun: Like I said, I had to stay faithful to London's testimony. At the same time, a key point was to get outside of his personal experience and try to generalize from it in rehashing the

problems of Stalinism and the Russian/Eastern European "Peoples' Democracies," where Marxism is a state ideology and no longer an ideology of critique. Secondly, it was necessary to adapt the book into a film that transmitted a message—we can call it that I think—a message accessible to Communists and Marxists, and that's why the film tries even harder than the book to stay within the *interior* of the Communist world. As honest as the common view of the Czech trials and the Stalinist purges might be, it's still a view from the exterior. If we had taken this outside point of view, the Communists would have refused the message, claiming that it was the adversary talking. So in making the film, it was Costa-Gavras and Yves Montand's intention as well as mine to pose a very difficult problem for the Communists, but one that they could still reach. That is what happened, eventually. Whereas they refused the film in '69, today, the "Eurocommunists" accept it.

We weren't pretending to do a globally historic sort of film on the Czech trials, really. Our fundamental choice was to do something that spoke to the Communists' memory as well as their ideology. That's where certain choices were made in the adaptation and that's why the film finally ended up being accepted by the Communists. In France, it was concretely a. . .you hear that? Concretely [laughing]. Koestler was right. . .a question of six years before the film was received and understood by the Communists. Initially their critique was that the book was positive but the film was negative. Then, after its nationwide broadcast on the celebrated TV program *Les Dossiers de l'Ecran (Screen Files)* in 1975, a P.C.F. leader who is dead now, Kanapa, went on television saying that the Communists should be happy that the film exists. Accepted.

Cineaste: *Did the fact that you had lived an experience with ties to London's have anything to do with you being chosen as screenwriter for* The Confession?

Semprun: No. At the time the film was made I hadn't yet written of my experience, and there were very few people who really understood it. But what is sure is that Costa-Gavras and Montand, without knowing the whole of it, did know that I had been in the Communist Party and that, hence, I could manage a better vision of London's narrative.

Cineaste: *You've already stated that cinema is a more effective means of action than literature. What can be hoped for from a more or less "political" cinema such as yours?*

Semprun: I think the essential point is to foster the birth of a

reflection. As is the case with novels, I don't think you can actually change society with films. You do it with social and therefore practical political action. A film can provoke this action only indirectly. Films can try to help awaken a spectator's consciousness. They can give information and provoke a reflection that might eventually play a part in producing an action. OK. That's speaking generally. There are also specific cases. Obviously, the two or three things that I wrote on Spain had a certain particular object in mind—to speak to my country on a number of political problems connected to the struggle against Francoism, etc. But they were still in this general area of provoking a reaction in consciousness.

Cineaste: *To what extent are* La Guerre est Finie *and* Les Routes du Sud *autobiographical?*

Semprun: Well, it's obvious that there are a certain number of autobiographical points in these two films, but really less so than is said and believed. In the roles of Diego in *La Guerre* and Juan Larrea in *Les Routes,* Montand might look like a sort of double for me. Larrea works in film; both are Spaniards living in France, etc. The informed viewer makes these autobiographical connections and concludes that my latest film in a continuation of my first. That's a view that is correct, and yet superficial. First of all, there's an enormous difference between the two characters played by Montand. . . .

Cineaste: *The intellectual* engage *of* Les Routes *and the professional militant. . . .*

Semprun: Of *La Guerre est Finie.* Yes, and Larrea's essential characteristic is contrary to my own. He is someone who is tired, yet still faithful—politically speaking—whereas I am not at all tired and not at all faithful. Larrea is someone who, despite defeat and fatigue, stays loyal to the Communist Party. He continues to carry out missions for an idea which he only half believes in. I broke with it.

Cineaste: *I didn't think the official party connection was terribly obvious in the film—the fact that he was* still *a member. I suppose this was supposed to have been made clear when Larrea was in Barcelona.*

Semprun: Yes, that's it. Sure, it was not explicit, it was not said. But there is a language in all that that's the special baggage of the Spaniards; the language, you could say, of the Communist position. And Larrea's rapport with the guy in Barcelona made it clear, in my opinion.

Curiously, *Les Routes* could never really be a continuation from

La Guerre because it is actually based on a story/episode that I developed even before I had finished writing *La Guerre est Finie.* More than a sequel, *Les Routes Du Sud* is the end of a certain cinematic cycle and a certain series of characters related to anti-Francoism. Now, I'd have to say that it's a sort of adieu to this genre of cinema for me.

Cineaste: *Why did Joseph Losey take on a film like* Les Routes du Sud? *Did he specifically want to deal with the subject of Spanish politics and the anti-Franco opposition?*

Semprun: No, not at all. With regard to Spanish politics we had a great deal of discussion and many problems. He is a man who maintains his faith regardless of what happens, who has no desire to say anything critical about the Communist Party. We had a fair number of conflicts on Spain and this served to reduce the film's critical element with respect to politics.

Cineaste: *Yes, but still, in view of his active support of the Spanish Republic during the Civil War, he must have been interested in something related to the opposition struggle.*

Semprun: Right. He still remembers the era of the Spanish War in the United States and what an important period it was. The solidarity, the International Brigades and his Hollywood era during which he participated extensively in political life and later suffered for it. Granted, that all counts, but his interest in an analysis of the *contemporary* political situation in Spain is another story. Losey's fundamental reason for wanting to make this film, after reading the ten or so page treatment that I had given him, was his excitement about the character of the young woman, Julia.

Cineaste: *That Julia character, played by Miou Miou, bothered me. Like Genevieve Bujold's character before her in* La Guerre est Finie, *she seemed unreal, exaggerated, perhaps the idealized creation of an older man. Young, nubile, quickly ready to make love to Montand's character—it was too predictable and distracted from the other credible aspects of the films. And Julia was somehow overly hateful as well for me—too extreme.*

Semprun: Well, the role of Julia...you have to...I don't dispute here what you say. It's very possible that in my view of this character there were things that could have been incorrect, a vision from the outside. That's possible. But an important point is that Losey was very carried away with the notion of Julia, and he immediately wanted Maria Schneider to play the role. It was written for Schneider, not Miou Miou.

Cineaste: *I see his point.* The Last Tango in Paris/The Passenger *type ambiguity.*

Semprun: She couldn't do it because at certain times it's difficult for Maria Schneider to work and, well, she couldn't do it. And so, at the last moment, just ten days before the filming was to begin, they chose Miou Miou to replace her. Now Miou Miou and Schneider are not at all the same woman, but it was impossibly expensive to push back the shooting dates and rewrite the role for her as it should have been done. This change resulted in Losey's taking less interest in the young woman's character and this, along with the actual cutting of scenes, may have contributed to the non-authentic feeling there—the feeling that the character was being described by an outsider. And me, too. When I saw the film I said, "But that's not it at all." As I had conceived the character, she was supposed to be disturbing, not detestable.

Cineaste: *In America, the only documentary on the Spanish Civil War that is widely known and distributed is Frederic Rossif's* To Die in Madrid. *However you have also made a two hour and twenty minute documentary on the subject —* Les Deux Memoires (The Two Memoires) *— and it's the only case of you actually making, 'directing' a film yourself.*

Semprun: Right. The two films are not at all the same. Rossif's film is a montage of documentary footage whereas mine is a film of interviews, coupled with certain documents that strike in like flashes of the imagination. Someone speaks of the concentration camps in southern France where Spanish refugees were placed, and images of the camps appear. *The Two Memoires* is a film of interviews with people who were on the Francoist side as well as those on the Republican side. There are well-known leaders, as well as unknown rank and file militants. It was made in 1972, well before Franco's death. Part of it was shot underground, without authorization, in Spain, and for this reason the film is somewhat limited. There is more testimony from the Republicans and the left because it was very difficult to approach an old Francoist general on the subject. He'd come back with, "Who are you? Who are you doing this for?" So we had to use some people who had developed a certain distance from the regime—like Dionisio Ridruejo. From the Republicans, there were Irujo the Basque, Carrillo, Sanchez Montero...

Cineaste: *You interviewed Carrillo?*

Semprun: Yes. At that point he had not yet published *Demain,*

L'Espagne (Dialogue on Spain), and we had established a relationship that was at least neutral. The film, then, is a kind of critical inquest into the Civil War that works through the memories of those who lived it. Obviously, it is full of contradictory truths.

Cineaste: *It's virtually unknown. . . .*

Semprun: Because it was very badly distributed, and because Spain was not exactly in fashion that long before Franco's death. Also, as a purely critical work, it wasn't a film that could be co-opted by a specific group or party. Everyone had something to say for and against this and that in it, and perhaps it was a bit difficult for the French public. The film never achieved significant distribution in Spain either. It's a bit cursed. But there are some other films like that in Spain. There's one by Jaime Camino which even plagiarized my title a little—*La Vieja Memoria (The Old Memory)*. It was also made with interviews, but with much better means than mine, and after Franco's death, after censor problems and all. It has very interesting interviews with real Francoists who are still Francoists.

Cineaste: *And* Canciones para despues. . . .

Semprun: *De una Guerra (Songs for After a War)*. That's a very interesting film, not really on the Civil War. Rather, it is the story of the beginnings of the Franco regime, its early years, and it's told through the hit songs of the postwar era.

Cineaste: *What real opportunities are there in Spanish cinema today? Do you have ideas about finally working there in the future?*

Semprun: Not only do I have ideas, but I believe that one of the main reasons why I'm not working in film now here in France is that I intend to start doing so in Spain. That is to say: working in a new language, in a new production system, and a new vision. For the moment though, it's not at all easy. Spanish cinema is not moving at all like the great realist explosion of the Italian cinema after fascism. Quite the contrary. it has moved into a phase of total depression. Spanish cinema's production structure is in an enormous crisis and completely dominated by huge, American multi-national companies. For the moment, there is not one Spanish film in production.

Cineaste: *It sounds like the political depression there. The void.*

Semprun: It is connected with a lot of things and would be interesting to analyze. I'm not saying there are no filmmakers in Spain, only that for the moment they are not expressing themselves. There is not that long-awaited explosion. There is, if you like, what I would call the end of the cinema of allusive, cryptic anti-Francoism.

Cineaste: *Like the work of Carlos Saura?*

Semprun: Yes, like Saura. There is not the necessary explosion of a new cinema with a real vision of Spain today.

Cineaste: *And Jaime Camino* (Las Largas Vacaciones del 36), *he's not even moving?*

Semprun: Camino isn't doing anything, and hasn't for two years. It's a transitional period in this field too in Spain.

Cineaste: *Might Luis Bunuel return to work in Spain?*

Semprun: No, I don't believe so. I saw him recently in Paris and he had no intention of going back to make films in Spain.

Cineaste: *Evidently, you prefer working on fiction films. Did the subject matter of* The Two Memories *preclude a work in this, your usual, fictional idiom?*

Semprun: In this specific case, I wasn't able to do a fiction film because I didn't have enough money and, as I was saying before about directing, it's too complicated. Still, this one was rather a special case. It was a documentary, but one without any narative commentary—absolutely no voice-over to explain things. I wanted to avoid the usual commentary—God's voice telling the truth about the Spanish Civil War—and so you only hear the voice of the person being interviewed. You hear the voice of Carrillo giving his version of May '37 in Barcelona and then cut . . . the voice of the POUM leader Solano giving a version which is exactly the opposite. I didn't intrude to declare, "He's right" or, "He's wrong." I listened. Had you asked, "But what does Semprun think?," I'd have to have said that such a question was a little naive. The point was to confront and clash these contradicting truths and lies. I appear in the film to be interviewed just once towards the end by Montand—*La Guerre est Finie's* character—in order to answer that question: "What is your political position in this film?" And I say that my political position is to listen. To listen to the voices that were censored for so long by whatever officialdom. The voice of the POUM, censored by the Communists; the voice of the Anarchists, censored by the POUM; the right, the center. Let everyone speak. Break through this monolithic history of the Spanish Civil War; break through and establish a more honest, realistic discussion of this period. My discourse was silence.

Cineaste: *As you contemplate a given political action, or even the writing of a book or film, I'm wondering how you manage to break through the pessimism that your political experience and viewpoint must surely have engendered.*

Semprun: I never pose a question on the grounds of pessimism

or optimism. I think that it must first be posed—though I'm exaggerating a little here—in terms of ethics. Should or should not be. . . .

I don't believe that, at the start, the efficacy of a given action should necessarily be called into consideration. It's a common mistake to try, in order to take courage, to believe or make believe that the action that one is taking will succeed immediately. It's an exasperating phenomenon that's strongest among the exiled emigres—the emigres I've known in the Spanish exile as well as the Chilean, Argentine and other Latin American comrades and friends—this will, this need to approach the moment of victory in order to be more active and militant. Clearly, taking on actions and responsibilities is easier on the solitary, moral level—as with the writer, for example—where the question of the potential success of an action is less obstructive. In the mass, collective sphere, it is very difficult.

Cineaste: *Surely you must have somewhere felt that you might prefer to just give up the so-called struggle, that it was all too ridiculous. Your Juan Larrea had this budding unsurety, and it made him argue all the more violently and defensively with his son in a sort of last ditch effort. Have you had these doubts?*

Semprun: The example of the character in *Les Routes du Sud* is a very interesting one because, again, it enables me to differentiate myself from it. I had purposely chosen to feature in *Les Routes du Sud*, and on a different level in *La Guerre* before it, the thing that really interests me—continuing fidelity despite doubts. My own personal case has been quite different and for reasons quite simple. When I really had doubts, I helped set off a discussion among the leadership of the Spanish Communist Party, which then cut the issue short by expelling me. I have had doubts, but I haven't actually had the personal experience of having continued to work despite the doubts. For me, doubts are not something passive. Doubt can only be active. It provokes a new reflection and, hence, a new practice, a new praxis.

26—VINCENT CANBY

The power of the *Times* critic

Vincent Canby is one of the most influential film critics in the world by virtue of his position as first-string critic for the New York Times. The power of critics like Canby to influence the commercial fate of a film has become of great concern to many observers of the film industry. The following interview, in fact, was prompted by remarks made by Bernardo Bertolucci in the Winter 1979-1980 issue of Cineaste. The director complained about what he called the "irresponsible" and "arrogant" attitude of the Times critics. He felt that they were unable to understand or appreciate films from foreign lands which employed non-traditional forms. Bertolucci further argued that the New York Film Festival was a "slaughterhouse" for unusual foreign films. Despite the self-serving nature of some of the comments (Bertolucci's Luna had been solidly panned by the critics), Cineaste felt that Bertolucci's questions warranted further attention and invited Canby to reply.

Canby has a solid background in journalism and a longstanding interest in film. In his college years at Dartmouth in the early forties he was already writing about film. Fron 1960 to 1965 he worked at Variety, covering foreign films, and in 1965 joined the Times, becoming first-string critic in 1969. Since then he has also published two novels, Living Quarters and Unnatural Scenery (both from Knopf). Gary Crowdus and Dan Georgakas interviewed Canby in his Upper West Side Manhattan apartment in February 1980.

Cineaste: *When did you start writing for the* Times?

Vincent Canby: I arrived at the *Times* in 1965 when Bosley Crowther was still film critic and the second-string critic was Abe Weiler.

Cineaste: *You were at the* Times *when Renata Adler replaced Crowther?*

Canby: Yeah, Renata came in while I was there. I was second-string when Renata was the film critic. Then, when she left, I took over. That was in the spring of '69. She did one year and then elected to leave. Everybody liked to think she got bounced but she wasn't. She'd just had it. She came back to *The New Yorker* and did five weeks this year and said it just confirmed her original decision.

Renata is a marvelous writer, but I think her interests are too wide-ranging to stay happy in films for very long. She was one of the best things that ever happened to the *Times,* though, because she is so full of idiosyncracies that she really served to break the style that Crowther, if only through time, had imposed on film criticism at the *Times*. It would have been very hard, I think, if you knew anything about the *Times* or had worked there before, to come in and follow Crowther without slipping into some of his attitudes which might not be your own. Renata came in knowing nothing about the *Times* and wrote exactly what she wanted to write. It was very liberating.

Cineaste: *OK, now the big question that's on everyone's mind. Just how influential or powerful is the* New York Times *critic?*

Canby: Well, the only power is the *Times,* because the *Times* critic really doesn't exist outside the *Times*. A critic does have power at certain times about certain kinds of films. It's a rather complicated subject. On a film like *The Exorcist,* for instance, it doesn't make any difference what the *Times* critic says.

Cineaste: *A film like that is virtually "critic-proof."*

Canby: Right, whereas for a Satyajit Ray film, like *The Middleman* or anything like that, what the critics say—not just the *Times* critic, but all the New York critics—is important, because if all the critics say it's not a good film, then it doesn't get bookings outside of New York.

When Bertolucci talked to you about the power of the *Times,* he was being half-assed, because what he was really bitching about was the fact that he'd gotten a lousy review, which is always a terrible thing. He'd been the fair-haired boy up until *1900,* and I think he's been spoiled. It's very tough, and it's very sad in a way, to have been

very successful and then to make a couple of films that are very un-
successful. I don't think the *Times* killed *Luna*. I mean, I don't think
the *Times* is responsible for *Luna* being a dog.

Cineaste: *It's clear that Bertolucci was disappointed about getting
a bad review. His additional argument, though, was that in a
specialized situation, like a festival screening, where a film might not
have a distributor, a poor review could dissuade anyone from picking
it up.*

Canby: Well, that's a very legitimate comment. Since I've been at
the *Times,* we've had two or three different policies on what to do
about the films at the New York Film Festival. Each time we've
adopted a new policy, it's been one that the people who run the
festival have asked for.

When Bosley first started covering the festival, I think the *Times*
would run a sort of "what happened at the festival yesterday"
column, which was a chatty kind of thing covering the two or three
films that had been shown. They weren't really reviews—but of
course it tipped off everybody who read the column as to whether or
not he liked the films. So distributors who were looking for films to
pick up would comb that column, looking for clues as to whether or
not they should buy something.

The *Times* soon decided that policy was neither one thing nor the
other, and that the films should be reviewed. So, about the time I
arrived, they were reviewing the films the day after they were first
shown at the festival, and they were shown twice. When Renata took
over and I was the second-string critic, there was a policy of review-
ing the film when it was shown at the festival, and then running an
entirely different review when it opened commercially, even if it
opened three to five days later. She would review it on Monday, say,
and I'd review it on Wednesday.

It didn't take the management long to figure out that that was sort
of silly. So we adopted a policy that is only slightly different from
what we do now. The festival wants reviews, so we review the film
the day it is shown at the festival, and include a note if it will be open-
ing commercially within the next week or so. If it doesn't open within
a couple of weeks, then we run a recap of the review, which seems
to make people happy, except when they get bad reviews. The
festival wants the reviews and the producers want the reviews, as
long as they get good ones. But there's no way to fix it so
everybody's happy.

Bertolucci's absolutely right about one thing, though—if you're going to pan a film that is opening the festival, it sure as hell is going to dampen the enthusiasm of a lot of people. But a lot of people who go to the opening night don't give a damn about movies anyway. It's not a real festival audience, or at least not like any other audience during the festival. Most people go to the festival because they want to see the film, and they couldn't care less about the *Times* review. But since the *Times* is the only paper that covers the festival day-by-day, what we say does get a lot of attention.

I don't remember all that well everything Bertolucci said in the interview. There was something about how Janet Maslin and I didn't understand certain films or weren't sympathetic to certain kinds of films. Well, I suppose we're human. We aren't sympathetic to films we don't like and, for any number of reasons, we don't respond to certain films.

Cineaste: *But when you're reviewing a film at the festival, are you aware, sort of in the back of your mind, that maybe what you say is going to influence whether or not a film is going to be picked up for distribution or, assuming it already has a distributor, whether or not it will get theatrical bookings outside New York?*

Canby: I try not to be, because if you worry about that, you aren't going to write anything worth reading. You're going to write like a certain former drama critic for the *Times*—I mean, one paragraph is up, and the next paragraph is down. So you can't think about that. This is the job you do as well as you can, and you certainly can't worry about business deals.

There's another thing Bertolucci brought up which I think is really quite true, although it isn't true of a daily paper like the *Times*. He said he couldn't understand why we even cared to write about films we didn't like. Well, that may be true for somebody writing for a weekly or a monthly, where you can get by with that. On a daily paper, however, you can't pick your films that way. It's like covering fires, it really is like that. That's how film criticism on daily newspapers began—it was a report on what happened yesterday.

But I would much prefer to write about films that I liked. It's much easier, it's much more fun because you can be enthusiastic. You can't really write ineffectually about films you like because you're bound to hit something that's fairly accurate in your response. It's much more difficult to write about films you don't like. John Simon is the only one I know who writes well about films he doesn't like, and that's very peculiar.

Cineaste: *How do you handle the problem of all these special-ized films, particularly foreign films which come out of a peculiar context—you know, one day you've got to see a film from China, and the next day one from Hungary, and so on.*

Canby: I think you also raised that in your Bertolucci interview, about my problem with the Wajda film. That's quite true. There are times when you just don't know the content. You try to find out as much as you can about a subject, but some of those Wajda films from the sixties are absolutely baffling, because they involve so many local political problems. There's no way of really understanding that . . . I mean, you *can* understand it, but

Cineaste: *It takes a hell of a lot of homework.*

Canby: That was true of *Angi Vera*. It's difficult to know exactly where we stand in relation to it. It's a very interesting film, but it's also a very cool film, in a way, because it seems to me the movie very carefully maintains its distance from the character. I think that's a choice of the director, though, and not something that's been imposed on the film by fear of censorship.

Cineaste: *Have you ever thought of bringing in specialists for these national cinemas?*

Canby: Not really. After all, we are a daily, general circulation newspaper. Sometimes, however, on something like a dance film—and I know nothing about dance and the dance films I have seen I haven't liked very much—we'll get Anna Kisselgoff, the *Times* dance critic, to do it.

Apropos of this, I received a terribly asinine letter from Joe Losey about my review of *Don Giovanni*. Now I'm not a music expert, but I do know that opera very well, so I elected to review that myself. After all, Losey is a film director and *Don Giovanni* is not a filmed opera, it's a film, so I had no hesitation about writing that review. As I say, I'm not a musician, and I'm sure there are musical aspects of the film I don't understand, or didn't get, but I do know what it looks like as a movie, and it's a joke. He attempted to do something and he did it very badly. I thought what he did to it was scandalous.

Anyway, the letter from Losey also harped on this thing about the power of the *Times*. It began by recalling our thirty years of mutual admiration, or something like that. Well, thirty years ago, I was standing in a cornfield in Illinois. I had one meeting that I can remember with that man, when he was filmmaker-in-residence at Dartmouth seven or eight years ago and he came to New York with the head of

the cultural center up there, and we had lunch. I think that's the only time I ever met him.

His letter then became very sarcastic as he talked about how I must have had great satisfaction to have hurt his film the way I had. He went on about how, "I really can't take exception to what you're going to write about my film, *but* I think you should reconsider what you're written." It was full of the same kind of. . . well, it expressed the same reservations that Bertolucci did.

I don't think it's an accident that both of them, who live and work in Europe, stressed the power thing. You see, power is something that in Europe is entirely in the hands of people like Losey and Bertolucci. That's not a bad thing, that's fine. Movie-makers there do have power, I think. I don't know if they have more than they do here, but the press there in relation to those people is nothing. The European journalists who cover films for the dailies are either predictable or they're Rona Barrets and really of no interest.

People like Losey and Bertolucci have absolutely no respect for these people. They treat them like dirt and the members of the press kowtow to them. I've seen all this at Cannes on too many occasions. So-called critics kiss the asses of these people all over the place. They're happy when Joe Losey even remembers their name. They're happy to be invited to some crummy cocktail party to rub shoulders with people who couldn't care less about them, except to use them. European film people have a very low opinion of the press, and that's why I think these two men are really outraged when films that they obviously have great faith in are received with something less than enthusiasm.

Cineaste: *Do you think that part of the power of the* Times *is a result of the laziness of the critics in the rest of the country who pretty much form their opinion after reading what's in the* Times?

Canby: No, I don't. I think there are lots of good people all over the country. A *Times* critic is perhaps spoiled to a certain extent because he's paid only to write reviews. I mean, I do nothing else—I don't do interviews—or only very seldom—and I don't have to do feature stuff. I keep very busy, though—I write three to four reviews a week, plus a Sunday piece, but I'm not doubling as anything else. Outside of the big cities, there are very few film critics who do just that. And, by God, it's a nice job! It's also reassuring. I mean, you don't have to view a film one day and then go out and interview the director the next day. That's something I don't do. Of course, if the director were someone like Bunuel—a man I think is really one of the

masters of our age—I'd knock myself out to talk to him and do whatever he wanted. But the rest of the people I just don't have to deal with. It helps my peace of mind and I think it makes my writing better. You can't do that on many newspapers. It's very difficult, I think, to be a reporter and a critic.

Cineaste: *So we've generally agreed that the power of the* Times *critic really depends on the kind of film we're talking about. Given that, who decides, or how is it decided, which films get reviewed?*

Canby: Generally, it's up to me. It's always a slightly difficult proposition, because you can't cover everything and there are some things I just play by ear. We used to regularly cover the Whitney Museum, for example. Whatever they showed, we would review. But the Whitney programs have gotten worse and worse, so I decided, well, if something sounds special, then we'll cover it. They're also getting more and more into video, which is not really my field.

On the other hand, it seems to me that the Film Forum is doing remarkable things. They're showing a lot of truly fine films.

Cineaste: *And in a situation like that, a* Times *review can make all the difference.*

Canby: Well, I'm very seldom disappointed with the Film Forum, because I can pick what I want to see, and I usually pick things I think I will respond to. They had *The Wrong Move* there recently, an early Wim Wenders film, and although most people probably couldn't care less about it, I do like Wenders and I like Peter Handke, who wrote the screenplay, very much. He's a fascinating writer. I probably wrote more about that film than anybody reading the *Times* would ever want to read.

There are other places we don't cover at all. I don't think we've ever covered the Millenium. Once it gets very far out, there's just no space. There's readership, I suppose, but the space in the *Times* is very dear. There's a lot of competition for it, and I'm aware that when we're using space, somebody else is being deprived.

Cineaste: *You also decide whether Janet or yourself will cover a film?*

Canby: Right. A lot of it has to do with the fact that I know there are certain filmmakers Janet is interested in and that she would respond to much more enthusiastically, or with much greater passion in one way or another, than I would. I try to make assignments on that basis because it is better when someone's interested in a director or a subject.

Cineaste: *What are the criteria or priorities for deciding what gets reviewed? Obviously, you have to review all the major studio films. After those, what?*

Canby: We try to review most things that have a commercial run of some sort, that is, they're shown more than just once or twice. Frequently, though, you don't have enough time to cover everything, because every week brings a new festival or retrospective.

Another festival we have covered in the way we do the New York Film Festival is the "New Directors, New Films" festival at the Museum of Modern Art. But we keep our options open. Two or three years ago, I went to the first six films in that festival and they were all so lousy I just said, "Forget it! Why write about them?" I mean, it's not as if we're depriving the public, or that we have to warn the public about the films shown at a museum. But then the Museum got very upset, just as I'm sure the Whitney must now be very upset that we don't cover their programs—even if we cover them unfavorably, that is, by giving them bad reviews—because a lot of their funding depends on proving that they're providing some kind of service to the field. If we don't review them, they have more difficulty proving that.

Cineaste: *Does the* Times *try to distinguish its cultural coverage in terms of the kinds of films it reviews, from the two other New York daily papers? That is, there's a* Times *reader and there's a* News *reader.*

Canby: That's something I haven't thought about, but I guess it's understood in my mind somewhere that the *Times* reader might well be interested in different kinds of films.

Cineaste: *I think that's a definite factor. I know it comes into play when distributors decide where to spend their advertising dollars, so it would certainly apply to the impact of reviews. I mean, a review of a particular foreign or experimental film, say, appearing in the* Times *would likely translate into box-office impact for that film, whereas a review of the same film in the* Daily News, *despite its large circulation, might mean very little.*

Canby: I really haven't thought about that. Although at one time I thought it might be good if we could get a critic who's more interested in or capable of reviewing the avant-garde stuff than I am. I came back from the Whitney one day last year out of my mind. For something like ninety-eight minutes I'd watched one of those bad abstract films—you know, absolutely *nothing,* not even any interesting scenery. So for ninety-eight minutes I'd been sitting there,

pinching myself, looking at the exit sign, looking at my watch. Back at the office I ran into Hilton Kramer, the *Times* art critic, and I said "Hilton, maybe we should talk about this, you know, and have you review some of these films." Hilton—who has a Jack Benny-like delivery—looked at me sort of coolly and said, "I decided a long time ago—if it moves, it's not for us."

Cineaste: *You know, there really isn't an audience for those films. It's very much like poetry. Everybody says there's this tremendous poetry audience, but nobody buys the books, so where's the audience?*

Canby: Exactly! Andrew Sarris is right, I think. Andrew has been covering these films longer than I have and he can be very funny when he starts describing the avant-garde scene. "*What* avant-garde?" he says. I've been seeing these same films since 1948. They're anything *but* avant-garde!"

Cineaste: *And the only people who go to see them are other people who want to make films like that, or people who already make them, and if you take those people away there's nobody left but a few people from the Council on the Arts who think they have to do something for artists.*

Speaking more generally now, how do you define your function as a critic? Are you just a consumer guide?

Canby: Well, I hope not a consumer guide, although I suppose any critic on a daily paper is a kind of consumer guide. Every once in a while I'll meet somebody who has just read one of my reviews and, at the end of the discussion, he'll ask, "Now, should I go or not?" It's unfortunate, but what most people want from a review is to be told whether to go or stay home. That's increasingly true, I think, because they're so used to the TV reviews which last maybe sixty seconds at most and tell the person, usually in a funny way, whether or not he should see a particular movie. I should think because of that, newspaper readers would be more receptive to the kind of review that, I hope, we're writing—better and better. The kind of film criticism we're writing in the *Times* today is far different from the criticism in the forties—it's far more knowing, far more personal, and far less moralistic or pious.

The kind of criticism I'm trying to write—and I don't do it as well as I'd like—is, I suppose, a mixture of all the things that good criticism should be. That is, it's principally one man's response to a work, and that response is on several levels—it's analytic, it's expository, descriptive, and personal. The function of a critic is to write

something that will approximate what the experience of watching a film was like, and all the various responses he had. Invariably, you sort of build up a readership and the readers know how to bounce off you. If they know you have that blank spot about, say, hospital movies or rock films or whatever, they'll take that into consideration and still be able to make up their minds whether or not to go see it.

Cineaste: *Do you ever decide to write about a particular film so that somebody who probably wouldn't go to see it would be more open to it? I mean, having seen so many of them, you see something that the average person just wouldn't see.*

Canby: Well, I don't think I'd ever say that. If it's a difficult film, or a film that I'm aware would not immediately create interest, I'd try to write about it in such a way that it will create new interest, but in an honest way, so you don't con a lot of people into seeing something that's going to bore the hell out of them.

The Wenders film, for instance, was very difficult to write about, because although I found it fascinating, I was also aware that the six or eight other people in the screening room with me were all snoozing. They couldn't have cared less about it. So, when it came time to write the review, I described the various elements in my background that made the film interesting to me. But a lot of times I know I don't do that adequately.

Cineaste: *How explicit in a review do you feel a critic should make his or her politics or ideological orientation?*

Canby: As explicit as possible, I think, at least for certain kinds of films. I mean, writing about *Black Stallion,* you're not going to get into politics especially. But a lot of it just comes up automatically, it's self-evident in what you say in your review. A lot of this is self-evident in, say, a review of a film like *Memories of Underdevelopment.* There are a lot of very revealing things that a good critic will say about a film like that, just in describing the film accurately. I think if the review is any good, the point of view you have on that work grows out of the review.

I remember a documentary produced by David and Barbara Stone—and David is an old friend—but they made this documentary on Cuba which was the most boring thing. It was very well-meaning, but it adopted that sort of gung-ho attitude that somebody is likely to have when he's selling something. I mean, I'm sympathetic to the Cuban revolution and its aims, but this film was too much. It wasn't for any audience but an audience of the already-committed.

Cineaste: *How would you define your own politics?*

Canby: Skeptical, I suppose, and to the left of center. I don't belong to any party. I used to be a Democrat, but now I'm not anything. I'm left of center, I guess, but how far to the left changes from week to week, year to year. The reason I love *Memories of Underdevelopment* is that I identify with that man. I think that is the position of so many people in the Western world, who want a better society and yet can't quite bring themselves to be a part of it, to go through all the red tape and disappointment and other steps—the commitments—that lead to a better society.

Cineaste: *How do you preserve your freshness in looking at films? Sometimes you must say to yourself, "Oh, my God, I've got to look at another film today!"*

Canby: That's a real problem. I don't think you can consciously prepare yourself. We're all sort of like race horses, though. You think you're tired but then, once you get into the film, if there's something there, there's no problem. There is a problem when you've got material that is mediocre, when you get one mediocre film after another. That's a dangerous situation, because everything begins to look so dull and soft and mushy, and there's nothing to respond to. You feel swallowed up in mud. There's no problem when the film is very, very good or very, very bad. You have the impulse then to write and it's satisfying to write.

Something I found very difficult to write about the other day was the Claude Sautet film, *A Simple Story*. Claude Sautet is somebody whose films I do not respond to. They're so genteel, so discreet and elegant. There's absolutely nothing in poor taste in them. *A Simple Story* is one of those movies that halfway through you want to stand and yell, "Fuck!" You know, just to shake 'em all up, to have somebody do something vulgar and in poor taste.

Cineaste: *Some of your Sunday pieces, in which you do little interviews with yourself, seem to be attempts to get away from the formula of the sober think-piece.*

Canby: That's because there are a lot of things I have questions about. I have a lot of questions about my own vocabulary, because I write so much, and I'm aware of repeating myself and falling into patterns of writing, and using adjectives in a way that bores me in the writing, so it must bore the hell out of somebody reading it. Those pieces are a way of sort of stepping aside.

Sometimes I have problems with Sunday pieces because, if you're doing daily reviews with any passion, you've pretty much, in one way or another, said almost everything that might go into a think-

piece. Not always. About once a month there's one I want to do, something I've not done before. But the others are pretty tough because the edge has been taken off.

Cineaste: *What are some of the other problems in writing criticism for a daily paper? Deadlines? Space limitations? Copyediting?*

Canby: I don't have any of those particular problems. I mean, I've never been censored, and the copy desk doesn't fool around with the copy too much. I can't remember any time that I've ever been cut on the daily, certainly not whole paragraphs, nothing of real length. One of the perks of being the first-string critic is that you get as much space as you want and you're generally listened to. The second-stringer sometimes has problems with space. But I've never had any major problems like that. If we have six reviews running on one day, part of the space problem is solved by the fact that I have just so much time to write six reviews, so they're all going to be pretty short anyway.

The *Times* has a style book, though, and I don't know if I'm always totally up on what the style is. Sometimes the style is pretty silly. There was a brief period, shortly after I became film critic, when—I think it was Ted Bernstein—decided that there should be a differentiation between the use of the word "American" and "United States"; America referred to the continent and United States to the country. I didn't know about this and I'd written a review of something that made a reference to the "American way of life." I was reading the paper the next morning on the subway coming in to work and the phrase had been changed to "the United States way of life." I almost had a heart attack! I came tearing into the office, shouting, "Who did this? Who?" I was informed that this was the style. So Dick Shepard, who was later our cultural editor and who's one of our best reporters and feature writers, agreed with me, and we made up a list of all the things that we'd have to change to conform to this policy, such as Theodore Dreiser's novel, *A United States Tragedy,* and so on. It was obviously ridiculous.

Cineaste: *What are some of the workaday aspects of your job as a film critic?*

Canby: Well, we make up screening schedules and assignments as far in advance as we can, but the opening schedules are constantly being revised, so a lot of time is spent in paperwork, just making up the schedule and keeping it up to date. I've seen as many as seven or eight films in one week, I guess, but that's a lot. You can't easily

maintain your bearings when you're seeing that many movies. I don't like to see a film too far in advance of its opening. Ideally, I see a film a couple of days before I write it up, or maybe the day before.

Generally, though, I see two to four films a week. I hate to get a backlog of, say, eight films that I haven't yet written about, because that can get very tough. I mean, they don't run together, but you don't write freshly when you write that many at one time.

There are also a lot of letters and I don't have time to answer anywhere near all of them. I don't have a full-time secretary.

Cineaste: *Is much of it poison pen mail?*

Canby: I'd say about sixty per cent of it is poison pen. About thirty to thirty-five per cent are from people interested in finding out when a film was done or who did it, and about five per cent say, "Gee, you're terrific." You don't get many of those.

My favorite poison pen message is on my bulletin board. For years, about every few months I would use the word "unequivocably." One day I got a very funny postcard which just said, "Unequivocally, goddamn it! Look it up." He was right, of course. The mistake had even slipped through our copy-readers. I'm a terrible speller.

Cineaste: *Do you take notes during a screening?*

Canby: Yes. Not extensive, they're sort of signpost notes. Sometimes they're ideas, but mostly they're just descriptive things which help to fix something in my mind. Then, before writing a review, I go over those notes and make a brief outline of important points.

Cineaste: *Do you do much background reading on a film?*

Canby: There are some critics I read. Agee, occasionally. Actually, one of the best things to read is Renata Adler's book, not necessarily for the ideas, but for the cleanness in the use of the language. But I don't read that much film criticism. I try to stay away from contemporary stuff, at least until I've written my own, because otherwise you end up arguing with your colleagues, which is a fatal trap to fall into.

Cineaste: *When do you find time to go to all the cocktail parties with the producers and actresses?*

Canby: I don't! I don't like cocktail parties. I don't like small talk of that sort. I mean, there's no way of talking seriously about anything, or even talking in a friendly, relaxed way, because everybody's selling something. I don't want my ass kissed and I don't want to kiss anybody else's ass.

Cineaste: *Do you find it best to keep a healthy distance between yourself and filmmakers?*

Canby: Yes, although I don't think that critics who do go to these parties are compromising themselves. They're just being social. But I don't like cocktail parties even with my best friends. Cocktail parties are impossible places to meet anybody. You can't get anywhere by standing around and spilling stuff.

Cineaste: *Does the* Times *have ethical guidelines for its critics?*

Canby: Well, we aren't allowed to accept paid trips and that sort of thing.

Cineaste: *Do you find yourself frequently pursued by publicists?*

Canby: Sure. You know, "Long time, no see! Why don't we have lunch?" I think the biggest wastes of time in the Western world are business lunches in restaurants, with someone trying to sell something to somebody else.

Cineaste: *We have difficulty with the independent filmmakers, most of whom we know. They put no pressure on us, but when it comes time to write the review, there is something when you know the people, and you know the problems they've had and what they're trying to do, so there is a tendency to go easy on them.*

Canby: That's why I find it much easier not to have any dealings at all with filmmakers. Friendships inhibit the writing and, although you may not be aware of it, friendships or acquaintanceships do shift one's feeling. As Andrew Sarris once said, the worst blackmail is not money offered under the table, but seeing the director and his wife and two small children walking down the street and looking rather poorly.

Cineaste: *What are your thoughts about this recent controversy involving critics who were trying to sell screenplays to producers whose films they were reviewing at the same time?*

Canby: Oh, I don't know, I suppose there are some who've probably been too sloppy about this and who like to hobnob with movie names. I think anybody who seriously wants to write a screenplay shouldn't be penalized because he's a film critic. Of course, there are certainly ways in which to try to separate the two activities as much as possible, although it's pretty tough to separate them if the critic is reviewing films of the producers he wants to sell a treatment to. That gets awkward and complicated. But if you want to write screenplays, then, goddamn it, you should get in there and do it.

I'm surprised, though, that producers would pay a dime to some

of these people who've never written a coherent sentence in their lives, certainly not in fiction.

Cineaste: *How did you decide to try your hand at writing fiction?*

Canby: I think that anybody who sees as many films as I do has to do other things to keep sane. I have lots of other interests and they keep me fresh for writing about films. In a way, that's why I was prompted to write fiction. Actually, I was hesitant about trying to write fiction because I thought I needed the pressure of a daily deadline. On a daily paper, I cannot write ahead of time. I really need to know when the thing has to be in, and even then I often barely make it. I just squeeze in under the wire, all the time, sometimes even a few minutes late. Anyway, I thought that after about thirty years of writing for newspapers, that I wouldn't be able to write fiction, that I wouldn't have the discipline to do something that required a long, long time. But I found I could do it, and I had great fun doing it.

The reason I could do it is because I wanted to do it so much. I didn't try fiction until . . . well, my first book came out in 1975, when I was fifty. I wrote it in about four and a half weeks, but I'd been planning it for about twenty years. On the other hand, once I started to write it, it was the most exciting experience I've ever had because I realized I could do it. It was like finding a whole new life. The same thing happened with the second novel. It took me about four years to prepare for it. I had made a lot of notes on weekends, so by the time I got to it, I knew pretty much what I wanted to do. I mean, I hand't plotted it all out in my head, but I'd got the tone, the voice somehow, and, once I got into it, it was like hang-gliding. It was a most lovely experience.

Cineaste: *Will you write another novel?*

Canby: I hope to. I've also written three short, one-act plays which were supposed to be done last fall at the Manhattan Theater Club, but we got involved in a hassle about the casting.

Cineaste: *Do you think the experience of writing fiction has perhaps added a new dimension to your critical writing?*

Canby: I suppose so, because the more you do, the more you can do. Most of us operate on only about five per cent of our capacity. I feel it's given me a certain appreciation for words, although I think I've always had that.

One thing it's really made me aware of is the quality of literary criticism in this country, now that I've been the butt of an awful lot of it. Outside of New York, Chicago, Washington and Los Angeles, the

quality of literary criticism is terrible. Compared to film criticism, it just doesn't exist. Film criticism is much, much better all around the country. But books are really short-changed. They're just handed out. I mean, you know, "Who wants this one?" They're reviewed by people who are doing every other job. They're usually done very quickly and the pay is poor, so it's really hit or miss.

Cineaste: *Have you thought about publishing a collection of your film reviews?*

Canby: Not seriously. I don't want that material to go on the remainder counter too. I can fill a couple of counters now. I don't really think they would read well; it's an awful lot to ask of daily criticism. I think there are very few reviews that can stand up that way. Besides, many of my reviews appear in the collection published by Arno Press a few years ago [*The New York Times Film Reviews, 1913-1974—ed.*]. And I'm not a pace-setter, as far as critical ideas go, I know that. So there's not much point in publishing mine. Frankly, I don't think there's much point in publishing most of those collections.

27—JOHN BERGER

The screenwriter as collaborator

John Berger is a writer whose work is noted not only for its diversity—poetry, art criticism, essays, novels, and screenplays—but also for the originality of its insight, the frequent innovativeness of its technique, and above all for its consistent socialist perspective. Berger's longtime friendship with Swiss filmmaker Alain Tanner led to his first efforts at screenwriting. The films on which they have collaborated include the documentary, A City At Chandigarh (1968), and three fiction features, La Salamandre (1971), The Middle of the World (1974), and Jonah Who Will Be 25 in the Year 2000. The following interview was conducted by Richard Appignanesi, utilizing questions prepared by Leonard Quart. The transcript of their discussion was edited for publication by Gary Crowdus.

Cineaste: *How did your collaboration with Alain Tanner begin?*

John Berger: I first met Alain Tanner in the mid-fifties. I was living in London at that time, working as a journalist and an art critic, when Alain came to London to make his first film under the auspices of the British Film Institute. Alain and another Swiss director—Claude Goretta, who is now as well-known as Tanner—made *Nice Time,* a twenty-minute film about Picadilly Circus in the center of London at night. They filmed continuously, from about 10:00 p.m. 'til about 4:00 a.m., when the last prostitutes went home. I was very impressed by the film when I saw it. Lindsay Anderson, a friend and supporter of Tanner's, suggested that I meet him, and that's how I first met Alain.

In later years, although he had no possibility of making more films, Alain used to come back to London. I remember one time he was working in the shirt department of Harrod's, one of the most fashionable department stores in London, selling shirts. In the evening he would come to our home and have supper with us, and we used to talk about poetry, because Alain is really interested in poetry, as well as films.

Some six or seven years later, when I had left London and was living for a while in Geneva, where Alain lived, we used to meet and talk. At that time he occasionally was making films for Swiss television. One of these was a thirty-minute film about the architecture of Chandigarh in India, which had been built by Le Corbusier, another Swiss. Alain asked me to write the commentary for this film, which I did. The kind of commentary I wrote, although we didn't realize it at the time, was perhaps a little prophetic of some other things we were going to do. Instead of writing a descriptive commentary about the architecture, what I used were quotations from poets and political theorists which were placed in juxtaposition—sometimes ironic, sometimes confirmative—of what was seen on the screen.

Later, Alain had the opportunity, aided by French television, to make his first feature film, *Charles: Dead or Alive.* He discussed it with me quite a lot, but I didn't actually collaborate with him on it. Since that film was relatively successful, he was able to raise more money from producers to make his second feature, *La Salamandre.* I collaborated with him on the scenario, and that's how it all began.

Cineaste: *Can you describe your role in that continuing collaboration?*

Berger: It's very difficult to answer that kind of question, because

in the answers there is always a mixture of natural modesty and a kind of loyalty. When two people have collaborated on, let us say, three-and-a-half films, in addition to being very old friends, that question is a bit like asking a married couple, "What is your role in your marriage?" It's possible to do so, perhaps after you've had a divorce, although even then it may not be the truth. The best I can do is to very briefly describe how we work. First we discuss an idea together, and then begin working on a scenario. I suppose that most of that work is mine, although what is fed into it is also Alain's; but in the writing of the scenario, in a purely physical sense, I play the major role. When it comes to turning that scenario into film, it is certainly Alain who plays the major role. I'm not usually present at the shooting, because I would have no function to serve, and, in such circumstances, the fewer people hanging around doing nothing, the better. When he arrives at the rough cut of the film, I see it, and then sometimes we discuss how to improve it—perhaps it means cutting out a sequence, or shortening a sequence, or changing the order of the sequences—and at that moment I make a small contribution.

Temperamentally—and I suppose this comes very near to that marriage question, so I hesitate really—but Alain has a very strong sense of film style, and, in cinematic terms, a strong sense of imagination. What perhaps I offer is a strong sense of form, of how all the parts must fit together and add up to a totality. I think that is a fair description of our two characters in relation to one another.

Cineaste: *Tanner's films reflect a sense of bittersweet, disappointed promises, or, at best, very small gains in consciousness. Do you share Tanner's disillusionment with political panaceas?*

Berger: Well, I think what you have described as Alain's disillusionment with current politics applies to the last film, to *Jonah*, but I don't think that particularly applies to *La Salamandre*, and certainly not to *The Middle of the World*. *Jonah* was a film about what happened to the generation of sixty-eight during the seventies, and it is not possible to take such a theme without—I would rather reject the word "disillusionment"—a certain re-examination of hopes that perhaps, marvelous as they were, in retrospect appear too facile.

When we talked about *Jonah*, before the script was written, we described it to ourselves as a film about individual dreams of transforming the world. The image we used was that we would try to show this dream like a large colored square of silk on the ground, and then the air would come in under the silk and blow it up, so it became almost like a tent or a canopy. Then, we said, we must take

that tent down, bring it back to the earth, at its four corners. In a way, that is the movement, the melody, of that film. We continually are seeing a colored hope rise, and then pinned back onto the earth—the earth here functions as a kind of reality principle. This melody, this counterpoint of hope and realism, is what the film is about, but I don't think that quite adds up to disillusionment.

Cineaste: *Would you describe the films you've done with Tanner as Marxist?*

Berger: I think that's for the viewer to say. All I can say is that I think both Alain's and my own attitude to the world and to contemporary reality are enormously influenced by Marxism. The way that we see society, and individuals in society, is continually illuminated by the Marxist analysis of society and history. I don't think there is very much political difference between us. We might, I suppose, take a different attitude to some particular event. I haven't, for example, talked recently to Alain about Iran. Maybe we would find we are not in total agreement about an interpretation of recent events in Iran; I don't know. But I don't think there are any essential differences between us.

Cineaste: *Tanner has described his own political views as those of an undogmatic Marxist. Does such a formula describe the predicament of the non-activist or the artist?*

Berger: Marxism has contributed, and still contributes, a great deal to his vision. At the same time, he is certainly undogmatic and unsectarian in his Marxism, so I would agree with that definition of Alain as a person and as a thinker. Whether his view of the world would be different if he were an activist—yes, clearly it would be. And, if his films were primarily films which encouraged political activism, they would be different films. The films that we have made together are more reflective films.

If one thinks of films whose aim is to politically activate, although not in a crude way, one obviously thinks of Godard, especially later Godard. Alain and I share an admiration for Godard, and we follow his work with great interest. My own formulation about Godard is that he is the great film critic of our time, but, unlike most film critics, instead of writing his criticism in words, he makes films which are criticism of film. Alain, on the other hand, is essentially a storyteller—it's a different function.

Cineaste: *Tanner's films seem very marked by a consistent sense of the absurdity of human behavior. There's a foolishness, even a lot*

*of clownish behavior, which seems very important to him. Do you
share this preoccupation?*

Berger: In *La Salamandre,* for example, that scene in the forest
when the two friends suddenly break into an absurd kind of song and
dance, is a very obvious scene of the type you must be referring to.
But I'm not sure that the function of that scene is simply to show the
absurdity of human behavior. It seems to me that that is actually a
lyrical moment. It is a lyrical moment about hope, but also about
disappointment, and I think hope and disappointment can exist
together perfectly without adding up to absurdity. In fact, one of the
great illusions of the left is the belief that everything can always be
resolved, that one doesn't actually often have to *live* perhaps a whole
lifetime with contradictions, that one has to at one level live a kind of
dualism. With the left's impatience about this—from which many
things spring, including sometimes absolutely disastrous
things—there is a tendency to think that, when those contradictions
are allowed to exist in a story, one is talking about absurdity. I don't
think one is talking about absurdity, I think one is often just talking
realistically and maturely about life.

This particular aspect, however, does point out one difference
between Alain and me. You see, all of Alain's films, up to now, have
been set in Switzerland. Alain has a particular view of Switzerland,
one which I would almost define as a love/hate relationship. He is
compelled, again and again, to come back to the Swiss experience.
The history of Switzerland and the nature of Swiss society, seen
within the confines of the Swiss borders and with an awareness of
what is happening beyond them, leads to a certain sense of the
absurd. Let me give just one example. It's very easy to knock
Switzerland. Everybody knows all the jokes about the Swiss and their
cuckoo clocks, their bankers, the gnomes of Zurich, and their quite
cynical international monetary policy—no more cynical than any
other capitalist country, actually. At the same time, Switzerland's
army is a civilian army, in the sense that every man is conscripted
and must serve in the army for one or two months every year,
depending on his age, and he keeps his rifle and ammunition at
home. And this works! There aren't any incidents; these arms aren't
used; there are no insurrections, no protests. On one hand, that is, in
a sense, an achieved ideal, because this is a civilian people's army, in
which the soldiers keep their own arms, democratically, in their
homes. On the other hand, given what Switzerland is—a super-
consumer bourgeois capitalist society—this is also an absurdity.

Now, Alain's view in these films is, as I say, rather confined to Switzerland. My own view is not confined to that. This is not to say, necessarily, that my view is superior, but Switzerland as a country interests me less. My view is wider, not necessarily deeper, but a wider one, and this means that perhaps I have a view which is far more conscious of the tragic than of the absurd. Naturally, if I collaborate with Alain on a film, I accept his framework; what goes into the frame is different, and at least part of that is my contribution and carries with it my view of the world. But the frame, the essential frame of the location, is Alain's.

Cineaste: *That leads to the question of why you, as an Englishman, born and bred, choose to live outside of England and the United Kingdon?*

Berger: [Laughs] Well, that's a question which is very difficult to answer briefly, because it would require a large autobiographical conversation. I mean, I've lived outside of Britain now for about twenty years, and I had the idea of leaving Britain long before that, but I didn't quite see the opportunity of doing so. The very simple answer is, I feel far more at home on the continent than I do in Britain. My grandfather came from Trieste, so maybe a kind of atavism is at work here. I very much like being in Slav countries; I think I understand something about the Slav character. But the short answer is that I feel more at home on the continent, particularly in the south and east. Not for political reasons, but just temperamentally, I feel far more at home there than I have ever felt in Britain.

Cineaste: *Another persistent feature of Tanner's films is his preoccupation with the nature of women and men's relationship to them. For example, the woman in* La Salamandre *seems to represent instinctual, even nihilistic, rebellion, and the two men, both intellectuals, are enthralled by her, reduced to a kind of acquiescence. Is this view of women entirely Tanner's, or do you share something of that view?*

Berger: No, I don't think that is really my view. As for *La Salamandre*, the difference between the men and the "salamander" didn't strike me as essentially a sexual difference. I saw it far more as a *class* difference. The "salamander" is a working class girl, the two men are middle class intellectuals, insofar as we know about their past and their background. The story obviously would have been different, but the "salamander" might have been a man, or, for that matter, the two journalists might have been women.

In *Middle of the World*, once again, I saw the difference between

the waitress and the man who falls in love with her as a class difference. There, the difference of class, however, was less direct, because the man was the son of a peasant, and she was the daughter of a worker. The essential difference in that film, it seems to me, was the difference between an Italian culture and an Italian working class history, which applied to the woman, and a Swiss history and a Swiss character, which applied to the man. So I would refuse those stereotypes of women being nihilistic, chaotic, tempting, and men as being sort of rational and ordered. No, I reject that completely.

Cineaste: *In* Middle of the World, *it seems to me that the problem of normalization is portrayed through the sexual relationship between the immigrant waitress and the managerial type.*

Berger: Well, that film began with Alain saying to me, "Can we make a film about an Italian waitress" —there are thousands of them working in Swiss cafes, at least in French-speaking Switzerland—"and a Swiss man who has an affair with her?" I think he added that the Swiss man should, in some way or another, be involved (in a career sense) with Swiss politics. That was all, at the beginning. So I began thinking about this very bare skeleton of a story, simply two characters, and this led me to think about the nature of sexual passion. The first thing I wrote was not a scenario at all, but two letters, one to the actress who was going to play the woman, and one to the actor who was going to play the man. We didn't know who the performers were going to be, but I wrote a letter to each of them, not really very much about the story, but about the nature of passion, what allows a person to be capable of passion, and what prevents a certain kind of person from being capable of passion.* Obviously, not incapable of infatuation, not incapable of sexuality, but, as I see it, of passion.

The story, the drama, was essentially about this. The waitress is a woman who is capable of passion, but in this case, she does not actually commit herself to this capacity. She doesn't do so, to put it very simply, because gradually she realizes the man is incapable of a similar commitment, incapable of passion. Put like that, it sounds very simple, over-theatrical. As the story unfolds, however, the man proves himself capable of a kind of madness. He sacrifices his career and marriage; he is, as they say, "mad" about this woman, and yet he is incapable of giving himself up to the unknown, which seems to

*John Berger's letters to the two actors in *The Middle of the World* have been published in *Cine-Tracts*, Vol. 1, No. 1 (Spring 1977).

me to be the very eye and heart of passion. Passion is a surrender of the self to the unknown. Everything about that man had conditioned him to reject the unknown, to not allow even the category of the unknown to enter either his mind or heart. This wasn't so with the woman, however, and so their affair ends.

So, when you ask, "Is the film about normalization?", I don't know. I see it as a film about passion, or, in this case, about a passion, or a mutual passion, which is not born. Of course, in a certain way that does fit into various social norms, because one could obviously say that our culture as a whole—our positivistic, empirical, opportunist but highly calculating, culture—tends, in its own terms, to reject the unknown, to reject mystery. Insofar as this man is a fairly direct product of that culture, and insofar as the continuation of that culture within these rather narrow positivistic terms can be called normalization, it's a film about normalization. But first and foremost, for me at least, it is a film about passion.

Cineaste: *Can you discuss the differences between what you imagine or visualize as a film and what Tanner acually puts on film?*

Berger: *La Salamandre* is very close to my original conception of the film. That is also true of *Jonah.* I think the one film which differs from how I had visualized it is *The Middle of the World.* But I really hesitate to talk about what those differences are, because I don't want to criticize that film unilaterally. Also, after talking to many people who have seen it, I think that my initial disappointment in that film was, to some degree, unfounded. In other words, I now think it is a better film than I thought it was when I first saw it. Perhaps I was disappointed simply because it did not coincide exactly with my first vision of the film. All I would add to that—because it's something Alain and I have discussed together, more or less publicly—is that the casting of the Italian waitress did not seem, to me, to be exactly right.

Cineaste: *Has your collaboration with Tanner now ended and, if so, why?*

Berger: Although at the present time I'm not working with Alain, our collaboration has not necessarily ended. I think we both conceive that we might do another film together. What is true is that I have not been involved with Alain on the last film he made, *Messidor,* or on the one he is planning to make now, in the United States or Canada. This is by mutual agreement, although I think it was actually myself who first formulated the idea that it would probably be better for us not to work together for the moment. The reason for this is as

follows. Basically, we made three films together—*La Salamandre*, *The Middle of the World*, and *Jonah*. There was another film, in between, called *Return to Africa*, which I didn't collaborate on, although in actual fact I did tell Alain the story upon which it is based. It was a story that more or less happened to two friends of mine, and I told it to Alain one evening in some detail, and that was the origin of that film. So we actually made three films together, and the fourth one during that time was a kind of unrecognized or unformulated collaboration. Now, in those three films there is a kind of development. It's not easy for me to define that development in very precise terms, but I think that from each film we learned something which we tried to apply to the next. I think the development reached a peak with *Jonah*. In other words, I don't think we could make that kind of film better, and if we made another film together, there was a danger that we would merely repeat ourselves. So it was a question of beginning again from a new base, or making another journey, and at that time, after *Jonah*, we found ourselves in somewhat different positions about this.

Alain, I think, was more interested in making films of a looser structure, films which, in a certain sense, were more experimental in their narrative, whereas I, because of my experience in writing stories not for the cinema, had come to a different position. Several years previously, you see, I had written the novel, *G*, which is an experimental work in terms of its narrative. But after *G*, the next major fiction work I wrote, *Pig Earth*, was about peasants, and in writing this I found it necessary to return to a much more traditional form of narrative. Therefore, when this moment arrived after *Jonah*, my current thinking about narrative was tighter and more traditional, just the opposite of Alain's. We both recognized this, with mutual respect, and therefore decided that it wasn't possible for us to make a new beginning at that moment. That's why I'm not working with Alain right now. But we're still very good friends, and sometimes we discuss his films, but in a very different way, just as friends, rather than as active collaborators. And, certainly, the possibility of our future collaboration still remains.

28—GILLO PONTECORVO

Political terrorism in "Ogro"

The rise of urban guerillas in Europe has posed artistic and political challenges to filmmakers on the left. Franco Solinas, Salvatore Samperi, Giuliano Montaldo, and Lina Wertmuller were forced to abandon projects on the subject. A number of German films (The Lost Honor of Katharina Blum, Germany in Autumn, Knife in the Head) relegated terrorism to a background element. Fassbinder's The Third Generation, which focused on a group of terrorists, had a narrative so fragmented that it was impossible to discern the characters' political motivations. In this context, Gillo Pontecorvo's Ogro, based on Operation Ogro, the 1973 assassination of Franco's first Prime Minister, Carrero Blanco, by the ETA, the Basque guerilla organization—was a significant cinematic event. The film took us inside the terrorist organization to provide an intimate understanding of the four protagonists responsible for the preparations for and execution of the political assassination. Corinne Luca's interview with Pontecorvo was translated from the French by Natasha Thomsen and Meg Hunnewell.

Cineaste: *Did you encounter any particular problems in getting* Ogro *produced?*

Gillo Pontecorvo: Yes. In 1976, shortly after we started working on the project, the Americans (United Artists) who were to have produced it got scared. Franco was dead, but the political regime was still half Francoist, and United Artists was afraid that the Spanish government would block the distribution of their other films in Spain. So we stopped for a year and a half. During that time there was a democratic movement in Spain, and the government changed. Since the danger of repercussions was lessened, we were able to renew the project. Following this, however, there was another interruption, apparently because the theme we had selected was too difficult and not very commercial. After four or five months of searching, we finally came up with two producers—an Italian, Franco Cristaldi, and his associate, Nicola Carraro; and a Spaniard, Jose Samano.

Cineaste: *The Moro affair occurred during this period. Did it encourage you to make changes in your scenario?*

Pontecorvo: Yes. It was during the kidnapping of Moro that we wrote the final version of the script, after hesitating between continuing or dropping the project altogether. The film probably shows the effects of many of these perplexities. We perhaps overstated the fundamental difference, as we see it, between armed struggle under a democratic regime and armed struggle under a dictatorial regime.

Cineaste: *In the original screenplay, the entire film takes place at the time of Carrero Blanco's assassination. Why, in the final screenplay, did you set the film in the present, treating the attempt on Carrero Blanco's life as a flashback?*

Pontecorvo: Because of the film's structure. I wanted to portray the present to show that deviation is possible in a form of struggle which was justifiable under fascism, but erroneous today. That is why, at a particular moment, the storyline of the assassination of the Spanish prime minister is interrupted to show Txabi today, killing two inoffensive policemen.

Cineaste: *The Italian critics, on the whole, have stressed the firmness of your position against modern terrorism. After seeing the film I would find it difficult to make a judgment, either positive or negative, on terrorism.*

Pontecorvo: Your impression may be a result of the way that, in general, I apprehend political problems. In *The Battle of Algiers*, one of the left parties accused me of being impartial, even though I was

firmly convinced I had taken a position in favor of Algerian independence. Instead of condemning the situation from the outside, however, by painting black all the action on one side, and white on the other, I tried to enter into these two logics and to see, from the inside, everything that was possible to see, all the while expressing a judgment which was historically in favor of one side and against the other. In *The Battle of Algiers,* it is the logic of colonialism which is condemned, and not the particular individuals who put it to work.

The same is true of *Ogro.* Txabi, who kills two clumsy and innocent policemen, is not a monster. I tried to see him as he is: someone who, on one hand, has a desire to remake man and society—a noble and generous desire—and, on the other hand, someone who has the capacity for a violence that can become savage. That is what I attempted to show when, for example, we first see him speak to his wife about mankind's future, of the need for things to change profoundly. Then he arms himself with a pistol, and goes out and shoots two policemen whom I wanted to portray as much as possible as non-military types.

Finally, my own opinion is given at the end, through the words of Ezarra, the other protagonist who refutes terrorism outside of fascism. While Txabi is dying, he asks his former friend, "But you are also a man. How can you ask a man to have so much patience?" Ezarra, tears in his eyes at the loss of a friend who fought with him against fascism, replies, "Nevertheless, this kind of courage is also necessary." Even if everything is incredibly barren, even if the prospects before us are discouraging, it is necessary to have the strength to go ahead and change things bit by bit, and not maintain the foolish illusion of being able to change the world through acts of this nature.

Cineaste: *The next to last scene in the film is very moving. We see Txabi, on his deathbed in the hospital, with his old friends in tears around him. Did you want to make the viewer cry?*

Pontecorvo: It is with this scene that the equilibrium of the film is balanced. Even if, emotionally, we are able to side with Txabi, who is about to die, we don't agree with him rationally and politically, and therefore the emotional participation would tend toward Ezarra, who, although he is crying for his friend, says "no" to him. If we hadn't had this scene, especially during the period of exacerbated tensions that followed the kidnapping of Moro, I would have given up my plan to make *Ogro,* because it seemed to me dishonest, quite frankly, to make a film on this subject if I couldn't offer a clear idea of

my own position. The important thing was to arrive, through an emotionally intense mood, at those words, "Nevertheless, this kind of courage is also necessary"—the courage of patience, of the everyday struggle of life—and it was necessary that those words be spoken honestly by someone we had seen in other political circumstances, leading a mission just as big as the assassination of Carrero Blanco. The emotion released in this scene serves as a sort of sounding board to underline these decisive words at a crucial point in the film.

Cineaste: *It's your novel use of pathos, actually, which allows the viewer to distinguish the emotional from the rational, two levels which the mass media have succeeded in confusing. In other scenes, however, your use of pathos reminds one of neo-realism. There is a very short scene where we see Txabi, as a child, being hit on the fingers with a ruler because he speaks in Basque to a friend. This scene—which shows us motivations, deeply rooted in childhood, which lead Txabi and his friends to resist oppression through violence—uses pathos in a very positive way. After the intensive use which neo-realism has made of pathos, however, wasn't it difficult to use it today?*

Pontecorco: Firstly, regarding the scene to which you refer, disallowing the speaking of Basque in school is a determining element in the story. Of the four protagonists involved in the assassination, to whom I have spoken at length, two of them told me that the deepest, longest-lasting impression left upon their memories was of being punished with a ruler. One of them, in fact, spoke about it for over two hours. Consequently, this scene synthesizes the mode of fascist repression against all forms of expression of national identity. Also, this scene is very short; it lasts about three seconds. I don't dwell on it. Besides, emotion, pathos, exist in life. They pose a problem in the cinema, but it is only a question of measure, of dosage. Since it is a facile method, when dealing with material which is emotionally moving, one must make an effort to use all possible antidotes: brevity, dryness, and a lack of underlining. Pathos should be expressed in passing.

Cineaste: *There is a scene where Txabi disobeys the prudent orders of Ezuru, and takes the enormous risk of going out and walking through the streets of Madrid to follow the trade union members, even though the city is overrun with police because of the demonstrations. Did you want to show another form of struggle against power through a suspenseful scene?*

Pontecorvo: I included this scene, on one hand, to show the

different kinds of struggle one can use against fascism, and, on the other hand, I wanted to develop the slightly fantastic and strange character of Txabi. I wanted to show his deep sympathy for those capable of exposing themselves to danger, his admiration of self-sacrifice, which, incidentally, came out of his Catholic formation as an ex-priest. Which is to say that the actual perpetrators of the assassination attempt against Carrero Blanco were aided by a communist union bricklayer who, although he did not share their ideas, was aware of the importance of their mission, and agreed to lend them a hand, although obviously not in the way it was recounted in the film

Cineaste: *The tunnel scene, when the four men dig a long tunnel under the road where the car of Carrero Blanco will pass and explode, is magnificent. It is a very long scene, and seems disproportionate in terms of its function in the overall plot.*

Pontecorvo: I wanted the viewer to feel the difficulty, the inhuman fatigue, they felt.

Cineaste: *Do you feel that a successful scene must involve elements—such as the length of the episode or the presence of numerous details—which go beyond the strict needs of the plot?*

Pontecorvo: Yes, there is a necessity for a realistic approach to action, a necessity to represent it as a form of document. It must be accented, more or less, depending on the subject. I pushed this tendency to the limit in *The Battle of Algiers*. When the film was nominated for an Academy Award, my American friends advised me to print on the poster the inscription, "Not one foot of newsreel is used in this film." They explained that "everyone here thinks this is a compilation of newsreel film." In *Battle of Algiers,* not only the images, but also the dialogue seems to come from reportage. Everything was filmed with a telephoto lens which gave it a graininess, the look of real events captured spontaneously. The theme of *Ogro* does not lend itself to a systematic development. Certain composites of the protagonists limit this sense of direct truth. In fact, *Ogro* bears no relation to the kind of cinema I usually make.

Cineaste: *You have made only five films in a period of over twenty years. Why are there such long intervals between your films?*

Pontecorvo: You know, I did no movie for ten years, refusing every project proposed to me, and refusing even the things I was proposing to myself, because I was so disoriented. I hope that I'm not going to wait another ten years before I make my next film. I would like to make something in a year and a half or so. But I have to

struggle with myself. The choice of the theme is always tragic for me. I am a perfectionist, so each time I have the impression that I could do better, that I'm mistaken, that I would be better off to drop the whole thing. Then I look at it again, I change my mind, I modify it so much that, in the end, the result doesn't please me any longer. I must struggle against this failing in myself.

Cineaste: *What is your view of the current crisis of the Italian cinema?*

Pontecorvo: In Italy today there are only six or seven major filmmakers who are able to make their own kinds of films.

Cineaste: *Don't most of the major Italian filmmakers have in common a new interest in the problems of private life and sentimentality?*

Pontecorvo: I would say that, formerly, there was an easily identifiable common basis in neo-realism. This cinema was replaced later by Italian comedy. Today I would be unable to describe the current situation of Italian cinema, and it is precisely that which is the symptom of the crisis—the absence of a common denominator between different *"auteurs,"* the absence of a school. But I think this is a temporary crisis, even though it now affects most of Italian cinema. For the smaller group of "auteurs," it is not difficult to make films. One cannot say that Fellini, Rosi, Ferreri, or even myself have problems.

Aside from the absence of a school, what is serious at this time is the effect of the economic crisis on the cinema. If the government does not apply new measures, a new law, make interventions within the industry, there is truly a risk that our cinema will collapse. There are no more producers, and the Italian distributors are no better. Returns on ticket prices and the government subsidies are only partial reimbursements of the high taxes imposed. But I believe that as a result of multiple pressures from the unions, writers, and producers, the government has realized that it must intervene quickly.

29—ANDRZEJ WAJDA

Between the permissible and the impermissible

Andrzej Wajda (pronounced vida, *to rhyme with* Ida) *is one of the founders of Polish cinema. His debut as a feature director was with* Generation *(1954), a film about the Nazi Occupation.* Kanal *(1956) and* Ashes and Diamonds *(1958) dealt with the war years and postwar political turmoil. These searing historical dramas thrust Wajda and the whole Polish School into worldwide prominence, capturing awards in Cannes, Venice, Berlin, Moscow, and London. During the nineteen-sixties, Wajda worked on films with contemporary settings at times but often had to work abroad because of government restrictions; and his work was of uneven quality. As a cinematic rebirth took hold in the Poland of the nineteen-seventies, Wajda was always in the vanguard, reaching one of the peaks of his career with* Man of Marble *(1977), a scathing indictment of postwar Polish events and the most socially challenging film ever made in the postwar Eastern Europe.* Without Anesthesia *(1978) analyzed the shadowy work of socialist bureaucracies;* The Maids of Wilko *(1979) chronicled lost hopes and disappointed romances of an earlier time; and* The Orchestra Conductor *(1980) contrasted the careerism of an ambitious provincial orchestra conductor with the dedication of an aged expatriate of world renown. At the time of the interview, Wajda was head of one of the eight Polish film units and president of the Association of Polish Filmmakers. He insisted he did not know English, but answered questions in Polish before the interpreter translated them. He spoke with Daniel Bickley and Lenny Rubenstein at the Berlin Film Festival in February 1980 and to Bickley alone at the Festival of Polish Films in Gdansk in September 1980, immediately following the historic strike settlement won by the shipyard workers there. The interpreter on both occasions was Krzysztof T. Toeplitz, a noted Polish film critic and scriptwriter.*

Cineaste: *You are both a director and a producer of films. How does that work?*

Andrzej Wajda: First, you must understand how film production in a socialist country is organized. The general policy of the national cinema—programming, distribution, exhibition, and production itself—is in the hands of the state. More practically, it is in the hands of one man, the Minister of Culture. At its worst, this results in all films produced being of the type *he* likes. Imagine Sam Spiegel having a monopoly on film production in the United States, and you have an idea of our situation. Because of this, we have searched for a system that would guarantee diversity and a measure of freedom in film production. From that search grew the concept of film units. Each unit consists of a director, a literary manager, and an executive producer. Around this trio are clustered other, usually younger, directors. The people in each film unit work together from a shared artistic viewpoint. They develop themes, write screenplays, discuss one another's work. With several such units, we can propose various film ideas to the Minister, who now controls all financing. The older, established director who has proven himself can vouch for the talent of a younger colleague, who normally would be unable to discuss new films with the Minister. That is my duty as a producer, to act as a go-between with the Ministry.

Cineaste: *So all feature film production originates in the units?*

Wajda: Yes. We have eight units working in Poland now; each produces about five features a year. I head one unit, Krzysztof Zanussi another, Jerzy Kawalerowicz a third; the other names probably wouldn't be familiar to your readers. The units exist for three-year periods, after which they may change. Each is formed around the distinct personality and interests of its head, who is the decisive influence on the themes and style of the films made in that unit. This idea of working units developed here in Poland. We consider it one of our greatest successes, and it has been adopted in several other socialist countries, including the Soviet Union.

Cineaste: *When did the units develop? Was there a struggle over them?*

Wajda: The postwar Polish cinema was created by a number of filmmakers and critics who, as early as 1929, had formed an organization called "START" to further the interests of noncommercial cinema. START included, among others, Aleksander Ford, Jerzy Toeplitz (the interpreter's uncle), Jerzy Bossak, and Wanda Jakubowska, and they put forward the slogan, "Film must be socially

useful." After the war, this group came to Poland with the Soviet army. The majority were members of the Communist Party, and their influence on the formation of the Polish cinema was decisive. After the war they contended that the Polish cinema must become a directors' cinema, even in the management of practical details, and not dominated by producers, and especially not by political advisors or bureaucrats. At that time the idea of film units was already being discussed by this group. Unfortunately, their ideas were not compatible with the bureaucratic structure of the new socialist government. This was a conflict from the very beginning. So the units were not actually created until after the revolution that brought Gomulka to power in 1956. Five units were started then. Among them was one called "Kadr," headed by the young Kawalerowicz. I belonged to it, and so did Andrzej Munk. The real beginning of what came to be known as the Polish School began in this unit. Still, the units never achieved the amount of independence we envisioned for them, and in the late sixties they suffered greatly from attacks by the government.

Cineaste: *Are you trying to increase the units' independence now?*

Wajda: Yes, exactly. On the wave of the recent political events, with all the changes now taking place in Poland, we are demanding complete independence in script selection and in financing films.

Cineaste: *You want the Ministry to give the units a certain amount of money, and for the units to decide independently what they wish to do with it?*

Wajda: It's a little more complex than that. You see, all the heads of the units are selected for three-year periods. By coincidence, this period is just now ending, and all the units must elect new heads, or managers, as we call them. What we want right now is for the managers to be selected from a list that will be chosen by the filmmakers' union. We'll allow the Ministry to choose the managers, but only from that list.

Cineaste: *But what about financing?*

Wajda: We want each unit to receive a certain amount of money at the beginning of each three-year period. At the end of this period each should pay this money back, recouping it from box office receipts, TV sales, overseas sales, and so on. In this way, each unit will be ultimately responsible for its own financing.

Cineaste: *And you're not afraid of commercial pressures replacing political ones?*

Wajda: No. The weakest aspect of Polish cinema is that it produces a lot of films that are completely unnecessary, that are not addressed to any audience at all. Of course, one might ask why we are fighting for added responsibilities, since these might make our lives even more difficult than before. But we are looking for a clear criterion of our activity, and we feel that the financial one is honest. At least it's much more honest than the political one. Commercialization, in the Western sense of the word, does not pose a danger to us. In Poland, every truthful political film is also commercially successful. So, too, are films based on classic Polish literature. We are not worried about an over-production of stupid comedies or anything like that.

Cineaste: *You're putting a lot of trust in your audience.*

Wajda: Yes, because the Polish cinema during its best years was supported by the audience, not by the Ministry. Audiences were much more intelligent and just in their judgments than the Ministry was. You should also know that the authorities are always juggling attendance figures. This happens two ways. First, theaters sell tickets costing either two or twelve zloties. For some films, two twelve zloty tickets are counted as twelve two-zloty ones, to increase the attendance statistics. The reverse happens to certain other films. The second way is through a different distribution system. A 16mm copy is made and distributed to schools, military units, and so on. So to the attendance figures reported by the theaters the authorities can simply add in the entire Polish army or all the school children. Of course, only certain films are distributed in 16mm. And this is a purely political decision, made by the Ministry. The only audience we want counted consists of people actually coming to the box office and buying tickets, not these millions of "abstract" spectators.

Cineaste: *Do you think this will eliminate many of the politically opportunist films?*

Wajda: Yes, precisely. When the Minister wants a supposedly political film, and is paying for it, he then has a vested interest in its success. If it is, in fact, unsuccessful, he merely manipulates the statistics to prove otherwise. That would not be possible in the system we propose.

Cineaste: *Which films now are the least successful with Polish audiences?*

Wajda: Those we call, ironically, "artistical." By this we mean those films trying to copy or follow western European

trends—obscure avant-garde or existentialist films, expressions of the filmmaker's "soul" and nothing more.

Cineaste: *Are there commercial pressures in your current production system?*

Wajda: Not really. But this has its good and bad sides. If a film plays to an empty house, it doesn't necessarily mean the film is bad; in some cases the public may be guilty. My task as director is not just to provide a nice evening's entertainment. The most important thing is to tell the audience something, to make people think, to initiate a dialogue. The most important moment in preparing a film is deciding what you wish to say. There are a lot of directors who have something meaningful to say, yet who lack the ability to put their ideas across on the screen. The lack of commercial pressure means that such a director may never develop or learn anything. An American director knows that the most important thing is to tell an interesting story. That is why American films are a good example for us. There *should* be pressure from the audience, since that pressure can be intellectual as well as commercial, particularly here in Poland, where our ambitions in the cinema are often much higher than our filmmaking capabilities. There hasn't been any interesting literature or painting in Poland recently; some music, perhaps, but it is film that provides the main current of artistic creativity. Anyone really interested in the arts is connected with film, and if you wish to say something political, film is the best means of doing so.

Cineaste: *Why is that?*

Wajda: I don't think anybody knows. A novel can end up in the wastebasket or the closet; it's too much of a private thing. To do a film you must have a screenplay accepted by the authorities, you must overcome a lot of difficulties, you must know how to fight for your ideas.

Cineaste: *Polish films have been based traditionally on classic literary works, yet it seems that many of the new films are made from original screenplays.*

Wajda: That's true. The best literature in Poland today is found in screenplays. Nearly all the best films in recent years are original stories for the screen. This is especially true of the younger directors; they all prefer to write their own scripts. These directors are the great hope of Polish cinema. I can't overemphasize how inspiring and challenging it has been for me to work with them.

Cineaste: *Let's shift the discussion to your own career. How did you become a film director?*

Wajda: I studied painting for about three years, but I didn't think my character was strong enough to be a painter. You must be very self-assured to be a painter, since you must always stand alone. A film director works with a group; a good sense of leadership can be enough to succeed. I gave up painting to study film, but I was never sure until the last moment whether I would really like being a director. For some time I was an assistant director, and I decided that if I had to remain an assistant or a second-unit director I would stop my film studies. But I had some luck, and early on was given my own feature to direct. Well, you can see I'm still at it.

Cineaste: *Can you tell us a little about the Polish Film School?*

Wajda: It was founded in 1947; I started my studies there in 1949. The school was formed by that same group of people I mentioned earlier. The actual content of their lectures was not as important as their goal to change the art of film and create a noncommercial cinema, nor as important as the meeting place the school provided for young people interested in film.

Cineaste: *Was the school left-wing?*

Wajda: The school's founders were, of course. As for the students, it is hard to say, since for our generation the war and occupation were the only experiences in life. That is why our first films all dealt with the war years. At an age when many start seeing films seriously, say about thirteen to nineteen years old, we could not go to the cinema because of the German occupation. I was very naive about films because of this; the first film that deeply impressed me was *Citizen Kane*. I first saw it during my second year at the Fine Arts Academy in 1948.

Cineaste: *Your early films, especially* Ashes and Diamonds, *are closely identified with the actor Zbigniew Cybulski. What sort of effect did he have on you?*

Wajda: Nobody has ever had an effect on me as Cybulski did. We worked closely together very often and very closely at the beginning of my career. He was my collaborator. We always discussed new films and developed the ideas for them together. Cybulski was the kind of actor who brought to films his own character, his own individuality. He was almost incapable of playing someone wholly invented by a writer; he always played himself. That's why he was so irreplaceable. Even after his death, I felt at first that he was still with me, planning my next film. I thought about him constantly. I was shocked when I realized that it was impossible to make another film with him, that his character would never again appear on the screen.

At that instant I understood that each of us is exceptional; when someone dies, something unique disappears from the universe. There is no replacement for individual human nature. That is why all films about dead actors fail; another actor cannot play the character, even if the dead actor is played by an actor of greater talent. The truth is in the impossibility of replacement.

Cineaste: *Have you ever developed a similar relationship with another actor or actress?*

Wajda: My attitude has been the same toward many other actors, but none has ever returned as much thought or understanding as Cybulski. I don't mean to say that they are to blame. My experience with Cybulski was also my first experience as a director. With him I learned that the director talks to the audience only through the actors. If you don't really love your actors, it is impossible to make anything meaningful.

Cineaste: *Around 1960 you made your first "contemporary" film,* Innocent Sorcerers, *a story about disaffected and cynical youth in socialist Poland. Its script was by Jerzy Skolimowski and it starred, among others, Cybulski and Roman Polanski. Was it well received by the Polish public?*

Wajda: Yes, it was accepted by the public, but not by the government. It was not released until a year after it was finished, and then it was very poorly distributed. It shocked the authorities in those times because it depicted such new and unexpected attitudes.

Cineaste: *They objected to the film from a moral point of view?*

Wajda: Yes, it's almost funny now. For example, in the film the protagonist owned a new tape recorder. In one scene he had the recorder sitting on the floor by his chair, and as he sat he idly punched it on and off with his foot. The authorities cut this scene from the film because they were shocked to see such a nonchalant attitude displayed toward such a highly prized technical device. They thought it was a terribly immoral scene. Another example: in Jerzy Andrzejewski's short story, it wasn't very clear why the young boy—the protagonist—refuses the love of a girl. This boy was played by Tadeusz Lomnicki, a very good and thoughtful actor. He acted the part out for me in rehersal, without the camera. It was clear immediately that the boy was a homosexual. He wanted to make love to the girl, yet he was afraid of something in *himself.* As Lomnicki rehearsed it, I knew that it was right, that I should make the film that way. But I wasn't courageous or self-confident enough to do

it directly or openly. In the official version of Polish reality, you see, homosexuality simply does not exist.

Cineaste: *So you felt the film was compromised from the beginning?*

Wajda: Yes. It was not even half what it should have been. Ironically, two or three years after the release of *Innocent Sorcerers,* a British film, *A Taste of Honey,* was released in Poland. Audiences understood immediately the homosexual character in that film; the situation was quite explicit. I believe, in general, that a lot of ideas originally born here are just not attempted, owing to moral obstacles, to the oppressiveness of old ideas and habits, and so on.

Cineaste: *But with* Innocent Sorcerers, *the problem was not only official pressures, but also a kind of self-censorship.*

Wajda: Yes. I was afraid to propose what I actually wanted to do. But even in its limited form, the film was officially censored and released only in a restricted way.

Cineaste: *Didn't almost ten years pass before you made another film on contemporary life,* Everything for Sale?

Wajda: Yes, and this was connected to the problems I encountered with *Innocent Sorcerers.* I believe, however, that any director who wants to keep in contact with reality must sometimes make contemporary films.

Cineaste: *Some Western critics have complained that your historical films are a form of evasion. Do you feel there is some truth in that?*

Wajda: No, not exactly. For instance, *Land of Promise* now appears to be a much more contemporary film than people realized when it was released in 1974.

Cineaste: *It dealt with a big strike in Lodz near the turn of the century, didn't it?*

Wajda: Yes. It was extremely successful, not only in Poland, but in all the socialist countries. It showed a basic life mechanism that hasn't existed here in many years. It was about competitive people, people whose success was connected to their own activities and abilities. This was in sharp contrast to our present situation, where your own capabilities or actions are less important to your success or failure than are outside circumstances beyond your control.

Cineaste: *To judge from many recent Polish films, this state of affairs seems to have given rise to a great deal of opportunism and careerism in Polish society.*

Wajda: Yes. This is a problem that concerns us deeply. A career

in our society is something very different from one in the West. You cannot become a celebrity here, as people can in the West; your scope is much more limited. To devote yourself completely to advancing your career, you must invariably stoop to rotten deals and swinish behavior; you must step on a lot of people. Honest people must expose and combat such a situation. It is important to defend the individual's identity and sense of integrity. It is important to defend ethical and principled values. These are vital themes for us; they can be seen in my film *The Orchestra Conductor,* in Krzysztof Kieslowski's *Camera Buff,* and in all of Zanussi's films.

Cineaste: *What can film accomplish in society?*

Wajda: Less than filmmakers wish, but much more than the authorities expect. It can be very difficult to make your point, but, from the letters I have received and the people with whom I have spoken, I think I succeeded with three films: *Ashes and Diamonds, Man of Marble,* and *Without Anesthesia.* Each film dealt with a subject that had never been treated or spoken of openly, yet, there on the screen, audiences could see their own lives, their hardships, their misery. True, these films were only representations of reality, but the fact that they were openly shown indicates that the political authorities were not entirely afraid to discuss reality. To have a film on the borderline between the permissible and the impermissible—that is always a success. It is very important to draw large audiences to such films. Many ambitious and beautiful films, some of which are politically very inquisitive, are nonetheless exclusive and elitist, and hence unsuccessful.

Cineaste: *You mentioned* Man of Marble. *Was it released without cuts in Poland?*

Wajda: No. There was one scene cut out. The young film director, played by Krystyna Janda, is with the son of Birkut in the Gdansk cemetery. They are looking for a grave, but are unable to find it. This, of course, means that Birkut was killed during the 1970 strikes in Gdansk.

Cineaste: *Were there problems in releasing the film in Poland?*

Wajda: Yes, but I was certain from the very beginning that it would eventually be released. The political climate at that time was such that there was a group against the film. But there was another equally important group—at least it was strong enough—that fought on my side for the film's release.

Cineaste: *Was there a struggle over cutting the one scene? And,*

if so, were you alone in that struggle, or were you supported by other filmmakers?

Wajda: No. I decided to cut out this scene, but on the advice of my friends rather than the demands of my opponents. Even those on my side in the Ministry did not feel the film could be released with this scene in it. The scene was impossible even for them to accept.

Cineaste: *Do you hope that it may be possible, in light of recent events, to restore the scene to the film?*

Wajda: Not exactly. What I actually plan to do is to make a sequel to *Man of Marble*. When I was recently in the shipyards, during the strikes, many workers there told me they want to see the story continued. I plan to begin the new film with the cemetery scene that was cut from *Man of Marble*.

Cineaste: *Will the sequel cover the recent events here in Gdansk?*

Wajda: Yes. It will begin in 1976, then jump back to the last years of the life of Birkut, the "man of marble." But the story's focus will be on the life of the young worker, Birkut's son.

Cineaste: *When will you begin filming this?*

Wajda: I would like to be filming it this very instant. Unfortunately, however, I don't yet have a script. So I must first get a script, then I have to have it accepted by the Ministry. So it may take a little while. But I want this to be my next film.

Cineaste: Man of Marble *was a great commercial success in Poland. Was* Without Anesthesia *also?*

Wajda: Yes. It was very well received by the audience and by critics. What is particularly interesting to me is that it was also well received abroad, despite its rather heavy dialogue, and despite its rather unspectacular nature.

Cineaste: *Some critics in the States were confused as to whether the main character was really in official disfavor.*

Wajda: I'm not surprised. The Polish audience, of course, understood it perfectly. I also learned that many French critics said the film was not only about Poland, but about France as well. They had no problem recognizing the symptoms of this kind of unofficial disfavor—the kind that is vague and unclear, that leads you to conclude there is something wrong with *you*. This film does not describe a phenomenon that is unique to socialist countries, but rather one that can be found in all societies dominated by bureaucracies.

It would have been possible, of course, simply to portray directly

what was happening. I suppose it would have been easy to invent some reason for the protagonist to be unaccepted suddenly by those around him. But that would have cut out all the important undertones from the film, and made it a tract or something, or just a depiction of an isolated event, without the atmosphere or the *process* of bureaucracy coming into focus.

Cineaste: *In* The Orchestra Conductor *there is a sense that art has become a weapon of cruelty for the young conductor, in the way we usually think of politics.*

Wajda: Perhaps. I could have set this film in the political world, but I felt it was better to transplant the conflict into the realm of art. I wanted to show that there is a kind of freedom that comes from artistic creation. Anyone who doesn't have a feeling of liberty inside of himself is incapable of expressing it, or giving it to others.

Cineaste: *In Kieslowski's* Camera Buff *there is an implicit notion that it is very difficult to be a successful filmmaker and, simultaneously, have a successful personal life. As a director who also has many organizational and political responsibilities, do you find it possible to have any life away from the cinema?*

Wajda: No, it is not possible to do much else when you are a filmmaker. To be a film director you must concentrate on filmmaking. There are moments when I feel I have never experienced anything; I have only made films. If you are married, you must find a wife—or a husband—who is able to understand your priorities. You must find a mate whose personality is so strong and self-assured that she or he will not be afraid of very often being in second place, so to speak.

Cineaste: *What do you see as the relationship between contemporary Polish cinema and the recent political events?*

Wajda: I think that Polish films of recent years, especially those of the trend called the "cinema of moral dissent," have been particularly successful in reaching Polish audiences. These films testified to the growing crisis in our country and stress that a real dialogue must exist between society and the authorities. Of course, it would be absurd to claim a causal relationship between these films and the recent developments in Gdansk, but it's not unreasonable to see a connection between them, if only of mutual concern.

Cineaste: *Will it be possible to maintain the close ties that seem to exist at the moment between the workers and filmmakers?*

Wajda: On the organizational level, if the workers achieve authentic representation, as they have demanded, then it will be possible. But if they are represented by bureaucratic leaders, as in the

past, then there will be no point in continuing any connection. It will be important, of course, for filmmakers, on a personal level, to know the real situation and feelings of the workers. You do not have to be a worker to make a film about workers, but you must know what you are talking about to make a film that speaks the truth.

Cineaste: *Do you feel that the artist has a responsibility to play a leading role in the transformation of society?*

Wajda: I consider myself a leftist, and I believe there is ample recent evidence to show that the working class itself is the most powerful leading force in Poland. But in a society such as ours, the artist *does* help shape opinions, and can function as a kind of conscience for the nation. In that sense, yes, we can and should play a leading role.

30—JOHN SAYLES

Counterculture revisited

John Sayles has had a meteoric career as a writer. At the age of twenty-five, he published his first novel Pride of the Bimbos *(1975) and had his Atlantic Monthly story "I-80 Nebraska" chosen for an O'Henry Award. In 1978, his second book,* Union Dues, *was the only novel nominated for both the National Book Award and the National Critics' Circle Award. A collection of his short stories,* The Anarchists' Convention, *was issued in 1979 and received an excellent reception. By that time, Sayles had already begun to write scripts for Roger Corman's New World Pictures. He is credited with* Piranha, The Lady in Red *and* Battle Beyond the Stars. *Since then he has scripted* Alligator, The Howling, *and a television film,* Perfect Match. *In 1980, Sayles released the first film he directed,* Return of the Secaucus 7. *Funded entirely by Sayles, the film is concerned with a group of nineteen-sixties "movement" veterans who have just turned thirty. The interview was conducted by Al Auster and Leonard Quart.*

Cineaste: *Why did you decide to make a film about the "movement" of the sixties?*

John Sayles: I had been doing some screenwriting, and realized I was having a better time writing the scripts than seeing the movies. I had always been interested in directing, and I had directed some theater. But seeing how people had made the jump from being a screenwriter to a director, I saw a good five years of writing screenplays ahead of me before I got that kind of opportunity to say, "If you want this script, you have to let me direct it." The other route was to make an independent feature; the usual way with that is to get some money together and make a horror film like *Prom Night* or *Friday the 13th*. Although I have written horror films, and seen some that I liked, I'm not that interested in directing them. I had about forty thousand dollars together from screenwriting, and I said, "Okay, I want to make a feature film as an audition piece," and decided to make something that I, myself, would want to see. If I'm going to make something outside the industry, it might as well be something that the industry isn't going to make. One thing I realized, with forty thousand dollars, is that the actors I could get who would be good had to be people who weren't in the Screen Actors' Guild yet, and who were all turning thirty. The script of the film was like an exercise to see what I could write that could be put in the can for forty thousand dollars.

Cineaste: *What was your experience of the sixties, and how is this reflected in your film?*

Sayles: It's interesting who the people are in the film. They're not me. The film is based on a group of people I met when I lived in East Boston during the mid-seventies. They were in their early thirties, and they were making decisions that their parents had made when they were nineteen, like whether to go back and finish college, whether to get married and have children. Many of them had been through VISTA, and I found I had more of an affinity with them than with the sixties kids I had gone to school with, kids whose parents were doctors and lawyers. They got radicalized in VISTA in different ways than the people in SDS got radicalized. They were bumping up against local politicians, people who were just trying to get welfare, people who weren't political at all, but who needed help. I also know that many of these VISTA people are still involved in politics, working for the school system, or in the prisons. I found it interesting that they were able to keep some kind of political feeling at a time when their lives were becoming more bourgeois. In fact, some of

them were becoming even more radical as they began living more stable lives.

Cineaste: *Now that you've done your first feature, do you have plans for others?*

Sayles: I had tried to sell the studio original ideas, but they had never been that interested, partly because Hollywood is a bit frightened of original ideas. After *Secaucus 7* showed in the Filmex festival, I immediately got one writing/directing offer from a major studio for an idea of mine—it's called *Blood of the Lamb*, and it's about a couple of guys who infiltrate a fundamentalist group. I have another writing/directing deal with 20th Century-Fox right now. It's a sort of high school romance that's going to take a hard look at class in America, a romance that you've seen zillions of times before—sort of John Garfield and Barbara Stanwyck, the downtown kid and the uptown girl—but it's set in 1966-'67, and takes people from Trenton High School. The girl goes off to Sarah Lawrence, and the guy goes to Miami to try to meet Frank Sinatra and becomes part of the "rat pack." I also want to capture the differences between people's intelligences, which is something that Americans are afraid to talk about. The worst thing you can tell parents as a teacher is, "Well, your kid's a nice kid, but he isn't very bright." That's just totally forbidden, and that's something that American films tend to step around whenever they do anything about class. At the same time, there are subjects that I'm interested in making films on that I don't think the studios are appropriate for.

Cineaste: *The characters in* Secaucus 7 *are less ideological and sectarian than many of the people who were connected with the "movement" in the sixties.*

Sayles: They are the people who went to marches, not those who planned them. They're people who did not go just to see what the action was, but who really felt very strongly about their commitments. They were issue-oriented and very concrete in their goals, not hard-liners or Marxist-Leninists who had a perspective that colors all their thinking. But I didn't want this to be an in-group film. I wanted my characters to be more accessible to an audience that did not participate in the "movement," and which might not like the characters if they met them in real life. I want the audience to come see the film, and possibly reconsider their own perspective on these people and the "movement."

Cineaste: *What was the relationship of your characters to the counterculture?*

Sayles: They still carried a bit of hangover from the counter-culture. They weren't hippies, and they did not go to Haight-Ashbury, but drugs were a part of their lives. At one point there was a real schism between life-style and political revolutionaries, but there existed a gray area in between where people could smoke a lot of dope, listen to records, and go on peace marches.

Cineaste: *Why did you make the most disrupted character, Jim, the most radical?*

Sayles: I'd say his problem is that he's painted himself into a corner. He is somebody who got hooked on activism, rather than on the spirit and ideas behind it, and he misses the limelight of the activism. He wants to be on the front lines, and what he's chosen is to work in a detox center, which is one of the best burnout places you can be in. I've worked in hospitals myself, and I know people who have worked in detox centers, and basically you've got about a year before you start feeling like you've been treading water too long. It is the front lines, but it doesn't provide a limelight and you don't feel like you're accomplishing anything much that's going to last, except on a very individual by individual basis, and even then the rewards sometimes just don't come. So, the problem was not that he was a radical, it's just that he was hooked on the wrong part of it to be happy now.

Cineaste: *What was your attitude toward the two working class characters, Ron and Howie? Did you see them as trapped?*

Sayles: They're people who probably complain the most when their friend, Mike, who they think has escaped, comes into town. He puts some perspective on what they're doing. And, at the same time, he might envy them a little bit, because Howie has three kids, and although he complains about them he's very proud of them, and that's the one concrete thing he thinks he's created and made in his life, even if he's working two jobs to support them.

Cineaste: *Although the women in the film are political, none of them is an overt feminist. Is there any reason for that?*

Sayles: What has happened is that the feminist movement has done for these women what it will, and it's now part of their life. So, they are working and they're not married, though they're wondering about having kids, but the pressure of the feminist movement is no longer on them; they don't feel like they have to do things just because they're feminists. They feel, "Yes, I can have kids and not work if I want to." These are women who have gone through the

"movement" and come out the other end, and, now, it's part of everything that they do.

Cineaste: *Why did you make Chip, who is the "straight" liberal, the comic foil?*

Sayles: He's useful in that he's not part of the group. He's good for exposition; you have to introduce all the characters to him, and also to show how this group reacts to an outsider. They're not going to agree with his politics to make things go more smoothly over the weekend, but they are going to try to include him in whatever they do. I also want to show the way that people work on each other, that Chip may change some of his ideas from knowing these people.

Cineaste: *If the "movement" had succeeded, or even been sustained, would their lives have been any different?*

Sayles: It would be different, because once the war was over the ways in which the "movement" would have been sustained would have allowed people to work full time and get paid for doing things that change their lives and change the way that wealth is spread around. More of them would be in politics. More of them, also, would be working for the state, and they would be happy about it, or at least feeling like there was some possibility in it. I think what's happened is that you find these people are now those who are complaining about the "me generation," these are the people who are saying, "Oh, my God, we've lost another one to EST."

If the "movement" had continued they would have had some place to put those energies, and would not have to feel, "I wish we could get something together here, I wish I didn't have to vote for Carter to keep Reagan out."

Cineaste: *Would a JT—the folk singer—have been different? He seems to suffer from a certain amount of psychological malaise.*

Sayles: He is somebody who would not be a whole lot different. He's somebody who's like a fly that never lights anywhere too long. You can hit him in the air, but you're only going to stun him, you're not going to squash him. He has contacts with political people, but he also has other friends who hang around in bars and sing patriotic songs by Merle Haggard.

Cineaste: *Is the humor in the film a comment on the charge that was always hurled at the left in the sixties, that it was humorless and unable to laugh at itself?*

Sayles: No, it's just the way I saw those people. I had a good time being with them, and still do. They're funny. Although people sometimes react to the humor in the film as if it's a gag, I didn't

structure the film like that. It's not a Mel Brooks or a Neil Simon movie, where everybody is a straight man or a stand-up comic and nobody laughs when they tell a joke except the audience, and they wait for five beats for the audience to laugh and then they start the action again. These people, if they say something funny, they laugh at it, they try to top each other. It's intrinsically part of their make-up.

Cineaste: *Why is the film much more dependent on dialogue than imagery?*

Sayles: Basically, I couldn't afford camera movement. I had a responsibility to the audience and to the actors to get the best performance possible out of them, so I said, we'll take nine takes for the acting and we won't shoot nine takes for a technical shot that looks great. I did what I knew I could do best. I never went to film school, and I'm still learning all that technical stuff. Sometimes a line of dialogue can save you a lot of shots that look great but don't tell you much.

There are directors who can tell a story with pictures, and there are also directors who don't quite tell a story. My main emphasis is making films about people. I'm not interested in cinematic art.

Cineaste: *You have made a number of films with Roger Corman. What sort of relationship do you have with him?*

Sayles: I had written a novel that I needed an agent to sell, so I hired an agent over the phone. His agency had a connection with an agency that represented screenwriters on the West Coast, and I sent them a script. I had always wanted to be a screenwriter, but I knew it was a waste of time to go out there and knock on doors. They said, sure, we'll represent you. I moved to Santa Barbara and the first job I got, because of a short story I had written, was rewriting *Piranha.* Corman said, "Forget this script, keep the name *Piranha,* we've market-tested it, it tested very high, and keep the idea of piranhas in North American waters. Make it something like *Jaws.*" My whole job was to contrive a reason why people, once they hear there are piranhas in the river, don't just stay out of the river but end up getting eaten. That's basically what they paid me ten thousand dollars for. The film came out well and made lots of money for them. Corman is very frank with exactly what has to be in the movie, and basically, after that, he leaves you alone. The people can be whoever you want them to be, as long as there are enough piranha attacks, or as long as there are enough people shooting people with machine guns. In the case of *Battle Beyond the Stars,* all Corman did was come to me and say, "We want to write a science fiction picture that's the

Seven Samurai in space." It was great fun, I always had a good time writing them. I found his suggestions usually very good. The people at New World don't take themselves tremendously seriously, which is good, and makes it a lot more fun to work there. I usually hope in those kind of genre films, you at least root for the people and not for the piranhas.

Cineaste: *Is there any possibility of getting some overt political message or political ideas into those films?*

Sayles: *Lady in Red,* which did not turn out very well, and probably will not be seen unless it's on Home Box Office, was a revisionist gangster film. It was basically a very political film about why the FBI was chasing after this hick bank robber, John Dillinger, instead of looking into Lucky Luciano, who was taking over prostitution in Chicago. However, by the time the film was made, some performances weren't what they could be; most of the scenes that explained why things happened were gone, and so what was left were the scenes where people shot each other. There's still about ninety minutes of that left. It's possible, but it depends on how the film comes out. I tried to convince somebody that *Piranha* was an allegory about the Red Guard, with the piranha representing the Red Guard, and that various characters were the Gang of Four, but it didn't quite wash. I didn't realize how political filmmaking is, political in the sense that it's like getting a bill through Congress, that you start out with something you want, but you're going to have to do other things just to get the money and get it made. You can be God in a novel, but the best you can be in a film is an enlightened despot, sometimes even less than that, depending on how much control the studio has.

Cineaste: *You said before that most studios were not interested in the kind of film you really want to make.*

Sayles: I'd say about a third of the ideas I have for films are things that studios would be interested in, if they were smart, because I think, if done well, they could be commercial enough. Corman likes to say, "You can make anything for any budget. You can make *Lawrence of Arabia* for, you know, one hundred thousand dollars—it's just going to look different. You can have three Armenians and a budget rent-a-camel." I have that same feeling, but I prefer to start with a budget and make something that's going to look good.

Cineaste: *You haven't given up writing fiction?*

Sayles: No, I'm working on a book right now, in between cracks, called *Los Gusanos*, which means "worms" in Spanish. It's about Cuban exiles in Miami, and I've pretty much done all the research. *Atlantic Monthly* sent me down to Miami and Key West recently, when the Freedom Flotilla was coming in, and I interviewed people down in Key West. I have the book in my head; it's just a matter of getting time to sit down and write it. And I write real fast, so I hope to have it done by the end of 1981.

31—KRZYSZTOF ZANUSSI

Workings of a pure heart

Labeled the moralist among the Second Wave of contemporary Polish filmmakers, Krzysztof Zanussi studied physics and philosophy before attending the prestigious film school at Lodz. Illuminations *(1973) brought him his first international notice with a theme about the grief of a young doctor over a friend's death. In* Camouflage *(1977), Zanussi dealt with the corruption of intelligence, which, without a pure heart, cannot hope to know the truth.* Roads in the Night *(1979) explored the importance of individual and social responsibility in Nazi-occupied Poland of 1943, while* The Constant Factor *(1980) portrays an individual who recoils from a society that assumes the corruption of everyone.* The Contract *(1980), originally made for television, cast Leslie Caron as an extravagant, retired American dancer who comes to Poland and attends an abortive wedding party during which the hosts and guests exemplify the crass corruption common in Polish high society. Jason Weiss interviewed Zanussi in October 1980 in Paris.*

Cineaste: *How has it been possible for you to make such strongly ethical films for a popular audience?*

Krzysztof Zanussi: Well, to use two examples with quite different backgrounds, it is, in a way, easier in Europe. *The Constant Factor* was made in Poland, a socialist country, and the state's subsidy was granted to me on the basis of my reputation. It is doing fairly well, and it was very expensive, but it ought to be able to break even. So, I'm free of any debt, in moral terms. And the Polish government wouldn't complain; they give the subsidy rather generously, as a basic policy of the country, even if the film is not all that flattering to the people who are in power in Poland.

Roads in the Night was made in West Germany. It was sponsored by West German television and it also had a rather generous budget. I had the freedom to choose the subject, I was offered a sort of *carte blanche,* also on the basis of my reputation with my previous film. So, I chose something which is quite controversial for Germans, but I always thought if I have such a *carte blanche* I should take advantage of it. At any rate, the film was accepted, and it has been repeated on national television in Germany twice. It has been considered rather a successful film in Germany, and, because of this, I've been offered new possibilities now. In the spring, German television will sponsor a film I will direct which will be made for theatrical release, and, later, television.

Cineaste: *Is there a structure for censorship in Poland? Do you have a free reign because of your reputation?*

Zanussi: It's very hard to describe, especially to the American public, how filmmaking in Poland functions. There is a Ministry of Culture, which makes all decisions. And there is a pre-censorship "script" which is offered to the censors. But I always hope that what I propose will be approved, because I know the rules of the game as well as the people who accept and approve my scripts. On the one hand, I'm not trying to please the authorities; on the other, I'm not willing to insult them, either. I try to comply with a certain dignity. And I understand that troubles are a natural part of my profession. I calculate them, I include them.

Cineaste: *Do you have to do everything through official Polish channels?*

Zanussi: Well, Polish authorities have to approve all my foreign contacts. They have the right to read whatever is being considered, be it a film or a play, and whenever I want to render my services elsewhere they have the right to know what is involved. In most

cases they don't object, but, of course, they don't find me these contacts. I, or my agent, have to make the contacts. I have signed with William Morris, and I sometimes get some offers via the agency.

In most cases, I make the offers and I bring in the producers, I seek them. But now, since my prize at Cannes, there is some sort of acceleration. All my older projects find producers more easily. I have, I think, too much to do; I'm overworked. But, on the other hand, at least such a moment in life has happened this once, so I can't complain. I have to work like mad, and maybe in two or three years I can slow down.

Cineaste: *You are working on a film about the Pope now. Are you using actual footage of the Pope himself, or is the film entirely fictional?*

Zanussi: It's a fictional film, but there will be some actual footage of the Pope intercut with the footage I am shooting with actors. There are three actors who play the Pope. I was approached with a proposition to make a film about the Pope, but what sort of film it would be was entirely my problem. I was supposed to find a way to make a film about a man, relatively young, head of state and head of a church. The problem was how he was to be represented. My solution was that I would show his surroundings, his background, etc., in a way that will permit people to better understand not only where he comes from, but what sort of attitudes and beliefs he represents, what sort of human experience, or existential experience, he has. Because he does not belong to Western Europe (Western Europe, for years, considered the Catholic Church as its own property), it was worthwhile to present how different his outlook on life is, which I will do by contrasting the destinies of other people whose lives parallel his. So, the Pope appears almost as a marginal figure, in several episodes, but he influences a lot of other people. He is reflected as in a mirror. And it is a dramatic story.

Cineaste: *In* Roads in the Night *you had a generation like your own in mind, growing up during the war.*

Zanussi: Yes, I think that the war in this film is sort of a decor; it might have been the First World War as well as the Second World War. The war is only the pretext for me to contrast vividly a problem which is probably universal, a problem which is mine, as well as everyone's. It is the tension between individual responsibility and collective responsibility, societal responsibility, and the fact that my most passionate disagreement with society cannot be expressed by total rebellion. In other words, in a case of real political controversy,

the individual must either pay for the mistakes of his/her compatriots, or oppose them totally.

Cineaste: *Did the fact that* Roads in the Night *put the Polish resistance in a very positive light work in your favor in terms of working with authorities on the film?*

Zanussi: No, no, no. I was not showing the Communist resistance; I was showing an aspect, in fact, which was not Communist. Just Polish people—in other words, the major resistance, which was not politically oriented, and certainly not pro-Soviet. I just took this stand, which makes the situation exceptionally dramatic, but, at least, true to the history.

Cineaste: *Was* The Constant Factor *basically up to you, other than the pre-censorship approval?*

Zanussi: Well, of course, I had to get this approval, and the subject matter is sort of unpleasant, and very critical of the society. But I managed to get this approval, and the prize in Cannes helped me enormously in the distribution of the film.

Cineaste: *Although the film is set in Poland, the problems it confronts are very real in most societies.*

Zanussi: The discrepancy between our ideals and our reality, between despising corruption and living passively in its grip, is a universal problem.

Cineaste: *On the one hand, you posed a society that doesn't accept death, and, on the other, an ethical man whose co-workers don't accept his ethical stance.*

Zanussi: True. The co-workers are already corrupt, and they don't want anyone to point out their corruptions. It's always very unpleasant to have one just person, one moral person; we hate the people who are more just than we are. We all have this reaction. As surely as we are imperfect, we don't like to have our imperfection pointed out. We want to see people who are more evil than we are, who are weaker—it makes us feel better.

Cineaste: *Why did you question society's ability to deal with death in* The Constant Factor?

Zanussi: Well, I rank death as a very important criterion of our life values. I think about it a lot, and I feel that the society that hasn't established a realistic attitude toward death is, in a way, culturally condemned. There is no inner strength, and that's frightening, because such civilizations don't survive very long. There must be something bigger in our life than death. In Hellenistic society, death is unacceptable, because it is too strong, too big; it destroys the

ultimate values. Death has to be treated in a way that the ultimate
values would be bigger and stronger than death itself. So, I confront
death, and I think the catalytic point for my protagonist is when he
discovers the physical presence of death, now very close to him
because of his mother, which puts him in a more vitally extreme
position. It is a consequence he has taken.

Cineaste: *The irony, of course, is that this position he finally finds
himself in inadvertently causes a death.*

Zanussi: Yes, that's the whole connection. First you see him ap-
proaching the death of a stranger in India. Later, an important per-
son, his mother, dies. And, then, he becomes the reason for
somebody else's death—a child's death. So there is that chain in this
argument. There is one point that might be relevant to this, one
observation that must be made. The protagonist in *The Constant
Factor* is the rebel, rebellious against society, because of the influence
of his father's legend, of the mother whom you see, of the grand-
father who died in the Warsaw insurrection. And you get a strong
sensation that the tradition obliges people to be rebellious, which is,
very evidently, a strong Polish characteristic. My society has survived
due to rebellion, because rebellion is an ultimate value.

Cineaste: *Because the country's been occupied so long?*

Zanussi: Right! Yes, for one hundred fifty years. And, even
before that there was a great tradition of individualism.

Cineaste: *Does this tradition of individualism survive despite the
government's structure?*

Zanussi: Oh, definitely. The socialist government influences peo-
ple to be more collective and, perhaps, more uniform, but the society
is far less conformist than many Western European societies. I'm not
talking about America, which is structurally and ideologically
motivated toward the individual. You know, I compare how diversity
and original opinions are praised in my country, and why these are
hardly tolerated in so many Western European countries where a
certain social position restricts people to a certain social circle, in
which they are obliged to have only certain opinions, a particular
interest, a certain style.

Cineaste: *Do you have a sense of who sees your films?*

Zanussi: Well, you know, any Polish filmmaker has immediate
access to government statistics which assess this sort of thing. These
are sometimes deceiving, because you can't tell how many people
will remember your film two years later, or how your film influenced

them, or if it influenced them at all. So, I have no scientific instruments to measure audiences, but I know for sure that if, let us say, *Camouflage* had far more than one million spectators, they weren't all intellectuals.

Meeting this audience has made me very hopeful; it's very tiring, but a great thrill. I know that I have a loyal audience wherever there is some sort of social migration. When people are coming and going, unstabilized, seeking, trying to find a new place in society—and these regions can be geographically defined in Poland—they go to the cinema in order to confront their life. They compare their lives with what they're shown in the cinema, because they are trying to find themselves again. These are people who came from the countryside to become workers, workers who are becoming students, etc. These people are looking around, they are curious, they want to find models in life, and they go to see my films.

Cineaste: *Do you feel a certain duty in this sense?*

Zanussi: Oh, yes. I think that it is a very important audience because it is an open audience. I am less successful, say, among the intellectuals who are very stabilized, who have their strictly fixed political positions, who are not besieged with doubts, who do not question the world or themselves.

Cineaste: *Are there any particular directors who might use the 1980 strikes as material for a film?*

Zanussi: Well, probably, which is, in a way, opportunistic. It is interesting to make a film about a strike before strikes happen. There were one or two films like that, sometimes in historical disguise, as in the case of Izro Kutz, who made a film about the strikes before the war, showing their importance and the sense of liberation that came from organizing a working-class movement. I think this shows that our cinema is not detached from life, even when we're using a language which is not always quite direct. Wajda's *Man of Marble,* which is about the condition of the working class in the fifties, is relevant now. *Camouflage* met with popular success not because people wanted to know what happens at the university, but because they recognized some diagnosis in the film that applied to the rest of the society. So, I think our cinema has been fulfilling its cultural duties and its social duties in the last several years, and the big successes we've had with our audience while touching on contemporary subjects the last five years show that the cinema is not abstract.

Cineaste: *Are there specific foreign influences in your films?*

Zanussi: Well, they're not prevalent, but they are noticeable. There was a strong influence of the French New Wave some time ago. I would definitely be able to recognize the influence of Bergman in my films. There are some Soviet directors, mainly Tarkovsky, who have influenced us somewhat. He's probably the most important of the directors after the war; he made a very special kind of cinema. I, personally, would invoke the names of Eric Rohmer and of Olmi, whom I like a lot. But I also like Francois Truffaut and Louis Malle, even if some of their films are disappointing. I love Fellini, because he's so amazing—he does things you'd never think about. And I was quite influenced in the late fifties and the early sixties by what I call the realistic American cinema, including people such as Elia Kazan. Now I am interested in the new wave of Hollywood directors, most of whom I know personally. I met Francis Ford Coppola when he was editing *Godfather I.* He had, of course, already made some films, but this was the beginning of his great career. Or in meeting Lucas, Spielberg, Cimino, and others, I recognize something very original and true in their work, which I respect.

Quite a few of the best Hollywood films are seen in Poland every year, which means that we see what is very deeply connected with the evolution of American society. Of course, these are only a small fraction of the Hollywood world, which also produces enormous amounts of garbage. But I think we look to this part of America, to Hollywood and independent production, with great admiration. The fact is, America is able to produce something and is able to digest it, which is, in a way, optimistic, and which shows there is more vitality in American cinema than in French cinema at the moment, or even in European cinema, with the possible exception of Italy.

32—MOLLY HASKELL

Film criticism and feminism

Molly Haskell is a film critic and feminist whose From Reverence to Rape *is a landmark critique of the treatment of women in the cinema. A member of the National Society of Film Critics, Haskell has been a theater and film critic for the* Village Voice *and* New York *magazine. Her work has appeared in a score of periodicals, including* Playgirl, Ms., Vogue, Film Comment, Saturday Review *and* Mademoiselle. *Haskell also has done programs for National Public Radio. The following interview was conducted in June 1981 by Gary Crowdus and Melanie Wallace, associated with* Cineaste *since 1980. It deals with the functions of film and film criticism, particularly how criticism conjoins with feminism, both theoretically and practically. Another focus is how the images of men and women on the screen have changed over the decades and whether women have made themselves felt positively in an art dominated by men.*

Cineaste: *In your book, you describe how you grew up with the movies. When did you first become seriously interested in films — enough to write about them as a critic?*

Molly Haskell: Well, it never really occurred to me to be a film critic, certainly not when I was growing up. I went to movies, like everybody else, as a social thing. I think it became less of a reflex pattern as I grew older, but it was still every Saturday afternoon or night. Then I went to college and majored in English, although I was primarily interested in the theater. At first, in fact, I wanted to be an actress, but, fortunately, I gave that up. Then I became interested in writing for the theater, in becoming a playwright.

After college, I came to New York, where I got a job at the French Film Office. I was there in the mid-sixties, which was a great time to be there because then the New Wave was at its height. I put out a newsletter on French films for the American press, and I would also interpret when the filmmakers came over. I had also spent a year in Paris and had become acquainted with the Cinematheque, so I had really become a film student, in a sense.

Some people who were reading the newsletter found out that I was interested in writing for other publications. I think Joe Morgenstern, who was then at *Newsweek*, was the first person to ask me to write. He had been asked to write a film article for the USIA publication, but he didn't have time to do it and so recommended me. While I was at the French Film Office I met Andrew [Sarris], and I asked if I could do some things for the *Village Voice*. That was about '68, I think, and my first piece was an interview. It turned out that the *Voice* needed another theater critic about that time, so I auditioned for and got that. What was funny about that was that I was something like fourth-string critic, low man on the totem pole, so I was covering Broadway, while all the important *Voice* theater critics were doing the attics and the basements and the Off-Off Broadway stuff, so I really got right into the Great White Way. I did that for about a year. Then Andrew expanded the film coverage and I went in as second under him at the same time as some other people were brought in. So that's the way I got into film criticism. It wasn't really something I set out to do. Film criticism was something I fell into, because I was interested in film, in the arts, and I wanted to write about it. I felt that, somehow, through film, as in all criticism, there was a way of expressing myself, of sharpening my sensibility against this material.

Being at the *Voice*, which was the most liberal publication in the

sixties, was a fantastic place to test yourself, to find out what your own perspective was, to develop your own voice. It was very free—there was minimal editing, and no one was looking over your shoulder about what you went to see—so I could do whatever I wanted. Also, I think that film, being so open—this is both a liability and an asset—to every kind of ideological, sociological, and esthetic approach, to every kind of new wave, new movement of thought, of methodology, is probably the most democratic art form. As for myself, I had become interested in the women's movement and feminism—it was sort of a distant voice which had suddenly become louder and more pressing—and, at the same time, I was struck by the fact that, at a time when women were doing so many things, making great advances, socially, culturally, and professionally, they were disappearing from the movies. So, very naturally, this became my theme.

Cineaste: *What function do you think criticism serves?*

Haskell: I think the appeal of film has always been that it is close to life; it's this hybrid art that's between fantasy and reality, between art and sociology, which combines all of these things. This is one reason I've always been more wedded to narrative film than to the more esoteric or avant-garde branches of it, because narrative film is, somehow, a way of coming to terms with one's own life. The conventions of narrative are those we recognize in some way as ordering our own lives. And this is the appeal of film criticism. At a certain point, film criticism suddenly became more attended to, it suddenly became a focus of interest at the same time that film itself was becoming less of a mass entertainment medium, and slightly more esoteric, more fragmented, more in need of explication, of recommendation. There was no longer this reflex pattern of people just going to see whatever was playing, of just walking in whenever they got there, then nudging each other to leave when they saw where they'd come in. It became an optional entertainment, something one needed guidance to go to, and in that sense film criticism suddenly acquired an importance that film critics actually had never expected it to have.

Cineaste: *Do you think there is any significant writing being done now in feminist film criticism or theory? What do you think of the efforts of the* Camera Obscura *collective?*

Haskell: I've read interesting pieces occasionally in *The Journal of Popular Film and Television.* They published a feminist critique of *Jaws* which was fabulous, and there was another piece on women in the horror film that was excellent. Ruby Rich has done some

interesting things for the *Chicago Reader.* I don't entirely agree with her—she's probably more militant, or more ideological, than I am—but I think she tries to reconcile film scholarship and feminism.

I'm not so familiar with *Camera Obscura,* but I think the problem with the structuralists in general is that they have no passion, no feeling, for film. You somehow don't recognize in their articles the same film that you have seen. They're always talking about texts. The language that they use is so completely removed from the film viewing experience, it's just a separate enterprise. Some of the feminist structuralist articles I've read not only misread, but actually misstate what happens in a film in order to make these procrustean arguments. There was an article about *Sunrise* in one of the academic film journals, for instance, which absolutely falsified the film to fit the thesis.

I don't think most of those articles really lead anywhere—I mean, you wonder what the filmic fruits of all those theoretical pieces are going to be. They theoretically scorn and despise Hollywood films, and, yet, the most interesting writing is done on these because they're the most interesting films. Strangely enough, in the name of third worldism or populism, they're really a self-perpetuating elite, and the more arcane you are, the more rarefied your little circle is, then the more exclusive it is.

Cineaste: *Do you see a particular role or mission for the feminist film critic? Are there some special qualities that you see feminism bringing to film criticism? On the other hand, do you think there are any dangers that feminism, or any explicit ideological commitment, brings to criticism?*

Haskell: Yes, in fact, I've always said that there is an uneasy alliance, even in my own mind. I've said in my book, and I've said since then, that I felt I was a film critic first and a feminist second. I still feel this, even though I'm not reviewing as regularly as I used to, because I've lectured at so many colleges where there's usually a cluster of scholarly film enthusiasts on one side, and the women's studies people on the other. These groups are rather suspicious of one another, because, on one hand, there is a danger when any movement become too narrowly ideological; on the other, film is suddenly expected to satisfy certain requirements which are *not* easily determined.

I remember being on a panel some years ago in a discussion about, "What happened to women in the movies?" Betty Friedan got up at one point with a proposal that we have a feminist rating system

for movies. Of course, the first objection to this is that, like the Catholic Legion of Decency rating, the forbidden film would be the one that everybody would rush off to see. But the other thing is, how do you determine what is the ideologically correct film, or a favorable portrait of a woman? Do you want woman to be shown progressively and triumphantly as the vanquisher of mighty odds, or do you want her to be shown truthfully as victim, as oppressed minority of the earth? So, first of all, there is this conflict within feminism as to how women *should* be shown. For me, there's absolutely nothing wrong with having a woman as a villain if she is done interestingly, such as the Louise Fletcher character in *One Flew Over the Cuckoo's Nest,* who, for me, is a much fuller character than the woman in the Ken Kesey novel. And there are characters I have mixed feelings about, such as the Faye Dunaway character in *Network,* because I think she was portrayed on a different level of reality than the male characters. There was William Holden being soulful, going through his trials of male menopause, and bearing this terrible weight of integrity. All the men were portrayed that way—realistically, even sentimentally— whereas Faye Dunaway was this very angular, extreme sort of caricature. In fact, the Dunaway character was supposed to be a parody of the male in that scene when she's making love and comes too soon.

This reminds me of Lina Wertmuller's comments about *Swept Away.* When I interviewed her, I said, "You know, we're a little sensitive about this whole idea of the rape fantasy, the woman who wants to be raped to find her true womanhood." And she said, "Well, you Americans don't understand that film. It's a parable, and the man is really the woman because he's the socially oppressed character, and the woman is really a man because she is the powerful person in that society." And I said, "Well, that's a wonderful syllogism on paper, but on film that's a real man and a real woman."

The feminist attitude, the feminist perspective, is something I can't deny; it's something that's part of me and that I feel very deeply. When I do see films, especially those with a *casual* sexist treatment of women, I'm disappointed that more women have not taken up the cudgel, because I do think it's something that women have to do. If women don't perceive these injustices, or fight for their independence, no one is going to do it for them. On the other hand, I do think it's an idea whose time has come, and it really has filtered down, whatever people might say, among all critics—general or special, male or female. Among Bosley Crowther and John Grierson

and others of that era, there was this sort of casual sexism; they were always ridiculing women's films and women's weepies, and I don't think critics can do that anymore. I mean, they might be anti-feminist, they might be defensive about it, but they're more conscious of feminism, they have absorbed its truths in some way or another. They can't be smug about it anymore.

There was a time—and I felt this during the late sixties and, really, during the seventies, when this tide was sort of in full flood—when there weren't any women in films, when you really could call attention to the injustices which seemed fairly simple to see at the time, and that what was needed was to get more women into the film industry, to get women in as directors, writers, and actresses. Well, now that there are more, we see, again, how complicated it really is. Is *Private Benjamin* good or bad? The question is asked, because it's a film that's gotten lots of women into the theater—it's real man-baiting, like *9 to 5*. I think they're two rather vulgar, seriously compromised movies that aren't all that funny after the initial premise.

I find myself taking a more specialized view of film than a lot of the feminists, and I find myself alienated from a lot of the rhetoric. I remember, once, going to a college where they introduced me by saying my book was about the systematic distortion and betrayal of women by Hollywood, and I said, "Well, I hate to tell you, but you've got the wrong woman. You'd better send me back to New York because that's not really what my book's about at all." There is this tendency for feminists to use Hollywood as a whipping boy for all our ills. The line they take is that we've all somehow been brainwashed by these gods and goddesses, and the idea of the perfect couple, and women having to marry in the end. There is a certain truth to all this, of course, their complaints are not entirely misplaced.

Cineaste: *It seems that feminism—as one of the more humanist approaches to politics—is a particularly fertile area for a more effective integration of art and sociology. The experience that you've talked about, however, sets these areas up as mutually exclusive.*

Haskell: Exactly. I also think the aestheticians have gotten increasingly anti-humanist. I'll go to colleges and universities where people see very few films, because film distribution is terrible, where people have never thought seriously about film history, they have no real knowledge of film; and, then, I'll come home and find some very esoteric articles by structuralists who never have to address this

audience at all, who never have to make themselves understood by this larger number of people who don't see that many films. What was exciting in the sixties was that the thematic and the aesthetic studies of film were coming together, there was a convergence, and it wasn't then considered academically disreputable to discuss films thematically, to discuss what they *meant*, and what was going on between men and women. Then, suddenly, during the last decade, there was this divergence that I regret very much, but I don't think this increasing specialization of film will stop.

I think that feminist film criticism can bridge these two areas. For instance, whether one is a Marxist or not, there is a point where feminism and Marxism come together. If one is more lifestyle-oriented, or whatever one's special angle on film, I think there is a point at which feminism can't help but converge with it. Film is a social medium, addressing itself to real men and real women.

Cineaste: *In the last chapter of your book, you described the decade from 1963 to 1973 as "the most disheartening in screen history." If you were to update your book today, how would you evaluate the most recent decade in terms of women's images on the screen?*

Haskell: Gradually, I think, little by little, women were coming back into the cinema. There was this anti-glamor mystique—women not wanting to be thought of as pin-ups and sex idols—that partly held women back, but they didn't have the economic leverage, either. In fact, we suddenly realized that, in certain ways, we really did miss the studio system, that it really had provided a lot of structure and apparatus, not only for women, but just for making films, for making enough films so that people could become apprentices, could learn to direct and do all these things, instead of having to come out first time at bat and risk falling on their faces. That protection provided by the studio system was gone, but, gradually, women, such as Joan Silver, Claudia Weill, and a lot of other independent filmmakers, began coming in either through the crevices or through the front door.

During the mid-seventies, however, it still had not become commonly accepted fact that women had disappeared from the screen. Everyone just assumed that because the women's movement was very much in the media, and they heard all about feminism—all this noise about bra-burning, and marches, and so on—that, certainly, there were women in films. It seemed to me that every year, during the Academy Awards, they would have to upgrade supporting

actresses into the leading actress category, just to get enough women to fill the five nominee positions. Finally, in 1977, along came *The Turning Point, Julia, The Goodbye Girl,* and a few others, and everybody was saying, "Ah, its 'The Year of the Woman.' " But it had taken that long for people to acknowledge that women had disappeared from the screen, that there were nothing but these buddy-buddy and male blockbuster action pictures.

For a few years, it looked as if there was going to be a groundswell of films addressed to women's issues—*Alice Doesn't Live Here Anymore* was one, then *A Woman Under the Influence, Diary of a Mad Housewife.* Actually, these were isolated examples, all done by New York-type directors, or young, hip directors, but, certainly, there was no feeling on the part of the film industry that this was something it *should* do. Also, this was about the time they did that demographic study to find out who *was* going to movies. In the old days, it was always thought that, whatever movie the family decided to see, it was the wife who'd made the decision, that the husband sort of went along with her. Then they did this demographic study and found that the profile of the average moviegoer was that he was male, single, and between the ages of fourteen and twenty-five. I think the operative age was fourteen, so they got the wheels cranking and made more and more science fiction films and disaster films. The idea was to get people into the movie theater by giving them something they couldn't get on television—violence, bloodshed, disaster. Not so much sex, really; they were still skittish about sex. Despite the fact that there was more sexuality, there was not very interesting sexuality in American films. Audiences were really more at home with violence than sex. Actually, it's violence that has sex appeal for most Americans, I think, or a kind of violent sexiness, sex done violently, particularly as it is in all these new horror films.

Cineaste: *You've talked about how the fifties was the decade of sexual repression, and the sixties was the decade of sexual licentiousness. What would you characterize the seventies as having been?*

Haskell: Well, there are different segments to the sixties. The sixties really extended into the seventies. Although it began in the late sixties, feminism was really a movement of the seventies. I think there was a time when there was a more interesting approach to sexuality on the screen, when the Production Code had lost its power and movies were more open, but not wide open yet. There were, I think, more interesting, more sensual stars then. But, once all

of the prohibitions were gone, the whole structure of the romantic fable was gone; whereas, in the old days, because of the Production Code and all the things you *couldn't* do, you had to keep a man and a woman apart for ninety minutes, and this created the need for song and dance or story. Story really is repressed sexuality; in essence, I think, that's what narrative is, certainly male-female narrative, and all narrative, in a sense.

There was this notion in movies of the seventies of Hollywood's having led us up the garden path. The recurring image, in fact, in films during the seventies was people looking at old Hollywood movies. For instance, the kids in *Summer of '42* watched Paul Henreid light Bette Davis's cigarette. Or Harry Guardino, in *Lovers and Other Strangers,* is in a motel room watching *Spellbound* for the seventh time while his wife is trying to get him to make love to her. Or Woody Allen and his Bogart fixation in *Play It Again, Sam.* So, as regards the notion that Hollywood had promised us somebody that looked like Gregory Peck or Ingrid Bergman, there was a superficial truth to the contrast provided by these seventies films. Here were these old Hollywood films in shimmering black-and-white photography, with studio sets and close-ups of these extraordinarily glamorous gods and goddesses, and then you saw Harry Guardino and his potbelly, or Woody Allen looking like a nebbish, giving everybody a kind of morning-after feeling of betrayal and disillusionment.

But I think that audiences were always aware of the fable-like quality to the Pecks and Lombards, Hepburns and Tracys, and, also, to the conventions themselves. First of all, the young lovers were really in their teens or early twenties, and when they got older than that, they played adults. Also, although the film might end with a fade-out on the kiss and everyone living happily ever after, there was room for the role of disenchantment that the transition to adulthood brought. There was always the henpecked husband and the nagging wife, or mom and dad, who weren't on some journey of self-fulfillment; they had accepted their roles as adults, or they expressed the cynical view. Consequently, you had the romantic lovers and the cynical adults.

Suddenly, in the seventies, you had people in their thirties who were playing both the lovers and the cynics. Suddenly, there were people who hadn't stopped looking for fulfillment, of reflecting the quest for self-discovery that preoccupies us. The fact that the institution of marriage doesn't last, that we don't expect it to, or that there's

no credit for growing old or for growing old together, leads to the panic that sets in, such as the portrayal of male menopause in so many films. Seventies' films also began to question traditional sex roles. I mean, there was always an ideal of male and female, that the man was as strong as an oak tree, and that the woman was a nurturing, nesting, sacrificial creature. In this symbolical idea of the couple, the man was always taller than the woman, so all through the thirties and forties Ingrid Bergman had to walk in trenches and Alan Ladd had to be put on a little box because he was shorter than all the women in Hollywood. We had the whole notion of the woman looking up to the man, literally and figuratively. Then, suddenly, along comes *Annie Hall,* where Woody Allen's sort of half Diane Keaton's size, or a film like *Agatha,* where Vanessa Redgrave is dancing around the ballroom with Dustin Hoffman and practically resting her chin on his head. This was really a radical reversal of all the rules of the mythology of the couple. That mythology also stipulated that there was this absolute attraction of opposites in every male-female couple. So, what was fascinating in *Norma Rae* was that Sally Field had this intense relationship with Ron Liebman, a labor organizer, and her husband, Beau Bridges, at one point asks her what's going on. She stops to think about it, because she hasn't analyzed it yet, and says something to the effect that, "He's gotten into my head." It was so refreshing to me, particularly at that time, when everyone was hopping into the sack automatically; I mean, when was the last time you saw a movie in which a man got into a woman's head, instead of into her bed? But the star chemistry is still so strong, and we're so conditioned to wait for that moment when they come together, that we look for it and hope for it, and there's some twinge of romantic regret in us that they don't make it. Similarly, I think people felt this way—I didn't so much—about *An Unmarried Woman* and *My Brilliant Career,* both films in which you have strong women with very desirable men who offer them the romantic moon, and both women reject the offer, reject the appurtenances of a conventional life for work.

Actually, in the case of *An Unmarried Woman,* there's a slightly different situation, because she doesn't really have a career, but, as I understand it, that's precisely the point. The criticism people had of that film was, "How can you feel sorry for this woman? She lives on the Upper East Side, goes jogging every morning, she's not entitled to our pity." And, yet, it's this kind of woman who's not intellectual, who's had the good life, who's been cushioned, who's really not

prepared for isolation, or for doing *anything*. She hasn't got any kind of career, or any kind of training. I think this is the kind of feeling you get from the film, and from Mazursky's direction, too. It's really very much her *fragility*,the fragility of her ego, and the realization that she is going to spend time alone—if not now, because she's with the Alan Bates character, then after that affair, which is probably doomed not to be forever or happily ever after. It's precisely this kind of woman who needs somebody to fall back on, who has to be able to learn to live with herself, financially and emotionally. For me, there was something very exciting about that. Also, I think people fail to see that there's something very cagy, or very smooth, about the Alan Bates character. I mean, he's not somebody who's going to support her in her journey toward self-realization. At one point, she's trying to explain to him why she has to really give herself to this job, and he says, "Of course, I approve of you working." He uses the word *approve*, and I think the condescension implied in that word is something Mazursky is very aware of. He sees into the future of this relationship and knows that it isn't really what she needs at this point.

Cineaste: *Do you think that the older woman of the seventies, such as Fonda and Clayburgh, is being frozen into a certain role?*

Haskell: You know, when the studio system started to disintegrate, it became clear that one of the gripes everyone had always had against it was that women and men were typecast, were more or less assigned a category and then were never really able to break out of it. The stories are legion of stars trying to go against the type to which they'd been assigned. According to Ingrid Bergman, she was typecast as a wholesome Swedish milkmaid, when she wanted to play temptresses. Jean Harlow started out by playing society girls, and then she naturally developed into a wench type, a slightly sleazier dame. Katharine Hepburn obviously could only play ladies of leisure; she was educated, she had to play a certain kind of woman. Rosalind Russell, Bette Davis, all of them created or conformed to certain types.

When Jane Fonda and Ellen Burstyn and others came along, they wanted to stretch themselves and not be categorized. But the mistake that actors and actresses often make, the illusion they have, is that they can do anything. Being completely in power, as Fonda is now, raises the question whether she's necessarily the best judge. For instance, from the advance word on *9 to 5*, it sounded like it was going to be a tough-minded satire on the office and sexual relations in the office. Somewhere along the way, whether it was the decision

of the director or the women themselves, they went for a broader and more vulgar kind of comedy in order to get the audience. This kind of self-censorship is, in a way, worse than the Production Code or the old studio system. We have enough sit-coms on television, so there's no reason the movies have to do them, but that's the mentality. I think it's discouraging that, now that many stars have the power to do more interesting or more audacious films, they suddenly pull in their horns and go for the broadest possible audience.

Jill Clayburgh is now very much in the position that Katharine Hepburn was in. She's doing the kind of roles that Hepburn was doing, playing the educated, upper-middle class woman who really does have a choice in life, who really does have a career, and people are reacting to her in the same way they reacted against Hepburn. We all love Hepburn now, but we forget that, during one period, she was labeled box office poison. Hepburn was never that hugely popular a star. She was always considered a little too upper class, too elitist, and Jill Clayburgh has that same elitist flavor. I think there's a sense that, with these films, we're seeing something being done over and over and over again; but I think there's something very delicate about what Clayburgh does, very difficult, similar though her films are.

Cineaste: *Why do you think there are still so few women directors in the American cinema? You've talked about directing being essentially a male-oriented activity, and perhaps that's the reason why, over the entire history of the cinema, there have been forty or fifty women directors here in the States, of which there are perhaps ten that the average movie-goer might have heard of.*

Haskell: Certainly, there are proportionately far fewer women directors, and they're not known at all. There should be a higher proportion here than anywhere else, given the age of liberation that's upon us, and the fact that America is the most progressive country in so many different ways. But I think it's hard for anybody to break into film in this country. In France, for example, the filmmaking elite is not split, as it is here, between New York and the West Coast. The elite in France is in Paris. It is a network of educated men and women that's really much more heterogenous, *sexually* heterogeneous, so women are in that elite as well as men. In the U.S., there's a much more open system as far as class goes, and, yet, it's much more closed sexually. Partly, it's the distrust of women on the part of men; partly, and particularly in Hollywood, I think, there's a real macho strain in filmmaking. The capitalist system's boardrooms are still

dominated completely by men; the whole idea of men getting together and making deals is a ritual that excludes women. Also, the kinds of films being made now—violent films or these huge *Star Wars/Close Encounters* type of extravaganzas—are not the kinds of films women are thought to be particularly adept at.

I wonder what the ratio of women is in film schools today, because a lot of the people making films now are the film buff/film student types like Paul Schrader, Brian De Palma, and Martin Scorsese. Unfortunately, these young directors are not really making films about women, either. The trouble is, nobody's telling them that they have to learn about men and women. In the old days the first thing you did was groove into the system of men and women and the stories that were being told about them, but, now, of course, it's all cinematography, visual mastery.

Cineaste: *Do you think that the history of the cinema would have been any different if, indeed, there had been an equal number of women making films? After all, men and women—fortunately or unfortunately—seem to share certain cultural attitudes.*

Haskell: I think misogyny is a trait that is found as much among women as among men, because women have identified with men. First of all, we're taught to live through and for other people, i.e., our husbands and our children. And, since men are the power brokers in our society, women obviously identify with them to the exclusion of other women. So, in many ways, men can afford to be more generous to women than women to each other. I think the most profound problem of all is women's failure to identify with other women.

Cineaste: *This raises the whole question of whether there is a feminist aesthetic. There's an unspoken assumption that there would have been a different world of cinema had women been in there all along making movies.*

Haskell: No, never. It really depends upon the individual. I wonder, for instance, if there will ever be a woman director who has the range of feelings for women that Mizoguchi felt. I'm just stunned every time I see one of his films—he was one of those people uniquely able to both love and like women, to portray them romantically as desirable creatures, and, also, as beings with souls and minds and moral dimensions. Among women directors in the past, Ida Lupino was actually a very tough and fantastic woman, and more of a feminist in her Raoul Walsh films than she was as a director. She was constantly going on about how women—you know, using the Noel Coward line—should be struck regularly with a

gun. I think she was being a little disingenuous some of the time. She probably wanted—as women will do, and for good reason—to make sure that everybody realized she was just a women, that she didn't want to be threatening. A lot of women's energy is spent reassuring everyone that they're not going to threaten them. They know, as the old women's wiles trick, that shoring up the male ego is the best way to get their own power; it's a devious way of getting power, to be sure, but it was really probably the only one.

Dorothy Arzner was interesting. Although she does not call herself a feminist, a valid case has been made that there is an implicit feminist sympathy in her films. She was not male-oriented, either romantically, as Ida Lupino was, or sympathetically, as Lina Wertmuller or Leni Riefenstahl, both of whom identified with men. Well, for Leni Riefenstahl it probably worked both ways, but Lina Wertmuller, as a professional, as a working woman who's had to tough it out in the male world of the film industry, identifies with men. I think she's really a woman who just, basically, doesn't like women. You feel this in all her films, especially the female grotesqueness she creates. Leni Riefenstahl got into the ultimate "old boy network" of all time, she really was the woman in the Nazi cabal. So, from the lesson that these women provide, there isn't much reason to expect that women directors would necessarily be kinder to other women. It really is very much a matter of individual temperament, and I think the whole notion of a woman's aesthetic is problematic.

Also, some of the most powerful women in the film industry are the ones who give this great sob story about how they missed the true woman's vocation. In her autobiography, *The Lonely Life,* Bette Davis went on and on about how her life had really been a waste because she'd been doing all these movies, instead of having a proper family. I think she's come to realize since then that she was probably better off being one of the great actresses of the world than hiding all that talent under a domestic bushel. But this was the myth, the mystique, and I think, to this day, women continue to feel guilty on every count. Working women and housewives see themselves in this conflicting way—each feels guilty, each feels that she's somehow being judged by the other and found wanting. Each is trying to live up to some impossible ideal of doing it all; whatever we do, we feel guilty that we haven't done the socially appropriate thing, or the domestically appropriate thing, that we really aren't giving our all. This is a myth that both men and women have subscribed to all

through the years, that domesticity is the woman's side of the bargain, and she had to keep it.

Cineaste: *One could possibly interpret a number of recent films as male backlash films. On the one extreme, there are the more sophisticated variants like* Kramer vs. Kramer *and* Ordinary People, *and, on the other end of the scale, are the exploitation films such as* Prom Night, Don't Go in the House, *and* Dressed to Kill. *What do you make of these types of films?*

Haskell: I think there is always a kind of reaction, a kind of backlash, which takes different forms. My response to *Kramer vs. Kramer* was that we're finally getting to see films that address women's issues—for instance, how do you manage the three-ring circus of holding down a job, bringing up a child and keeping house? But who gets to play the role? The men. In *Kramer vs. Kramer*, it's Dustin Hoffman. Or Burt Reynolds, picking up the pieces after a divorce in *Starting Over*. Concerning the phenomenon of menopause—even though it's figurative when you're talking about male menopause—Dudley Moore in *10* is the one who has the anxieties about getting older. So, what seems interesting to me is that when, finally, we get the subjects that women want to see, or that women are felt to be interested in or involved in, it's men who appropriate them and give them legitimacy. In other words, it's not what's actually being done in male-female roles, but the fact that a man does something that makes it important. So, if men are nurturing, as in *Ordinary People,* suddenly it's important. All these years, the institution of motherhood has been revered, but women themselves have always been criticized for either being too self-sacrificial, as in *Stella Dallas* or *Mildred Pierce*, or negligent, as in *Woman of the Year.*

In *Ordinary People,* I am fascinated by the Mary Tyler Moore character—we've all known it's true that mothers don't necessarily love their children equally, although it's a fairly exciting thing for movies to show—but she's given no sympathy at all, she's shown as completely villainous. For instance, when the Donald Sutherland character blabs their whole life story to a woman at a cocktail party, Moore is upset about this afterwards in the car. But the bias of the film is with Donald Sutherland, and she's the one who's a harpy for being angry at him. The male counterpart of the Moore character is Robert Duvall in *The Great Santini*. He's an authoritarian, unemotional, unnurturing character, and, yet, you have this sort of sneaking sympathy and admiration for him, and when he dies you

feel his loss. When Mary Tyler Moore walks out the door, it's just good riddance; there's not an ounce of sympathy for that character.

Of course, this is nothing new. In male weepies—I think it was Raymond Durgnat who coined the term—somebody like Spencer Tracy was always being emotional and nurturing. In *Woman of the Year*, for example, Tracy is not only a terrific man—good at his job and doing what a man does, going to baseball games and being entirely masculine—he's also the most nurturing of the two, he's the one who can take care of the child. When men did these things, they automatically had the best of both worlds, because they were heroic and manly and forthright, and, yet, they could also do the woman's shtick and be revered for that as well.

I think there is a real basis for the spate of backlash films today, and this is the whole idea of women suddenly coming into their own sexually, having sex lives, needing to be satisfied. According to all the reports, this has created widespread impotence on the part of men. There is a tremendous pressure on men now, the sexual pressure of having to perform, and women no longer faking it, pretending to be happy, and letting it go at that. A man's identity is much more wrapped up in sex, and more linked to his sexual performance, than a woman's. This is something that women have failed to appreciate because they're not crippled in any way by not having orgasms; it really doesn't affect them psychically that much, whereas it does a man. And, so, this sexual tension builds.

One form the backlash has taken, in terms of films, is the current vogue of nymphetomania, the use of children—Brooke Shields, Kristy McNichol, Tatum O'Neal, Jodie Foster—all these girls who are so sexually precocious, and yet who are, obviously, just little girls. They don't have real egos yet, they're not developed, they haven't gotten to the point where they can make demands, so there is a sense that they're still daddy's little girl. It's the *Lolita* fantasy—they look redolent of sexuality, they're presented that way in the films, and yet you know they're still virgins, and, in that sense, they make no demands. These are little girls who really aren't going to ask for anything, who aren't going to ask a man to perform, leaving him free to fantasize while she is still theoretically under his control. It's a perfect look-but-don't-touch sexual fantasy.

Another changing factor in all this—it's something you see reflected in the phenomenon of wife-beating—is that, previously, the one person the man has always been able to feel superior to was his

wife. His boss might step all over him at the office, and he might feel threatened out on the street, but he could always shore up his ego because of this woman who was dependent on him. So, if this woman is suddenly challenging his superiority, if she's actually working—not necessarily making more than he is, but at least no longer in a position of enslavement—then I think he does feel very threatened, because his ego, his self-esteem, has always been based on the prop of the woman's dependency. I think all this does have something to do with the reassertion that these sort of exaggerated virility epics deal in.

Apparently, women go to see a lot of the backlash violent films, so the message can't be pure hostility and pure aggression. If it were, I don't think women would go to see them. It's just like the whole notion of rape. I mean, a woman's idea of a rape fantasy is that Robert Redford won't take no for an answer. There's no such thing as fantasizing being held down by an unknown assailant in a dark alley. That's not a pleasurable fantasy at all. These films capture the sense of suddenly being thrust into a world in which we are now allowed to demand whatever we want sexually and are, in fact, expected to journey into the far reaches of sexual experimentation, and, because we're really very uncomfortable with that, these films offer a retreat.

Besides, a lot of these films are very marginal, and I think there's a tendency to get overly excited about them. One reason I've never been able to get excited about the Women Against Pornography movement—aside from the First Amendment question—is that I think they're really picking on something very marginal, something most women, even most people, don't go to see.

Cineaste: *There have been a number of documentary and narrative films on rape in recent years. Do you think that any of them have had any kind of impact in sensitizing or educating a general audience?*

Haskell: I think rape is an issue that men and women will never, ever have a mutual understanding about. The reason rape is so devastating for a woman to even think about is that it's an invasion of her very self, a self that's very fragile under the best of conditions. This is something that cannot be shown, that can only be communicated, and even then I'm not sure it can be understood, because of the connection between a woman's sexuality and her sense of self. The act of rape—the penetration, the violation of her body, something over which she has no control—is a reminder of her

eternal powerlessness, her eternally being open to invasion. It's much more psychically devastating sexually, because, in this sense, the sex and the psyche are intertwined. And this is something that cannot be shown in film.

In fact, the minute you show anything resembling rape on the screen, it's immediately eroticized. In this regard, I found *The Primal Fear* superior to *Rape of Love* because it was somehow less ideological. In a strange way, *Rape of Love* went by the book in presenting its case. It was never very convincing, though, partly because the girl was so attractive, and the rape itself—although the director tried to distance it—had the taint of eroticism because the girl was so voluptuous, whereas the woman in *The Primal Fear* was not, and the rape was shot in the least sexual way of any that I've seen on the subject. The Martha Coolidge documentary, *Not a Pretty Picture,* was interesting because it showed that borderline case of social rape—it was a date rape, as opposed to an unknown person in a dark alley, and that's a whole different thing. Rape is usually a criminal or quasi-criminal act, and the idea that some feminists are propagating—that all men are rapists—has to be done away with, because it really confuses the issue and is, in a way, counter-productive. Most male rape fantasies are just like female fantasies, in that most men know that they would never rape. What they're fantasizing is no closer to actual rape than the force fantasies that some women have.

Cineaste: *Turning to images of men, when you reviewed* Loulou *and* The Handyman, *you said that the myth of the proletarian hero was gone out of our lives forever, and that a new kind of man had come to the screen—a man who did not work and, in the case of* Loulou, *who had no intention of ever working, but who was simply desirable because of his availability. Is there really a new kind of woman who wants a man only because he is available?*

Haskell: Well, no one else liked *Loulou,* which I have never understood, because I loved it. The Lawrentian idea that there is this stud type who turns on women—particularly the upper class woman, the sort of frigid bitch who is sexually released by him—has always seemed to me a male fantasy, and largely a homoerotic fantasy. But *Loulou,* and particularly the character in *The Handyman,* are much closer to the type of men who would appeal to a woman, not just in fantasy, but in reality. He's a man who would give a woman his time, who—and this is the fantasy part—wouldn't be anxious about the fact that he's not succeeding in the world, that he's not economically

superior to her. Men have so internalized *male* criteria for success, that the image a man wants to have of himself is constituted by what other men would admire or respect. The trouble with this is where to fit the hero who's a laid-back, undriven, almost feminine kind of man who's able to relax and not feel propelled into the rat race, somebody who really has time to be with a woman. So the Handyman is a sort of misfit, a strange bird from out of nowhere, and there's something sad about Loulou, about his living off women. Until our society is truly unsexist, which it probably will never be, there won't ever be a man who can do that without having the taint of failure attached to him.

Cineaste: *Who do you think makes the most incisive films about contemporary America?*

Haskell: I would say Mazursky, because I think he listens more than other directors. There is a sort of wild mixture in Mazursky— of the sociologically authentic and fantasy, of satire, tragedy and comedy, and sometimes it comes off, and sometimes it doesn't. I mean, he doesn't always get it right, because he's trying to mix too many strains; sometimes he's got too many ideas and not enough control, but he's listening.

The problem is that we don't have an intellectual tradition in this country. It's still sissy to be an intellectual, to be sensitive, to listen. The American male is encouraged not to listen, but to perform, to be a man of action. Altman reflects this, in a sense; as brilliant as he is, there's also this sort of bravado, this sense of self-display, about his work. He's creating his own world that's not the real world, but rather a conscious repudiation of the world out there, or a re-creation without the confines, the restraints, the niceties. *The Wedding,* for example, really lacks incisiveness. There's a great film to be made about upper middle class weddings, but the whole point is that everyone is so hypocritical, trying to preserve the proprieties, while underneath everything is probably falling apart—but it's not chaotic, the whole thing is to maintain the social veneer.

I hadn't thought of Milos Forman as an American director, but that's what he's becoming. And he, too—he's European, an intellectual, and very sharp—he listens. I remember, he told a story at a dinner party about going to the Olympics to make a film, and he described it in a way that I'd never heard of before: that the first day there's this fantastic feeling of international euphoria, with everybody loving everybody else; then, the second day, some people have lost and gone home, and there's a little less feeling of euphoria; each day

the mood descends, degree by degree, until, at the end, nobody likes anybody, and there's no longer any sense of meeting across national barriers. He explained it in such a vivid way that it was one of the sharpest and funniest descriptions of anything I've ever heard.

Woody Allen, to some extent, is very incisive. There are some great moments in *Manhattan* and *Annie Hall,* which are, by far, his greatest movies. In *Manhattan,* for instance, we get a critical look at the relationship between the older man and the younger woman, and the realization that there is something ridiculous about it, that they can't relate to each other, they really can't have any kind of intellectual rapport. One of my favorite scenes is the one with Mariel Hemingway where she's in bed with Woody Allen, and they're eating potato chips and watching television, and she, in all the cruel immortality of her adolescent youth, says, "I'll *never* get a facelift." It's not a slur on older women, it's really a brutal awareness of the age barrier and of the people on either side of it. There's something very incisive in that scene, something that you don't ordinarily expect from Allen, because he is usually so self-involved.

The level of achievement in those two films is largely due to the magic of that cast and his relationship with Diane Keaton that gave him a sense of otherness that he doesn't have in his other films. In *Interiors,* Allen tried to conceive of serious, intelligent women, but I'm not sure he was able to because he's got an emotional bias that runs counter to that. He *loves* women—he doesn't really like them as much as he loves them—he pursues them, he's a womanizer, but actually identifying with them is something that may be a little beyond him. But, in any case, he's trying.

33—BUDD SCHULBERG

The screen playwright as author

 Budd Schulberg has always had an uneasy relationship with Hollywood. Son of one of the first movie moguls and raised in Hollywood during the peak of the silent era, he has seen tinsel town and its celebrities with and without their public facades. In What Makes Sammy Run? The Four Seasons of Success, *and* The Disenchanted, *he has written about some of the uglier aspects of the industry. Nevertheless, Schulberg believes good films can be made within the system. He scripted the classic* On the Waterfront *and the highly regarded* A Face in the Crowd. *His novel,* The Harder They Fall, *was the basis for one of the best fight films of the nineteen-fifties. Woven into all of Schulberg's work is a concern for social change. In the nineteen-thirties, he was a member of the Communist Party, but, after a dispute involving his first novel, he became a vocal critic of Soviet-style socialism. When HUAC investigated the film industry, Schulberg chose to testify, an act which he feels has been misrepresented and misunderstood. The interview which follows was made by Dan Georgakas upon the publication of* Moving Pictures: Memories of a Hollywood Prince *(1981). Many themes which have concerned Schulberg, both in his book and through his career, are reiterated in the candid and forceful style for which Schulberg is known.*

Cineaste: *In your new book,* Moving Pictures, *as in most of your previous writing on Hollywood, the emphasis is on producers and writers. You treat directors with less respect than most critics would, and performers are all but dismissed.*

Budd Schulberg: Directors and actors are obviously important. You can't make motion pictures without them, although sometimes you wish you could. In *Moving Pictures,* I don't consciously downgrade directors and actors. It's more that since my father had been a producer and writer, and since writing had really preoccupied our household ever since I can remember, the problems of writers interested me more than those of directors and actors. I also felt that my father's role in film history had been neglected, and I wanted to make up for that neglect. Besides, I do have material on directors. There's the strange case of Marcel de Sano, for instance, who made that one brilliant film in the early twenties and was never able to get another one together. I also have considerable material on Clara Bow, the "It Girl," who was the symbol of sex and flaming youth of the twenties, a chapter on George Bancroft, the now forgotten No. 1 star of the late twenties, and others.

Cineaste: *You also say that it really is true that von Stroheim ordered silk underwear for the men who were to play eighteenth century Tsarist troops in order to make them feel truly aristocratic.*

Schulberg: Yes, his extravagances were real. He is still controversial, of course. Some feel that it was crass front office producers who did him in. I think the von Stroheim experience was a tragedy. *Greed* was really years ahead of its time. Today the length and concept don't seem as mad as they did in 1928-'30.

Cineaste: *Nonetheless, you wrote that the producers weren't totally out of line in curbing him.*

Schulberg: That's right. From their viewpoint, making pictures was a business. They had considerable money to invest in any film, but there was a limit. If a man just went on shooting and shooting, as von Stroheim did, a Thalberg at Metro or a Schulberg at Paramount would be forced to call him in and say, "All right, enough."

Cineaste: *These responses lead me to ask exactly what genre you would put your new book in. It's partly an autobiography, partly a family history, and partly a history of Hollywood. One concern that stands out is your wish to remember important film figures you think have been neglected. The book ends as you get ready for college, suggesting it's the first in a series of books.*

Schulberg: In answer to the last part of your question, I do hope

to go on, since my own age is eighteen at the end, and the movies at that moment are about thirty years old. As I outlined the book, I thought of it as a braid. In other words, I didn't just want to write another memoir. I feel there's been too many of those. That form has been worked to death. What I wanted to write was a personal history of the movies from the Edwin S. Porter days, around 1903, as seen through the eyes of my family, particularly from my father's unique position. My personal life story would be woven throughout. Janet Maslin, *The New York Times* reviewer of my book, criticizes me for taking my role all too seriously. She says that I consider myself the keeper of the flame. She thinks it's pretentious that I find it difficult to divide Hollywood from myself. But it's a simple truth that, for me, they are entwined. My earliest memories are of things like going to the Adolf Zukor farm, or being on a set with Mary Pickford. For better or worse, the movies and I did grow up together.

Cineaste: *One of the things which struck me was that even though you and your buddy, Maurice Rapf, grew up surrounded by glamor, your responses were much like the boys who only saw film stars at the local Bijou. It seems incredible that your lives weren't more unusual or exciting.*

Schulberg: *New York* magazine has compared it to Huck Finn and Tom Sawyer. There's no doubt that in our growing up there was a universal element of childhood and adolescent friendship. It seems odd to outsiders, but not to us, that we had a very normal life—afraid of girls and all those things, except that the "girls" were starlets instead of, say, cheerleaders. And we had all those fantastic places to play— the castles, the ships, and even the streets of the Casbah. We watched them shooting *Ben Hur* and then played on the sets afterward.

I'm really glad I wrote this book, because I think if I didn't record some of the things which I include, they would be lost. If that is pretentious, then I guess I'm guilty. I don't want to go on and on about the *Times* review, which I must say was quite lengthy and generous, but I found it rather odd that she didn't relate the book to my other work. There are some obvious connections to *What Makes Sammy Run?, The Disenchanted,* and my screenplays. For example, it's no accident that in *On the Waterfront* I have the Marlon Brando character keep a pigeon loft on the roof. As I recount in *Moving Pictures,* I had my own loft with pigeons when I was a boy. During my research on the Hoboken waterfront, I saw that many

longshoremen also raised pigeons, and that gave me a sense of connection with them.

Cineaste: *It seems that you are not considered a serious writer by most literary critics. Why do you think this is the case?*

Schulberg: I'm somewhat surprised by that myself. Some people have written a hot first book and then fallen by the wayside, but I've stayed in there for forty years and been honorable to my trade. Some reviewers of the new book have said it was fortunate that, by accident, "one of our better writers" was placed in Hollywood at this critical time. But the neglect you speak of is real. I wrote a small book called *Four Seasons of Success* which studies six writers I knew—William Saroyan, John Steinbeck, Nathanael West, Sinclair Lewis, F. Scott Fitzgerald, and Thomas Heggen. Some of them were overpraised at the beginning and then punished. All were terribly neglected at one time or another. It's hard to believe that Fitzgerald's work was out of print. I suppose my career would be part of that larger picture.

Cineaste: *In the afterword to the published screenplay of* On the Waterfront, *you have some powerful things to say about the screen playwright. Can you conceive of any combination of financial or social circumstances in which a screen playwright could have as much power and respect as a stage playwright?*

Schulberg: I can conceive of it. Very easily. I've always advocated it. Getting the people who put up the money for the films to see it is something else again. I don't know why they don't think they can take a writer who is able to write a novel or a play effectively, and give him his head, and believe he can do just as well on a screenplay. I've talked to ever so many people about this. The only one who ever went every step of the way with me on this was Kazan, in the two films we did and a third one that never got to the screen. Kazan treated me and others—Inge, Tennessee Williams, Bob Anderson—with the same artistic respect he accorded to writers in the theater. There are some pretty good director-writer relationships, but, as far as I know, this may be the only instance where the director carried out the script and showed how the process I advocate could work.

Cineaste: *In serious theater, you don't have a play with a story by one person, dialogue by another, concept by a third, and so on.*

Schulberg: Also, no lines can be changed without the approval of the author. Why should films be any different?

Cineaste: *Do you think films would be improved with improved status for writers?*

Schulberg: I think they would be improved. I really do.

Cineaste: *Then you definitely downplay the* auteur *theory relating to directors?*

Schulberg: The only time I think it has real validity is when the director is also the writer of the screenplay. Any other time it's simply an excuse for stealing the credit of the writer. I think it's a smoke-screen. It's one of the most overworked theories of all the theories that have come down about film. I compare the great film with a horse race in which every one of the horses finishes at the wire in a dead heat. There's a great film only when the writer, the director, the performers, the cinematographer, and all the crew finish the race with their noses on the wire. Too often the victory is accorded to the director. I don't think we should deny credit to the director, but the director's contribution should not wipe out all other contributions.

I was at Dartmouth not long ago and I was surprised by what the film students didn't know. They knew John Ford, all right, but did anyone know Dudley Nichols? Not a hand went up. But without Nichols, an outstanding screenwriter, Ford would never have been able to make *The Informer*. Frank Capra, yes. Robert Riskind, his writer? No. So it went, on and on. *Citizen Kane?* Orson Welles's picture, of course. When I asked about Herman Mankiewicz, no hands. They thought Welles wrote it. The person who had a lot to do with the visual effects, which I don't think Orson knew very much about, was the cameraman, Gregg Toland. He was a genius. If he hadn't died so early, he would have been an outstanding director. The film editor on *Citizen Kane* was Robert Wise. I could go on and on. The contributions of every one of those people was essential to making that film what it is. Most people know only Orson Welles. I believed in my twenties, and I believe now, that the films will be better when the writer gets the credit and say he or she deserves.

Cineaste: *Staying with scripts, one of the things we've noticed in many recent films is the failure to maintain a coherent story line or even develop a theme. A lot of this is being blamed on the way directors work.*

Schulberg: I think many directors today search for their continuity, or even their basic theme, as they shoot. I had a discussion with Kazan about *Raging Bull*. I think it's a brilliant piece of work on many levels, and I think anybody interested in film should see it, at least twice if they can stand to. But they felt compelled to take those lines

from Brando in *On the Waterfront* —"I could have been a contender. I could have been somebody, instead of a bum, which is what I am." I felt they were "borrowing." I mean, using Terry Malloy's dramatic philosophy was their way of reaching for a theme.

Cineaste: *I found that part unconvincing. His brother did not betray him and, in fact, he had been somebody. So it didn't make any sense as a coda.*

Schulberg: But that film does work with the present generation. All my nephews and nieces adored the film. I don't mean to single out Scorsese. I really admire him. But I wish he and the others would pay more attention to theme. When I mentioned this to the Gadg,* he said, "These kids are not interested in themes. They don't give a damn about them." I don't think that concern with theme can be thought of as a passing fancy of the forties and fifties. Sophocles was interested in theme. Shakespeare was interested in theme. Tolstoy was interested in theme. Almost every great writer throughout history has known that themes were the beginning, the reason they were writing.

Cineaste: *The ghostwritten book that* Raging Bull *is based on delivers many of the psychological and social explanations that Scorsese chose to leave out.*

Schulberg: All I can say is that I do believe in structure in film, and I don't see it in current films as much as I'd like to. I might be considered old-fashioned in this respect, but I think structure is essential to art.

Cineaste: *How was it that you didn't do the script for* The Harder They Fall?

Schulberg: I had a fight with Harry Cohn about that, not the first or last. I had done the book on my farm in Bucks County, and I had also done the screen adaption there. He insisted that if I did the screenplay, I must do it at the studio. That was anathema to me. I really had left Hollywood because I couldn't stand that routine. It just did not fit my method of work. I said I would do the screenplay at the farm and then come out for conferences. That's how I am now working on the script for the remake of *A Face in the Crowd.* But Cohn wouldn't agree.

One thing I couldn't stand about that system was that there was a secretarial pool that typed up the pages, about four or five a day, as you wrote. They would send those pages right up to the front office.

*Elia Kazan is frequently referred to by friends as "Gadg" because of his love of gadgets.

The writer could not look at the work and turn it in when it was ready. The front office was more or less looking over your shoulder every step of the way. That's counterproductive to any real creativity. I refused to work under that system, so I didn't get to do the script.

Cineaste: *Were you satisfied with what you saw on the screen?*

Schulberg: I thought they did a good job with the exception of two scenes that run false. The first has to do with the motivation for the Max Baer character. In my book, the giant fighter—the progatonist and the victim—has been sleeping with the promoter's wife. When the promoter finds out, he really wants the fighter punished. In the film, the giant has killed a fighter in the ring, a fighter who was already on his way out. They have Max Baer say he wants to punish this giant because Max Baer should get the credit for the killing since he'd really been the one to soften up the fighter. That scene is completely untrue. I've known fighters all my life, and that includes fighters who have killed men in the ring. When I married Geraldine Brooks, two of our "best men" were prize fighters. The meanest fighters I've known—even Jake La Motta—would never say, "I reserve the credit for killing someone." That's just something they would never say or think. That really bothered me in the film.

The second thing was something that I spoke to my attorneys about at the time. At the end of the picture, Bogart puts paper in his typewriter and types the title *The Harder They Fall* on the book he is starting. He then writes, "Boxing should be abolished now." Since the title was the title of my book, I didn't want to be identified with that statement. I never wrote or believed in that. The character I created and the character Bogie played would not have written that line. I don't believe in abolishing boxing. I'm in favor of reforms. I've written about that a lot. Boxers have no protection once their career is over. I've proposed that they take one per cent of every gate to build up a pension fund. With these closed circuit fights bringing in the tens of millions, a pension system could be built up easily and quickly.

Cineaste: *Getting back to Moving Pictures I was struck by how sensitive you became about being Jewish once you left Hollywood. Jewish and Hollywood were synonymous, and both were bad.*

Schulberg: Friends of mine have also been surprised by how Jewish the book is, because they don't associate me with Jewish causes, with Zionism, or even with a very deep interest in the religion of Judaism. In writing the book I relived the shock and surprise and

pain at coming out of the sort of cocoon in which we were all so Jewish that we didn't think of ourselves as being Jewish. Our grandfathers were Jewish. They had beards and went to synagogues. Harry Cohn and Jack Warner didn't seem Jewish in that old country way.

It wasn't until I went to Deerfield that I was made to feel different. Perhaps I was hypersensitive, but I don't think so. The headmaster did indeed equate Hollywood with being Jewish, and to be anti-Hollywood was, in a sense, to be anti-Semitic. Having been expelled from B'nai B'rith by Rabbi Magnin, I used to say, at age fourteen or fifteen, without trying to "pass" or anything, that I wasn't Jewish. When challenged, I'd say, "Well, they kicked me out." I thought it was like the Elks. I began to feel an ostracism at Deerfield by the headmaster and some of the upper class student body. They made it clear to me how different I was. A more profound emotion came with the growth of Hitlerism. When he came down on fellow Jews in Germany as hard as he did, and as cruelly as he did, we were all Jewish again. It wasn't like the Elks.

Cineaste: *How do you account for the success of the Jews in Hollywood? They had native-born competition and other immigrant rivals, but they prevailed.*

Schulberg: It was a happy cultural accident that was not entirely accidental. These Jewish immigrants came from backgrounds where there was respect through the rabbinical tradition for art. Not that the Zukors and Laemmles were entirely aware of it, but I think they did have these seeds of culture. They came along, young and ambitious, at a time when the motion picture was just beginning and was looked down on by established groups. I think even Edison was a tiny bit ashamed of it. It wasn't one of his favorite inventions, like the phonograph. Motion pictures were a kind of honky-tonk, lowdown type of enterprise which the Jews were allowed to manage. Jews filled a vacuum that had been left by other people who might otherwise have been involved because of either the artistic or financial potential of the movies. Once Jews got a head start in the industry, they were able to pretty much monopolize it.

Cineaste: *You write that the headmaster of Deerfield stopped the showing of the Marx Brothers'* Monkey Business *because he thought it was coarse.*

Schulberg: I still have a diary that I go back to once in a while where I find a string of four letter words written after that man's name. After thirty minutes of the film, he thought it was in such bad

taste that he had it turned off. I had gone to some trouble to have my father send it to us. The film hadn't even been released yet. It's hard to imagine now how straight-laced that era was.

Cineaste: *The headmaster objected to the Jewish vaudeville elements.*

Schulberg: Yes, it smacked exactly of that—vaudeville and even burlesque. It was not fit entertainment for Deerfield gentlemen.

Cineaste: *You mention in* Moving Pictures *that you also once tried to do a script for the Marx Brothers. You also write glowingly of Chaplin. What do you think of people who try to rate one kind of comedy over another?*

Schulberg: Film is not a three ring circus, but a thirty ring circus. There are enough rings for all the gifted comedians. It's easy to say Chaplin was a genius, but so in a different way were the Marx Brothers. Lloyd was on another street. And then there was Keaton. There were so many really gifted comedians in those days. We don't seem to have that anymore. It's either Woody Allen or Jerry Lewis.

Cineaste: *Some of the French critics believe Lewis is a comic genius.*

Schulberg: I think they've overstated the Jerry Lewis case, but I do think Lewis is a very talented man. Maybe we should look at his work again and try to see it as the French do. I would add that I think he would be better served if he were directed by someone other than Jerry Lewis. It'll be interesting to see what happens in the film he's doing now with De Niro and Scorsese.

Cineaste: *Another one of your books,* The Disenchanted, *focuses on what happens to writers in Hollywood. Almost at the end of the book, a leftist screenwriter has just read thirty-eight pages by an essentially apolitical writer modeled on F. Scott Fitzgerald. He is overwhelmed by a sense that his own view of the relationship between art and politics, a view heavily influenced by the Communist Party, is wrong. He thinks: "My God, this was alive, while the other writers who were not defeatist, not escapist, not bourgeois apologists, and not 'cut off from the mainstream of humanity' were wooden and lifeless. Was it possible—and here heresy really struck deep—for an irresponsible individualist, hopelessly confused, to write a moving, maybe even profound, revelation of social breakdown?"*

Schulberg: That relates to a well-known controversy going on in the thirties. There was a communist literary line that a writer like Faulkner was a decadent author, and therefore incapable of writing

great literature. There were people who objected to that, who argued that you could be reactionary in your politics and still be extremely creative.

Cineaste: *I believe that* What Makes Sammy Run? *was attacked by the Party for being insufficiently revolutionary. They thought the Screen Writers Guild should have had a more prominent role.*

Schulberg: Yes, the Hollywood communists objected to the book. The first *Daily Worker* review was extremely favorable, but the author was called in to account for it and had to write a retraction. I still don't understand that, because I think that this was the first time in fiction written about Hollywood that the employee's side, in terms of the screenwriters versus the bosses, was really dramatized. In its own way, it was as radical as could be. I never understood it. I really didn't. But it's like some forms of religious fanaticism. The Party in Hollywood, dominated by John Howard Lawson and the Central Committee Commisar, V.J. Jerome, followed the Moscow line that was censoring and eventually eliminating the best writers in the Soviet Union.

Cineaste: *You've described yourself as a premature anti-Stalinist. Were you also a premature New Leftist?*

Schulberg: I never thought of myself that way, but I think my attitudes did presage and then overlap a lot of the attitudes of the sixties. The place where I took issue was that I felt the activists of the sixties were not really thorough enough. They took scatter-shots at society without any overall concept as to how to reconstruct. I think in that sense the movement was anarchistic, and that was one of the reasons it played itself out. It has left behind some valuable pockets of understanding, but like Saroyan's line in *The Time of Your Life,* I don't think it had a solid foundation.

Cineaste: *You started the Watts Writers' Workshop in 1965, right after one of the first major urban insurrections.*

Schulberg: I went down to Watts as soon as the curfew was lifted. I ran the Workshop there until I moved east in 1970, and then I started one here based on that experience. We brought some of the writers from Watts to New York. We started what's called the Frederick Douglass Creative Arts Center, which is now headed by an excellent person, Fred Hudson, who came from California, at my invitation, with seed money from the National Endowment for the Arts. In Watts we started with seven people and it grew to about fifty. This new one is more structured and has ten different classes, including film and television writing. We've held film and television

classes at the Screenwriters Guild offices, with members of the Guild sitting in as guest lecturers and tutors. We mount four new plays a year and publish a literary quarterly, *American Rag.** And we need all the help we can get.

Cineaste: *In* Moving Pictures, *you describe how as an adolescent you wanted to write a book about lynching.*

Schulberg: As I look at the letter from Clarence Darrow that we reproduce in the book (asking his help in documenting Negro persecution), I still don't understand where this feeling for black problems originated. It may have been from an early nurse we had, Wilma, whom I loved even more than my mother. My mother wanted to improve us and make us super-achievers, but, for real love, I went to Wilma. Although I wasn't ready to write *Judge Lynch* at age seventeen, the advice from Darrow and reams of research from the NAACP began an education in social injustice that could never be found in a prep school curriculum. I feel that we are now rolling back to the know-nothing days of the twenties and thirties. It worries me. Repression leads to rebellion. The Reagan policies are pushing blacks into a dangerous corner.

Cineaste: *In works like* Sammy *and* A Face in the Crowd, *you are very aware of how the media shape reality. How will you handle that in the new version of* A Face in the Crowd?

Schulberg: I can tell you more when I've finished the script. Right now all I can say is that I'm starting to reexamine the role of television and media in our lives. I plan to sit down with people who have expertise in the field like Norman Lear. I have a lot to learn yet. I can't imagine what it will be like when cable television is in everyone's home. It's going to have a tremendous impact on home life. I'll have to relate the old characters to some of these new realities. Being raised in Hollywood, I could see very early how the media shaped responses.

One of the most shameful episodes in Hollywood history, which I'll get into my next book, will be the campaign against Upton Sinclair when he ran for governor. It was all right when he was in the Socialist Party. He could be invited to the teas of affluent ladies. My mother had a group called the Friday Morning Club. Sinclair was accepted by Pasadena society as their eccentric Upton. When he won the Democratic Party nomination, he became a serious threat. The studio bosses panicked. They ganged up together and took a tithe

*For further information, write to the Frederick Douglass Creative Arts Center, 276 West 43rd Street, NYC 10036.

from everyone's salary for the Republican candidate. The money
was deducted before the checks were issued.

Cineaste: *You wrote about this in* Sammy.

Schulberg: But it's not fiction. It's true. They even made shorts in
which a Bolshevik with a bomb says, in a thick Russian or Jewish
accent, "Why shouldn't I vote for Upton Sinclair?" Upton credited
that campaign for defeating him. The studios announced that, if
Sinclair won, they would close down production and move every-
thing to Florida. It was a fascinating and heartbreaking campaign.
The dream of ideal democracy was up against vicious reality and
lost.

Cineaste: *I'd like to relate what you've just said with that passage
from* The Disenchanted. *Do you still consider yourself a socialist? A
Marxist? A left liberal?*

Schulberg: Romantically, I would be a socialist, but I don't find it
working. I'm disillusioned about power. I begin to think, like Arthur
Koestler, that there's something wrong with people when they get
into positions of power. I like the socialists when they're down, but
once they get in, as we've seen in the Soviet Union, China, and
Cuba, they seem as dictatorial and authoritarian as the people they
displaced. Before I die, I should like to get a better answer to your
question. I'm really serious. I'm in the position of a left liberal who
believes in getting as much for the under-classes as can be obtained
under our present economic system. At the same time, I fear that
next step into a soviet system. Speaking selfishly now, I personally
would have less freedom under a soviet system than I do now. At the
same time, I have serious questions about this social order. In
Sanctuary V, the only political book I've done, my main protagonist
is someone who seeks, but doesn't find, a socialism with a human
face. I suppose that would come as close to my philosophy
as anything.

Cineaste: *Do you feel that Cuba marks an improvement in
Soviet- style systems?*

Schulberg: I think Fidel is more humane than the other major
Soviet-style leaders. However, I feel that things like holding Hubert
Matos in prison all those years was a misuse of power. I think that
writers have been circumscribed and have not been allowed to
express themselves as fully as they should. I think there have been
social benefits for people in general, for the poor, for the peasants.
An enormous improvement has been made there, no question about

that. But there's still only one mindless newspaper, *Granma*. I think we still need a Cuban Dubcek. Maybe that's Quixotic.

Cineaste: *How does the Polish Solidarity movement fit into your thinking?*

Schulberg: That does give one hope, but once they got into power, what would happen? I don't know. At this point, it would be wrong to pick at them, for, God knows, we're altogether on their side. They could help Poland break out of its political and economic straitjacket. If they survive.

Cineaste: *The question of the freedom of writers to write has marked your career for a long time. In relation to your testimony before HUAC, you are quoted at some length in Victor Navasky's* Naming Names. *Do you think he's done a good job?*

Schulberg: His pretense of balance is overstated. I think he went in with a preconceived verdict rather than dealing with a very complex problem with an open mind. I think the book's been overpraised in that respect.

Cineaste: *Do you consider his treatment of you as fair? Obviously, he quoted you accurately, but what do you think of his commentary on you?*

Schulberg: People advised me not to speak with him, but that went against my principles. They advised me that no matter what I said, it was his book, his court. He was prosecutor, judge, and jury, and so, no matter what I offered, I couldn't win. Unfortunately, he hasn't done what you have offered to do—let me look over the transcript before publication. There are some serious errors in which he quotes me as saying things like, "The discipline of the Communist Party is something not understood by the Communist Party." Obviously that makes no sense. What I said was that the rigidity of party discipline was something that could not be understood by liberals and even sympathizers outside the party. There simply isn't space within the format of this interview to cite all the misquotations and questionable paraphrases. Under the guise of "fair play," it's a hatchet job.

Although I cite chapter and verse on John Howard Lawson's heavy-handed and authoritarian approach to *Sammy*, Navasky prefers his rosy description of Lawson as a scholarly non-censor simply interested in social culture. I think I am able to be more objective than Navasky. What can you say about a man who writes that a dinner for Elia Kazan at the New York Public Library could be called a reunion of informers because it was attended by Jerome

Robbins, Abe Burrows, and me? There were two hundred people at that dinner, most of them invited by the Library itself—publishers, distinguished writers, directors, and actors with no relationship to the House Committee, pro or con. Why is it wrong for McCarthy to indulge in guilt by association, but not wrong for Navasky, who exhibits exactly the same bullying tactic of playing fast and loose with the facts in order to pound home his censorious opinion?

Change one letter, and you have Victor Nalasky, which is where this "reasonable scholar" is really coming from. Victor Lasky thinks anything left of center is subversive. Nalasky damns the left of center people like Schlesinger for not falling in line behind the Fifth Amendment "principle" like him. Anybody who equates membership in the American Communist Party with "left wing politics" is either a fool or a knave.

Ultimately, it is my word against Lawson's. I say that they either wanted me to write according to their counsel, and, if I didn't do it that way, I would not be allowed to write. People don't realize that in order to get out of other chores and assignments, you had to ask permission to write a novel. You had to have permission to go away. You just couldn't go to Carmel or the Canadian woods or Vermont and write the book you wanted. You couldn't do it any more than writers in the Soviet Union can do it today. As I said before, they forced their reviewer to recant the original review of *What Makes Sammy Run?* They called him in on the carpet in open session. It was very much like what happens in the Soviet Union. I realized it at that time. Facing V.J. Jerome, I thought, "So now, that's the real face of the Party. It's not those nice, basically liberal, well-meaning people in Hollywood who want to improve the lot of working people." It was its own form of dictatorship—as much of a dictatorship as it could be in this country when they had not yet come to power.

When Navasky took Lawson's side at the end, my heart sank, because, if he takes Lawson's side, if he believes Lawson really was a simple social do-gooder and not a commissar type, then he, in a sense, does not believe my story. Basically, he is calling me a liar. I think this shows where Vic stands. I know he'll shudder, but I think his position could be called, without distortion, a kind of neo-Stalinism.

Cineaste: *Were you aware of the Richard Wright controversy at that time?*

Schulberg: Yes, I related the two cases. I had his pamphlet

defending Bigger Thomas against Communist criticism. I wrote a similar defense of Sammy Glick.

Cineaste: *Wright was in Europe at the time of HUAC?*

Schulberg: He basically escaped all that by exiling himself.

Cineaste: *In writing about* On the Waterfront, *Peter Biskind has argued that the hidden theme of the film is a justification for testifying before the government investigative committees.* * *How much of that is true?*

Schulberg: That's twisting the facts to fit a theory. I researched the waterfront for more than a year. I was down there almost every single day. It was really the public hearings on the waterfront that began to tip the scales somewhat in favor of the rebels. There were people who didn't want to testify, but who knew that if they didn't tell what was really happening, things would never change. I was struck by that and discussed it with Kazan. We never thought that this was a great way of getting back at people like Jerome and the Hollywood Stalinists.

Cineaste: *You're saying that the theme of testifying was imposed by the historical conditions that were being played out on the docks.*

Schulberg: It came directly out of the research. I attended every day of the anti-crime commission hearings. Ever so many people really took their lives into their hands by getting up to testify against the mob. It seemed a logical, dramatic element for the picture. Father Corridan urged the longshoremen to testify as the key to breaking mob control of their union, and bringing it back to honest trade unionism.

Cineaste: *Both the Irish and Italians have a strong code of silence—omerta is what the Sicilians call it. One is never to speak to outsiders, especially the government, about problems.*

Schulberg: "Deef 'n' dumb" is how they put it on the docks. As a result of that, even victims of the mob remained silent. This silence was obviously an ally of the corruption of the waterfront. It may overlap our personal histories, but it comes right out of events. I should note here that the afterword which appeared in the *On the Waterfront* screenplay book was rejected by *American Film.*[†] The New York Times Magazine published it and said it was one of the best things they'd had in years. I frankly felt that, possibly, censorship

* See "The Politics of Power in *On the Waterfront,*" by Peter Biskind, *Film Quarterly,* Fall 1975.

† This was long before Peter Biskind became editor of that magazine.

was involved. A strange thing about people who are against blacklists is that they don't really object to their own.

Since you bring up Biskind's pejorative interpretation of *On the Waterfront,* I think it should be public knowledge that, four months after the publication of *Moving Pictures,* Biskind's magazine has yet to review it. Here is a personal history of the pioneers of American film, including my own father who worked with the Father of the American film, Edwin S. *(The Great Train Robbery)* Porter, here is a book favorably reviewed by *The New York Times, Time,* Wallace Markfield in *New York* magazine, welcomed by John Huston, Frank Capra, Arthur Schlesinger, Jr., David Halberstam, and scores of distinguished people inside and outside the film industry, and *American Film* ignores it. And when my publisher questioned *American Film,* he learned that it had been assigned to Victor Navasky, who so far has failed to write the review. Navasky's only connection with Hollywood and film is to have written a book on a Congressional Committee investigation which singles me out for personal attack. His knowledge of films and Hollywood history is so thin that he confuses the great director, George Stevens, Sr., with his son, the dedicated Chairman of the AFI, George Stevens, Jr. There were hundreds of directors and writers in Hollywood especially qualified to review *Moving Pictures*. To assign it to Navasky is like assigning a book by Teddy Kennedy to Bill Buckley, or a work by Simon Wiesenthal to the Imperial Wizard of the Ku Klux Klan. I consider this treatment of my book unprofessional, didactic journalism, and a disservice to the principles of the American Film Institute for which *American Film* presumes to speak.

Cineaste: *Coming back to* American Film *and its rejection of your* Waterfront *essay, might the problem have been that you make the Hollywood producers look very shortsighted in describing how every major studio turned the screenplay down?*

Schulberg: I don't know. I was just amazed when they sent it back. I've never said anything about it until this moment, but I felt it was politically motivated.

Cineaste: *Is this another example where a news publication takes the screenwriter more seriously than an industry-supported publication does?*

Schulberg: Yes, I think the anti-Hollywood element is something the *Times* would relish and *American Film* would resist. Our producer, Sam Spiegel, was furious about it. But, what the hell, my

piece was controversial but accurate. Any honest film magazine would have grabbed it.

Cineaste: *How much of a role did Kazan and Brando have in shaping the final look of the film?*

Schulberg: First, I went to the waterfront. I walked it, watched it, tried to become part of it. Then Kazan joined me and he walked it with me. He met all those people. We went to church, we went to rebel meetings. We scouted locations together. You might say we found Hoboken. When Marlon came along at the end we walked him through and exposed him to the longshoremen who were models for the role he was playing. It was a living process. Originally, I had done research on the Manhattan side of the river in Chelsea. Local 291 was the driving force in the insurgent movement of the International Longshoreman's Association. We wanted to shoot it around the Manhattan piers, but it was too busy there and very noisy. We started thinking of New Jersey. We had some contacts there who opened Hoboken to us. We realized that it was an ideal place to shoot—small, compact, quieter, and you still had the background of the river.

Cineaste: *Did you hope the film would help clean up the ILA? People are very glib when they write that art can't change reality.*

Schulberg: We hoped very much that the film would come out before the National Labor Relations Board vote. I always suspected Sam Spiegel was dragging his feet on that. He didn't want the film to be used that directly, in a way that you might call propagandistic. He didn't want to get involved in that struggle. I was disappointed that it came out right *after* the vote, which was heartbreakingly close. At the same time, it did some good. Father Corridan, the Karl Malden character, feels the picture made it much more difficult to maintain the kind of brutal shape-up system that had been common for decades. So we had some effect. His fellow waterfront priest, Father Carey, is still there at St. Xavier. He believes our film helped bring about important reforms. As to the broader implications of your question, we should remember that Upton Sinclair's *The Jungle,* for example, did have an effect on the meatpacking business.

Cineaste: *A recent article about Hoboken in the* Times *said that the reforms were all superficial, that the waterfront was much the same as when you filmed.*

Schulberg: They're right and they're wrong. The docks are still controlled by the same crime families as then. The stealing, the loan-sharking, is exactly the same. But there's a hiring hall now. Job

security has gone so far the other way it's now a guaranteed annual wage. But that hasn't weakened the control of the mob. If you stand up against them, they still knock you down.

Cineaste: *Hollywood is full of uncompleted projects. Do you have any particular regrets?*

Schulberg: Every writer has a handful—no, a bushelful—of pictures that he wanted to make. Two bother me. One was *The Enemy Within,* the Bobby Kennedy book. If Jerry Wald had lived, I think we would have done it. No one else was brave enough to try it. I also wanted to do a strong film called *In the Streets,* about Puerto Ricans in New York. Sam Spiegel walked out on it after I was halfway through a screenplay. After that, we were never able to mount the film as we wanted, so I just put it aside.

Cineaste: *Is it just as hard to get a quality picture through the Hollywood Machine as it ever was? You'd think a Budd Schulberg or an Elia Kazan, much less a Schulberg-Kazan picture, would have easy sailing.*

Schulberg: They want you to do what *they* want you to do. Occasionally there's a happy medium. I'm hoping the new *A Face in the Crowd* will be one of those occasions. It does happen. Every once in a while there is a film that goes against the stream. But it's tough, very tough. I think it's tougher right now than it has been for a long time, mainly because of these blockbusters, which are costly. The personal film is very difficult to get backing for, whether you're Kazan, Schulberg, or anyone else. I don't think directors are helping. Some of them have enormous ability, but they're interested only in technique.

But I don't want to leave an impression that making good films is hopeless. It's like the salmon swimming upstream. Most of them die, but if a few didn't make it, there'd be no salmon. So I continue to try to make movies in Hollywood. Another way to go is the way my niece, Sandra Schulberg, is working—in the independent arena. She was involved with *Northern Lights,* which was made on a budget of a few hundred thousand dollars. Unfortunately, they tell me that for the next one, their budget will double. But they do it on their own money they raise personally. I admire what they are doing very much.

Cineaste: *You spoke of the Hollywood directors who are infatuated with technique. Some of this filmic "quoting" and "homage" strikes me as ghoulish, and the direct result of paucity of ideas and lack of social concern.*

Schulberg: It also has to do with film schools. The early people made films out of experience, whereas so many of the younger people come out of film schools where technique is stressed. They take from other movies rather than from life. If they are middle class to begin with, without roots in other kinds of experiences, movies become the tool of their experience.

Cineaste: *One thing you say in* Moving Pictures, *however, is that we still don't know the history of the movies, or even understand how some of the films we love came to be made.*

Schulberg: It's appalling that a medium that affects so many millions of people around the world seems to generate so little interest in its origins. It's as if nothing of Jefferson, Franklin, or even Washington were known. It strikes me as wrong that someone like Edwin S. Porter is so utterly neglected. I mentioned Porter to both Scorsese and Kazan, and neither of them had heard of him. They knew Griffith. Not only was Porter before Griffith, but there were others with Porter in the opening years of the century who've been totally neglected. I'd like to redress that if I can. That's a major reason for writing *Moving Pictures*. So many people who were important have been forgotten. I could see how the history of films was being distorted because what has not been recorded is erased. There is a lot of scholarly work to be done in this area.

Cineaste: *There are very few genuine oral histories.*

Schulberg: Unfortunately, that method didn't become popular until most of these people were already gone. That's really a shame. I blame myself as well. I was friends with Mickey Neilan. David Selznick had put us together as a writing team. I spent day after day with Mickey. We had an awful lot of fun, but I didn't sit him down and ask him about the beginning, about his role with Mary Pickford, about 1914, 1915, 1916, and the days before Hollywood. He was a gold mine. I really was so aware of Mickey that I had Gadg put him in the original *A Face in the Crowd,* to play the Senator running for the White House. That was the last thing Mickey ever did. But I was more hung up on this idea that's always fascinated me—the rise and fall of these people—than in actually sitting down and getting their recollections of the early days.

Cineaste: *You've always been content to be a writer.*

Schulberg: That's right. To be a producer, or to spend the time directing, was something that never appealed to me. If I could get my say, as I did with Kazan, I didn't see any point in getting involved with production.

Cineaste: *Why haven't you written more films?*

Schulberg: I take quite a bit of time preparing for a film. I like to do very thorough research. I don't want to begin until I feel I know everything I can possibly know about the subject. Also, I've been very lucky. I have very strong feelings about content, but I have been able to support myself by writing what I wanted to write. So I only wanted to do films that dealt with things I cared about. That eliminated an awful lot of pictures—ninety-nine per cent of them.

For a while I was living in Hollywood again, from 1964 to 1969, and my agent would drive me crazy. He'd call and say, "I've got a $250,000 picture for you. It's a piece of cake." I'd ask what it was and he'd say something like, *The Queen of Sheba*. That literally was one I turned down. So that's one reason why I haven't done more films. I really care about the movies. I take them seriously as a writing form. I think more scripts ought to be published. What is published now is more or less a haphazard selection, an accident. Scripts should be thought of as literature to be preserved. That's why I'm proud to be part of the Screenplay Library that Professor Bruccoli set up at Southern Illinois University Press. My old man wrote "photoplays" for Porter and Zukor seventy years ago, and one of the things *Moving Pictures* is saying is that I'm proud to continue in that tradition.

34—SATYAJIT RAY

In retrospect

In the summer of 1981, the Museum of Modern Art in New York mounted a festival of Indian films. Udayan Gupta, associated with Cineaste *since the mid-seventies in a variety of functions, used this opportunity to interview four major Indian filmmakers. Three of those interviews appeared in the last issue of Volume 11 in a roundtable format which could serve as an introduction to Indian cinema for those unfamiliar with its development and challenges. The fourth interview, with Satyajit Ray, the Indian whose films are best known in the United States, appeared in the subsequent issue. Rather than deal with just a single film, Gupta questioned Ray, the dean of Indian cinema, about Ray's entire work, the obstacles he had to deal with, and his general perspective on cinematic art.*

Cineaste: *How did* Pather Panchali *change you. Did it help you discover Bengal?*

Satyajit Ray: I certainly discovered rural life while making *Pather Panchali*. There's no question of that. I'd been city-born, city-bred, so I didn't know the village firsthand. While hunting locations in rural areas, and, after finding the village and spending some time there, I began to understand. Talking to people, reacting to moods, to the landscape, to the sights and sounds—all this helped. But it's not just people who have been brought up in villages who can make films about village life. An outside view is also able to penetrate.

Cineaste: *What have been other influences on your work?*

Ray: Bibhuti Bhushan [the author of *The Apu Trilogy* and *Distant Thunder*] influenced me very much. In fact, I knew about village life by reading *Pather Panchali*. I felt a rapport with him, with the village and his attitude towards it, which is one of the reasons why I wanted to make *Pather Panchali* in the first place. I was deeply moved by the book.

I have also been moved by Tagore's work, which is not necessarily rural. Of course, our cultural background, our cultural makeup, is a fusion of East and West. This applies to anybody who has been educated in the city in India and who has been exposed to the classics of English literature. After all, our knowledge of the West is deeper than the Westerner's knowledge of our country. We have imbibed Western education. Western music, Western art, Western literature have all been very influential in India.

Film, as a purely technological medium of expression, developed in the West. The concept of an art form existing in time is a Western concept, not an Indian one. So, in order to understand cinema as a medium, it helps if one is familiar with the West and Western art forms. A Bengali folk artist, or a primitive artist, will not be able to understand the cinema as an art form. Someone who has had a Western education is definitely at an advantage.

Cineaste: *Indian critics often contend that* Pather Panchali *was a radical film because it completely altered India's film economy. It proved that it was possible to make viable films without studio patronage. Did the film really have an immediate impact?*

Ray: I don't think so. Although the audience and critics recognized the film as a landmark of sorts, filmmakers weren't that quick to follow. There was no immediate influence discernible in other directors' works. That came much later. In the last five or six

years, filmmakers coming out of the Film Institute in Poona have acknowledged that they have been influenced by *Pather Panchali*.

Cineaste: *Are you surprised that your films have been so well received outside of India?*

Ray: I never imagined that any of my films, especially *Pather Panchali*, would be seen throughout this country or in other countries. The fact that they have is an indication that, if you're able to portray universal feelings, universal relations, emotions, and characters, you can cross certain barriers and reach out to others, even non-Bengalis.

Cineaste: *What is the most unsatisfying film you've ever made?*

Ray: The most unsatisfying film, *Chiriakhana (The Zoo)*, is not being shown in my current retrospective. For one thing, it was not a subject of my choice. I was forced by circumstances to do it. Some of my assistants were supposed to do the film, but they suddenly lost confidence and asked me to take it on.

Chiriakhana's a whodunit, and whodunits just don't make good films. I prefer the thriller form where you more or less know the villain from the beginning. The whodunit always has this ritual concluding scene where the detective goes into a rigmarole of how everything happened, and how he found the clues which led him to the criminal. It's a form that doesn't interest me very much.

Cineaste: *What's been your most satisfying film?*

Ray: Well, the one film that I would make the same way, if I had to do it again, is *Charulata*. There are other films, such as *Days and Nights in the Forest*, which I also admire. Among the children's films, I like *Joi Baba Felunath (The Elephant God)*. It works very well. It's got wit. It's got film eye. It's got a face, a very satisfying face, and some wonderful acting. I also enjoy making the musical films because they give me a chance to compose music. And they're commercially successful, which gives you a certain kind of satisfaction. I like *Kanchenjungha*, too. That's probably because it was my first original screenplay and a very personal film. It was a good ten to fifteen years ahead of its time.

Cineaste: *It has a fragmented narrative.*

Ray: Yes. Our audience likes a central character, or a couple of central characters with whom they can identify, and a story with a straight narrative line. *Kanchenjungha* told the story of several groups of characters and it went back and forth. You know, between group one, group two, group three, group four, then back to group one, group two, and so on. It's a very musical form, but it wasn't

liked. The reaction was stupid. even the reviews were not interesting. But, looking back now, I find that it is a very interesting film.

Cineaste: *The women in your films tend to be much stronger, more determined, more adaptable and resilient than the men in your films. Is that a reflection of Bengali social history?*

Ray: That is often a reflection of what the author has written, a confirmation of the author's point of view expressed in the books on which the films are based. There have been many strong women characters in Tagore and in Bankimchandra.* But it also reflects my own attitudes and personal experience of women.

Cineaste: *Which is?*

Ray: Although they're physically not as strong as men, nature gave women qualities which compensate for that fact. They're more honest, more direct, and by and large they're stronger characters. I'm not talking about every woman, but the type of woman which fascinates me. The woman I like to put in my films is better able to cope with situations than men.

Cineaste: *Is Charulata the archetypal Ray woman?*

Ray: Yes, she is.

Cineaste: *Starting from* The Music Room *and continuing on to* The Chess Players, *you go back and forth between old culture and new culture, tradition and progress. Sometimes I get the feeling that you are leaning toward tradition and the old culture and are somewhat disapproving of what is new.*

Ray: I don't disapprove of what is new in *The Chess Players.* There is a very clear attitude expressed in the fact that the feudals are not involved in what is happening around them. Although I am sympathetic to the characters, there's also a clear suggestion that these people are no good. But I am more interested in a way of life that is passing and the representatives of that way of life. You can find the same thing in Chekhov's *The Cherry Orchard* and it fascinates me.

Of course, you risk flogging a dead horse in saying that feudalism is stupid and wrong. But you also feel for the characters in those films. They're pathetic, like dinosaurs who don't realize why they're being wiped out. There's a quality of pathos in that which interests me.

Cineaste: *Most Western critics feel that your vision of India is a bleak and despairing one.*

*Bankimchandra, a ninteenth century Bengali novelist renowned for his social novels, could be called the Bengali Dickens.

Ray: *The Middleman* is really the only film of which that sort of remark can be made.

Cineaste: *But others have found* Days and Nights in the Forest *despairing.*

Ray: I wouldn't call it such a despairing vision. Certain unpleasant truths are expressed in it, but that is part of drama, it applies to all kinds of films. You can analyze a Western film and find a very despairing statement about Western values. You can't make happy films all the time.

If you're making a film about problems, but you don't have a solution, there's bound to be a despairing quality. In *The Big City,* both husband and wife lose their jobs. There are no jobs around. They drift apart, there is misunderstanding, and they come together again. But they still don't have any jobs, and they may not have any for quite some time, but that doesn't make it despairing.

The only bleak film I have made is *The Middleman.* There's no question about that. I felt corruption, rampant corruption, all around. Everyone talks about it in Calcutta. Everyone knows, for instance, that the cement alloted to the roads and underground railroad is going to the contractors who are building their own homes with it. *The Middleman* is a film about that kind of corruption and I don't think there is any solution.

Cineaste: *You've often said that you don't think it's right, important, or necessary for an artist to provide answers or make judgments, to say that this is right and this is wrong. You've stayed away from major political statements.*

Ray: I have made political statements more clearly than anyone else, including Mrinal Sen. In *Middleman* I included a long conversation in which a Congressite* discusses the tasks ahead. He talks nonsense, he tells lies, but his very presence is significant. If any other director had made that film, that scene would not have been allowed. But there are definitely restrictions on what a director can say. You know that certain statements and portrayals will never get past the censors. So why make them?

Cineaste: *Given the political climate in India, is the filmmaker's role one of passive observer or activist?*

Ray: Have you seen *Hirak Rajar Deshe (The Kingdom of Diamonds)?* There is a scene of the great clean-up where all the poor people are driven away. That is a direct reflection of what happened

*Congressite: A member of the Congress Party in India.

in Delhi and other cities during Indira Gandhi's Emergency. In a fantasy like *The Kingdom of Diamonds*, you can be forthright, but if you're dealing with contemporary characters, you can be articulate only up to a point, because of censorship. You simply cannot attack the party in power. It was tried in *The Story of a Chair* and the entire film was destroyed. What can you do? You are aware of the problems and you deal with them, but you also know the limit, the constraints beyond which you just cannot go.

Cineaste: *Some people see that as an abdication of the filmmaker's social role. A number of critics, especially those in Bengal, feel that you aren't political enough, that you can go further, but that you just haven't tested your limits.*

Ray: No, I don't think I can go any further. It is very easy to attack certain targets like the establishment. You are attacking people who don't care. The establishment will remain totally untouched by what you're saying. So what is the point? Films cannot change society. They never have. Show me a film that changed society or brought about any change.

Cineaste: *What about filmmakers such as Leni Riefenstahl, who presented the Nazi version of the Aryan myth, or Sergei Eisenstein, who used film as a tool of the revolution?*

Ray: Eisenstein aided a revolution that was already taking place. In the midst of a revolution, a filmmaker has a positive role, he can do something for the revolution. But, if there is no revolution, you can do nothing.

Riefenstahl was helping a myth, the Nazi ideology, and the Nazis were very strong at the time. In the early days of fascism, even the intellectuals were confused. Tagore was led to believe that Mussolini was doing something wonderful, playing a very positive role, until Romain Rolland told him he was wrong, that he hadn't understood the full implications of fascism.

Cineaste: *How do you see your own social role as filmmaker?*

Ray: You can see my attitude in *The Adversary* where you have two brothers. The younger brother is a Naxalite.* There is no doubt that the elder brother admires the younger brother for his bravery and convictions. The film is not ambiguous about that. As a filmmaker, however, I was more interested in the elder brother because he is the vacillating character. As a psychological entity, as a human

*Naxalites: A radical left movement that started in rural Bengal in 1967 and has had lasting impact on the Indian left.

being with doubts, he is a more interesting character to me. The younger brother has already identified himself with a cause. That makes him part of a total attitude and makes him unimportant. The Naxalite movement takes over. He, as a person, becomes insignificant.

Cineaste: *But can you make such a distinction between ideological gestures and emotional gestures? Isn't the ideologue also an intellectual being? How can you create such a dichotomy?*

Ray: Why not? I don't see why not. Anybody who identifies himself with a movement is depending on directives from higher figures who are dictating, controlling their movement. If you took the controlling characters, *that* would be interesting. Then you could make a film about the Naxalite movement, an Eisensteinian film about revolutionary activity. But you cannot do that under the present circumstances in India.

Cineaste: *I am not the only one who feels that you emphasize emotion. Robin Wood has written that you are more interested in communicating emotional experiences than in expressing ideas.*

Ray: That's just not correct. One thing that should be clearly discernible in my films is a strong moral attitude.

Cineaste: *Is that a product of your religious upbringing, of being Brahmo?**

Ray: I don't think so. I don't even know what being Brahmo means. I stopped going to Brahmo Samaj around the age of fourteen or fifteen. I don't believe in organized religion anyway. Religion can only be on a personal level. I just find that the moral attitude I demonstrate is more interesting than any political attitude I could bring to my films.

Cineaste: *Is the moral attitude sometimes too simple? In* Pikoo *you seem to be suggesting that infidelity can lead to a variety of problems, that changing social and sexual values have hurt the social and family fabric.*

Ray: *Pikoo* is a very complex film. It is a poetic statement which cannot be reduced to concrete terms. One statement the film tries to make is that, if a woman is to be unfaithful, if she is to have an extramarital affair, she can't afford to have soft emotions towards her children, or, in this case, her son. The two just don't go together. You have to be ruthless. Maybe she's not ruthless to that extent.

*Brahmoism: A liberal, modern reformist faith which goes back to the monotheistic origins of Hinduism; strongly anti-idolatry and anti-casteism, however.

She's being very Bengali. A European in the same circumstances would not behave in the same way.

Cineaste: *How did Charulata resolve the problem of infidelity? She, as we are led to believe, went back. Was she being unfaithful or just caught between. . . .*

Ray: She was unfaithful but she was also confused because the husband was good. He wasn't a rake. Charulata probably felt sympathetic and was attempting to patch up the situation. The husband realized too late that he himself was responsible for what had happened. That is why at the end of the film there is the suggestion that they will come together, but that it is too soon for a reconciliation.

Cineaste: *How much of your own sentiments are in your characters? Reviewing* Distant Thunder, *Pauline Kael wrote, "Ray has put something of himself into Gangacharan, something of his own guilt, of weakness, of commitment." Is that accurate?*

Ray: Critics forget that I'm basing the film on someone else's work that already exists in another form. In *Distant Thunder*, Gangacharan is very close to Bibhuti Bhushan's concept. The real question should be whether the author himself had this feeling of guilt and weakness. I'm not the originator of the story. Why drag me into it?

It's true, the fact that I have chosen to portray a character in a certain way does imply a sense of identity and understanding. I understand Gangacharan, his motivations, his behavior, his reactions. For me, he is a believable, fully-rounded character, and his transformation at the end is very moving, but he is not my reflection.

Cineaste: *Are you suggesting that people who don't read the books from which your films are made may have a difficult time understanding or interpreting your films?*

Ray: Yes, in the sense that they tend to ignore the original author completely. They're thinking of the narrative as a total creation, from beginning to end, by the filmmaker, and that is usually not true. I choose a story or a novel for certain elements in it which appeal to me. In the process of writing the screenplay, the theme may be modified, but most of the original elements will be retained. Often the screenplay evolves as a criticism of the original. After reading a story many times, you may feel that a certain character would not behave the way the author has described, so some changes are made. Once I have read a story and gotten to know it, I will leave the

story behind and start from scratch. At the end, if I find that certain changes are convincing, I'll keep them and forget the original.

Cineaste: *Some critics feel that you romanticize poverty, that the poverty and misery in your films never become ugly.*

Ray: I think that *Pather Panchali* is fairly ruthless in its depiction of poverty. The behavior of characters, the way that the mother behaves towards the old woman, is absolutely cruel. I don't think anyone has shown such cruelty to old people within a family. *Distant Thunder* takes place in a very pretty setting and this is a point that Kael makes, that Babita is a baby doll or something. She doesn't know that some Brahmin wives in the villages were very beautiful.

Cineaste: *Isn't the point in* Distant Thunder *that a famine occurred without a scorched earth and starving faces?*

Ray: Yes, that's what happened during that famine. It was only after everyone started coming into the cities that it became clear that people could die of hunger even when there had been a good harvest. That was the point of that particular famine. As for my use of color, it came straight from the author's description—that nature was very lush, that everything was physically beautiful, and, yet, people were dying of hunger.

Cineaste: *You, Fellini, Kurosawa, and Bergman all started making films around the same time. Many critics feel, however, that you have lagged behind, that you haven't taken the aesthetic and narrative risks that Fellini or Bergman have taken. As you come to the end of nearly thirty years of filmmaking, how do you see your own career in comparison with others?*

Ray: I think I achieved maturity at a pretty early stage. It has been my preoccupation to achieve as much density as possible within a superficially simple narrative structure. I don't think of the Western audiences when I make my films. I am thinking of my own audience in Bengal. I am trying to take them along with me, and this I have succeeded in doing. At the beginning, this audience was extremely unsophisticated. They were used to trash or the naive Bengali film. you had to take them along slowly. Sometimes you took a leap as in *Kanchenjungha* or in *Days and Nights in the Forest*, and lost them.

These kinds of risks, especially in relation to their audiences, haven't been taken by Bergman or Fellini. Bergman is fairly simple, although he can be very austere and rigorous, and he is often aided by some marvelous photography. As for Fellini, he seems to be making the same film over and over again. There is a lot of bravura

in his films, in spite of the fact that he's not so interested in the stories, and people go to see that bravura.

I can't do all that Bergman and Fellini do. I don't have their audiences and I don't work in that kind of context. I have to contend with an audience that is used to dross. I have worked with an Indian audience for thirty years and, in that time, the general look of cinema hasn't changed. Certainly not in Bengal. You'll find directors there are so backward, so stupid, and so trashy that you'll find it difficult to believe that their works exist alongside my films. I am forced by circumstances to keep my stories on an innocuous level. What I can do, however, is to pack my films with meaning and psychological inflections and shades, and make a whole which will communicate a lot of things to many people.

35—COSTANTIN COSTA-GAVRAS

"Missing"

In the late 1960s, Costa-Gavras had to scour all over Europe and North Africa to find funding for Z. By the 1980s, although his political stance was as radical as ever, the international financial success of his films led to Missing (1982), his first film for an American studio. Dealing with American intrigues in Latin America, the film caused a mild tremor in establishment circles. The U.S. State Department felt compelled to issue a statement attacking the film and the New York Times moved over political analyst Flora Lewis from the editorial page for a very critical film review in the influential Sunday Entertainment Section, a review quite at variance with the one appearing somewhat later by regular first line film critic, Vincent Canby. The interview was conducted by Gary Crowdus, the founder of Cineaste, and still one of the three editors as the magazine went into its twelfth volume.

Cineaste: *Do you think the political climate in the U.S. today will be more favorable for* Missing *than it was in 1973 for* State of Siege?

Constantin Costa-Gavras: Yes, it's a very different period; a lot of things have changed. Since then you've had Watergate, and you've also had President Carter speaking about human rights. Some people criticize the politics of that as somewhat contradictory, and that's partially true, but it was an historically important moment. Carter made an issue out of human rights, and now political officials around the world are obliged to speak about human rights. Even the Reagan Administration, which is pulling back on that issue, has had to create an office for human rights and go through the motions.

Another important aspect is that young people, many of whom were radical, who were in universities during the late sixties and early seventies, are now in important positions. Even if they've changed a lot since then, they don't see the world through the same eyes as their predecessors.

Cineaste: *What sort of political impact did you hope* Missing *would have in the U.S.?*

Costa-Gavras: When you make a movie, you don't know what sort of political impact it will have. Nobody can predict that, least of all the director. All you can do is say [joins hands in prayerful attitude], "God, I hope some people will go to see this movie, and that some critics will like it."

For instance, if you had asked me when we were making the movie, "Do you think the U.S. Government will take a position on your movie?," I would have said, "No, it's impossible, there's no reason for it." About an hour ago, however, I was told that the State Department has taken an official position on my film. It'll probably be in the newspapers tomorrow.

Cineaste: *Really? That's incredible! You couldn't buy publicity like that.*

Costa-Gavras: I know. It's really a mistake on their part. They did the wrong thing.

Flora Lewis's article in *The New York Times* could be seen as another example of the film's political impact. Because this film was based on a true story, I tried to stay as close as possible to the truth, to avoid manipulating things. But she accuses me of distorting things, of manipulating facts. She also completely misquoted me throughout that article. The film's dialogue is misquoted, too. And Seymour Hersh, who is also quoted in the article, has said he's never been so badly used in his entire journalistic career. So I think it's significant

when an important journalist like Flora Lewis takes that position and manipulates things in her own way.

Cineaste: *Why doesn't the film specify that the events took place in Chile?*

Costa-Gavras: I thought it was necessary not to do so for several reasons. First of all, I would like the audience to play detective a bit, to try to figure out what country it is. You know it's in Latin America, of course, but I want the audience to participate somewhat, to use the information, the knowledge, we all have. For instance, there was just one stadium used like that, and, at the end, we openly speak about Santiago. There are probably some people who don't know where Santiago is, but not too many. Besides, I knew that every newspaper, every magazine, would mention Chile. The same thing happened with *Z*. Greece is never mentioned in the film, and yet everybody spoke about Greece.

Universal would have liked to put at the beginning of the film, "Chile, September 1973." By saying that, though, it becomes a local problem, and it also becomes a historical thing—far away, ten years ago, who remembers that? But I think these things are still happening. It could be Argentina; it could be El Salvador. People are disappearing all over the world.

Cineaste: *Was there any political interference from Universal?*

Costa-Gavras: Two weeks before we began to shoot, they asked me to change some of the names. They explained to me why it would be a legal problem to use the real names, as the book did. Finally, I realized it wasn't so important to use all the real names, so I changed them. But not the country. Absolutely not.

From the very beginning, I made it clear to the producers, Edward and Mildred Lewis, that if I agreed to do the movie, they should allow me to do it the way it should be done, and they never interfered. They always told me what they thought about the script, the cutting, and so on, but I always had the last word.

Cineaste: *No problems from Universal?*

Costa-Gavras: No problems from Universal at all, which seems to surprise everybody. In fact, it surprised me a little bit, too, because I had heard so many things. But they were really great, and they're still great, because they're spending money and really pushing the movie. Universal is very happy with the movie.

Cineaste: *What advantages did you find in working for an American company?*

Costa-Gavras: The financial comfort, because what happens to

us in Europe is that you have a budget, but you don't have all the money. So you start the movie with some money missing and the producer goes around trying to raise it. Sometimes the producer phones me and says, "Hey, Costa, we have a dinner with so-and-so tonight," and you have those dinners where you have to sell the story to people with money, and that's the worst part of it.

Cineaste: *How did the project originate?*

Costa-Gavras: I was sent the book and a script written by someone I prefer not to mention because I didn't like it. The original script took Charles Horman's position, leaving the U.S., travelling throughout Latin America, discovering all those horrors that Charles discovered, and then deciding to stay in Chile. I feel that the problem nowadays is not to show the miserable living conditions in Latin America, or to show how the Allende government was good or bad. The problem today is the "disappeared." Nobody does anything, so it becomes a system of terror.

I told the producers that I would like to start the whole thing from the book. There you have the personal story, the relationship between the father and son, the old generation and a new one, the father disagreeing with his son's way of life. You also have the father discovering an aspect of his own country and beginning to question his own beliefs. There must be millions of Americans like him— an honest man, but one who doesn't understand completely what's going on, and when he finally learns, he protests. It was clear that this was the part of the book to use.

I did a six-page outline which they accepted. Then I said, "I cannot do the script myself. I'd like an American to work with me." We went through some names, and I saw the movies they had done and their scripts. I finally decided on Donald Stewart. He had scripted several things for television and the film *Jackson County Jail*. He had also worked as a journalist. I met and talked with him and had a very positive impression. I told him I would like to work together, to spend the necessary time, some months, together to discuss and to write, the way I always have with Franco Solinas, and he accepted those conditions.

When we finished the script, however, I felt that something was not right with the dialogue. It seemed to me that the father and the young people, the two generations, spoke the same way. Don and I gave it another try, but nothing good came out, so I asked Edward Lewis to find someone who could help me change the dialogue. Eddie suggested John Nichols, a novelist who wrote *The Milagro*

Beanfield War and *The Magic Journey.* I read his books and was very impressed. He's written some extraordinary dialogue. I explained the problem to him and told him to do everything he wanted. John didn't have any cinematic experience, however, so he came back with 400 pages, this enormous book! Then I went through it and kept some of the stuff he'd done. John added some things to the relationship and the dialogue.

Cineaste: *Yet he has no screen credit.*

Costa-Gavras: Unfortunately not. I spoke to the Writers Guild, because I was furious, but they refused to give him a screenplay credit. I asked if he could be given a screen credit as Advisor to the Director, but they refused even that. I was very unhappy, because in Europe, even if a friend gives you a little idea, you can put his name on the screen to show his participation. I mean, it's no big deal, it doesn't hurt anybody, but here they're very strict.

Cineaste: *Do you think that if you had shown Charles Horman to have had greater sympathies for the Allende government, or to have been more politically aware, that it would have weakened audience sympathy for his plight?*

Costa-Gavras: I don't think Charles Horman was a very political person. I saw a couple of short films he did, and his parents showed me all his letters and writings. It's very clear that he was a kind of neophyte. Today I met someone who knew him and he told me, "Charles was exactly like that."

Cineaste: *If he had been shown to have been more politically aware, one wonders whether the audience would have reacted like the U.S. Embassy people do in the film?*

Costa-Gavras: I'll tell you, if Charles Horman had really been a radical, I would have shown him as a radical. That was one of the problems we had, to portray Charles Horman exactly the way he was. But even if he *had* been a radical, that doesn't give anyone the right to kill him or make him disappear. If he had been a radical, I would have taken the film in that direction, and tried to develop it more, because it would have been more interesting dramatically.

In the film, in fact, we have the father contradict himself in this regard. At one point the father is asked by a U.S. Senator, "Was your son a radical or a liberal?," and he replies, "What difference does it make?" Later, when the father confronts his son's wife, he accuses his son of being too far on the left, as if it would be easier to accept his son having been shot because he was too far on the left. I would like to have had the opportunity to play with the viewer who

says, "Oh, of course, he was shot because he was a radical," but I didn't really have that opportunity here.

Cineaste: *What happened to the script that you and Jorge Semprun wrote for a production of Malraux's* Man's Fate?

Costa-Gavras: It was rejected by the Chinese. A few years ago Hua Guofeng visited Paris with a whole delegation. At that time I met with their Minister of Culture and told him about our project. He said, "We need people like you coming to our country to work with our people, so why don't you visit?" So I went to China and we saw all the locations, and I was able to talk with old Chinese workers who had participated in the insurrection.

We also showed the Chinese *State of Siege* and *The Confession,* because they had already bought *Z.* For the screening of *The Confession,* we had a lot of Chinese officials, and, at the end, they applauded. A couple of them said to me, "Very strong movie, very strong," but I didn't really know what their reactions were. During the next few days no one said anything about the movie, so, just before we left, my wife, Michelle, said, "Look, I'd like to ask you a question. What do you think about *The Confession?* What are your political feelings?" One guy spoke in Chinese for about ten minutes before the interpreter translated for us, so there was a big suspenseful moment, like in a Hitchcock movie. He said, "We liked the movie a lot. It shows exactly what happened here for several years," and he spoke about the Cultural Revolution. "Those things happened to everybody," he said. "I myself spent four years in a camp." Apparently they thought the movie looked very much like their own experience. Whenever they spoke about Stalin, though, they'd say, "He was seventy per cent good and thirty per cent bad." That was their view of him.

Later, when we sent them the finished script, they said, "No, you'll have to change this and change that." The producers thought it could be done in the Philippines or somewhere else, but I felt that was ridiculous, that the only place you could do it would be in China, so I just gave it up.

Cineaste: *You've also written some unproduced scripts with Franco Solinas.*

Costa-Gavras: Franco and I wrote four scripts together. *State of Siege* you know, of course. We also wrote another movie you probably saw, *Mr. Klein,* which was directed by Joseph Losey. There were some problems with the production, they wanted a certain kind of casting, so I left. We also wrote *Cormoran,* which is about

multinational corporations, a very good subject, and one other script which I will probably do sometime.

Cineaste: *Is there a chance you'll film the* Cormoran *script?*

Costa-Gavras: We should revise it because the situation in Europe and the relationship with the multinationals has completely changed in the last three or four years. We have a socialist government in France now, and the Communist Party in Italy has a completely different position.

Cineaste: *Do you think the individual critic's or viewer's response to* Missing *will depend on his or her politics?*

Costa-Gavras: Yes, of course, it's an immediate reaction. What's most important, in terms of the viewer's response to a movie like this, is one's political convictions. It's an interesting psychological issue, because you accept or reject the movie. I've had some people tell me, "This is a great movie. Politically there are some things I don't understand, but I don't care about politics." They just respond to the human problems and ignore the political aspects, although both are related. Some people reject the whole movie, saying, "It's not true." This is not a superficial reaction, though—it's a politically profound one. People are somehow moved because it's a personal story, and the only way to get rid of that emotion is to reject the whole thing, to say, "It's not true, it's a fake story, I was manipulated." But you have to deal with that emotion, not just during the movie, but afterwards, the next day, and in discussion. I don't now if you can change people politically with a movie, but you can start a political discussion.

Index to Interviews in *Cineaste*

(Roman numerals refer to volume, numbers to issue)

Achugar, Walter, IV, 3
Addison, John, VIII, 2
Alea, Tomas Gutierrez, VIII, 1
Alvarez, Santiago, VI, 4
Arrabal, Fernando, VII, 2
Bacso, Peter, XI, 4
Badham, John, IX, 2
"Bardot, Brigitte," IV, 4
Bellocchio, Marco, IV, 1
Bergenstrahle, Johan, V, 2
Berger, John, X, 3
Bertrolucci, Bernardo, V, 4; VII, 4; X, 1
Bertucelli, Jean-Louis, IV, 4
Bird, Stewart, X, 2
Brownlow, Kevin, X, 4
Canby, Vincent, X, 2
Cine Manifest, VI, 3
Costa-Gavras, Constantine, III, 3; VI, 1; XII, 1
Dassin, Jules, IX, 1
Eguino, Antonio, IX, 2
Farr, Raye, IX, 2
Fassbinder, Rainer Werner, VIII, 2
Fofi, Goffredo, V, 3
Fonda, Jane, VI, 4
Gabor, Pal, X, 2
Garnett, Tony, X, 4
Gilbert, Bruce, IX, 4
Goldberg, Bernard, VII, 4
Granados, Daisy, X, 1
Hanson, John, X, 1
Haskell, Molly, XI, 3
Hidari, Sachiko, IX, 3
Hurwitz, Leo, VI, 3
Ibarra, Carlos Vincente, X, 2
Irola, Judy, X, 1
Karnad, Girish, XI, 4
Karmitz, Marin, IV, 2
Kartemquin Collective, VII, 1
Klaue, Wolfgang, VII, 3
Koff, David, IX, 4
Kopple, Barbara, VIII, 1
Kuehl, Jerome, IX, 2
Laurot, Yves de, III, 4; IV, 1
Lawson, John Howard, VIII, 2
Lierop, Robert Van, IX, 1
Lillienthal, Peter, XI, 4
Littin, Miguel, IV, 4
Loach, Ken, X, 4
Lopes, Fernando, VII, 3
McConachy, Susan, IX, 2
Mahoma, Nana, VII, 3

Makavejev, Dusan, VI, 2
Mariposa Film Group, VIII, 4
Marzani, Carl, VII, 2
Mehta, Ketan, XI, 4
Monty Python's Flying Circus, VII, 1
Mwinyipembe, Musindo, IX, 4
"Oscar," VIII, 1
Oshima, Nagisa, VI, 2; VII, 4
Palestine Cinema Association, VI, 2
Parks, Gordon, VIII, 2
Perry, Hart, VIII, 1
Petri, Elio, VI, 1
Poirier, Ann-Claire, X, 3
Poitier, Sidney, VIII, 3
Pontecorvo, Gillo, VI, 2; X, 4
Rauchendorf, Heinz-Dieter, VI, 3
Rocha, Glauber, IV, 1
Rosenthal, Alan, IX, 2
Rosi, Francesco, VII, 1
Rossellini, Roberto, VIII, 1
Rouch, Jean, VIII, 4
Sanjines, Jorge, IV, 3; V, 2
Sarris, Andrew, II, 1; IX, 3
Sayles, John, XI, 1
Schaffner, Franklin, III, 1
Schott, John, IX, 2
Schulberg, Budd, XI, 4
Sembene, Ousmane, VI, 1
Semprun, Jorge, IX, 4
Sen, Mrinal, XI, 4
Shaffer, Deborah, X, 2
Shrader, Paul, VIII, 3
Sjloman, Vilgot, VIII, 2
SLON (French film collective), V, 2
Solanas, Fernando, III, 2
Springer, John, X, 3
Tanner, Alain, VI, 4; VII, 4
Tavernier, Bertrand, VIII, 4
Traore, Mahama, VI, 1
Trevino, Jesus Salvador, VIII, 3
Varda, Agnes, VIII, 3
Vaughn, E. J., IX, 2
Vazquez, Emilio Rodriguez, X, 2
Vega, Pastor, X, 1
Vidor, King, I, 4
Volonte, Gian Maria, VII, 1
Wajda, Andrzej, XI, 1
Weir, Peter, XI, 4
Wertmuller, Lina, VII, 2
Yurick, Sol, IX, 3
Zanussi, Krzysztof, XI, 2

Dan Georgakas began writing about film for Detroit-area publications in the early 1960s. He first wrote for Cineaste in 1969 and has been associated with the magazine ever since. His academic training in labor history was obtained at Wayne State University and the University of Michigan. He has taught in various writing programs and universities in the New York-New Jersey area. Previous books include two histories of Native Americans, Red Shadows and The Broken Hoop; Detroit: I Do Mind Dying, a study of urban rebellion; In Focus: A guide to using film; and The Methuselah Factors—Strategies for Longer Life. He is presently working on Solidarity Forever, an appreciation of the IWW.

Lenny Rubenstein, an editor of Cineaste for over a decade, has his academic training in English (BA from New York University) and modern European history (MA from Brooklyn). He has taught at the New School for Social Research, branches of both the City University of New York and the State University of New York, as well as at Rutgers University, Adelphi University and Mercy College. In addition to frequent contributions to the alternative press, he has written The Great Spy Films—A Pictorial History.

5.9.86

11.95 pub.

#30180